KT-454-771

BECAUSE I TELL A JOKE OR TWO

Comedy, politics and social difference

Edited by Stephen Wagg

London and New York

First published 1998
by Routledge
11 New Fetter Lane, London EC4P 4EE

Simultaneously published in the USA and Canada
by Routledge
29 West 35th Street, New York, NY 10001

© 1998 Selection and Editorial Matter, Stephen Wagg.
Individual Contributions, each Contributor.

Typeset in Joanna and Bembo
by M Rules

Printed and bound in Great Britain by
MPG Books Ltd, Bodmin, Cornwall

All rights reserved. No part of this book may be reprinted or
reproduced or utilized in any form or by any electronic,
mechanical, or other means, now known or hereafter
invented, including photocopying and recording, or in any
information storage or retrieval system, without permission in
writing from the publishers.

British Library Cataloguing in Publication Data
A catalogue record for this book is available from the British Library

Library of Congress Cataloging in Publication Data
A catalogue record for this book has been requested

ISBN 0–415–12920–6 (hbk)
ISBN 0–415–12921–4 (pbk)

For my friend Ivor Dembina, who learned, eventually, to tell a joke or two

People say I'm the life of the party
'cos I tell a joke or two.
Although I might be laughin'
Loud and hearty,
Deep inside I'm blue.

Smokey Robinson and the Miracles
'The Tracks of My Tears'

CONTENTS

CONTENTS

LIST OF CONTRIBUTORS

Maggie Andrews is Head of Media Studies at Chichester Institute. She is currently writing a book about the Women's Institute for Lawrence and Wishart.

Frances Gray lectures in the Department of English Literature at Sheffield University and is the author of *Women and Laughter* (Macmillan, 1994).

Dave Huxley teaches in the Department of the History of Art and Design at Manchester Metropolitan University.

C.P. Lee teaches in the Centre for Media, Performance and Communications at Salford University. In the 1970s, he was a member of the band Alberto Y Lost Trios Paranoios, perhaps best-known for 'Heads Down, No Nonsense, Mindless Boogie', their moving tribute to Status Quo.

Jane Littlewood teaches Social Policy at Goldsmiths College, University of London and is the author of *Aspects of Grief* (Routledge, 1992).

John McCallum is a lecturer in the School of Theatre and Film Studies at the University of New South Wales in Australia.

Mike Pickering lectures in the Department of Social Sciences at Loughborough University. He is co-author of *Acts of Supremacy: Popular Theatre and Imperialism* (Manchester University Press, 1991) and co-editor of *Everyday Culture* (Open University Press, 1987).

Laraine Porter is film officer at the Phoenix Arts Centre in Leicester and also teaches Cultural and Media Studies at De Montfort University.

Mark Simpson is a journalist and author. His books include *Male Impersonators: Men Performing Masculinity* (Cassell, 1994), *It's a Queer World* (Vintage, 1996) and *Anti-Gay* (Cassell, 1996). He likes to think he's witty, but he can't tell a joke to save his life.

Stephen Small teaches in the Department of African American Studies at the University of California, Berkeley. Previously he was a lecturer in Sociology at the University of Leicester. His most recent book is *Racialised Barriers: The Black Experience in the United States and England in the 1980s* (Routledge 1994). He is currently writing a book about blacks of mixed origins (mixed race) in Jamaica and Georgia during slavery.

Stephen Wagg is a Senior Lecturer in the Department of Sport Studies at Roehampton Institute in London. He co-edited *Come on Down? Popular Media Culture in Post-War Britain* (Routledge, 1992) and *The Social Faces of Humour* (Arena, 1996). He also writes on sport and childhood.

Paul Wells is Senior Lecturer in Media Studies at De Montfort University in Leicester. His book *Understanding Animation* was published by Routledge in 1996 and he is now working on a full-length book about American situation comedy.

Frances Williams is a journalist and former editor of *Diva* magazine.

INTRODUCTION

Stephen Wagg

This book has emerged from the familiar dialogue between personal pre-occupation, political conviction and circumstances, as I will briefly explain.

For good or ill, and whether I intended it or not, I came from an early age to see myself as someone that others found funny. This experience made for a certain introspection. It was easy, for example, to feel that the facility for getting a laugh was the only aspect of me that might be of interest to the outside world. This would induce some panic if the expected laughter failed either to materialise, or to stop, in the right places. More importantly, my experience of humour itself became, and remained, ambivalent. Watching a comedy show on TV or listening to a comedian, I would find myself laughing, certainly, but more often judging, comparing or analysing, from the standpoint of a fellow producer. Comedians, especially the male ones, are often brittle creatures and natural competitors, liable to feel that a laugh gained by a fellow performer is a cheap one, or that a joke which was told well could nevertheless have been delivered better, or whatever. Besides, for such people ('us', as I felt, deep down) comedy is work and work, for most people, is not a laughing matter: I remember once telling a comedian friend one of the funniest jokes I'd heard in a while and telling it, I felt, very well – he gave a solemn nod, recognising the joke's merits, and replied simply: 'Good one'.

In the late 1970s I made a good friend who at the time was a teacher and playwright but who subsequently became a stand-up comedian. Through him I met and befriended other performers and these associations enabled me to organise some comedy shows of my own. I compered the shows myself, perhaps thinking that this was the logical extension into the world of work of a role I was already used to playing socially. I wrote my own material for these shows and this material was often so witty that it flew over the head of every member of the audience. True, in one show I got a couple of laughs as well but I knew now I should settle for being neither in, nor wholly out of, comedy. Writing about comedy, politically

and sociologically, seemed a better and, for me, more satisfying way of relating to the whole enterprise.

So I wrote a political analysis of British satirical comedy (Wagg, 1992) and was approached to write similarly on British 'alternative' comedy. This latter article would appear in a book on humour and society (Paton, Powell and Wagg eds, 1996) and, thinking that there should be more in the book specifically about comedy, as distinct from humour, I volunteered to find other contributors. I found several. Indeed, I found too many and it was soon apparent to me that there must be a separate book. This book should explore as many of the relationships between comedy, politics and social difference as I could think to confront. There were three reasons for choosing this theme.

First, it has been assumed in much commentary in this area that comedy has only briefly, and in the hands of certain performers, become 'political'. Some 'alternative' comedians in Britain, for example, were, according to this view, 'pretty political' in the early 1980s; now, though, they've either recanted or they've resolved to plough a lonely, if principled, furrow and have, in any event, been eclipsed by a regiment of cheerfully 'unpolitical' 'post alternative' comics. This seems to me quite wrong. Comedy invariably has a political thrust and, potentially, political consequences; it isn't only political when it is practised by a Marxist or when it involves a joke at the expense of the Prime Minister. The essays in this book, I hope, bear this out. All of them, in one way or another, see comedy in relation to powerful social and political ideas – assuming these ideas, undermining them, or perhaps challenging them.

Second, most people reading this book would, I think, accept the existence now of a multiplicity of political realms. The convergence of politics and culture in the post-war world has created new political discourses around a range of important social differences: in addition to state and party politics, therefore, we now speak of the politics of gender, of 'race', of sexuality, of ethnicity, of the body, and so on. One or other of these themes informs each chapter in the book. (The adoption of the term 'social difference' should not, however, imply a necessary endorsement, by the book's contributors, of the currently fashionable tendency – among postmodernists, those perceiving 'New Times', and others seeking to look 'beyond left and right' – to speak of social 'difference' as though social 'inequality' had somehow disappeared.)

Third, while there is some academic literature on humour and comedy, it deals predominantly with the theoretical aspects. I'm thinking here particularly of Michael Mulkay's book *On Humour* (1988) and two by the leading writer in the field Jerry Palmer, *The Logic of the Absurd* (1987) and the

more recent *Taking Humour Seriously* (1994). Between them, these books offer ample guidance to students on how comedy might be conceived and studied. Indeed, as Michael Pickering, one of the contributors to this book, remarked in reviewing *Taking Humour Seriously* 'enough ground has surely been theoretically set out for the satisfactory future development of this field. What we need from this stage on is a series of intensive case-studies of particular comic forms, particularly themes and issues concerning humour' (Pickering, 1995: 338). That is exactly what this book has tried to achieve; its chapters, while theoretically quite closely argued, are nevertheless primarily case-studies in the politics and history of particular comic forms in particular societies: Britain, the United States and, in one instance, Australia.

The contributions are arranged as follows:
The first two chapters are essentially about comedy and class. In Chapter 1 I discuss changing ideas and representations of social class in the British television sitcom since its inception in the 1950s. Then C.P. Lee considers class in relation to region when he gives an account of the life and career of Frank Randle, a comedian very popular during the early part of this century among the working classes of the North West of England.

Chapters 3 to 6 are variously concerned with comedy and gender. Here, first, Maggie Andrews offers a feminist reading of situation comedy, this time with regard to its portrayal of domestic life. Then Laraine Porter analyses the use of female stereotypes in British comedy and gives a largely Freudian reading of the busty blondes and looming harridans that have long been a staple in this area. Chapter 5 is also centrally about gender: Frances Gray examines the roles given to women in the now widely redeemed *Carry On* films. In addition, she has a number of important insights into the signification of the female body in comedy. This is followed by a wide-ranging interview with Jo Brand, one of Britain's most successful female comedians, much of whose act is about men, women, sex and the body.

Chapters 7 and 8 look at the relationship between comedy and sexuality. Mark Simpson discusses male double acts in comedy and the extent to which, in a homophobic society, they offer a 'safe' representation of same-sex tenderness. Then Frances Williams charts the development of the lesbian comedy scene in Britain, showing how the often overtly politicised lesbian comedy of the 1980s has given way to a new brand of comedy, rooted in the politics of desire.

Four chapters now deal variously with comedy as it has addressed 'race', nation or ethnicity. Chapter 9, by C.P. Lee, focuses on the Marx Brothers and relates their comedy to the experience of the (often Jewish)

immigrants who came to the United States at the turn of the twentieth century. Then, in Chapter 10, Paul Wells looks historically at TV sitcom in the United States, charting ideological shifts within the genre; Chapter 11, by John McCallum, shows how different comedians have reflected changing ideas of national identity in post-war Australia; and, in Chapter 12, Stephen Small offers an account of the development of black (mainly Caribbean-descended) comedy in Britain.

My own study of the relationship of comedians to political processes in the United States and Britain forms Chapter 13 and two final chapters discuss the now widely posed question (see, for example, Jacobson, 1997) of comedy and transgression: Dave Huxley then considers *Viz*, a magazine which makes important comic constructions of, among others, the people of the North East, of working class women and of 'juvenile humour'. Finally, Jane Littlewood and Michael Pickering offer a closely argued discussion of comedy and its relation to the contemporary shibboleth of 'political correctness'.

I'd like to acknowledge the help I had in setting this book up from Michael Pickering, Laraine Porter, and C.P. Lee. Thanks also to Jo Brand, who gave up a couple of afternoons to engage with me in the conversations which form the substance of Chapter 6 and, for friendship, encouragement, time and general assistance along the way, thanks also to Alec McAulay, Ivor Dembina and Ian McDonald.

BIBLIOGRAPHY

Jacobson, Howard (1997) *Seriously Funny: From the Ridiculous to the Sublime*, Harmondsworth: Viking.

Mulkay, Michael (1988) *On Humour*, Cambridge: Polity Press.

Palmer, Jerry (1987) *The Logic of the Absurd*, London: British Film Institute.

Palmer, Jerry (1994) *Taking Humour Seriously*, London: Routledge.

Paton, George, Powell, Chris and Wagg, Stephen (eds) (1996) *The Social Faces of Humour*, Aldershot: Arena Press.

Pickering, Michael (1995) Review of Jerry Palmer *Taking Humour Seriously* in *Media, Culture and Society* Vol. 17 No. 2 April pp 335–8.

Wagg, Stephen (1992) 'You've Never Had it so Silly: The Politics of British Satirical Comedy from *Beyond the Fringe* to *Spitting Image*' in Dominic Strinati and Stephen Wagg (eds) *Come on Down? Popular Media Culture in Post-War Britain*, London: Routledge.

1

'AT EASE, CORPORAL'

Social class and the situation comedy in British television, from the 1950s to the 1990s

Stephen Wagg

'Ay, and what do you dislike most, then?' asks Wilfred Pickles. 'Stuck-up fowk'. Roars of applause. 'Jolly good! and will you just tell me what you like most?' Good neighbourly fowk'. Increased applause. '. . . and very right too. Give her the money'.
> Richard Hoggart, describing a broadcast of *Have a Go*, a BBC radio show of the 1950s, in *The Uses of Literacy*.

And with every exaggerated anecdote and every shout of, 'Go for it my son', as they gulped another tequila slammer, they were desperate to prove two things. Firstly that they had money, and secondly that they'd made it themselves. They were definitely not old money. Because in Britain history has given us a distorted view of class, we seem to believe that the class we're from is determined not by your position in society but by your accent and whether you slurp your soup.
> Mark Steel *It's Not a Runner Bean: Dispatches From a Slightly Successful Comedian*

This chapter looks historically at the life of the different social classes in British society, as represented in television situation comedy.

The situation comedy is an important, but ambiguous, institution in the pantheon of British popular culture. On the one hand, situation comedies (sitcoms) are a staple of British broadcasting: in any given week, there will be a number of these programmes in the schedules of all the major television channels in the UK and, when one such show has run its course, it will, in the normal course of events, be replaced by another. On the other hand, while some – like *Steptoe and Son* (which ran from 1962 to

1

1974), or *Fawlty Towers* (two series: 1975, 1979) attained the status of 'classic', bringing regular repeat broadcasts for future generations, very few sitcoms have lived long in the memories of those who watched them. Of the 650 or so situation comedies written for British television since the Second World War, I doubt that many more than 40 or 50 are remembered by many people. Moreover, there is widespread derision for the banality, suburbanism and heavy-handedness perceived in the average British sitcom: the comedian and columnist Jeremy Hardy wrote recently of 'our feeble sitcoms, based on the premise that a sofa with people sitting on it is in itself funny' (the *Guardian* 30 November 1996). That said, both the revered 'classics' and the legion of forgotten or derided sitcoms are worth studying.

The 'classics' are perhaps most interesting at the level of consumption. This is because they travel across both time and social space: that's to say, in the domestic television market, they have an appeal that goes well beyond one social class or one age group. They therefore suggest to us something of what we are, as a society, and, within that, some of the more deeply embedded notions of class that might be found in the culture of post-war Britain. One theme I want to explore here is the widely canvassed idea (for example Bowes 1990) that successful sitcom in Britain has almost always hinged on ideas of authenticity and pretension in class identities: one central character may be pompous/aspiring/convinced s/he is better than all this, only to be trumped, time and again, by a doggedly unreconstructed companion.

But it is important also to examine the whole volume of output of situation comedy. The writers of these comedies are, after all, acknowledged for the acuteness of their social observation and were it not for the low kudos accorded both to television and to 'sitcom' as a specific form (something noted in relation to the United States by Paul Wells, elsewhere in this book), some of these writers – Ray Galton and Alan Simpson, Roy Clarke, Derek Waring, Dick Clement and Ian La Frenais, John Esmonde and Bob Larbey, Vince Powell and Harry Driver, Johnny Speight, Jimmy Perry and David Croft, Carla Lane, Laurence Marks and Maurice Gran – might be recognised as considerable dramatists. This is not to claim the work of these writers as the first rough draft of social class history in Britain, but their work does, I think, bear witness both to objective changes in the class structure of post-war British society and to trends in the culture of different social classes therein.

With these general thoughts in mind, then, I'll examine situation comedy on British television since its inception, having first clarified some basic matters of origin and definition.

SITUATION COMEDY IN BRITAIN: SOME BACKGROUND

Situation comedies have the following, broadly agreed, characteristics: they invariably come in series (usually of between six and a dozen episodes); they are normally broadcast at peak viewing times (between 7 and 9 pm); they have a core of regular characters, with familiar scenery and sets; they last for 30 minutes, occasionally longer; they have a form of dramatic plot; ordinarily, there is laughter on the sound track, recorded from a studio audience; each programme has a self-contained plot; it is usually made for the home market (although sitcoms are exported to other countries this is often, especially in the case of the United States, in format only); a happy ending is common; it is likely to be repeated (between 50 and 60 situation comedies are nowadays available on British TV in any given week. Of these around two thirds are repeats, the bulk of them on satellite channels); structured jokes are rare; action usually takes place in the British Isles in the present or recent past; and certain writers and producers will tend to specialise in the making of these programmes (see Taylor 1985: 15; Bowes 1990).

As a popular cultural form the sitcom, at least in Britain, grew out of the light entertainment provision for BBC Radio in the 1930s. Two influences combined to bring it about: the sketches, derived from music hall and variety, which comedians like Arthur Askey and Richard Murdoch began to perform as part of a longer show – their show *Band Waggon*, first broadcast in 1938, is thus the earliest forerunner of British sitcom proper – and the sitcoms already current on US radio, which BBC executives had heard on visits to the United States.

Radio comedy in Britain boomed during the Second World War, the government having closed all cinemas and theatres, and here the show that gained the greater hold upon the popular imagination was ITMA. ITMA ran from 1939 to 1940 and again from 1942 to 1949. Its title was taken from a headline in the *Daily Express* (IT'S THAT MAN AGAIN, referring to Hitler) and its concoction of class stereotypes (gin-soaked colonels, screeching cleaning ladies, meddlesome men from 'the Ministry'), one-liners and funny voices was immensely popular: at its height it had an audience of around 16 million and between 1943 and 1949 there were over 35 shows a year. During its lifetime ITMA maintained the important sitcom traits of regular characters, plots (of a kind) and, at least for a series or so, a stable locale (successively a ship, a seaside resort, a manor house, a far distant country, a Scottish castle and a guest house for tramps).

After the war there was a steady output of radio comedies about the

3

demobilising of the armed forces: in *Stand Easy* (1946–51) a bunch of soldiers are launched on 'civvy street', in *Much Binding in the Marsh* (1947–54) an RAF station is converted into a country club, with all the airmen now in civilian occupations, and so on. But the trend now was toward domestic comedies, notably *Ray's a Laugh* (1949–61), in which the comedian Ted Ray bantered with his fictitious wife, played by Kitty Bluett, and *Take it From Here* (1948–60), which featured a family called the Glums (Medhurst 1989, Taylor 1994).

There was almost no TV sitcom during the early 1950s, when the BBC still had a monopoly on broadcasting. In fact history records only a couple: *Life with the Lyons*, based on the real family life of the American couple Ben Lyon and Bebe Daniels, which was on both radio and TV in the early 1950s, and *Emney Enterprises* (1954–7), written by and starring Fred Emney, whose unvarying comic persona was of a large, inebriated, upper class male, who puffed a cigar and peered through a monocle. One should also include *Billy Bunter*, the stories of a guilelessly greedy boy at an Edwardian public school: *Bunter* ran from 1952 to 1962 and was broadcast twice in an evening – not an unusual practice at that time.

Situation comedy on television began to proliferate in the late 1950s, however, a development almost wholly attributable to the introduction of ITV in 1955: in the second half of the decade around 14 sitcoms were generated for BBC television and 18 for ITV companies. At the BBC this involved the transferring to TV of several more existing radio sitcoms.

THE 1950s: NEVER MIND THE BARRACKS

Few of the situation comedies written for television in the 1950s lasted for more than a single run of six episodes, and almost none will be recalled now, except by archivists. Nevertheless, although the programmes are diverse, some of the contours of social class which have tended to define British situation comedy since then were already visible in this decade.

There is, first of all, a general avoidance of working class life. Only *Club Night*, which was shown on BBC television in 1957 (and ran from 1955 to 1958 on radio) seems to have attempted this. It was set in a Working Men's Club in the north of England. Here, as so often subsequently, much of the humour derived from the petit bourgeois traits of a central character – in this case, the bossy club treasurer.

Second, sitcom writers and audiences have always favoured the character who is culturally 'of the people' but who is formally working on his own account. This character – the tipster, the travelling salesman, the wheeler-and-dealer, and so on – has ducked and dived his way through

a myriad of sketches, sitcoms and comedy routines. Max Miller played him on stage and Miller's jokes fed the popular male fantasy of freedom from domestic surveillance and regular access to sexually available landladies and other 'girls as do'. The appeal of such a character was that he seemed to serve no master, being free of the constraints either of being employed by others or of the collectivised life of the shop floor. These characters were particularly popular in variety after the Second World War: stand-up comics such as Arthur English (English and Linton, 1986) represented the 'spiv' or 'wide boy' who flourished during rationing and could always find you a joint of beef or a pair of silk stockings.

In the 1950s these sitcom characters often did their conniving in uniform, reflecting the continuance of conscription in Britain at the time. There were shows such as *The Skylarks* (BBC, 1958) about a Royal Navy helicopter crew, *Tell it to the Marines* (Associated-Rediffusion, 1959) and *The Army Game* (Granada, 1957–61), the latter containing an archetypal wide-boy character (Corporal Springer) to set beside Sergeant Bilko of *The Phil Silvers Show*, imported from the USA. (Through regular repeats, Bilko remains a favourite with British television audiences, 40 years on and long after it has been forgotten in the United States.)

Elsewhere, similar characters could be found in *Educated Evans* (BBC, 1957–8), in which Charlie Chester played a Cockney racing tipster (portrayed originally by Miller in a film of 1936) and *East Side – West Side* (Associated-Rediffusion, 1958), in which Sid James, as his first solo vehicle, plays a Jewish trader in the East End of London.

A variant here was the amiably work-shy – as in *Nathaniel Titlark*, a poet and son of the soil (BBC, 1956–7) and *The Artful Dodger* (BBC, 1959), who preferred supporting Manchester City to gainful employment. Similarly *Club Night* contained a character called 'The Wacker', who was always trying to scrounge a drink.

Third, there is also a fondness, especially in the military sitcoms, for an aristocratic stereotype: effete, bumbling and possessed of extremely cumbersome names: *The Army Game*, for example, threw up officers called 'Upshot Bagley' and 'Geoffrey Gervaise Duckworth', while *The Skylarks* offered Vice Admiral Sir Godfrey Wiggin-Fanshawe and Captain Crocker-Dobson. These names are 'fancy' and signify 'toff': as the writers of *ITMA* and the forces comedians of the 1950s found, there were many laughs to be had at the expense of the officer class.

Finally, in the formats of TV sitcoms of the 1950s, there is already ample recourse to the media and showbusiness professions: *Dear Dotty* (BBC, 1954) is set in a women's magazine; *Joan and Leslie* (ATV, 1956–8) features the writer of an agony column; in *Living it Up* (Associated

Rediffusion, 1958), Arthur Askey and Richard Murdoch run a pirate TV station from the roof of Television House, in the style of their earlier *Band Waggon*; *Don't Tell Father* (Associated-Rediffusion, 1959) is about a screenwriter; in *Gert and Daisy* (Associated-Rediffusion, 1959), veteran entertainers Elsie and Doris Waters play veteran entertainers now running a theatrical boarding house; and *My Husband and I* (Associated-Rediffusion, 1956), *Our Dora* (Granada, 1956–7) and *The Two Charlies* (BBC, 1959) all featured theatrical folk – the first of these placed at the genteel end of showbusiness (represented by the actress Evelyn Laye and her husband, playing themselves), while the latter two were set in the dying days of that essentially working class entertainment: the variety theatres. *Scott Free* (BBC, 1957) is about out-of-work actors who become entertainments officers in the fictitious seaside resort of 'Bogmouth'.

These sitcoms, then, are on the whole not about the interior life of the social classes; few of them are about families, as such, nor do they probe family relationships unduly. Only one sitcom of this period (*The Larkins*, ATV 1958–60) has a suburban family setting and in another (*Abigail and Roger*, BBC 1956) an engaged couple never kiss. The sitcoms of this time are more likely to have non-domestic contexts – ordnance depots, boarding houses, private schools, newspaper offices, and so on – and the more successful ones feature characters who, in a comparatively rigid social structure, find some small social space to call their own: crafty wide-boys and duckers and divers doing shady business. The most powerful TV situation comedy of the decade, though, appears to have been generated by a character set deliberately in apposition to these survivors and their ways of getting by: this is the role played by Tony Hancock in *Hancock's Half Hour*, which transferred from radio to television in 1956.

TONY HANCOCK AND THE POLITICS OF EAST CHEAM

The bare bones of Hancock's biography, personal and professional, are well known. *Hancock's Half Hour* began on radio in 1954; it ran, with great success, on radio and TV concurrently between 1956 and 1961 – by 1960 it was attracting 28 per cent of the adult population, or around half the viewing public (Goodwin 1995: 112); in 1961, Hancock dispensed with Sid James, his co-star and foil, and produced a solo sitcom called simply *Hancock* (BBC, 1961–33), whereupon he parted from his writers, Ray Galton and Alan Simpson. He was unable to repeat the success of his incarnation as 'Hancock', descended into alcoholism and killed himself in 1968. The character created by Galton, Simpson and Hancock has endured

in a way that none of Hancock's other work has. There are regular repeats of the shows, sales of cassettes and videos are high and there have been two remakes of the show. One, with actors Arthur Lowe and James Beck taking the parts of Hancock and James respectively, was aborted in 1973 on the death of Beck (Lowe, 1996: 132); in the other, in 1994, comedian Paul Merton replayed the solo shows of 1961–3. The scripts have also been redramatised in other languages (Sweeting, 1996). All this establishes *Hancock* as a popular cultural phenomenon.

The context for the Hancock programmes is in a sense domestic, but makes no concession to social realism. Initially, on radio, he lives or associates with largely unexplained characters played by Hattie Jacques, Kenneth Williams, Bill Kerr and Sid James, the most important, aside from Hancock's own, being James's. Later, on TV, he shares with James alone, while, as a private individual, nursing worries that the relationship might be thought 'poofy' (Hancock and Nathan 1969: 76).

The Hancock character is in many ways the model of a dyspeptic, status-anxious, petit bourgeois suburbanite stomping grumpily about the lower reaches of Middle England. Geographically, he is deliberately placed on the tantalising edge of respectability: the writers take Cheam, a comfortable middle class dormitory area in the South London suburbs and strand Hancock, not only in 'East Cheam' ('East' in London signifying 'working class'), but in a road called 'Railway Cuttings', houses next to railway lines being the least desirable. Then, in 1961, the character has moved to Earls Court, close enough to the West End of London to give the promise of sophistication but known, nevertheless, for its numerous low rent flats and cheap hotels. 'Hancock' has no visible means of support, while 'James' is the archetypal Cockney doer of dodgy deals, laughing a sensually raucous laugh and remaining oblivious to Hancock's pretensions. Hancock's part, which bears the absurdly grand full name of 'Anthony Aloysius St John Hancock II' expresses, as his first posthumous biographer noted, 'childishness, obstinacy, indignation, rudeness, prejudice, lechery, the abandonment of principles for profit or status, ignorance, arrogance, smugness, ambition, pomposity, stupidity and cunning' (Hancock and Nathan, 1969: 79). These numerous failings are redeemed partly by the character's recourse to colloquialisms like 'Stone me!' and 'bonkers', unacceptable lapses for the genuinely aspiring in the 1950s, and, chiefly, by his vulnerability. Ultimately the Hancock character is not oppressive, so much as lost, in his pretension. Ironically the pathos of 'Hancock' was seen to its greatest effect when the regular cast, created to play off his pomposity, had departed: in his best known show, 'The Blood Donor' (1961), 'Hancock' is completely humiliated when, having summoned the courage to give blood, he is told

that the brief blood test he undergoes initially is not, as he has supposed, the actual donation. 'It may be just a pinprick to you, mate', he tells the doctor, still uncomprehending. 'But it's life and death to some poor bloke'.

Reflecting later on the success of the project with Hancock and James, writer Ray Galton said: 'It wasn't so much the crookedness of Sid that we used as his earthy realism, as opposed to Hancock's phoney artistry' (quoted in Goodwin, 1995: 109). It's this interplay between realistic and romantic notions of the relationship between the social classes (or the sexes – see Maggie Andrews' chapter in this book) which seems to me to characterise the most successful sitcoms on British television. The changing nature of this interplay forms the principal thread running through the rest of this chapter.

THE 1960s: IN SEARCH OF REAL CLASS

Around one hundred situation comedies were developed for British television in the 1960s, again mostly from original ideas, with the occasional adaptation of an existing novel. This decade, therefore, sees the establishment of the genre in Britain, but, although many – perhaps half – of these have a domestic setting – the period is notable more than anything for its diversity: of social class and work contexts, of domestic arrangement and of region, among other factors. Straightforward married couples, with or without children are on the whole rare and account for only around a dozen sitcoms during the 1960s.

This will have derived in part from a liberalisation both in the arts, with the emergence of working class playwrights, the writing of 'kitchen sink drama' (Taylor, 1963) and the final withdrawal of the Lord Chamberlain's powers to censor British stage plays in 1968; and in broadcasting administration, exemplified in particular by the 'mischief' (Hare, 1982) encouraged by Sir Hugh Greene during his Director Generalship of the BBC (1960–69). Thus, during the 1960s, we have the first situation comedies to focus on members of the clergy: *Our Man at St Marks*, about an eccentric vicar (Associated-Rediffusion, 1963–5), *All Gas and Gaiters* (BBC, 1967–71), featuring a bishop, a chaplain, a dean and an archdeacon and *Oh, Brother*, about a novice monk (BBC, 1968–70). Likewise, there is the first sitcom set in a prison: *Her Majesty's Pleasure* (Granada, 1968–9).

The diversity of locales takes in bedsits (*The Bedsit Girl*, BBC 1965), hairdressing salons (*Barney is My Darling*, BBC 1965–6), Co-op wet fish counters (*The Big Noise*, BBC 1964), law courts (*Brothers in Law*, BBC 1962; *Misleading Cases*, BBC 1967–71), bus depots (*On the Buses*, 1969–1973), hospitals (*Doctor at Large*, LWT 1969–70), hotels (*The Flying Swan*, BBC 1965), ships

(Mess Mates, Granada 1960–1; HMS Paradise, Associated-Rediffusion, 1964) and small Mediterranean countries (If the Crown Fits, ATV 1961). Explicit effort is also made to encompass different regions of England in TV sitcom, as with The Likely Lads (BBC, 1964–6), which was set in the north east; Nearest and Dearest, which featured the fractious relationship between a brother and sister who inherit a pickle factory in Lancashire (Granada 1968–72) and The Liver Birds, about two young women in Liverpool (BBC 1969–79, revived 1996).

Reference to the home life of the suburban lower-middle classes is comparatively scant, and, when it takes place, this life appears repressed and stultified, as with the mother-dominated child-man persona first played by Terry Scott in Hugh and I (BBC, 1962–4) and re-presented by him in subsequent sitcoms.

There are reprises for the shady wheeler-dealer character (Citizen James, BBC 1960–2; Corrigan Blake, BBC 1963) and sometimes he has a stable institutional context – as in Three Live Wires (Associated Rediffusion, 1961), in which Michael Medwin portrays a crafty Cockney foreman in a TV repair and sales shop, looking after his mates and subverting the pompous shop manager. But three themes seem to me to be important in the writing and the public reception of British sitcom in the 1960s.

First, there is a concern, variously expressed, to represent working class life. In The Rag Trade (BBC 1963–5; LWT 1977), for example, the action takes place on the shop floor and revolves around the powerful advocacy of the workers' interests by Miriam Karlin's shop steward, and the bafflement of the shop manager (Peter Jones) and the foreman (Reg Varney) in dealing with her. Since none of these major players is demonstrably more unscrupulous than the others in the conduct of industrial relations, this is an essentially sympathetic portrayal of unionised factory life. In some sense a wheeler-dealer in the Sid James mode, nevertheless Karlin's character is militant on behalf of her class, rather than herself, and this seemed to inspire widespread public affection: her frequent injunction in the programme, 'Everybody out!', became a popular catchphrase in the mid-1960s (Taylor, 1994: 212–13).

Working class sitcom then moves in different directions. The Dustbinmen, which was developed from his own play by Jack Rosenthal and ran to three series for Granada (1969–70) weds sympathy to social realism in the portrayal of working class life; the men swear, read 'girlie' magazines and conduct various fiddles behind the back of the officious depot manager. Despite complaints by 'clean up TV' campaigners (such as the National Viewers and Listeners Association, founded in 1964), the programme was regularly top of audience ratings.

More significant, however, in the quest to create 'real' proletarians in TV sitcom is *Till Death Us Do Part*, which ran on BBC television from 1965 to 1975 and was renewed, first on ATV (1981), and then, using most of the original characters, as *In Sickness and in Health* (BBC, 1985–92).

Of all the writers of sitcom for British TV, Johnny Speight, who scripted *Till Death* . . . is probably the one most determined to present an unretouched picture of working class life. The show, set principally in the home of an middle-aged docker called Alf Garnett, grows out of Speight's early life in Canning Town, a dock area in London's East End. In his early career, Speight had written mainly for comedian Arthur Haynes, who in his TV show specialised in 'various know-all working class types bucking against authority', but, as Speight recalled, the

> limitations I had as a writer were engendered by a silly convention that because he was Arthur Haynes, and it was *The Arthur Haynes Show*, there was a danger that anything he said in character would be taken out of character and attributed to Arthur Haynes the TV personality, i.e. if Arthur, portraying a typical working-class character, had referred to coloured people as 'them coons' and 'nignogs' in the way that say Alf Garnett does, he could have had the stigma of racial prejudice attached to his own name. Whereas when Alf Garnett says it, no blame can be attached to Warren Mitchell, the actor who portrays him. . . . As a writer I found this becoming more and more irritating and wanted more and more to delineate characters who would take the blame for their own abysmal ignorance . . .
>
> (Speight, 1973: 232)

Speight worked through a complex and contradictory politics, wishing partly to celebrate working class life and partly to ridicule the reactionary elements within it. Garnett's racism and sexism, because it was so often humanised by pathos, made it one of the most controversial sitcoms in the history of British television; moral guardians of the right disliked the language, while sections of the left saw it as an endorsement of anti-social attitudes.

In the ITV companies, by contrast, there is the development of a heavily caricatured working class. Whatever else may be said of *On the Buses*, which ran for 73 episodes between 1969 and 1973, it made no pretence to social or political realism. Its characters – bus drivers, apoplectic at the sight of girls in mini-skirts, lugubrious inspectors and looming wives – are reminiscent of the seaside postcard humour of Donald McGill (Orwell, 1941) and the drama is escapist and low farce. Ironically, Speight

produced a similarly farcical sitcom for LWT called *Curry and Chips* (1969), but, whereas *On the Buses* had concentrated on work, (imagined) sex and domesticity, *Curry and Chips* had a racial theme and featured the white comedian Spike Milligan, blacked up as a 'Yez-Pliz' Asian stereotype, paradoxically with an Irish name; it caused widespread revulsion and closed after one series.

Second, there is a marked determination on the part of some writers to explore the interior life of the different social classes. In *Till Death . . .*, for example, although Alf is occasionally seen on the docks, most of the action takes place in the home of the Garnett family, with the right wing father railing either at his son-in-law, who is unemployed and a socialist, his daughter, or at his wife. The anger he expresses toward his wife usually blunts itself on her obliviousness and he is redeemed, like 'Hancock', by pathos: he is invariably humiliated in arguments; he often becomes frustrated and close to tears and, as many viewers will have seen it, he did work for his living, in contrast to his daughter's husband, however more enlightened the latter's views on social questions might have been. In the sitcoms which depict the family life of the middle classes, too, there is a more realist tendency: in *Marriage Lines* (BBC, 1963–6) George Starling, a young, newly married clerk in the City, argues frequently with his wife Kate (in one episode, they unintentionally persuade the girlfriend of one of George's work colleagues to consent to marriage: their row at the party where the question is popped overcomes her previous conviction that marriage would be boring); similarly, in *Not in Front of the Children*, a title which evokes the classic suburban hypocrisy of hiding marital discord from younger members of the family, a solid middle class couple quarrel and make up regularly over 35 episodes (BBC, 1967–70).

Third, the issue of social mobility has a sharper treatment in the 1960s. Reference to particular perceived social trends – the growth in social mobility, the emergence of the geographically mobile 'affluent worker' (Goldthorpe, *et al.*, 1968a, 1968b, 1969) and the consequent decline of the traditional working class community (Willmott and Young, 1958; Hall and Jefferson 1976) – was the common coin of public discourse in Britain in the 1960s. Sociologists had, since the 1950s, been deliberating upon the problems of 'meritocracy', and the notion, popularised by the Labour Party, of a new Britain, based on achievement, rather than aristocratic privilege, was an important theme in the General Election of 1964. As Westergaard and Resler noted, a few years later:

> The premise that individuals are markedly less tied to a particular socio-economic level from birth to death than they were a

generation or two ago, is built into a great deal of commentary about contemporary society – professional and lay commentary alike.

(Westergaard and Resler, 1976: 279)

Some, they observed, welcomed this apparent new fluidity in a previously rigid class structure; others feared 'a loss of personal anchorage' (Westergaard and Resler, 1976: 279–80).

In their separate ways, *Steptoe and Son* (eight series, BBC, 1962–74) and *The Likely Lads* (three series, BBC, 1964–6) address this theme. Both are built around the relationship between two men (father and son, workmates, respectively) and they are driven, comedically, by the aspiration of one, which blunts itself on the immutability of the other. *Steptoe and Son* are rag and bone men living in Shepherds Bush, an area of inner West London, known for its markets and traders. Their house is awash with the tatty and useless bric-a-brac they have accumulated and they are manifestly poor. Harold, the son, talks (unfeasibly) of bettering himself and has larded his accent in anticipation of doing so: this half-gentrified voice (he frequently calls his father a 'darty old man') generates much of the comedy. The father, Albert, mocks his son's pretension and remains earthily and can-tankerously himself. He's not above feigning helplessness, though, if Harold ever does look like leaving, but there is never a sense that he will. The Steptoes represent a lumpen petit bourgeois – a kind of lower middle class in rags. Although beholden to no bosses or shop stewards, they are neither duckers nor divers. The deals they do are most likely dodgy for them, bringing them old pots and pans and white elephants. They will never be other than they are and they find a dignity in that; one realises this, and the other doesn't, which, again, is a major factor in the comedy.

The Likely Lads, by contrast, although it has a similar theme, is about working-class, wage-earning people, with some scenes set on the shop floor. Moreover, for one of the two central characters, the prospect of social mobility is real: indeed, when the show was revived in 1973, he had a new job in middle management and was engaged to the boss's daughter.

In the first series, Bob Ferris, who's employed in an electrical compo-nents factory in Newcastle, is ambitious and Terry Collier, his workmate, isn't. Terry's life is one of unpostponed gratification – beer, girls, having a laugh – while Bob is more sensitive; he wants a career and marriage. Bob frequently rebukes Terry for his fecklessness but throughout, even when he has moved into a white collar world and married, part of him is nevertheless drawn to Terry's way of life. In *Whatever Happened to . . .*

Bob's fiancée/wife Thelma becomes the third main character. She represents striving, onward and upward to ever greater respectability. Pragmatic and exquisitely pretentious, Thelma tries to ensure that Bob makes all the right moves in relation to his career and his new class position, but this increasingly becomes a war for her husband's soul (they marry at the end of the first series), with 'that Terry Collier' trying, as she sees it, to tempt Bob to perdition.

Steptoe and Son and The Likely Lads are two of the most enduring British sitcoms in popular cultural memory, and many who have reflected on them will have read them as essentially conservative, in effect telling members of lower social and cultural groups that they should know their place. This was the strong impulse in working class life recognised by Hoggart in The Uses of Literacy: you must never want, or think yourself, to be 'a toff'. But there are alternative interpretations. One might be that for Harold Steptoe and Bob Ferris to fulfil their aspirations and live happily ever after would, aside from not being funny, be an unacceptable complicity in the sustaining of an exploitative society: while there is a working class, then better to be in it. Another reasonable inference is that cultural authenticity is what counts: to want to be successful does not in itself condemn a person, but to moderate your accent to please your social betters, in the manner of Harold Steptoe and Bob and Thelma Ferris, does. In this latter context, it's possible to argue that such comedies were viable only in a society wherein class (economic position) and status (culture, social honour) were, effectively, the same thing. But the prevailing ideology of 'openness' in British society during the 1960s, bulwarked by the media celebration of pop stars, film actors, photographers and the like who came from working class backgrounds, brought with it an important severing of class and status: by the late 1960s, for a large segment of the British population, you could be rich, successful and drop your 'h's.

These considerations are, of course, redundant in relation to the other major situation comedy of the 1960s. Dad's Army, which ran on BBC from 1968 to 1977 takes place during the Second World War and features a mostly aged platoon of the Home Guard planning to defend a British seaside town against the Germans, should they invade. The focal character is Captain Mainwaring, a local bank manager in uniform, whose pomposity founders in the escalating shambles of the platoon's operations: several members are clearly too old for any kind of active duty; his languid second-in-command, Sgt. Wilson, seems to take little notice of him; another member, a spiv with a pencil moustache, conducts black market business; officious minor functionaries rush in to invoke regulations governing the use of the church hall, and so on. There is no subversion or

overt disrespect for Mainwaring; it is simply that his brusqueness and delusions of military grandeur become pathetic when set against the group's collective incompetence.

Dad's Army harks back to a world in which social positions were more rigid and relationships more straightforwardly authoritarian. In such a social world the petit bourgeois class harboured historically nurtured resentments which flowed both upward and downward. As John Le Mesurier (who played Sgt. Wilson) recalls, the role of Captain Mainwaring identified:

> a central, but rarely performed character in the British class system – the product of the lower middle class – essentially conservative, fiercely patriotic and strong on the old values – but a natural opponent of idle aristocrats as much as of upstart workers. Naturally, Captain Mainwaring disapproved of Sergeant Wilson, whose accent and manners suggested a comfortable background, one that had evidently removed any sense of ambition or daring. Indications of sloppiness or excessive caution ('Do you think that's wise?') were met by explosions of indignation and a frenzy of activity signalling another usually hopeless adventure for the Walmington Home Guard.
>
> (Le Mesurier, 1985: 114)

There is, of course, a reassurance to be derived from situation comedies rooted in a social structure of the past, in which people do not look beyond their social positions and authority is undermined, not by deliberate subversion but by mounting, unintended chaos. Not surprisingly, therefore, the writers of *Dad's Army*, Jimmy Perry and David Croft, have provided a steady supply of similarly situated comedies to the BBC since this initial success: It *Ain't Half Hot Mum* (1974–81) is about a British Army concert party performing in India, once again during the Second World War; *Hi Di Hi* (1980–88) takes place in a holiday camp during the late 1950s; *You Rang M'Lord?* (1988–93) is set in a stately home, apparently in the 1920s; and the principal characters of *Oh, Dr Beeching* (1996) all inhabit a village railway station, before such places were closed, following the recommendations of the Beeching Report of 1963. In these latter comedies, otherwise rigid class relationships are increasingly subverted, not only by chaos, but by lust: in It *Ain't Half . . .* 'the bellowing Sgt Major Williams' looms large over a camp performer called Gloria, 'scattering malapropisms and disparagements against all men who dress as women' (Howes, 1995); in *Hi Di Hi*, the resident radio announcer smoulders with

half-concealed desire for the young toff who, improbably, manages the holiday camp; in *You Rang M'Lord?* a young lesbian aristocrat fancies her father's maid; and in *Oh, Doctor Beeching*, behind the strict proprieties of station life, the manageress of the snack bar is, apparently, conducting an affair with the stationmaster. A similar concoction is to be found, in more baroque form, in the long running *Are You Being Served?* (BBC, 1973–85), for which Croft was again co-writer. Here the cheerful vulgarity of the seaside postcard enters a department store, old world in ambience although this time not apparently set in a previous era, and mocks it's Edwardian status hierarchy: the camp Senior Sales Assistant frequently announces that he's free, the Head of Ladies Fashions, who commits the cardinal sin of trying to 'talk posh', frets constantly about her 'pussy', and so on. As in the *Carry On* films (more extensively discussed by Frances Gray in this book), the self-importance of these minor authority figures is undone by the sexual innuendo they can't help uttering: they cease to be their positions, and become their bodies instead.

THE 1970s: BEING SERVED?

The 1970s brings a further 175 or so situation comedies to British television screens, signalling the increased importance of this kind of programme in the pursuit of audiences. A review of this substantial body of work reveals, most notably, a more central concern with the personal and domestic problems of middle, and lower middle class life and, although there are other developments and continuations, which should be discussed, this trend seems to define the decade.

Few sitcoms of the 1970s deal focally with working class life, and, of the ones that do, none has left any lasting memory. Certainly little cultural significance can be ascribed to *Under and Over* (BBC, 1971) in which the singing group The Bachelors played Irish navvies working on the Waterloo Tunnel in London; or to *Up the Workers* (ATV two series 1974, 1976) which was set in a Midlands factory; or to *The Wackers*, which was made in 1975 by Thames Television, featuring a Liverpool family of intermarried Protestants and Catholics and caused widespread protests on Merseyside. Comparatively few involve the direct subversion of authority, although the fondly remembered *Porridge* (BBC, 1974–7), in which a crafty convict runs rings round an officious prison officer, is an important exception here.

There is the occasional recourse to the past, as with the popular *In Loving Memory* (YTV, 1979–86), in which a woman runs an undertaking business in a northern town during the 1920s, assisted by her gormless nephew

(six series 1979–86) and *Get Some In* (Thames, 1975–7) about three young men of different backgrounds, serving in the RAF in the 1950s. The existence of black families in the British class structure is at last acknowledged in sitcom (*The Fosters* LWT, 1976–7; *Empire Road* BBC, 1978–9) and there is still the occasional concession to region. This might mean a straightforward northern setting, as with *Our Kid* (Yorkshire TV, 1973); it might be in the context of a north/south theme: for instance, in *Not on Your Nellie* (LWT, three series beginning in 1974) a Bolton woman comes south to help her father run a London pub and in *Odd Man Out*(Thames, 1977) the owner of a Blackpool fish and chip shop inherits a factory in Sussex from his father; or it might be in an unspecified 'generic north', wherein *Last of the Summer Wine* (BBC, 1973–) is situated. This latter, which, at the time of writing, has run for 23 years and around 150 episodes presents a whimsical and mummified social world occupied principally by three elderly male characters. One offers sardonic reflections on village life; one harmlessly falsifies his war record; the third, rejecting the gentle sobriety of the other two, lusts openly after a local woman. She is a classic harridan figure, one of several in the cast who represent the kind of small town, lower middle class respectability that is upheld by people who know 'what's what'. As in McGill's picture postcard world (Orwell, 1941), the various men of the village flee before such women and, in one instance, seek solace with the only other type of woman in this social world: the brassy blonde (see Chapter 4). *Last of the Summer Wine* exists to a degree outside of a specific time, space and social class – part, perhaps, of it's appeal.

From time to time, too, sitcom writers during this period address the plight of the aristocracy, many of whom are now facing genteel penury in their huge country homes: in *The Last of the Baskets* (Granada, 1971–2) the twelfth Earl of Clogborough abandons his stately home and huge debts in favour of a distant relative, the humble Clifford Basket; in *A Class By Himself* (HTV, 1972), the impoverished Lord Bleasham comes to rely on money-making schemes devised by a student hitchhiker; in *His Lordship Entertains* (BBC, 1972), Lord Rustless turns his stately home into a hotel, of which he becomes the inefficient manager; in *The Upper Crust* (LWT, 1973), the reduced circumstances of a peer and his wife land them in a council flat; and in *To the Manor Born* (BBC, 1979–81) an aristocratic widow with financial problems sells her ancestral home to a *nouveau riche* grocery tycoon, moves into a small lodge in the grounds and travels tempestuously toward romance with the new owner – a symbolic rapprochement between new and old elites.

But most situation comedies of the 1970s are, one way or another,

about the interior life of the London middle and lower middle classes and, in particular, about the access, or otherwise, to various satisfactions.

To begin with, in the 1970s, there is a proliferation in British sitcom of the child-man phenomenon. The leading character in *Some Mothers Do 'ave 'em* (BBC, 1973–8), hapless, accident-prone Frank Spencer, lacks any serious class dimension. But Ronnie Corbett's mother-dominated bachelor in *Now Look Here* (BBC 1971–3) does not. He works in an office and, when there, he feigns a liberal attitude but, in reality, because of his mother, he has no fun, fun being by now a permissible aspiration for middle class people, following the relaxation of various laws and attitudes in the 1960s (Newburn, 1991). The series leads him out of his domestic shackles toward marriage and the running of a pub, the setting of a sequel, *The Prince of Denmark* (1974). The childishness of the character played by Terry Scott in *Happy Ever After* (BBC 1974–8, returning as *Terry and June* 1979–87) lies largely in the cravenness with which he regards his employer and the panic he evinces when some shelves in the marital home fall down twenty minutes before the boss and his wife are about to arrive for dinner. In *Happy Ever After*, Terry and June live in Ealing; in *Terry and June*, they are transplanted, with a new surname, to Purley, a South London district more widely associated with lower middle class, suburban conformity. Terry survives these crises because, as Maggie Andrews notes in her chapter (see Chapter 3), June has so much more sense than her child-husband, but, ultimately, he has no more fun than the Corbett character: his insecurities and his uptightness condemn him. In an episode of *Happy Ever After* the bombastic Terry, chatting in bed with June, has a tantrum when he learns that she doesn't vote Conservative, nor does she like the chocolate liqueurs he has been bringing her weekly for many years: she gives them, she tells the mortified Terry, to the cleaning lady who, Terry immediately exclaims, is 'a socialist'. June patiently persuades Terry to consider a list she is compiling of his faults ('Well, if you can think of any'). She also suggests that sex should be preceded by a little romance. They return to their honeymoon hotel where, in the morning, June has another item for her list.

Some sitcom writers, it appears, tried to deal more openly with the matter of gratification by creating middle class characters actively in pursuit of illicit pleasure. A flurry of shows appeared featuring businessmen 'with an eye for the ladies', and so on, but none, apparently, caught the public imagination. In 1973, for example, Galton and Simpson wrote *Casanova* for the BBC, in which a licentious public relations executive conducts numerous flirtations, while his wife, secretary, and god-daughter frown on. Despite being portrayed by the popular character actor Leslie Philips, *Casanova* closed after one series. Similarly, no more was heard of

Birds on the Wing (BBC, 1971), in which Richard Briers plays a dubious, much travelling businessman with 'designs on the opposite sex', nor of The Rough with the Smooth, about two bachelor flatmates with similar designs (BBC 1975).

The issue of pleasure was, on the whole, more successfully handled domestically, in the context of some generational or class conflict. Sex, for instance, is central to the deliberations of the grown up children in And Mother Makes Five (Thames, 1974–6, four series); to their mother, a vet's wife, they seem obsessed with it. In the longrunning Bless This House (Thames, 1971–6) the travelling salesman of yore, played inevitably by Sid James, encounters domestic resistance from a strong wife and from modernity, as represented by his teenage son and daughter. Through the heated transactions he has with his children over their boyfriends and girl-friends, he is taught that fun is now not only for sales reps to sample in the boarding houses of life. In The Cuckoo Waltz (Granada, 1975–80) sexual morality and class are run together: Gavin, rich, flamboyant and prone to talk of sexual liberation moves in with young married Chris and Fliss when his own marriage breaks up; despite repeated attempts, though, he never gets the beautiful Fliss into bed. And a similar, but more complex, mingling of class and sexuality occurs in Man About the House (Thames, 1971–6) and its derivative George and Mildred (Thames, 1976–9).

In Man About the House, a young trainee chef shares a flat with two women, a clear signifier of sexual modernity which brings the disapproval of the landlords, the down-at-heel, petit bourgeois Ropers, who live, fit-tingly, in the basement. The Ropers dinginess sets off the glamour of the three apparently liberated youngsters upstairs. In George and Mildred, the Ropers are transplanted to a new housing estate in suburbia. Mildred Roper is happy here and frequently wants sex; George pines for some-where less posh, and is too tired for sex; but he successfully subverts the snobberies of the family next door, who have named their sons Tristram and Tarquin, and the materialism of his wife's sister and her husband. Thus the striving between the Ropers is nicely weighted: she wants to live among snobs (bad) and to have sex (good); he wants to be back among Hoggart's 'good neighbourly fowk' (good) but can't manage the sex (bad). George and Mildred says, as so many British sitcoms have appeared to say, that to be yourself and to stay with your own kind is important; it also proposes that, if you can't have fun, that's funny.

Rising Damp (YTV, 1974–8), another success of the 1970s, is also about a sexually unsuccessful landlord. The landlord, Rigsby, has three tenants: a slow-witted white youth; a suave, middle class black African man, the object of much half-witted racism from Rigsby, but for whom he is no

match in an argument; and an unmarried woman, who clearly reciprocates his lust for her, but whom he is still too scared to engage in a relationship. Rigsby is a dowdier, more downtrodden Hancock – cowardly and prejudiced and, once more, redeemed only by pathos: he can't have fun, even when it's offered him. A similar fate befalls the miserable inspector from *On the Buses*, who retires to Spain with his unmarried sister in *Don't Drink the Water* (LWT, two series, 1974); all that sun and sand and he can't settle.

There is also an increased recognition by sitcom writers that the pursuit of happiness can both bring its problems and take place in more than one kind of household. Some sitcom characters are now divorced, as in *My Wife Next Door* (BBC, 1972) and *Maggie and Her* (LWT, 1978–9), there is a sitcom about an unmarried mother (*Miss Jones and Son*, Thames 1977–8) and one about a househusband, who has to deal with the prejudices of his neighbours (*His and Hers*, YTV, two series: 1970, 1972).

Other notions of fulfilment are played out in the sitcoms of the 1970s. Two notable ones are about 'dropping out'. *The Good Life* (BBC, 1975–8, 30 editions) is about the nascent 'green' tendency in the English middle classes and begins with the decision of Tom Good, a draughtsman in advertising, to abandon his career and, with his wife, seek self-sufficiency by turning their back garden into a small farm. The Goods' home was set in Surbiton, yet another signifier of semi-detached, suburban conformity (although, as one of the cast recalled, the real Surbiton is composed mostly of old Victorian mansions now divided into flats, and the series was shot somewhere else – see Eddington, 1996: 128). The neighbours, social climbing Margo Leadbeatter and her materialistic husband Jerry have an affection for the Goods, which mingles with the familiar cocktail of snobbery and incomprehension.

In a more parodic vein, in *The Fall and Rise of Reginald Perrin* (BBC, 1976–9) a minor executive rebels against the monotony of his career and suburban home life by faking his own death, taking a fresh identity and starting out on a new life, which nevertheless features all the same people as his old life. In the final series they set up a commune. Here politicised notions of fulfilment become the stuff of comic fantasy, as they do in *Citizen Smith*, another popular sitcom of this decade. Here the central figure is Wolfie Smith, a young left wing political activist, whose rhetoric and grandiose ideas are blunted on the incomprehension of those around him; there is a generational element here too, the most uncomprehending being his girlfriend's parents. Wolfie is leader of the minuscule Tooting Popular Front – again, there is some nice signification here: 'popular front' connoting heroic revolutionary struggles and Tooting an unremarkable inner suburb of south west London.

19

R.T.C. LIBRARY, LETTERKENNY

302
14

40019356

But, in a very real sense, the most politically ambitious sitcom of the 1970s was Fawlty Towers (BBC, two series: 1975, 1979). Basil Fawlty is a manic, ill-tempered hotelier in the west of England, who, like 'Hancock', Bob Ferris, Harold Steptoe, Mildred Roper, Rigsby and other leading British sitcom characters, believes himself to be above the hoi polloi. He is cowed by his wife, with whom his temper and bombast cut no ice, and is habitually rude to a Spanish waiter, to a deaf colonel who is a permanent guest in the hotel and to anyone else who happens to check in − so long as he perceives them to be of lower status than himself.

Fawlty Towers was the brainchild of the comedy actor John Cleese, who spoke at length on LWT's The South Bank Show in 1986 about the politics of its conception. The programme appeared to grow out of Cleese's work to help modernise the business of management, begun in the training films produced by his company Video Arts. In a lengthy interview, Cleese lamented the often-invoked incapacity of 'the English' to show their feelings; this he related to both sides of the sales process. The boorish Fawlty is a paradox because, on the one hand, he represents how not to treat the public (according to Prunella Scales, who played Mrs Fawlty, the show only stopped because Cleese and his co-writer Connie Booth 'stopped getting angry about hotels' − TVAM 29 October 1986); on the other hand, Fawlty expresses the rage that so many uptight English consumers are holding in. As Cleese told Melvyn Bragg:

> I think one of the reasons why Basil Fawlty was a very successful creation in the long run was that he embodied a kind of thing that the English feel sometimes. Which is because they can't say: 'This is . . . Sorry, this is . . . this food is not good enough' or 'I bought this pair of shoes and I want you to replace it'. You know. Because they can't do these simple acts of self-assertion. They tend to [adopt] on the surface a kind of brittle politeness and underneath [there's] a lot of seething rage. And I think that so many people in England feel this that that was one of the reasons why they could identify with Basil. Also . . . I mean he's a monster, and yet people feel quite affectionately about him, which is a very strange paradox.
>
> (The South Bank Show, ITV 12 January 1986)

Fawlty Towers emerges therefore, at least in terms of the writer's intention, as a kind of middle class, commercial equivalent of Till Death Us Do Part in that it was created to ridicule, and thus to erode, some bad behaviour perceived in the culture of a class; Fawlty Towers substitutes lower middle class

condescension and rudeness for the working class racism in Till Death . . .
One cannot, of course, assume, in the case of either programme, that this
was the way in which most of the audience understood these sitcoms.
Fawlty, like Garnett, is redeemed by pathos ('he is not in control of his
own life', as Cleese suggests in his South Bank Show interview), but both
characters successfully abuse the people they deal with on a considerable
scale: in Fawlty's case this involves a gallery of English comic stereotypes,
including nagging wives, deaf old people and foreigners with only a
fitful command of English.

THE 1980s AND 1990s: DON'T LOOK BACK

Around 350, that is over half, of the situation comedies produced indige-
nously for British television have been made since 1980. This, though, has
apparently little to do with the introduction of a new channel in 1982:
Channel Four accounts for only about 20 of almost 250 sitcoms devised
for British TV during the 1980s. Despite the high casualty rate of these
shows, and the often sardonic response they get from TV critics, the
demand for them is higher than ever. This growth of output brings, as one
might expect, greater diversity, but, again, certain trends are discernible,
either being inaugurated or being developed.

First, there is, as before, no more than the occasional glimpse of the
working class, at work. The most important exception to this is the
comedy drama Auf Wiedersehen, Pet (BBC, 2 series, 1983, 1986), a gently
humorous requiem for the traditional working class community, written
by the creators of The Likely Lads; in it, several men from the building trade
are obliged by the decline of heavy industry in the UK to become
migrant workers in Europe. Also, in the 1980s, the employment of
female workers in manual jobs was increasing, while that of males
declined (Mitter, 1986), and this is reflected in Sharon and Elsie (BBC,
1984–5), featuring female workers in a greeting card factory, and Making
Out (BBC, 1989–91), about women who work in an electronics factory
in Manchester.

Writers also address the experience of mobility out of the working class
in new ways. Two sitcoms stand out here, both written by Maurice Gran
and Laurence Marks, and both playing with social ideas popularly associ-
ated with 'Thatcherism'. Get Back (BBC, 1992–3) is about two men who
grew up on a council estate in north London, but made a lot of money in
the 1980s. One, Martin, loses much of his in the recession and he and his
family move into his father's flat. The other brother, Albert, in accordance
with the perceived 'selfishness' of the decade that made him rich, refuses

to help. The other is Birds of a Feather (BBC, 1989–), set in Essex, which employs many of the key cultural signifiers of the Thatcher decade.

During the 1980s, much political debate and popular cultural commentary focused on Essex and the outer suburbs of east London. Here, it was argued, now lived a section of the ex-working class made prosperous by the Thatcher reforms. They were, in the main, self-employed manual workers – plumbers, plasterers, bricklayers – and their materialism and conservative views, reflected in the rash of young right wing Tory MPs returned in Essex constituencies, was thought to be the base for successive Thatcher election victories. At a time when people were increasingly being classed according to their role in consumption (dress, favourite bands and so on) rather than in production (their job), this social group was widely seen as approaching the pinnacle of cultural crassness: they read the monosyllabic Sun newspaper, they watched satellite TV, they spoke 'Estuary English', and so on. The comedian Harry Enfield parodied this development in a character called Loadsamoney and jokes about Essex girls abounded, along with a kind of socially generated Identikit picture of two mythical young women from the area. These two girls, Sharon and Tracey, announce their class through their apparel (tight, stonewashed denim skirts and white stiletto-heeled shoes), the way they dance (round their handbags) and the male company they keep (their boyfriends are insensitive young men, with fast cars that have furry dice hanging off the rear view mirror). Neither they, nor their boyfriends, are gifted intellectually.

Gran and Marks, by calling the central characters of Birds of a Feather Sharon and Tracey work to oppose the negativity of this stereotype and, so to speak, to re-value it. Here Sharon and Tracey are East Enders transplanted to a neo-Georgian house in the affluent suburb of Chigwell. They have therefore successfully consummated the dream of Harold Steptoe and Mildred Roper, but they have made no concessions in the matter of class culture; for them class and status are effectively severed. They speak as they always did, are sustained by each other's common sense, and leave the social pretension to their sexually voracious neighbour Dorian. Moreover, their new home and the boarding school education of Tracey's son are paid for out of the ill-gotten gains of their husbands, intellectually stunted villains serving prison sentences. Sharon and Tracey are not averse either to money or to sex, but they can do without either if they have to. Their more highly born friend Dorian is a snob and promiscuous, her promiscuity undermining her snobbery.

These recent programmes seem to define what are now the limits of British sitcoms' address of working class life. It will seldom be examined in itself, being thought perhaps a minority or sectional interest in an

increasingly individualistic culture. It is more likely to be seen as a component of someone's past (the reason, for example, why they speak as they do) and something which, given the white collar redundancies, negative equity and house repossessions of the 1990s, they may fear going back to. Hyacinth Bucket, for example, the grotesquely pretentious suburbanite of *Keeping Up Appearances* (BBC, 1990–) would rather die than experience the contented dilapidation enjoyed by her father and sisters, who all live on a council estate. Similarly, in 1995, Rodney Bewes discussed a revival of the *Likely Lads* with one of the writers:

> Ian said it would be so funny if Terry had got on terribly well and Bob, who had such aspirations to middle class respectability with his semi-detached house and car, was one of the new poor.
>
> (Grant, 1995)

THE 1980s AND 1990s: YES, POSTMODERNIST

In such a large body of work, there is, predictably, a wide sprinkling of occupations to be found depicted in the sitcoms of this period – doctors, solicitors, dentists, vicars, heating engineers, vets, antique dealers come in some abundance, but the world of work most favoured in the last fifteen years as a setting for situation comedy appears to have been the media. As I noted earlier, some of the first sitcoms on British TV had a location of this kind but in the 1980s and 1990s comedies about life in some part of the communications industry have seemed to proliferate. The dozen years between 1982 and 1994 brought the following:

- *Goodbye Mr Kent* (BBC, 1982), *Foxy Lady* (Granada, 1982–4), *Executive Stress* (Thames, 1986–8), *Hot Metal* (LWT, 1986, 1988), *Us Girls*, (BBC, 1992–3), *Absolutely Fabulous* (BBC, 1992–6) and *Nelson's Column* (BBC, 1992-3), all of which have journalists or publishers as central characters;
- *Let There Be Love* (Thames, 1982–3), *The Happy Apple* (Thames, 1983), *My Husband and I* (YTV, 1987–8), *The Big One* (Channel Four, 1992), and *So Haunt Me* (BBC, 1992–4) that feature advertising executives;
- *Colin's Sandwich* (BBC, 1988, 1990), *As Time Goes By* (BBC, 1992–) and *Joking Apart* (BBC, 1993–4), in which the principals are writers;
- *The Kit Curran Radio Show* (Thames, 1984) which is about a disc jockey, and:*Night Beat News* (Channel Four, 1984), *Hilary* (BBC, 1984), *Filthy, Rich and Catflap* (BBC, 1987), *Drop the Dead Donkey* (Channel Four, 1990–), *Terry and Julian* (Channel Four, 1992), and *My Dead Dad* (Channel Four, 1992) where most of the main characters work in television itself.

This growth in the recourse to the media-related professions is first and foremost a reflection of the move toward a 'postmodern culture', in which the elites and values of impression management enjoy a special eminence.

Huge state and corporate budgets are expended on advertising and much of our leisure time is spent consuming media imagery concocted by the sort of people, and via the kind of machinations, that tend to be portrayed in contemporary TV sitcom. Thus, because as a society we live increasingly 'in' the media and advertising, comedies which are located in these worlds seek some common cultural ground with their audience. Once that common ground is established, the comedy works according to the respective cultural politics of the writer and the viewer. Advertisers, for example, may be humanised by love or ineptitude, or they may be redeemed by turning away from their profession altogether and becoming writers on their own account − as in So Haunt Me, itself written by a former advertising executive. Similarly, the amorality of a fictitious TV news team could be seen either as demystifying the business of television newsmaking or as a carnivalesque celebration of an ultimately meaningless enterprise.

Comedies which touch on the artifices of the media are, also, ultimately, an ingratiation with the audience − they say 'We want you to know how all this stuff is put together, behind the scenes' (Goffman, 1959; Wagg, 1992, 1996). This notion strongly informs the ethos of media, public relations and advertising-related occupations and has influenced recent British TV sitcom in a second way. A number of recent shows have been steeped in caricature, pastiche and postmodern irony, and their characters based on cultural or media stereotypes, rather than on occupants of a purportedly real world.

Arguably the first of these sitcoms was The Young Ones (BBC, 1982, 1984). At a talk I attended in Manchester in the mid-1980s, the producer of The Young Ones, Paul Jackson, spoke of the impatience with which many people now regarded the average British sitcom, wherein rather miffed suburban parents remonstrated with their teenage children 'for playing their Cliff Richard records too loud'. The Young Ones, by contrast, is peopled by the stereotypes adults have created of young 'folk devils' (Cohen, 1972) − the 'hippie', the 'punk' − and they are placed in an often surreal setting (animals talk, characters eat pieces of furniture, bands come on and play halfway through the programme and so on). This show was followed by: Brass (Granada, 1983–4; Channel Four 1990), a pastiche of the sagas of Yorkshire mill-owning families; 'Allo, 'Allo (BBC, 1984–92), a spoof on depictions of the French Resistance to the German Occupation in films about the Second World War; and Hot Metal (about a newspaper tycoon),

Filthy, Rich and Catflap (BBC, 1987, about a TV comedian), The New Statesman (YTV, 1987–92, featuring a parodically self-seeking Conservative MP) and The Brittas Empire (BBC, 1991– , set in a leisure centre with an absurdly officious manager) all of which were played in heavy caricature.

A cluster of other situation comedies of the period have similarly postmodern elements: in Dear Ernest (Central, 1982), the central character goes to Heaven; in Blackadder (BBC, 1983–90), Chelmsford 123 (Channel Four, 1988, 1990) and Maid Marian and her Merry Men (BBC, 1989–93) historical characters talk in late twentieth century idiom. The leading part in So Haunt Me is a ghost; Red Dwarf (BBC 1988–93) takes place on a time-travelling space ship; a TV repair man in Goodnight Sweetheart (BBC, 1993–) every week escapes his demanding wife and takes shelter in the 1940s; and Comrade Dad (BBC, 1986), A Small Problem (BBC, 1987) and Snakes and Ladders (Channel Four, 1989) are all set in the future.

But the most sharply drawn situation comedy to emerge in this context was hyper-real, rather than surreal, and was set wholly within the framework of a fictitious TV chat show.

KNOWING ME, KNOWING YOU: THE POLITICS OF ALAN PARTRIDGE

Alan Partridge is a fictional television personality, first seen reporting sports news on the spoof news programme The Day Today (BBC, 1994). Transplanted to his own television show (Knowing Me, Knowing You . . . With Alan Partridge, BBC 1994–5) he positively drips with the cultural signifiers of contemporary Lower Middle England, his consumption profile becoming almost eerie in its attention to detail. Partridge eats at chain restaurants which have a twenty four hour carvery or a Sunday platter; he listens to Chris de Burgh and The Eagles; he favours Roger Moore over Sean Connery in the role of James Bond, because 'no one else could wear a safari suit with the same degree of casuality'; when one of his shows is broadcast from Paris, his co-host wears Cologne, while he has dabbed on a bit of Slazenger Sports; he drives a Rover Vitesse Fastback; he wears blazers and V-neck pullovers; his favourite piece of furniture is 'a genuine eighteenth century Queen Anne wardrobe hollowed out to make room for a huge television set and a video'; and so on.

Indeed, for Partridge, whole societies can only be understood through consumption:

> . . . the Swedish don't have a bad life, really, when you think
> about it. I mean, they get up in the morning, have a bowl of

swede, um, pop in the Volvo, whack on a bit of Abba and zip over to IKEA. I mean, you know, that's my Sunday . . . apart from the swede [. . .] I have Kelloggs Commonsense . . .

Expectably, therefore, although even within the fiction his show is going out on BBC2, the discourse of the programme is heavily commercialised, wherever Partridge can make it so. For example, in his Christmas show (*Knowing You, Knowing Yule* . . . BBC2, 1995), he introduces Santa Claus:

AP: Now Father Christmas is in fact none other than Mike Taylor of the Norfolk Rover Dealer Network. Mike, thanks very much . . . for being Father Christmas. Thank you.
MT: It's a pleasure, Alan.
AP: Mike, I heard recently that Norfolk Rover are offering 0 per cent finance on selected models this season. Is that true?
MT: That's absolutely true, Alan. The snowy weather has enabled us to freeze the prices on the whole of the Rover 600 series.
AP: Right.
MT: But, Alan, I understand you have a Rover Vitesse Fastback.
AP: Yes, I do.
MT: And what do you particularly like about it?
AP: Well, apart from the walnut and leather interior which, I think, really does give it luxury car status, the thing that impressed me most was the overall economy. I mean 38.4 miles to the gallon at a constant 56 miles an hour I think makes it a class leader.

(BBC2, 1995)

For Partridge, these badges of consumption bulwark other more conventional snobberies. For instance, when a guest claims him as a fellow 'working class boy' he counters:

I did go to East Anglia Polytechnic and I've got a couple of pretty good 'A' Levels . . . and, very quickly, as regards working class, my parents did own their own home and we holidayed now and again in Spain. So I don't think that's quite right.

(BBC2, 1995)

Partridge's world is a world of sales: sales managers, sales conferences, sales talk. But his philistinism is never far from the surface, during the course of his various transactions with his guests, he collides with every conceivable social difference. Knowingly, or unknowingly, he insults: an

all-female punk band ('Lady drummer. Very good. Close your eyes – could have been a man'), the leader of his house band, who, it transpires, is gay; a disabled athlete who insists angrily that he can 'still shag'; two lesbians; and the new commissioning editor for BBC2, whom he brackets with 'that lot upstairs' who wear baggy linen suits, flip-flops and John Lennon glasses: 'I loathe these people . . . I wish all of you BBC2 people would just get on a bus and drive over a cliff . . . I'd happily be the driver'.

Knowing Me, Knowing You . . . is, in a sense, a work of cultural revenge, of one tendency within the middle class upon another. The programme works through postmodern culture (the knowing irony, the heightened realism, the TV show about a TV show) and against postmodern culture (especially that part of it, strongly associated with the Thatcherite lower middle classes, which holds that Shakespeare is no better than Jeffrey Archer and Abba's music is as good as Beethoven's and that taxpayers' money should not be spent on sustaining opera houses for toffs). Partridge is a Basil Fawlty of the television studio, although whereas Fawlty's prejudices are propelled by powerful invective, Partridge becomes abject in the revelation of his. Both Fawlty and Partridge are failing to deliver a service, but Partridge's failure is rooted in the contemporary politics of equal opportunities: unlike Fawlty, he is shamed by his ignorance of social minorities and, thus, of market niches. Moreover, he represents another important ideological battle within the contemporary British middle classes – the battle to keep inverted commas around the word 'culture'. Knowing Me, Knowing You . . . satirises the perceived undermining of public service ideals, and concomitant notions of cultural diversity and excellence, in contemporary British broadcasting, typified for many by John Birt's Director-Generalship of the BBC and by the provisions of the Broadcasting Act of 1990.

ASSESSING THE 1980s AND 1990s:
ONLY FOOLS AND HORSES WORK

But discussion of recent British TV sitcom shouldn't be confined to the why's and wherefore's of postmodern culture and, indeed, scant reference to such culture can be detected in the most enduring situation comedy of the period.

Only Fools and Horses ran on BBC television from 1979 to 1996 and enjoyed a steady audience of around 15 million from it's third series (Hildred and Ewbank 1991: 136). The central character, Derek Trotter, could trace his comic lineage back through Harold Steptoe and the

various incarnations of Sid James, to the spivs popularised by Arthur English in the 1940s. Like them, Trotter is culturally working class, but technically working for himself. Like the Steptoes, though, he represents one of the lowest rungs on the tall ladder of self employment, being based on the fly pitchers and unlicensed traders whom the writer John Sullivan had observed selling from suitcases in the markets of south London (Hildred and Ewbank, 1991: 125). The Trotters lived in Peckham, the area of south-east London where Alf Garnett had lived, but by now with the docks which had employed Garnett in decline and the communities they had supported disintegrating, Peckham had acquired a reputation around the capital as rough. Only Fools . . . though, remained doggedly optimistic from the beginning and tried throughout to portray a community thriving in 'the new multi-racial London' (Hildred and Ewbank, 1991: 124, 126–7). Del Trotter lives with his younger brother Rodney and his grandad (replaced by an uncle after the death of the actor concerned in 1984) on the twelfth floor of a council block. The fact that the block is called 'Nelson Mandela House' is never mocked. The Trotters are part of a coterie of duckers and divers and bit-of-this, bit-of-that merchants who sometimes have money and sometimes don't but, like Sharon and Tracey, never think of being other than they are. Their unpretentiousness is set off by the character of Boycie, a comparatively prosperous car dealer in a camel hair coat, whose belief that he is better than they are makes him ludicrous. Again like the young women of Birds of a Feather, the Trotters are allowed the occasional material success and, when it comes, they celebrate in style – something inspired by the writer's visit to a pub in the Old Kent Road in the late 1970s 'to find that the tough guys with callouses on their knuckles, who used to like a pint, were now sipping umbrella-topped cocktails' (Hildred and Ewbank, 1991: 150). The sense of community in Only Fools . . . even survives an urban riot (Christmas Special, 1993). And when watched by an estimated 24 million people in three closing episodes shown at Christmas 1996, the Trotters finally get rich, they still make a sentimental return to their council flat, sighing and shuffling their feet in an apparent reluctance to leave. Importantly, in the Trotters' new opulent surroundings, Only Fools . . . is no longer viable.

So, once again, the 'good neighbourly fowk' invoked to Wilfred Pickles in a church hall somewhere in the United Kingdom in the 1950s have preserved their integrity in British television sitcom to the present day. They have simply been diversified, to take account of social history, a good case in point being Desmond's (Channel Four, 1989–94), also set in Peckham, with a cast of Anglo-Caribbean characters. One, Michael, is an

Anglicised thirty something, successful (a bank manager) and prone to self-regard; he uses phrases like 'gotta get out there and play hardball' and, in one episode he joins a club for black achievers. But his social pretensions are always trumped by the common sense of his father, Desmond, his mother and his sister, as well as the incomprehension of the eccentrics who congregate in his father's barber's shop. (*Desmond's* was Channel Four's most successful sitcom and only ceased with the death of Norman Beaton, who played Desmond, in 1994).

Nor have writers or audiences apparently withheld any sympathy from sitcom characters who did their ducking and diving at the dole office. Despite often ferocious assaults in the British popular press on 'social security scroungers', another of the most popular sitcoms on British screens during the 1980s was *Shelley* (Thames, 1979–92), whose eponymous hero gets sacked from a lot of jobs and generally avoids work. Shelley, though more cocksure, recalls 'Hancock' both in his inflated view of himself and his proneness to row with officials. Similarly, the Boswell family in *Bread* (BBC, 1986–91, 68 editions) are formidable in their dealings with the local labour exchange.

In suburbia, in post-1980 sitcom, *Terry and June* has transmuted into *Ever Decreasing Circles* (BBC, 1984–9) and *One Foot in the Grave* (BBC, 1990–). The heroes of these sitcoms, Martin Bryce and Victor Meldrew, unite with similar characters from preceding sitcoms in their inability to have fun. Bryce would have been unremarkable in the 1950s, but the social changes of previous decades have made Bryce a 'nerd' and Meldrew, according to some children who confront him in one episode, a 'miserable old git'. Bryce is a pedant, excessively concerned with 'law and order', while Meldrew is more militant in his intolerance. *One Foot in the Grave* at times attracted audiences of 17.5 million and its hero, with his catchphrase of 'I don't believe it' has, predictably, been called 'the voice of a bewildered society', bereft of standards (Bedell, 1993).

Leisure centre manager Gordon Brittas is a more modern species of 'nerd' – essentially Captain Mainwaring, a classically lower middle class figure, updated to incorporate the fruits of innumerable short courses, during which he has imbibed the necessary managerial jargon and 'good practice'.

Such people are funny because, again, they don't comprehend the pursuit of pleasure and happiness. Elsewhere in recent sitcom, though, this pursuit is, in effect, a paradigm. For example, much of the dialogue in *Brush Strokes* (BBC, 1986–91) is about sex; likewise for the flat-sharers of *Men Behaving Badly* (Thames, 1992–4, BBC 1994–) and *Game On* (BBC, 1995–). The protagonists of *Dear John* (BBC, 1986–7) seek fulfilment in a

singles club; the doctors, father and son, in Don't Wait Up (BBC, 1983–90) have both been through divorces; in Duty Free (YTV, 1984–6), couples clandestinely swap partners; in Fresh Fields (Thames, 1984–6, later French Fields 1989–91) a couple buys a house in France; in May to December (BBC, 1989–) a couple seek marital happiness across the twin divides of age and class; and so on. The most decisive consummation of the quest for pleasure in the canon of British sitcom, however, has been Absolutely Fabulous, which ran on BBC from 1992 to 1996, in which Edina and Patsy, two affectionately parodied pleasure seekers from the fashion business are the central characters, and whose hedonism is set off by the sobriety and social responsibility of Edina's daughter; in the final episode, as TV critic David Aaronovitch noted (Independent on Sunday, 10 November 1996), hedonism wins.

Contemporary sitcom, then, drawing on earlier currents within the genre, has generally been about the forsaking of pretension and the pursuit of pleasure, within respective class cultures. In these complex times, no commentator on culture would advocate one straightforward political reading of a single of these series, let alone the British sitcom as a body of work. To some the comparative contentment and lack of ambition of the Trotters or the cheerful work-shyness of Shelley, the fulminations of Victor Meldrew or the self-centredness of Edina and Patsy, will seem retrograde; to others, they will represent, in their separate ways, the authentic culture of an increasingly open society. But, then, as at least one sitcom appeared to acknowledge, it isn't as open as all that. Yes, Minister, like its sequel Yes, Prime Minister (BBC, 1980–7), is about the dealings between Sir Humphrey Appleby, a suave, upper class, Oxbridge-educated civil servant and his fumbling political master, Jim Hacker. The joke in Yes, Minister is that Sir Humphrey, for whom class and status are still the same thing, and for whom prime ministers are no more of a social or political threat than Basil Fawlty or Citizen Smith, always wins.

ACKNOWLEDGEMENT

Most of the material for this chapter was culled from Rod Taylor's exhaustive Guinness Book of Sitcoms; to footnote my dependence on this book in the normal way would have meant swamping the text. I'm grateful also to: Michael Bowes, who provided me with some material; to Wendy Perkins at The South Bank Show and Laraine Porter, who arranged some screenings for me; to Patrick Marber and John and Kathleen Mannering, who lent me videos; and to Ian McDonald, who shared his childhood reminiscence of Get Some In with me as well as commenting on the first draft of this chapter.

BIBLIOGRAPHY

Bedell, Geraldine (1993) 'Victor, a hero for our time' *Independent on Sunday* 28 February.

Bowes, Mick (1990) 'Only when I laugh' in Andrew Goodwin and Garry Whannel (eds) *Understanding Television*, London: Routledge pp 128–40.

Cohen, Stanley (1972) *Folk Devils and Moral Panics*, London: McGibbon and Kee.

Eddington, Paul (1996) *So Far, So Good*, London: Coronet.

English, Arthur, with Linton Mitchell (1986) *Through the Mill and Beyond*, London: Mildmay Books.

Goffman, Erving (1959) *The Presentation of Self in Everyday Life*, London: Allen Lane.

Goldthorpe, John *et al.* (1968a) *The Affluent Worker: Industrial Attitudes*, Cambridge: Cambridge University Press.

Goldthorpe, John *et al.* (1968b) *The Affluent Worker: Political Attitudes*, Cambridge: Cambridge University Press.

Goldthorpe, John *et al.* (1969) *The Affluent Worker in the Class Structure*, Cambridge: Cambridge University Press.

Goodwin, Cliff (1995) *Sid James: A Biography*, London: Arrow Books.

Grant, Linda (1995) 'The lad most likely to . . .' [Profile of Rodney Bewes] the *Guardian* 12 August p. 25.

Hall, Stuart and Tony Jefferson (1976) *Resistance Through Rituals*, London: Hutchinson.

Hancock, Freddie and David Nathan (1969) *Hancock*, London: William Kimber.

Hare, David (1982) 'Ah! Mischief: The Role of the Public Broadcasting' in Frank Pike (ed.) *Ah! Mischief: The Writer and Television*, London: Faber and Faber.

Hildred, Stafford and Tim Ewbank (1991) *The David Jason Story*, London: Blake Publishing.

Howes, Keith (1995) 'Privates on parade' the *Guardian* 15 April.

Le Mesurier, John (1985) *A Jobbing Actor*, London: Sphere Books.

Lowe, Stephen 1986) *Arthur Lowe: A Life*, London: Nick Hern Books.

Medhurst, Andy (1989) 'A History of Sitcom' Pamphlet published by British Film Institute.

Mitter, Swasti (1986) *Common Fate, Common Bond*, London: Pluto Press

Newburn, Tim (1991) *Permission and Control: Law and Morals in Post-War Britain*, London: Routledge.

Orwell, George (1941) 'The Art of Donald McGill', reprinted in Sonia Orwell and Ian Angus (eds) (1968) *The Collected Essays, Journalism and Letters of George Orwell: Vol. 2 My Country, Right or Left 1940–3*, London: Secker and Warburg.

Speight, Johnny (1973) *It Stands to Reason*, London: M & J Hobbs/Michael Joseph.

Sweeting, Adam (1996) 'East Cheam Revisited' the *Guardian* 29 July.

Taylor, John Russell (1963) *Anger and After: A Guide to the New British Drama*, London: Methuen.

Taylor, Paul (1985) 'Theories of laughter and the production of television comedy' Ph.D. Thesis, University of Leicester.

Taylor, Rod (1994) *The Guinness Book of Sitcom*, Enfield: Guinness Publishing.

Wagg, Stephen (1992) 'You've Never Had it So Silly: The Politics of British Satirical Comedy from *Beyond the Fringe* to *Spitting Image*' in Dominic Strinati and Stephen Wagg (eds) *Come on Down?*, London: Routledge.

Wagg, Stephen (1996) 'Everything Else is Propaganda: The Politics of Alternative Comedy' in George Paton *et al.* (eds) *The Social Faces of Humour*, Aldershot: Arena Press.

Willmott, Peter and Michael Young (1958) *Family and Kinship in East London*, London: Routledge and Kegan Paul.

Westergaard, John and Henrietta Resler (1976) *Class in a Capitalist Society*, Harmondsworth: Pelican.

2

THE LANCASHIRE SHAMAN

Frank Randle and Mancunian films

C.P. Lee

A darkened stage at the Opera House Blackpool. The audience hushed, thrilled, waiting, eager with anticipation. The small pit orchestra strike up a jaunty melody of the time and a spotlight hits the wings stage left. The overture comes to its cacophonous crescendo and stepping out from the wings . . . nobody. The orchestra strikes up again, and again nobody. The audience begin to titter nervously and the spotlight moves slightly from side to side like a bloodhound's nose. Suddenly there's a shout from stage right, the spotlight swings its beam towards the coarse northern voice and, to the audience's cheers, illuminates a grotesque looking human being, all arms and knobbly legs dressed in full highland regalia, kilt, sporran and a tam o'shanter with a four-foot feather stuck in it waggling obscenely over the head of comedian Frank Randle. It floats backwards and forwards like a question mark as Randle's head shoots out from his shoulders like a demented chicken. The delighted crowd are coasting along happily, short bursts of laughter carrying along over the top of a general air of amazed amusement. The laughter explodes as Randle lurches towards centre stage and stands, arms akimbo staring at the audience. They're just beginning to settle down, preparing themselves for whatever Frank's going to do next when his head snaps back and he glares at them through bizarre rolling eyeballs. Waves of laughter swell across the stalls and balcony like an incoming rip tide. He lets the laughter calm down again before speaking, 'By 'eck, I don't know where this draught's coming from – but I know where it's going.' And twirling his hips to get his kilt and sporran into full swing he triumphantly pushes his audience into further gales of laughter. And so a typical Frank Randle show begins.

Born in 1902, and dying in 1957 of TB and alcohol abuse, Randle was the most popular, successful and highly-paid star of his time, yet few people south of Birmingham ever saw him perform or even ever heard of him. He was part of a phenomenon, a genre we now call it, that of a regional comic (though, as I will argue later, he was something more than

that). By dint of their voices alone the regional comics were uniquely of their community. Some, like Albert Modley, 'Lancashire's Favourite Yorkshireman', were able to cross over to a wider national audience, but Randle, who often referred to himself as an 'amateur', never appeared to extend his bailiwick beyond his homeland of terraces and mills, chimneys and ginnels, whippets and ale houses, Golden Miles and Alhambras.

In this chapter I intend to examine the career of Frank Randle from the perspectives of class and language by analysing not just his stage output but another unique phenomenon of the north west of England, the Mancunian Film Corporation, a fully-fledged independent film production company that produced movies from 1928 to 1955. Going without West End release, or even national press coverage, Randle's movies for Mancunian, dating from 1940 to 1953, were 'bigger box-office attractions than contemporary Hollywood movies starring Flynn, Dietrich or Robert Taylor' (Montgomery, 1954).

So who was Frank Randle? He started life as Arthur McEvoy, changed his name to Arthur Twist, then became Frank Randle. To his adoring fans he was King Twist, with his yacht moored off Blackpool South Pier, a Lagonda sports car, and a mansion on the highly select Lytham Road. To cultural historian Jeff Nuttall he was the personification of Loki the Norse god of mischief; to John Fisher he resembled 'the Trickster archetype of the American Indian' (Fisher, 1973). He was an instinctive anarchist, permanently at war with all forms of authority, be they chief constables or theatre managers, whilst he was riding high on earnings of a £1,000 a week. Three decades before rock drummer Keith Moon's 'wild man' image was generated through his antics on tour with The Who, Randle would regularly destroy his dressing room with an axe whenever he took umbrage at some snub, real or imagined. Manic and uncontrollable, he occupied a realm of the senses based on earthiness, pleasure and a basic honesty about the human condition that despised hypocrisy, cant and humbug. On one memorable civic occasion he was invited as guest of honour to a Lord Mayor's banquet. Jeff Nuttall takes up the story:

The mayor steps forward to greet him.

'Mr Randle, may I say how honoured I am to extend a heartfelt welcome to you, our most distinguished citizen.' People are relaxing now. The smiles become real. He is sober and collected. There will be no scene.

'Thank you Mr Mayor. However, I must insist the pleasure is mine entirely. It is an honour indeed for a troupe of humble players to

enjoy the full panoply of civic hospitality. Shall we move into the banqueting chamber?'

'One moment, Mr Randle. This is my wife.'

'Well that's your fucking fault owd pal.'

(Nuttall, 1978, p 99)

Here was a man who burned down a hotel where he'd received bad service, fired a loaded revolver at a recalcitrant extra on a film set, hired a plane to bombard Blackpool with toilet rolls after an obscenity conviction. A man who was truly mad, bad and dangerous to know and yet adored by his audience. As far as the public were concerned he couldn't put a foot wrong. If he refused to go onstage for whatever reason (usually because he was drunk and incapable) the fans would forgive him, get their tickets refunded and go and see him the next time. How could this man who, if heckled, would hurl his false teeth at the offending miscreant, command the attention and respect of those he courted as his peers (that is, the audience)?

A simplistic answer would be that Randle was a very good comedian who drew on a variety of comic characters to amuse his audience. A more complex answer would be that Randle was, to put it basically, 'the people', he was his audience, or, at least, a manifestation of its mythical signifiers; his culture in microcosm; a mirror that reflected the industrial working classes' spirit of the time. For that culture was universal and not restricted to a language ghetto, a dialect barrier of regionalism as it were. It is a misconception to imagine that he couldn't, or wouldn't, play south of Birmingham. On several occasions promoters attempted to launch Frank on the West End stage in a bid to gain him national stardom. Most notably, Sir Oswald Stoll, who had the misfortune to watch Randle crash and burn at his expense when the sophisticated West End audience found Frank's randy old hitchhiker persona vulgar and unfunny, and in 1952 impresario Jack Hylton had the same experience with a bizarre production entitled Televariety. This must have seemed like a stroke of genius when it leapt from the former bandleader's over-fertile imagination, television's taking punters away from the theatres, what to do? Put the television in the theatres, or at least combine the two. So we have the hit TV show, What's My Line, hosted by Gilbert Harding, live on stage, punctuated with sketches from Randle's Scandals: Frank and his crew from up north. To say the critics slaughtered this ill-conceived turkey would be an understatement and the West End audiences stayed away in droves. Inevitably the show was a financial disaster and closed after two weeks. What happened

next, however, is highly instructive. Taking advantage of a last-minute cancellation, Randle moved his troupe into the Metropolitan, Edgeware Road with a hastily-improvised show called The New 1952 Scandals and played to packed, enthusiastic houses. The *Stage* noted:

> Down at the Met, up in Manchester, almost everywhere else you like to mention, ordinary decent people, who in their unsophisticated way keep the music hall alive, seem to have the advantage of recognising a good thing when they see it, and of not being afraid to let themselves go.
>
> (Fisher, 1973)

Noted critic Hannen Swaffer caught Randle at another foray south, at the Kingston Empire:

> I have seen many fine performances in over thirty years of theatre-going and my favourite performances are as follows, Wolfitt's Lear, Olivier's Othello, and Frank Randle's Buttons.
>
> (Mellor, 1982)

Rather than showing Randle 'crossing over' as was achieved by other 'regionalist' or 'ethnic' comics like Modley, Harry Lauder, or Arthur Lucan as mad Irishwoman, Old Mother Riley, I would argue that it just goes to confirm why he never could.

What Randle achieved at the Met or the Empire was an art of consolidation through recognition. He held up a mirror to an audience who recognised a universality of truth. Disregard the physicalities of flat, shifting vowels and glottal stops, between Brigante inflected Lancastrian pronunciation and the Norman French inflections of east London cockney, dialect didn't matter in the domain of the tribal shaman, the tribe in question consisting of what the *Stage* critic called 'ordinary decent people' with their 'unsophisticated' ways, i.e., the working class. It was the middle classes that had problems relating to Randle. The freshly-minted petty bourgeoisie prim and proper in their polite, suburban semis, reacting with horrified distaste to the antics of the Trickster King Twist.

CINDERELLA: Oh Buttons – Thwarted again!
RANDLE (*as Buttons*): Never mind lass, I'll open a window.
CINDERELLA: Oh, Buttons, have you ever been thwarted?
BUTTONS: Nivver stop love, nivver stop. It's this gassy ale.
(Buttons then blows a long, low note on a bugle at the end of his passage.)

For this particular exchange Randle was fined five guineas for obscenity and lewd behaviour, by those upholders of middle-class, moral probity, the local magistrates.

Randle, of course, could be 'enjoyed' by the middle class, only it had to be done away from home in the darkened privacy of a theatre or cinema. There develops a kind of ritualistic function to the attendance at Hulme Hippodrome or Blackpool, a kind of pilgrimage to Lourdes in reverse. You work all year then take your break in a boarding house by the sea where you can ritualistically dip your feet in the dirty waters of Frank and be blessed by his presence secretly as one of the 2000 other souls who've come for benediction, for that brief moment, unlaced, cut loose from the confines of your expected behaviour. Back to your roots, laughing with the rest at what Frank dares to name, for Randle is frank by nature as well as name and Frank's function in the ritual is to allow his audience a brief dalliance in the garden of earthy (sic) delights. Middle or working class, it didn't matter, Frank was there to show you from where you came, to where you were going, and the bits in between.

Jeff Nuttall claims with some justification that,

> So cruelly oppressed is the mind of the Northern worker, so deeply stained with the guilt and humility which is the means and the effects of subservience, that, once removed from his own hearth, his own street, his own neighbourhood, he imagines himself surrounded by hypercritical strangers.
>
> (Nuttall, 1978, p 59)

Social life for all classes during Randle's life was rigidly bounded by ritual and order; proprieties had to be observed at all times. Yet it was a schizophrenic set of rules for living by, so much was taboo. People bathed naked in tin baths in front of the parlour fire. In order to get to the outside toilet people would have to pass through the kitchen, everybody knew your (body's) business. Men employed down the pit, worked naked in their own piss, shit and sweat, in the workplace and the washhouse these basics of human reality manifested themselves in a healthy vulgarity, but once at home, bodily functions were put back where they belonged, unspoken, hidden, guarded and guilty, the domain of small children and geriatrics, the people burdened with a moral legacy of Methodist and Baptist chapel and Sunday school. The explosion of mirth generated by Frank Randle was a much-needed safety valve, not unlike the old tradition of the Lord of Misrule. Nuttall goes on so far as to claim

When a celebrity, then, a wealthy and distinguished man, makes it his mission to relieve these tensions he will be more than just funny. He will be adored gratefully by an entire class . . .

> (Nuttall, 1978, p 59)

So what was Randle's act like? In terms of jokes, paid for by the punch-line, there were hardly enough in Frank's act to last a modern comic like Bernard Manning five minutes. There was certainly no swearing and in comparison to the likes of 'mainstream' comedians like Jim Davidson or even a so-called 'alternative' comedian like Ben Elton, his material appears totally innocuous. But we must remember to put Frank and his ilk into a historical context and bear in mind that this was in the days when the stage was censored by the Lord Chancellor and Victorian Mrs Grundyism operated throughout the land, hard labour was still the sentence for homosexuality and sex outside marriage was considered a grossly anti-social act, roughly on a par with manslaughter. There is, it must be noted, one comparable present-day performer who comes close to Randle's personification of the Zeitgeist, and that would be Steve Coogan's Paul Calf. However, we should bear in mind that Coogan is not a comedian per se and that Calf is a comic persona, the creation of an actor's craft. Randle was the real thing.

Let us take a closer look. Dressed in outsize, baggy shorts, festooned with a rucksack, bugle and a flagon of beer, hair standing up as if in shock, clutching a hiking stick, Frank Randle would clomp on stage in vastly oversized boots worn on the wrong feet.

> Eee, A've walked through Europe, Irop, Earop, Syrup, Wallop, Jallop an' me feet are red 'ot.

The delivery is intoned in high-rolling cadence, almost, you might dare say, like a High Church sermon. It's a style of delivery developed by neces-sity, Frank started performing before the invention of public address systems.

> A've just had a bit of a narrer squeak. Ah were goin' across a field, there were a bull innit.

This is storytelling, not the staccato delivery of one liners we've come to expect from present day comics. Randle is inviting the audience into his mind, allowing them to become privy to his view of their world. And now there is danger in it, a bull is on the loose. The bull is one of our

oldest symbols of unbridled sexuality and strength. In European culture it is both feared and admired, a potent symbol.

Oooo! It were a fierce 'un. It 'ad a couple of prongs on it as long as this stick!

He thrusts his hiking stick out at an angle from his groin in a deliberately phallic gesture.

But it were a damn sight sharper than this 'un I can tell yer'.

So the shaman transforms his stick to a penis, a real magic wand.

Aye, it come tuppin' away at me . . .

'Tupping' is old English for copulation, still in use in rural communities. Things have become even more dangerous. Randle is in danger of being buggered by a bull! The original phallic obscenity is now extended into bestiality.

I thowt it were apologising the way it kept bowing and scraping away . . .

Randle's giant boots paw the ground like some cartoon beast, emphasising the implication of tremendous power being forced into subservience – a hint of the working classes?

Aah shooed it away wi' me 'andkerchief . . .

The delivery is drawn out on the opening syllables almost like a yawn. The old hitchhiker's not a man to be fazed by a rampaging bull. He flourishes a large, spotted handkerchief.

Oh . . .

Dawning realisation . . .

It's red . . .

On stage, panic, confusion and flailing limbs.

It made it a damn sight worse. By gum did I pick 'em up. I fairly sizzled. I catched up wi' a rabbit. I'd a passed it only it got between me legs.

Another signifier of fertility, the rabbit, unbridled procreation, getting in the way, right there between Randle's legs.

Ah sed to it, 'Eh, come on. 'urry up or else get outta road. Ah sed let somebody run as can.'

Ayeee! Ahm the grandaddy of all hitchhikers, Ah'll be 82 in a couple o' days. Ah'm as full of vim as a butcher's dog, Ah'm as lively as a cricket.

'Lively' mutates into a belch, a piece of vocal horseplay that will increase as Randle keeps swigging from his beer flagon. The belch in northern humour is a signifier for the hard drinking man, but Randle's personification is not the perfected observation of comics like, say, Freddie Frinton or Jimmy James. They played happy go lucky drunks, more like your uncle at a wedding when he's had one too many over the odds. Randle's volcano-like eruptions are more menacing, bordering on aggression. Randle plays his belching like an instrument, and, as so often in his real life, it acts as a precursor to potentially lethal violence.

Ah'll tek anybody on.

The instantly recognisable bombast of the bar room braggart.

Ah'll tek anybody on at me age or height – dead or alive – An Ah'll run 'em, jump 'em, walk 'em, fight 'em . . . Aaaah . . .

Another huge belch is forming.

Ahyeee! An 'ah'll play 'em at dominoes!

The final crescendo of absurdity mingling with self deprecation.

Eeh, 82 an' just look at these for a pair of legs. I tossed a sparrer for these an' lost.

Hitching up his enormous hiking shorts, with a great clattering of billy cans and paraphernalia, what can only be described as a leer passes across Randle's face.

Ah just passed a couple of tarts ont road yonder. Eeh! They were a couple of 'ot 'uns.

Toothless gums smacking together in delight.

One of them went like this 'ere to me . . .

Hands coyly clasped in lap, head tilted, Randle flutters his eyelashes in some dreadful parody of sexual come-hitherness.

Ah sed to 'er, 'No thanks love . . . ah'd rather 'ave a Kensitas!'

There are two areas of cultural resonance in his statement. One, the men who will steadfastly rebuff wily female sexual advances (the joke being that we know he's a randy goat), and two, an open acknowledgement of sharing reality with the audience in his use of a current advertisement for Kensitas cigarettes, proving that he is just, simply, one of the people.

And then with relentless inevitability Randle marches on towards the whole purpose of his act, in fact the whole purpose of his life – alcohol. To be precise, beer, the working man's staff of life, the sure-fire way of escaping the drudgery of everyday life. His hitchhiker routine is punctuated with explosive belches and the rocking gait of the drunk. The cocksure bravado and hyperbole of the saloon bar orator. It's a characterisation the audience instantly recognises. Perhaps through Randle there's a vicarious or voyeuristic pleasure to be quaffed; Puck becomes Punch, and there's no harm in a little drink now and then is there?

A series of belches like a car jerkily stalling every few feet, leading to a ricocheting burp that denotes a painful passage through the gut. Relief for Randle and the audience.

By 'eck. Ah think ah'd better 'ave another sup.

He's going to go through it all again and does.

All slops

A big laugh of recognition. There's a brewery called Alsops.
Another enormous belch.

Yeh'll 'ave to excuse BUURP!! By gum, there's thirty-six burps to the bottle. Ah'll sup this stuff if it keeps me up all neet. It's all

arms and legs . . . No body . . . Bururp! Ah sed to the landlord of the pub where Ah got this. This ale's a bit thin int it?'

He sed, 'Aye, so tha'd be if tha'd come up through them pipes.' He sed, 'Ah bet tha's nivver tasted owt like that?' Ah sed, 'Nay, but Ah've paddled innit.' Buurp!

Now, having poked fun at landlords, brewers and himself, Randle can cut loose and drag in the inevitable end product of drinking twenty pints, urine.

eee, that just reminds me. Ah once sent a bottle like this away to be analysed. The must 'ave gorrem mixed up at'other end. They sent me a postcard sayin', 'Dear Sir, your horse is in perfect condition.' Buurp!!

What taboos have been touched on during Randle's routine? Sex certainly, and not only between male and female, but man and beast. Beer and bodily functions too, but there remains one last taboo to be broken, one more subject, the granddaddy of them all, before Randle's hitchhiker will clomp off the stage and head for the nearest pub. And that taboo is death.

Look at me, Ah'm 82. I could jump a five-bar gate . . . If it were laid on floor like. Ah were at a funeral t'other day. Ah were comin' away from graveside. An' this chap comes up to me an' 'e says, 'Ow old are you?' An 'Ah sed, '82', and 'e sed, 'There's not much point in you goin' 'ome then is there.'

If Randle was unique, so was the next cultural phenomenon we are about to view. Inextricably linked to Randle it allows us a glimpse of an industrial and social by-product of the twentieth century that, as far as my research has uncovered to date, has no parallel anywhere else in the British Isles – that of a fully fledged, independent, regional film production company.

Prior to 1900 cinema was the domain of the enthusiastic amateur, but it didn't take long for entrepreneurs to realise the commercial potential of the new medium, and the experimenter/inventor like Birt Acres and William Friese-Greene quickly gave way to travelling showmen like Walter Haggar and Randall Williams, who both took cinema 'on the road' away from rented shop stores – 'penny gaffs', as they were known – into travelling booths touring the fairs and festivals of England. Haggar and others

began to produce their own short movies for exhibition in their travelling shows. Robert Paul produced his own films which had a permanent home in the Alhambra Variety Theatre, Leicester Square (the site on which the Odeon now stands). The original engagement in 1896 was for two weeks; he remained there for five years.

Manchester too had its pioneers. Though no names of the individuals involved have come down to us, we know that in 1898 Lama Films had offices on Bridge Street in the city centre. Their main claim to fame was the production of 'newsreels' of the Boer War with titles like The Relief of Mafeking and The Storming of Spion Kop. These films were made by taking the actors on a tram to Heaton Park, where dressed in an approximation of army uniforms they would run up and down hills whilst being filmed. Little else is known about the company except that they filed for bankruptcy in 1915, presumably the First World War being a little harder to recreate in a public park.

But in 1928 Manchester was to get its own film company. It would feed the needs of a public that seemed to have a propitious appetite for celluloid, and it would keep them satisfied for 25 years by providing them with a diet of their own heroes and heroines. This was the Mancunian Film Corporation which was founded and run by the diminutive figure of Mr John E. Blakeley.

J.B. (he liked to be addressed Hollywood style) entered the business in 1908. It was then that he and his father, who ran a market stall in Warrington, opened up a 'penny gaff' in the city centre. By 1910 he and his father had noticed that movies could be big business and they bought the Arcade Cinema in Levenshulme, Manchester. After that, picture houses in Northwich, Ardwick, Rawtenstall, and other areas in the north west became part of the Blakeley circuit and diversification followed during the First World War when the family became distributors too, buying and leasing out products to show on their circuit. Extremely valuable lessons regarding supply and demand were learned during these formative years, lessons of how to gain maximum exposure for your product, eliminating competition, prioritising available resources and, most importantly, so J.B. claimed, giving an audience what it wants. These lessons would stand Mancunian films in good stead when promoting the career of Frank Randle.

It was more or less inevitable that film production would become the next logical step for J.B. and 1928 saw the official founding of the Mancunian Film Corporation. The first film to be turned off the production line was Two Little Drummer Boys starring Wee Georgie Wood. As with all subsequent Mancunian products J.B. acted both as director and pro-

ducer as well as being managing director of the distribution company. In an interview in the *Manchester Evening News* in 1948 he denied that he also wrote the scripts, but admitted: 'I guide the script. I map out the scenes. I want and tell the script writer to fill in the plot.' By feeding out *Two Little Drummer Boys* to his circuit J.B. was able to recoup his expenditure and, with judicious programming, generate a market for Mancunian. A whole series of silent movies followed in rapid succession.

As yet, none of these was filmed in Manchester, most of his silent output was shot on location and where studio interiors were needed J.B. used one of the many available established film studios in London, most notably the Riverside Studios in Hammersmith. Talkies arrived in earnest in the UK in 1930 and now J.B. was able to utilise one of the north's great assets, comedians.

In 1934 the moderately well-known George Formby was coaxed down south to a studio above a garage in Southall and there for £2,700 J.B. made a movie called *Boots Boots* in which George sang 'Why Don't Women Like Me', and his wife Beryl danced to 'Chinese Laundry Blues'. There was a vague plot about gormless George working as a boot black in a hotel, and the rest, as they say, is history. George Formby catapulted himself into the hearts and minds of the British public (but not Frank Randle's: when told by Blackpool Opera House management that Formby was now top of the bill, a position they'd both shared up to that point, Randle came on stage and declared, 'Ladies and gentlemen, it's perfectly clear that George Formby is the only star of importance in this show, so George Formby can entertain you now.' No doubt George Formby would have been quite willing to, except for the fact that Randle had trapped him in a lift back-stage. He of course repaired to the pub next door until the furore died down.) To say that Randle loathed George Formby wouldn't be inaccurate, but it would be an understatement.

The pair of them were born in Wigan, and were roughly the same age, but there the similarities end. In essence they are the Yin and the Yang of Lancashire comedy: Formby awkward and gormless, Randle sharp and earthy. Formby's appeal lay in his mawkish sentimentality and local lad charm. Essentially he was 'safe'. Even if his ukulele tunes were slightly risqué you wouldn't mind your daughter going out with him. Not so Randle. Randle was dangerous, he flew over a comic edge to bring home to his audiences lessons in life. He trod too near the boundaries of taste.

Continually aware of each other's presence on the northern variety cir-cuit Randle couldn't have failed to notice how Formby's star was in the ascendant. Georgie made *Boots Boots* for J.B. and it catapulted him to national stardom; except for occasional forays south, the majority of

which were disastrous, Randle had to be content with a localised, regional stardom.

Maybe Randle's loathing of Formby stemmed from professional jealousy, but I would argue that it goes much deeper than that. Randle was operating from within the realm of a dark secret, a secret that informed and drove his manic intensity not just throughout his professional life, but his personal one too. While Formby had been born into a comfortably-off showbusiness family, Randle was illegitimate.

Having a bastard, being a bastard, were two of the great taboos of English society up until the liberalising campaigns of the late 1960s began to have their effect. It was a social stigma with far reaching consequences for the victims. To be illegitimate was to be branded as somehow 'unworthy', 'dirty', call it what you will; to be illegitimate was to be an outsider from the norms of common decency.

This is what drove Randle in his frenzied attacks on the conventions of his times, and, I would argue, it was the guilt and paranoia of his social situation that drew him into his loathing of Formby. Formby the man who had everything, but most of all what Frank could never have – legitimacy.

Randle's association with Mancunian started during the Second World War and it was an association that proved fruitful for all concerned. A string of 'army' movies flowed out in quick succession. *Somewhere In Camp, Somewhere On Leave, Somewhere in England*, all entitled *Somewhere* in order to confuse the enemy should they invade, so it is claimed. Several writers have put forward the theory that the *Somewhere* series are direct antecedents of the *Carry On* films and an early Granada TV comedy show, *The Army Game*, which is currently being rerun on Granada's satellite channel, Granada Plus.

Both Mancunian and the *Carry On* films used a regular ensemble cast. This establishes a sense of continuity and also provides the audience with a familiar set of faces, and familiarity breeds content. Also common to both movie companies is extensive use of location shooting, certainly, in the case of Mancunian, and, possibly, in the case of *Carry On*, a result of economic determinants. Textually, whilst there are similarities in terms of an 'earthier', more bawdy content in the oeuvre of each organisation, the more modern, or recent, *Carry On* can be seen to have more leeway in content format than any of the Mancunian's would have dared, but the groundwork was laid in the Dickenson Road studios nevertheless.

Granada Television's *The Army Game* has been cited as an English TV response to the American *Phil Silver's Show* aka 'Sgt Bilko'. Whilst there is indeed much truth in this observation it is necessary to point out that 13 years previously the groundwork for a show of this type had been, once again, laid down by Randle and Blakeley. Their *Somewhere* series was less

concerned with an England at war, but more with the effects of conscription on working class young males. Unable to control their destinies they made the most of it with all they had at their disposal, wit and solidarity. These were the elements that The Army Game freely adapted. Northern humour was also present in the shape of Ted Lune, gormless sidekick and straightman to many local comics. ('Are you putting it about that I'm barmy?' – 'Why? Do you need any help?')

The only claim for the Somewhere films we can make with any certainty is that they taught all concerned exactly how much money there was to be made in movies with a purely regional appeal, and when the war ended and Mancunian and Randle teamed up for the not-surprisingly named Demobbed, it was to mark a watershed in his relationship with J.B.

J.B. had sold the family cinema circuit, skilfully one could say, to John Brennan who operated a larger one. Directorships of a newly relaunched Mancunian Film Corporation were also offered to the two remaining large-scale distributors in the north of England, Henry Moorhouse and Sir Frederick Emery. A final directorship was offered to the star turn of Mancunian, Frank Randle, and so the company's success was about as assured as it could be. Frank's films would get preference on the screens of northern England. Three of Frank's films were shot for below £60,000 and went on to gross nearly a quarter of a million before the rights were sold.

The reason why they could be made so cheaply was the founding of what became referred to at the time as the 'Hollywood Of The North', the Mancunian Film Studios, in a disused Methodist Chapel in Dickenson Road, Rusholme, right in the inner-city area of Manchester. The cost of converting the Chapel into a studio production facility, quoted at £75,000 in the Daily Dispatch, was almost all met by a government film finance grant designed to help the ailing post-war British Film Industry. Their first fully 'home-grown' production was Cup Tie Honeymoon starring Sandy Powell and costing £40,000. Despite the Manchester Evening News' review of the movie after its Hollywood style premier at the Deansgate Cinema,'I cringe with shame and horror for everybody associated with this film', it went on to gross £95,000 at the box office.

J.B. acted simply as a mediator for Randle's on-screen antics. A new production assistant was puzzled during her first day on set to find whole sheets of script blank except for a note that said, 'Frank – Bus'. She finally plucked up enough courage to ask J.B. which bus, what bus? 'No, no', he replied, 'That's business. Frank'll come and do his business'. And Frank would too, charged up on Guinness and whisky. J.B., a devout Catholic, would make the sign of the cross before each take (not that there were many) and Frank would zoom off into his Trickster universe, parading his

'amateur' status for the world, and who cared tuppence, he was King Twist and Cock O' The Midden, it was him they'd paid to see.

And the character in the movies is very much Randle the man. We don't get the vulgar boatman character, nor grandad (except in one melodrama made for another company), nor even the old hitchhiker. It's a younger Frank, sometimes sporting his teeth, more often than not looking as if he'd just stepped on the set from the Welcome pub next door, which indeed he usually had. The 'real' Randle, if it is indeed he, seems relaxed and at home in front of the camera. And so he should be. He's surrounded by friends and admirers in exactly the same situation as if he was playing Hulme Hippodrome. The audience know what to expect from Frank and he knows what to give them for he is their cipher, their mirror. Nobody participating in this ritual cares a feather or a fig what London or the critics say. The journey they're about to embark upon may be alimentary or elementary, what we can say for certain is that it is transactional, it empowers and emboldens the audience to revel in their common cultural psycho-geographical space and reality. For Randle the journey is an alcohol-fuelled rollercoaster ride to a certain early death; neither participant would have it any other way – the magick works, neither participant gives a toss. Randle has triumphed.

What makes it so hard for us today, viewing these incredibly amateur-looking feature films, with their scenes that never go anywhere, or never end, just tail off, the stationary camera, the improvised dialogue, the appalling sets, is to understand why they were so popular. I think it's because we've lost the key to nuance. This is not the key to subtlety. Randle was known as the master of the single *entendre*. We are now so overwhelmed by stimuli and imagery that we've lost that ability to decode the vibrations sent out by our older performers. The Trickster, by dint of gift or daemon, inhabits a realm of consciousness or reality that is a mentally created hyperspace; we, careering on our merry way into the twenty-first century, can never, ever experience what it must have been like in the audience for a Frank Randle show – we can only make a guess, based on flickering ghosts thrown by a cine projector.

Randle was punished for being our spirit of mischief. He was harried and hounded. In particular he was harried and hounded by the Chief Constable of Blackpool, Harry Barnes. A staunch Methodist, Chief Constable Barnes took over the running of Blackpool in the mid-1940s. His first act was to seek out obscure nineteenth century by-laws that had long been forgotten. Barnes dusted down these anachronisms and set to with the vengeance of a one man crusade to clean up the tide of filth he saw as engulfing Blackpool.

His first victim was the band leader Vic Oliver who was arrested for speaking on stage on a Sunday! It was inevitable that Randle and Barnes would eventually have a showdown and the showdown came in the summer season of 1943. Barnes complained to the management of the South Pier and had Randle's Scandal's performance of 'This Is The Show That Jack Built' cancelled. The Chief Constable claimed he was acting in response to claims that the show was concerned with 'unsavoury matters' and 'business'. Randle stormed into Barnes's office and told him directly what he thought of him. Effectively, from then on, they were at war.

In 1946, again at the South Pier, Randle's show 'Tinker Taylor' was brought to a close by the police and local magistrates. They claimed that the show's agreed script had been 'embellished with gestures that were disgusting, grossly vulgar, suggestive and obscene' (Nuttall, 1978, p 83). He was fined £30, and the rest of the cast were fined £5 and £1 each, depending on the amount of gestures they had made. More trouble, this time in Manchester, was to follow. He was warned that certain lines had to be cut from his version of Cinderella. Randle went on and did them anyway. That night he was able to bribe himself free.

Back in Blackpool in 1952, Chief Constable Barnes had not forgotten his implacable foe and Randle's Summer Scandals at the Central Pier were the object of much police attention. Randle was in free fall and with hindsight perhaps he was pushing his performance capabilities to the limit. The Summer Scandals featured Randle as a randy, beer swilling vicar, Gus Aubrey as a thinly disguised homosexual scoutmaster as well as the old standbys, such as the old hitchhiker and the vulgar boatman. Randle was summonsed on four charges of obscenity. Here is what the police objected to.

> A silent Chinaman shuffled across the stage. Randle asked the audience, 'Is that King Farouk?'
> CINDERELLA, to Buttons (Randle): 'I'd like to do you a favour'.
> BUTTONS: 'A'd rather have a bolled egg'.
> And CINDERELLA again: 'I'd like to talk to you'.
> BUTTONS: 'It's nowt to do with me. It'll be me father agin'.
> And finally, 'There's a flea loose in the harem and the favourite will have to be scratched'.

Randle was found guilty on all counts and fined £10 on each summons. The rest of the participating cast were also fined as was the theatre manager. As the 1950s moved on, Randle grew wilder and the arrests and summonses more common. It would be too easy to draw a parallel

between Lenny Bruce and Frank Randle: they occupy different spheres, different time zones. Bruce, in a sense, was concerned with the hypocrisy of American society; Randle was concerned with the common people and his place within their mythology as a healer through laughter. What is common to the two of them is the relentless grinding down of their creative potential by the never-ending onslaught of legal action and the negative contribution this made to their states of health and well being. Both of them were outsiders consumed by society. In essence they functioned as ritualistic scapegoats.

Here is Frank Randle's weary response after being busted once too often, addressed to his audience, as he sat on the edge of the stage:

> Ladies and gentlemen, you have seen that the little show we have presented for you this season has been under a great deal of criticism. You have seen that certain citizens, some of them quite eminent have seen fit to call our performance, 'filthy', 'obscene', 'offensive', and that may well be their opinion, but I come to you ladies and gentlemen and ask you to be my final judges. I am, like you, a simple man, born of simple folk, a man of the industrial north of England. My pleasures are simply – My packet of Woodbines, my glass of Guinness. The simple joys of the seasons. Simple people of our kind understand the facts of life in a way that many of our critics don't. You will know that my little bits of fun are founded upon the facts of life and because you understand life and the realities of life – I ask you to be my judges.
>
> (Nuttall, 1978, p 84)

Here, in Randle's own words, is credo of non-conformity inherent within the Trickster/Shaman performer, whether they be of the north or south, east or west. Randle's enduring appeal lies, nowadays, very much in our recognition of him as a regional comic. No matter with which of his contemporaries we juxtapose him, he remains essentially northern. The veracity of this statement lies in the very success of 'crossover' artists like George Formby, or Max Miller, who is quintessentially cockney, or southern. Randle's perversity lies in his stubborn refusal to make regional concessions, undoubtedly he would have been unaware of such concessions, the bailiwick in which he operated was very small indeed, and governed, I dare say, by his awareness of his social standing as an illegitimate child during the first half of the twentieth century.

Randle's triumph lies in the fact that as a participating director in the Mancunian Film Company he was able to steer his particular view of a

specifically localised frame of life into financial success. Possibly it was his distrust of all things not directly concerned with him and the needs of those closest to him that brought about his enforced regionalism. Whatever the circumstances, it was the stigma of his early years and his subsequent championing of the causes of the working class in his own area that created his fame and, more importantly, led to his harassment and possibly, even, his untimely death.

NOTES

The uncredited material in direct quotes is taken from a collection of press clippings, undated and unannotated, lent to me by John E. Blakeley's grandson, Michael. I have credited them where possible.

The transcript of Randle's stage act is taken from a Regal Zonophone 78 rpm recording issued in 1955, recorded live at Blackpool Opera House.

For more information on the Trickster and Shaman the reader is recommended to look at Levi-Strauss, Claude (1968) *Structural Anthropology*, Penguin Books.

BIBLIOGRAPHY

Fisher, John (1973) *Funny Way To Be A Hero*, Frederick Muller Ltd, Great Britain, p. 155.

Mellor, Geoff (1982) *They Made Us Laugh*, George Kelsall: Littleborough, p. 85.

Nuttall, Jeff (1978) *King Twist, A Portrait Of Frank Randle*, Routledge: London.

3

BUTTERFLIES AND CAUSTIC ASIDES

Housewives, comedy and the feminist movement

Maggie Andrews

When I ask my ten year old daughter what she wants to be when she grows up she is uncertain. What she does state with determination is that she doesn't want to be married; being a housewife, even a mother, has little space in her dreams. I suspect this has more to do with the popular culture she consumes, the sitcoms such as *Roseanne* that she watches, than having a feminist mother. What I intend to explore in this chapter is the way in which women could use sitcoms to challenge dominant versions of femininity, specifically around the construction of the housewife. This can be done because of the polysemic nature of popular culture texts, which ensures that they may have as many readings as readers, positioned as they are by their class, gender, sexuality and other cultural specificities. Even with many traditional comedy texts, such as *On the Buses*, there have been spaces for women to negotiate meanings and to contemplate possibilities of change in the role of the housewife. Furthermore, an important shift occurs in sitcoms in the late 1970s from texts within which women were portrayed as the objects of humour, or as merely in a supportive role, to what I call 'housewives comedy' (such as *Butterflies*) where women have a significant voice; indeed at times theirs is the dominant voice within the text. This voice expresses many of the same concerns and criticisms in relation to domesticity, housewifery and finally child care as 1970s and 1980s feminism.

Comedy does not exist either in a cultural or a theoretical vacuum. It is therefore necessary to explain a little of my approach to comedy and the construction of housewifery in post-war Britain before discussing sitcoms in more detail. Comedy is, like all popular culture, part of the much wider social, economic and political processes within which the 'popular' provides space for what Gledhill has described as 'pleasurable negotiations',[1]

whereby the consumers of texts negotiate their meaning in order to make sense of them within their own particular social or cultural framework. Such thinking has made a significant contribution to some feminists' reclamation of popular culture and to their understanding of the pleasure it provides for women, and it has facilitated the reading of popular texts in ways which emphasise their radical potential. For example, Winship argued that women's magazines 'are dreams of a better and different life but one that remains well within the spectrum of possibilities'.[2] Thus, popular texts may open up in women's minds the possibilities of change and contribute to re-negotiating the boundaries of acceptable female behaviour, thus bringing into the public sphere issues previously reserved for the private domain.

Comedy has potentially a unique ability to be political in that it operates so frequently by transgressing boundaries. As one of the most easily recognisable boundaries, gender is frequently utilised verbally, narratively or visually to create humour. Much of the comedy of both stand-up comediennes and in sitcoms owes its existence to saying the unsayable and doing the undoable of the hegemonic culture. As Jenkins argues:

> Jokes, tend to cluster around points of friction or rupture within the social structure, around places where a dominant social discourse is already starting to give way to an emergent counter-discourse; jokes allow the comic expression of ideas that in other contexts might be regarded as threatening.[3]

Some theorists would argue, as Jenkins does, that topics receiving attention within the sphere of comedy may consequently not be taken seriously outside that sphere and that this may therefore neutralise potential radicalism. Against Jenkins, I want to suggest that by utilising the idea of Bakhtin and the carnivalesque a more radical reading at the representation of housewives in comedy can be utilised. Indeed, rather than neutralising the radicalism of women's laughter, comedy, particularly in women's cultural spaces, is always potentially threatening to dominant social orders, processes and power relationships. As Greer has pointed out: 'Laughter can be about power.'[4] Parody and ridicule can operate to undermine or justify the position of powerful groups. Mothers at a school gate or in a toddler group, Posy Simmonds cartoons and, since the early 1970s, feminist songs of the women's liberation movement such as 'The Maintenance Engineer' have used humour to challenge male power and to renegotiate what it means to be a housewife. It is within this tradition that the popularity of *Butterflies*, *Roseanne*, *2.4 Children* and *Grace Under Fire* must be understood, and enjoyed.

Housewives have not been over represented in sitcoms. It could be argued that they have in many series been conspicuous by their absence and indeed, that sometimes it has been this absence which has provided the 'situation' for comedy: it created a sense of freedom, disorder and at times even anarchy away from the customary controlling domestic presence of the housewife. Such a tradition of the absence of a housewife or a mother can be seen to operate in comedies as diverse in time, form and theme as *Father Dear Father* and *The Young Ones*. There are housewives in series such as: *On the Buses*, *Till Death Us Do Part*, *Terry and June*, and *Bless this House* but their role is unquestioned and at times they seem to be almost part of the *mise-en-scène* rather than the comedy.

Women in sitcoms of the 1960s and 1970s frequently provide an object for male humour, the site or butt of what in the 1980s and 1990s may be seen as politically incorrect humour, but which was once very popular. The frequent tirades of Alf Garnett in *Till Death Us Do Part* are remembered for the virulence of their racism, but it must be remembered that insults to his wife, calling her 'a silly moo', came thick and fast also. As Goodman argues 'That women have so often been the butt of jokes in western culture says a great deal about that culture. Principally it reveals the jokers have primarily been men'.[5] She sees the silencing of women in comedy as synonymous with that of women in the wider public sphere. The objectifying of women by comedy is also related to women's subordinate position in the wider culture. Just as they play a supporting role to men in society, so in comedy they can be a backdrop for the focus on the 'real action' of men. The role of sitcoms in television programming is usually governed by the necessity to gain as wide an audience as possible, preferably not antagonising viewers, and therefore women cannot be so completely objectified or marginalised in the way they can be by some stand-up comedians. And there have been some very significant changes in the last twenty five years of comedy as evidenced by the popularity of Jo Brand and Victoria Wood and the success of *Butterflies*, *Roseanne* and *2.4 Children*. Arguably these shifts and changes could only have occurred on the back of the feminist movement, for as Goodman argues: 'To tell a joke is to take the subject position: to assert subjectivity',[6] a subjectivity which requires an increase in confidence, brought about by political activity and consciousness-raising. Popular culture, however, was able to take the influence of feminism well beyond the narrow confines of those who identified themselves as feminist. Indeed, because of the availability of media texts and the ability to enter them, to negotiate the meanings of their signs and signifiers as it was felt appropriate, 'housewives comedies' provided a forum for the discussion of housework and domesticity that

feminism, with its primarily white, middle class and academic bent, could not. Goodman points out that Roseanne Barr's autobiography indicates she turned to comedy in response to the exclusivity of feminism. Instead she claims 'I figured I could say everything I wanted to say by being a housewife'. In so doing she was certainly able to reach a much greater number of women from a wider variety of backgrounds than feminism ever could. This may be an indication of how very central the concept of housewife is to twentieth century western women's culture.

It is important, however, to be aware that the role of 'housewife', as it is represented in late twentieth century media, is historically and culturally specific. It is in no sense either natural or traditional; Catherine Hall, for example, has argued that it has a nineteenth century and middle-class origin.[7] Housewifery has developed hand-in-hand with childhood in the twentieth century; particularly since the Second World War, and only briefly halted, perhaps, by the women's movement in the 1970s. To understand this and to be aware of the version of housewifery that comedies like Butterflies challenged it is necessary to explore how the role of housewife developed in connection to the post-war welfare state.

The 1945 Labour Government's formation of the welfare state was welcomed by many women who saw, for example, the National Health Service, as offering real material improvements in women's lives. House building, the spread of essential services like electricity, water and drainage accompanied by the provision of free vitamins, in the form of orange juice and cod-liver oil, all offered the possibility of bringing up children in a healthier environment than previously. The spectre of unemployment, poverty and the appalling toll it took on women, who in the depression of the 1920s and 1930s had tried to make ends meet, was to be abolished. Indeed Alan Sinfield has argued that the:

> Idea of welfare-capitalism is that the state attempts an unprecedented pact with the people, almost all the people, to protect us from the manifest disadvantages of capital; which are in brief, cyclical recessions that throw people into poverty and despair and the disregard for poverty and suffering however caused.[8]

Just as debates around the effects of the depression had been focused on the health and welfare of young children so too did the dreams of a welfare state. Healthy, happy, bouncy babies and children represented the future that Britain had fought for evidenced in many films made by the Documentary Film Movement, such as Humphrey Jennings's Diary for Timothy (1944). It was not just a material improvement in the nation's

young that was looked for in the new post-war Jerusalem. The emotional welfare of children was also focused upon, in direct contrast to the wartime evacuation which was based on a strategy of looking after the physical welfare of children. Freud's writings had only begun to be translated into English in the 1930s and the post-war period saw his ideas becoming more widely accepted and the work of Freudians like Bowlby, on the need for children to have a mother's constant love and attention to grow into balanced adults, was incorporated into 'common sense'. Mothers became responsible for the emotional as well as the physical well-being of children. It was a responsibility which they were expected to undertake full-time and the 1950s saw a moral panic focused on 'working mothers' and their 'latch-key children' – a derogatory term even now. Arguably after the carnage of war there is often a focus on the welfare of the new generation, but the focus was not just on children but on the behaviour of mothers and women as a whole. Denise Riley argues that 'the coincidence of proto-natalism with the end of the war intensified the "facts" that all women were mothers, or potential mothers, that all women were marriage-prone'.[9] What motherhood incorporated was to go on expanding for the next 40 years: running a taxi-service for children, organising pre-school play groups, attending numerous after-school clubs and activities, providing educational support and counselling difficult teenagers were all part of the remit by the 1970s.

Furthermore the post-war period saw the range of people to whom the housewife should provide physical and emotional care increase, to include husbands or partners, sometimes also relatives, friends and employees. The women's caring role was given a physical manifestation in early television adverts for washing powders and household items such as Persil, where women were encouraged to feel that they were being judged by the whiteness of their children's clothes or their husbands shirts. Alternatively in a 1959 Kellogg's advert a middle aged white collar worker's success at the office was portrayed as apparently dependent on his wife ensuring that he had a 'proper breakfast of Kellogg's cornflakes before his tea and toast in the mornings'. This notion of the skilled, equal but different partner was one that women's organisations such as the Women's Institute and the Women's Co-operative Guild had argued strongly for in the post-suffrage era of the 1920s and 1930s, seeing it as an improvement on the dual oppression and labour of working class women at the end of the nineteenth century and early twentieth, for whom finances had dictated that they participated in paid labour after marriage. The war-time Beveridge Report (1943), the blueprint for the welfare state, had been based upon a model of the family which stressed the 'equal but different' partnership

of men and women, with women's work being in the domestic sphere. The introduction of Family Allowances and the organisation of welfare benefits proposed by Beveridge (and in the main implemented) recognised women's domestic labour as women's organisations had wanted. Arguably it also, unfortunately, took such labour for granted. Thus in the post-war welfare state it was not just the expansion of motherhood which was of significance but also the expansion of the role of housewife. This was evidenced by the increasing importance placed on the 'companionate marriage', which was signalled by the formation of the Family Planning Association and the setting up of Marriage Guidance centres in the 1940s.

However, the idealised model of a post-war housewife displayed in so much advertising and in official discourses was just that – a model – and one that was based upon a white, middle class, non-working, southern, suburban housewife with a husband and a couple of kids living in 'consumer wonderland'. Although such an image was increasingly portrayed in adverts, and following the introduction of ITV in 1950 these images entered right into the living rooms of many women's homes, they did not tally with the lived experience of most (or possibly any) women. Many women felt themselves marginalised from the discourse of this model, either by class, race, region, sexuality, family structure, work or other factors. However, this model of the ideal housewife pervaded the consciousness of all women, in that they interacted with it, or internalised it and judged themselves by it, whilst also struggling against and re-negotiating such an image. It is a model based upon separate spheres and indeed the humour of sitcoms was frequently reliant on a perception of innate differences of gender at times compounded by other differences such as class, race or aspirations of such. In an episode of Bless this House (Thames Television 1971–6) entitled 'Get me to the Match on Time' the apparently idealised marriage of Sid James and Diane Coupland hinges on the tension produced by the wife's wish to take the family to her sister's wedding (seen as a female priority) and Sid's desire to spend the afternoon in a traditionally male activity – attending a football match. It is significant that a housewife's wish to attend the wedding is predicated upon her desire 'to show off her beautiful family' and thus is dependent on a sense of herself as a women being judged according to the well-being of her family. Thus, this traditional sitcom primarily re-enforces a notion of separate spheres, women's identity and pleasure being gained from their success in looking after the physical and emotional welfare of their family. Indeed women who do not comply to such ideals of housewifery are perhaps seen as justifiably the butt of humour. Olive in On the Buses (London Weekend Television 1969–73) is a case in point. She is unproductive in

either paid or unpaid labour and consequently defined as a useless failure and justifiable victim of humour. A childless, unattractive woman who is unable to cook (making her different from the idealised, equal post-war wife), she is categorised quite differently to 'mother' whose successful exercising of the 'womanly skills' of homemaking and consumption ensures that she receives respect.

However, even though this comedy is in many respects underlining a hegemonic notion of housewifery, it also at times provides a space for a more radical reading by transgressing society's gender boundaries in the interests of comic effect. In the episode entitled 'Mum's Last Fling', mother abandons her traditional role to engage in a romance, leaving Stan, Arthur and Olive to do the housework. She rushes out, after hiding her pension book, attired in a mini skirt, false nails, a blonde wig and thigh boots, thus becoming the object of ridicule and humour. Stan and Arthur iron and clean, wearing pinnies and complaining that 'this house is not worth living in since mum went potty over that ponce' and 'this isn't man's work'. It is significant that as they feel their manhood threatened they resort to homophobic insult. Although the resolution of the narrative has mum returning to 'normality', there is a suggestion that the *status quo* has been disturbed when she remarks on their housework activities: 'Now I know you can do it, I shan't have to work so hard in future'. The humour in such a narrative may be open to all sorts of 'pleasurable negotiations' by women viewers.

Another potential source of pleasure for women watching sitcoms comes from a discourse of men as children – a notion not unfamiliar to many sites of female culture (such as toddler groups and school gates) even in the 1990s. For many women the concept of the skilled housewife may also incorporate a perception of women as easily competent, hard working, reliable and arguably more organised and adult than men. Much of which is embodied in *Terry and June* (BBC 1979–87). Long suffering June Whitfield refers to Terry Scott as 'dear' in a somewhat maternal way. In the absence of children, June mothers Terry and is complicit in his harmless childish pranks and immature boasting that often narratively move the plot along. When in an episode based upon a day trip to France Terry has missed the ferry, he takes a hovercraft to meet her and is looked after by a stewardess. She explains that 'he had a little boy lost look' as June smiles knowingly. If, in *Terry and June*, women adult competence is benevolent, in *Fawlty Towers* (BBC 1975–9), where a west coast hotel becomes a surrogate family home, it is arguably represented as more repressive and severe. If June is the indulgent mother, Sybil, Fawlty's wife, is the disciplinarian one. That women are kill-joys and lacking in a sense of humour is, arguably,

not an uncommon cultural perception, 'You can't take a joke' Terry tells June, although her reply ('Well, I took you') allows women viewers complicitous humour around the idea that men are too stupid or childish to be taken seriously. This more common interpretation of a wife as a signifier of restraint is also found in *Whatever Happened to the Likely Lads* (BBC 1973–4). This series, based upon the relationship between two youthful friends ten years on, portrays the marriage of one (Bob) to his wife Thelma. She symbolises control and restraint, on drinking, his eating habits and 'having fun'. Marriage demands that Bob be 'grown up' in contrast to the rather laddish behaviour that his friend Terry engages in. Much of the humour comes from the tension around the boundary between adulthood and lad that Bob is constantly crossing and re-crossing. It is not, however, just a question of age. Thelma, her mother and consequently Bob's marriage represent middle class pretentiousness. Indeed in an early episode focusing on Bob's wedding preparations, even Bob's prospective father-in-law lines up on the side of good honest male working classness against the middle class airs put on by the females.

Women, particularly, in the 'never-had-it-so-good' years of post-war Britain, have often been perceived as consumers, both positively by advertisers and negatively in popular culture as the spenders of male, hard earned, money – Audrey in *Coronation Street* is a prime example of this phenomenon. Feminists such as Mica Nava have argued the significance of consumption as it 'offered women new areas of authority and expertise; new sources of income, a new sense of consumer rights and one of the consequences of these developments has been a heightened awareness of entitlement outside the area of consumption'.[10] If consumption is, at some level, regarded this way, then perhaps that explains why it may be highlighted as an area of tension in popular culture. Women sometimes appear to be portrayed as social climbing, pretentious, aspiring to be something they are not and, as such, to be false or deceitful in a way that is qualitatively different from the pranks and lies of Terry Scott in *Terry and June*. In *George and Mildred* (Thames Television 1976–9) because of Mildred's middle class pretensions, she becomes the butt of much humour, a tradition that Patricia Routledge maintains as Hyacinth Bucket in *Keeping up Appearances* (BBC 1990–). Such middle class pretentiousness may also be linked to the perception of women as more likely to vote Tory, which Bea Campbell explored in *Iron Ladies*,[11] although it is a tendency that she sees as changing. Whatever the statistical reality of political analysis, when in *George and Mildred* a women Tory MP comes to dinner with their next door neighbours, Mildred is not only impressed but portrayed as fawning unpleasantly. George's usually disapproved of uncouth behaviour,

epitomised on this occasion by his getting drunk and asserting that he has always voted Labour, is almost thrown into a more positive light by comparison. This traditional sitcom, like so many others, had indications of the cracks in the idyll of domestic bliss and the ideal of the housewife's role. Indeed, their marriage is so far from the idealised, companionate partnership that, in one episode, at Mildred's insistence, they visit a marriage guidance counsellor. Both husband and wife are rendered speechless when asked to think what they have in common. Mildred's complaints are given an airing, which although humorous many women may also find poignant 'What have I got for all these years but a pile of old rubbish' she demands as they survey their possessions after moving house. 'You've got me, dear' says George. Mildred's reply of caustic 'Exactly' sums up the gap between ideology, representation and lived experience for many housewives of the period.

It was a gap arguably first spoken of in private women-only spheres, among both the informal and the formal networks, upon which 1970s feminism was built. Betty Friedan had described the misery of many American housewives in The Feminine Mystique[12] in the early 1960s, referring to it as 'the problem with no name'. Eventually in 1970 the first Women's Liberation conference was held at Ruskin College and contained a variety of criticism of the housewives' role. Now women began to express their discontent in public. The Peckham Rye One o'clock Club, for example, argued that 'our window on the world is looked through with our hands in the sink and we have begun to hate the sink and all it implies'.[13] Such criticisms of housewifery were taken up by the Wages For Housework Campaigns in the 1970s and 1980s, especially when in 1977 they held an alternative Mother's Day celebration, giving each women a daffodil as they arrived. The opening speech declared 'All of us are housewives and mothers – we do the work of mothering other people. We're tired of doing it for free . . . Few of us can get time off even on Mothers Day'.[14] Other speakers, after referring to the Icelandic housewives strike, went on to point out; 'when a woman stops, everything stops'. Similarly in Till Death Do Us Part (BBC 1965–75), Alf's wife had early emphasised their different positions by concentrating on his tendency to overplay illness and demand attention, having her running up and down stairs. She justifiably grumbled; 'But when it's me, I can't take time off. I can't go to bed. I have to carry on as usual'.

It was, however, the genre of housewives comedy that took this a significant stage further, giving women the dominant voice, not just the occasional aside. In these texts women and their experiences were the main focus of the texts, as they were in feminist texts. When Ria in Butterflies (BBC 1978–)announced 'I devote my entire existence to this family ship.

I am the cook, the laundry maid and the captain', her husband agrees that she is indeed the captain of the ship, thus centring the re-evaluation of domestic labour and responsibility. Not surprisingly, the Wages For Housework campaign went one stage further than sitcoms, arguing that 'as all women's work is essentially housework and all housework is a labour of love so all women's work is low paid and low status'. This link between paid and unpaid work is significant, as although Ria mutters about getting a job at times, a low paid and low status job would solve few of her problems. Indeed the only working woman to be seen in the series is Ruby, Ria's cleaner. Interestingly Ruby's role is at first very minor and no more than a prop to the family's antics. She comes briefly in and out of scenes holding cleaning utensils and making desultory comments such as 'It's peeing down outside!' Her role expands when Ria's children start to work, and an episode which focuses on the problem of Ruby's penchant for shoplifting establishes that Ria and Ruby have more in common, because of their position within their families, than they have class divisions between them. The debate about housewifery went on simultaneously within *Butterflies* and the Wages For Housework Campaign, which whilst never expected to be successful, did galvanise women's discussion around the area of domestic labour; its significance in the life of the nation, and, perhaps more importantly, women's resentment of it. Even journalists such as Jill Tweedie, who opposed the campaign, nevertheless engaged in the debate, explaining her own attitude to housework thus: 'My only way of accepting housework is either to ignore it, shut off my brain and try to do it like a robot, or pretend to myself that I love to do it and I am therefore good. What do I feel? The horrid resentment of a mind bred to slavery and faced with freedom'. Jill Tweedie's writings are an indication of the resistance to cultural assumptions of women's 'natural' affinity to housework, being voiced by feminists. Such complaints are voiced by Ria in *Butterflies*: 'I wish to say one word about my cooking. I do not like cooking. I am not happy cooking. Cooking upsets me. Horses cannot fly, birds cannot gallop. I cannot cook'. Her incompetence at cooking is a signifier that contrary to popular belief housewifery, like typing, does not come 'naturally' to women. Thus this sitcom carried into the popular sphere many of the debates and discourses of feminism, which had always been at one level about creating a cultural space for women where they could prioritise their issues and concerns. This occurred in women's conferences, consciousness-raising and other women's groups, although arguably these were predominantly the domain of the middle class. The media have always provided a forum for discussing women's issues and for a much wider constituency of women than feminism can ever hope to reach.

Women's magazines since the nineteenth century have done this as did women's films in the 1940s, a tradition continued by the housewives comedy of the late 1970s, with its laughter based in Greer's words on 'parody and a sense of shared inclusion'.[15]

Feminism in the 1970s took as its slogan 'the personal is political', seeing it as important to move private resentment and discontent into the public sphere and in so doing redefine the private complaint as a political issue. To do so there was a need for women to define their own voices and to dominate texts rather than just be allowed small asides. This happened in Butterflies and the housewives comedy that followed it. Indeed its very name is significant in this. In 1972 Michelene Wandor wrote in Spare Rib of:

> overwhelming pressures, which are the reality behind the vision of 'happily ever after' . . . The emotional focus of this dream is the woman, caught in a million gossamer threads lightly woven into the finest and most delicate mantle of suffocation 'Love' and a women's place within the home.[16]

The suffocation and release, or the search for release Michelene Wander described, were the themes of Butterflies, emphasised by the images of butterflies, caught, killed and pinned into a frame of a house, by Ria's husband Ben, which accompanies the theme tune. Due to the formulaic conventions of sitcoms Butterflies offers no release for Ria either. (She rejects the temporary release of an affair with Leonard.) This may irritate the modern viewer greatly. But sitcoms often focus on situations which may be looked at comically, and which in many respects to outsiders are absurd but ones in which the participants opt to remain. Arguably this is also just why Butterflies was popular with housewives (in the 1970s and when the programme was repeated in the 1990s). They often saw in the comedy the absurdity of their role; like Jill Tweedie they often resented it but they still found themselves financially or emotionally trapped in their situation. Questions about why women may gain an unconscious gratification from, or have an investment in, the housewives' role, which makes them reticent to give it up, came well after Butterflies had been and gone. What was significantly radical in 'housewives comedy' was that the role of the middle-class housewife was seen as suitably ridiculous to be the situation for a comedy.

Butterflies defines the role of the housewife as the problem by surrounding Ria with a family who are 'fundamentally alright'. They do not display particularly significant levels of selfishness or malice. Ria's husband, by the conventions of the period, is well meaning and considerate. This indeed emphasises an important feminist point that it is the socially constructed

role which is the problem, not the individual personalities of men. Hence Greer in *The Female Eunuch* berates women's tendency to blame their unhappiness with married life on the individuals concerned or on their own failings, rather than on the middle class myth of love and marriage.[17] It is significant that Ria is financially comfortable. The financial insecurity of the inter-war years never appears in these texts and the women's lives appear to fulfil the promise held out by the welfare state, according to Sinfield. Ria does not lack financially in any conventional way, although it is understood that primary decision-making over major expenditure is a male prerogative. Ria explains how she and Ben chose the car: 'My husband couldn't decide whether to get a little one each or a big one between us. So he got a big one between us for him to use'. As I have argued, consumerism has been seen by many feminists as a source of power for women, but Ria, unable to influence major financial decisions, sees the more mundane expenditure, as, for example, when shopping for groceries, as yet another restrictive chore. Consumerism seems to offer Ria little power; rather it is a restriction and an unwelcome responsibility. Many recent feminists, including Anne Oakley,[18] have argued that the consumer revolution, bringing domestic technology such as washing machines and microwaves, has not led to any reduction in the number of hours spent by housewives on domestic labour. Rarely is a housewife seen outside the house, unless she is on her way to or from the shops, her shopping bags signifiers of the Michelene Wandor's gossamer threads which pull her back to the house; carrying shopping bags defines Ria to the external world.

Significantly, it is when Ria is about to enter a supermarket one day that visually and narratively *Butterflies* gets closest to being an overtly feminist discourse. The camera follows Ria's gaze to focus on women, tired, exhausted, disenchanted and engaged in a joyless struggle with family shopping. Ria defiantly pushes away her trolley and marches home empty handed. Her sons' dismay at finding no activity in the kitchen, the cupboards empty and Ria doing her nails at the kitchen table in a rather detached way, results in the following exchange with her sons:

RIA: I was in the high street today. I was watching people, watching housewives mainly: women with shopping bags, women with boxes women with grim faces and oven timers ringing in their heads. I saw me.

RUSSELL: Oh, come on.

RIA: If I'm not buying food, I'm cooking food. If I'm not cooking food, I'm washing up after food.

ADAM: Guess you're just having a bad day.

RIA: I'm not having a bad day, on the contrary, I'm having a good day, that's why you're not getting any dinner.

The potential radicalism of this situation is diffused by Ben returning home and taking Ria out to dinner, another temporary solution. Ria voicing her discontent despite these contrived and temporary solutions arguably allowed many women pleasurably to negotiate the text so as to consider the potential, however small, for change in their lives. Maybe more importantly the burden of isolation and personal sense of failure of many housewives was diminished by its being voiced in the very public sphere of mainstream television.

By focusing on a woman in her forties *Butterflies* does allow the problems of women's domestic role to be seen in terms of mid-life crisis, ageing problems of 'empty nest syndrome', rather than a questioning of house-wifery. Housewives' boredom, frustration and resentment could be seen as a by-product of smaller families and the utilisation of technology (how-ever mythical such a narrative may be). Ria's children being grown up allows the constant demands and expectations placed on mothers to be focused through the comic device of exaggeration to the point of ridicule. When Adam complains, 'I'm kind of skinny, one missed meal and I might fade away', laughter is the only response. But within *Butterflies*, and the sitcoms featuring housewives that follow it, the 'common sense' explanation of women's domestic responsibilities – that young children apparently need a mother's care – operates as a structuring absence never really verbalised or challenged. This is where *Roseanne* (Channel Four 1989–) and *2.4 Children* (BBC 1991–) make a significant break with con-vention: they debunk a more fundamental myth in western society – that mothering young children is necessarily pleasurable. *2.4 Children* challenges images of motherhood and family life which is, in this British version of *Roseanne*, portrayed as chaotic, conflict ridden and dominated by the harsh reality of temperamental washing machines and children's sulks when bought the wrong make of trainers. Children themselves are a constant hassle to mothers, 'Why Meryl Streep didn't thank that dingo, I'll never know', Bill exclaims referring to the film version of the Lindi Chamberlain[19] story and her children's bad behaviour in the same breath. Just one of the many postmodern, media self-referential comments that are perhaps to be expected from a comedy with a title that takes a tongue-in-cheek attitude to notions of the normal family, and that calls the wife and husband Bill and Ben respectively (names which will be identified by older viewers as belonging to the Flower-Pot Men in 1950s children's television).

Indeed much of the humour in 2.4 *Children* relies on a shared audience knowledge that media images of families and lived experiences are wide apart; women's (and others') humour and enjoyment in the programme rely upon their complicity in and celebration of the deconstruction of myths of idealised family life, and of the housewife's role within it. In the first episode hectic early morning activity in preparation for school and work are interrupted by a voice from the television Bill's son is watching. 'Today's woman, she's soft, feminine, runs her own company as well as her family and still has time for passion.' Bill pauses, watches the screen with a look of incredulity before calling the unseen image a 'cow'. Turning off the television and denigrating media images as men's childish fantasies, she declares 'They're fairy tales by men with pony tails'. Bill further confronts social pressures to produce the 'ideal child' when called in by the daughter's form teacher to be told she is 'surly, uncooperative and totally disinterested in school.' She replies 'All that's normal for a fourteen year old.' Although Bill's husband is portrayed as well meaning and devoted, he offers little help to her. Frequently wearing silly hats, focusing on immediate and short lived pleasures, he is dangerously close to the husband as child phenomenon of earlier sitcoms such as *Terry and June*. The concept of family and the roles of mother and housewife within it, has certainly been re-negotiated and challenged by such comedy but the myth still seems to be holding tenaciously on, although arguably America is again leading the way in the challenges to this with the recent series of *Grace Under Fire*. Because this series focuses on a single working mother and her children, the very concept of family is challenged by 'the new independent mother' that Kath Woodward has argued is a phenomenon portrayed in some recent women's magazines such as *Marie Claire*.[20]

The social and economic realities of western women's lives: unemployment, low women's wages and the high cost of child care mean many women still remain housewives either part-time or full-time. Comedy programmes cannot change that but they can help change the meaning of the role and the way women think about it, they can deconstruct myths and representations compared to which women may feel a failure. In recent years, since the second wave of feminism in the 1970s, the isolation and silence surrounding the lives of housewives has been reduced. This significant achievement has freed women more openly to negotiate domesticity to suit themselves. It is not just the result of overt political campaigns, but also of that feminism to be found in popular fiction, film, television, and, as I have argued, in housewives' comedy. The deconstruction of the idyll of 'happy ever after', which many young girls

growing up in the 1990s reject, owes as much to Ria in *Butterflies*, *Roseanne* and *2.4 Children* as it does to Greer, the Wages For Housework campaign or the consciousness-raising groups of more overt feminism.

NOTES

1 C. Gledhill, 'Pleasurable negotiations' in E.D. Pribram (ed.) *Female Spectators* (Verso, London 1988).
2 J. Winship, *Inside Women's Magazines* (Pandora, London 1987) p. 14.
3 H. Jenkins, *What made Pistachio Nuts?* (Columbia, New York 1992) p. 251.
4 G. Greer, quoted in J. Bennet and R. Fargan, *There's something about a convent girl* (Virago, London 1991) p. 89.
5 L. Goodman, 'Gender and Humour' in F. Bonner *et al.* (eds) *Imaging Women* (Polity, Cambridge 1992) p. 288.
6 ibid p. 289.
7 C. Hall and L. Davidoff, *Family Fortunes* (Hutchinson, London 1987).
8 A. Sinfield, *Literature and Culture since 1945*, p. 277 (Routledge).
9 D. Riley, *War in the Nursery* (Virago, London 1983) p. 195.
10 M. Nava, 'Consumerism and its contradictions' in *Cultural Studies* 2 (1989).
11 B. Campbell, *Iron Ladies* (Virago, London 1987).
12 B. Friedan, *The Feminine Mystique* (1965 reprinted Penguin, Harmondsworth 1985).
13 *Spare Rib Reader* (London 1970).
14 J. Nicholls, 'Daffodils Card and Wages' in *Spare Rib 58* (Virago, London May 1977).
15 G. Greer, quoted in J. Bennet and R. Fargan, *There's something about a convent girl* (Virago, London 1991).
16 M. Wandor, *Spare Rib* (London, April 1972).
17 G. Greer, *The Female Eunuch* (Granada, St Albans 1971) p. 215.
18 A. Oakley, *Housewife* (Penguin, Harmondsworth 1976).
19 Lindi Chamberlain claimed her daughter was carried off and killed by a dingo in the Australian outback. Meryl Streep played her in the film version of events entitled *A Cry in the Dark*.
20 Kath Woodward (ed.) *Identity and Difference* (Sage 1997).

4

TARTS, TAMPONS AND TYRANTS

Women and representation in British comedy

Laraine Porter

This chapter examines issues of gender in popular British comedy. In particular it considers the preponderance of female comic stereotypes: the ingenuous curvaceous bimbo on the one hand and the nagging unattractive wife on the other, across a range of comic forms from cinema, stage, TV and radio to seaside postcards. Although it is impossible to talk in absolutes, for comic traditions are multifarious and shift across forms, history and social context, the recurrence of a particular and narrow range of female comic stereotypes is striking. However, every examination of the feminine must also acknowledge its opposite, so comic representations of masculinity must also be considered, particularly as comedy is often derived in the pairing of gender and sexual opposites.

INTRODUCTION: WOMEN IN CLASSIC COMIC NARRATIVES

Even a cursory glance through the archives of popular British comedy between the 1930s and the advent of 'alternative comedy' in the 1980s reveals both a numerical lack of roles for female comics and that the available roles fulfil a relatively narrow range of comic stereotypes. Exaggerated dumb blondes and squeaky bimbos on the one hand or moaning harridans and ugly hags on the other, have been the comic mainstays of female representation. If the examination of the feminine in comedy is extended to include male cross-dressers and drag artistes, as feminine surrogates which may either mock or celebrate femininity, then the stereotype expands to include the tyrannical mother-in-law and the voluminous matriarchal nightmare: the heavily corseted panto dame who generates humour from her unconvincing prosthetics.

Such comic representations give us insights not only into the comic constructions of femininity but also into the broader ways in which

femininities are conceived and constructed in popular culture: in other words, into the social, psychological and sexual implications of these constructions. Where do these constructions originate and what do they tell us about gender relationships, fears and anxieties regarding our sexualities?

There are several preliminary points to be made before moving on to address the main question. First, can comedy simply be understood in terms of gender difference either at the point of its production or at the point of its consumption? In other words, do men and women share the same humour or do women produce different forms of comedy and laugh at different jokes? This question is invariably a starting point for considering gender and humour but no examination of gender should posit a straightforward binarism, there can be no absolutes, merely tendencies. But against this, it cannot be denied that male and female audiences as consumers *en masse* are constructed differently within popular culture and contemporary society.

Second, comic pleasures associated with the recognition of certain stereotypes in humour cannot be disavowed. Often it is the recognition of the stereotype that elicits a comedic response at the outset. Like the pleasurable familiarity of the powerful, rotund matriarchs and their physically inferior, henpecked spouses in Donald McGill's classic seaside picture postcards, they remain an intrinsic and ubiquitous part of popular British comic culture, with associations of traditional comic pleasures and entertainment. Such overt sexual stereotypes have specific functions within the comic universes in which they operate and often work within the comic mode precisely because they are sexist and objectively insulting. Comedy is essentially an anarchic form that consistently resists notions of political correctness and polite behaviour. It is a cipher for anti-social desires that cannot be expressed elsewhere and as such often exults in the breaking of taboos and canonical attitudes regarding the body, sexuality and social behaviour. Successive waves of comedy have reinvented the comic object or victim, but only within narrow parameters and it is possible to trace the development of certain comic types across history and cultures as Howard Jacobson has done in his recent publication and TV series *Seriously Funny* (Jacobson, 1997: Channel 4 TV 1997). It is particularly striking to note the consistence of comedy derived around aspects of femininity; the female body, female sexuality, feminine activities and behaviour and her successive roles as wife, mother, matriarch and mother-in-law.

Many comic representations become funny when measured against their opposites: the well-behaved, politically correct counterparts politely circulating in more repressive cultural regimes. The more that a stereotype

is defined as problematic, the higher its value in comic terms. This is not to suggest that the stereotype can be cut loose from the ideology in which it circulates or that comic stereotypes must be freed from wider debates around representation in terms of race, class, sexuality and so on. But the project here is to examine the persistence of particular sets of sexual stereotypes and especially of the positioning of the feminine in comic narratives. Why, for example, have women repeatedly been cast either as dolly birds or harridans, and why when men emulate women in cross-dressing comic modes do they parody specific aspects of femininity such as breasts, female reproductive functions and certain feigned feminine traits and body language and dress?

The quest to understand the construction, function and circulation of the stereotype also needs a structural examination of comic modes and narratives themselves and an examination of how the stereotype functions in its comic universe. Certain kinds of comedy simply demand over-determined gender stereotypes: pantomime, bawdy farce and 'low' humour. The Carry On and the Pompeii cycle of films with Frankie Howerd spring immediately to mind. But the derivation of these stereotypes still needs to be questioned: what are their antecedents, how do they function in their wider contexts, what meanings circulate around them and how do these meanings relate to different audiences in terms of age, race, gender and class? This examination needs considering within historical contexts to understand how certain representations and sexual stereotypes have endured or changed over the past 60 years, particularly since the advent of television and the forms of comedy developed for the new medium such as sitcom and TV variety shows. These important questions need to be posited even if a fuller examination of the issues they raise is beyond the scope of this chapter. The interfaces between women, femininity and comedy are desperately under-developed fields of research, worthy of much wider investigation beyond the tentative first steps taken here.

A LASS AND A LACK: WOMEN, COMEDY AND THE PROBLEMS OF HISTORICAL RESEARCH

There are currently huge gaps in documentation, historical accounting and records of early women comic performers. This is particularly noticeable in the early and silent (pre-1929) cinema and in the late nineteenth and early twentieth century music hall, vaudeville and variety theatre and music hall. The majority of extant material is on television, but the recent television series Heroes of Comedy written by John Fisher (Channel 4 1994–5) was able only to include Joyce Grenfell in its gallery of otherwise male

performers. The absence of women from historical accounts of comic performance is open to different interpretations: either there were numerically fewer female performers than male or they have simply been written out of history. Feminist revisionist theory favours the latter suggestion and as the major gaps in documentation and research are prior to current popular memory, opportunities for oral testimony have been lost. In the period of silent cinema and in television history up until the 1940s, the great clowns have all been male: Chaplin, Little Tich, Max Miller among others. So whilst we have massive amounts of documentation, film footage, research and biographical material on Chaplin for example, we have next to nothing on his supporting female Edna Purviance. And who has heard of two wonderful American comediennes from the silent period, Anita Garvin and Marion Byron, who formed a superb female Laurel-and-Hardy-type duo with physical, knockabout comedy and sophisticated sight gags? It goes without saying that any historical survey of film and television is really a survey of what has been recorded, archived and preserved, rather than a definitive picture of what was available to audiences at the time.

We need to add to the vagaries and caprices of historical research and documentation, the fact that comedy was a difficult field for women to enter, particularly in the first half of the twentieth century. In his review of Max Miller in 1940, George Orwell comments upon the importance of bawdy comedy and its expression of the 'lowness' of life and gives an insight into the dilemma for popular female comedians:

> There was a music-hall farce which Little Tich used to act in, in which he was supposed to be factotum to a crook solicitor. The solicitor is giving him his instructions:
>
> 'Now, our client who's coming this morning is a widow with a good figure. Are you following me?'
>
> (Little Tich) 'I'm ahead of you'
>
> . . . I have never seen anyone who could approach the utter baseness that Little Tich could get into those simple words. There is a touch of the same quality in Max Miller. Quite apart from the laughs they give one, it is important that such comedians should exist. They express something which is valuable in civilisation and might drop out in certain circumstances. To begin with their genius is entirely masculine. A woman cannot be low without being disgusting, whereas a good male comedian can give the

impression of something irredeemable yet innocent, like a sparrow.

<div align="right">(Orwell, 1941: 191)</div>

If we accept that much popular British film and stage comedy has relied on sexual innuendo, bawdy repartee and the expression of base desires, and if even a liberal like Orwell felt it somehow inappropriate for women to perform such material, then their absence from the adult-oriented music hall, the variety theatre and the cinema was inevitable. But we need to ask why it was felt inappropriate for women to perform risqué humour that expressed sexual desire? The answer lies partly in the fact that the subject of such humour has been almost entirely male. In Little Tich's wordplay above, it is literally the figure of the woman who is the butt of the joke, the objectified 'other'. It would therefore be inappropriate for a woman to articulate sexual desire in this way, for traditionally her sexuality can only be understood as a direct function of his. This instantly problematises the woman's relation to jokes and joke telling where the traditional butt of the joke is the woman herself.

MEN, WOMEN AND COMIC SEXUAL DIFFERENCE

From the advent of classic narrative cinema in the early years of the century, through the birth of television in the 1930s and arguably until the advent of 'alternative comedy' in the late 1970s, women have occupied very prescriptive and clearly defined comic roles. Cast and used primarily as comic objects they have been peripheral to the production of humour. Numerically in the minority, those women who have attained comic stardom have tended to operate within the narrow range of personas and comic types available to them. Tarty, giggly blondes like Barbara Windsor, nagging wives such as Yootha Joyce, plump matriarchs like Hattie Jacques, frustrated spinsters like Hylda Baker and female grotesques like Anna Karen's 'Olive' character in On the Buses formed the paradigm for female comic typecasting. However, we must not discount their male counterparts: the rapacious Sid James in the Carry On cycle, the hapless George in George and Mildred, the long suffering Jimmy Jewel as Hylda Baker's brother in Nearest and Dearest and Arthur, the deadpan domestic drudge who's married to Olive in On the Buses.

Gender stereotypes collide with one another and comedy is often derived from a situation in which two people are mismatched. The battle of the sexes is one of comedy's most enduring themes. What we need to examine is not simply the pitching of over-sexed women against fearful

and inadequate men, large ladies against skinny husbands and so forth, but also what forms these oppositions take and why? What makes the pairing of Barbara Windsor and Sid James ripe for ribald innuendo? What is the essence of the comic difference between those two characters, and more importantly for our purposes here, where is the humour derived from Barbara Windsor's character and physique and why should a sexually attractive, pert young female like her be matched with an ageing, lecherous caricature of oversexed masculinity like Sid James? Put simply, why do ugly men still attract beautiful women in comic narratives?

Besides comedies of gender and male/female pairings, another tendency for female comic caricature has been the asexual, female gung ho characters exemplified by Joyce Grenfell and Margaret Rutherford, particularly in the St Trinians series of films. Here, the comedy is not derived from sexual mismatches, i.e. the presence of men in potentially sexualised situations, but from the absence of men and heterosexual liaisons; in other words, a community of spinsters and young girls. Here the comic potential is derived from the essential instability of the all-female environment and the nightmare scenarios associated with the exclusion of masculine logic, reason and authority.

What unites the narrow spectrum of female types in the traditional modes of popular British comedy of this period is their a priori definition by physicality and sexuality: the tart or dumb blonde by her over-determined sexuality, or her excess of sexual difference, and the tyrant or spinster by her absolute asexuality, or her lack of sexual difference. Both of these extremes are constituted as threats to men in comic narratives and therefore by definition (if we assume that the male viewer will identify primarily with the male protagonist) to the male viewer, for reasons that will be argued later. So if definition by sexual appeal – or its lack – is a common factor among images of women in traditional British comedy, the question which then needs to be addressed is how the comic feminine object functions in relation to the male comic subject, both within the comic diegesis and in its paradigmatic relationship to audiences and theories of spectatorship.

It must also be remembered that comic stereotypes are a mainstay of popular British comedy and pervade British culture from the seaside postcards of Donald McGill through the Carry Ons, Doctor and St Trinian films from the 1950s to the 1970s, in television sitcoms such as Marriage Lines (1962–6), On The Buses (1969–73), Steptoe and Son (1962–74), George and Mildred (1976–9), Nearest and Dearest (1968–72), Are You Being Served? (1973–85), Dad's Army (1968–77) and so on. Sexual stereotypes do not exist in a vacuum, however; they co-exist alongside a plethora of others

cast according to race, age, class, region and nation. Stereotypes and overblown caricatures abound in popular British comedy, often reflecting back and forth and interfacing with one another. Myths of black male and female sexual potency are common sources of jokes in Love Thy Neighbour (1972–5), where the dubious virility of white (honky) Eddie (Jack Smethurst) is cast against the overt physical prowess of his black neighbour Bill Reynolds (Rudolph Walker). The implied sexual frigidity of middle class women is a theme in The Good Life (1975–8) where the repressed Margot Leadbeatter (Penelope Keith) is contrasted to her coquettish neighbour Barbara Good (Felicity Kendal) and so on.

Overt sexual stereotypes function in traditional modes of bawdy humour, farce, innuendo and in comic agendas where male prowess and the attendant fears around its lack (impotency), are central to the comic narrative. In Carry On films, for example, Sid James' caricature of male libido is matched by Barbara Windsor's comic caricature of bosomy, blonde ingenuous femininity. The two caricatures occupy a balanced narrative position, as sexual binaries that ultimately complement and determine one another. However, the narrative balance is tilted firmly in favour of the male subject as female sexuality is invariably a function of masculine heterosexual desire; she is cast as the image and object of his desire and rarely is this pattern reversed. Her function is to produce comedy in relation to the male subject. She is determined by his sexuality, whether this be a measure of his prowess or an indication of his impotency. Yootha Joyce's unfulfilled libidinous femininity (in George and Mildred) serves to indicate her eponymous husband's inability and unwillingness to perform conjugal duties. Humour around male sexuality has of course long been a staple of British farce and bawdy seaside humour: a recurrent image is of male sexual dysfunction when confronted with the voracious sexual appetite of the less-than-attractive older woman or the over-demanding young sex pot.

This goes some way to answering the question earlier 'why do ugly men still attract beautiful women in comic narratives'? If she is determined as an object of his sexual desire (or fears) then she has no desire or sexuality independent of her male counterpart and is thus constructed entirely in the image of his, and arguably a collective male, fantasy. The beautiful woman also functions to reassure the less-than-attractive male that he really does not have to make too much effort with his appearance to attract 'gorgeous birds'.

The initial approach to comic sexual stereotypes outlined above sees them a priori as a function of narrative structure and balance: the superior, most exaggerated male libido wins the most over-determined feminine

stereotype: the busty, giggly blonde. She is often completely unaware of the effect that she has on the attendant male characters. Her sexual innocence is absolutely crucial, for, freed from her own desires, she functions only to satisfy masculine lust and, without any demands of her own, places the fragile masculine myth of potency under no threat. She is the ultimate object of a (mythical) masculine desire that will not judge or evaluate its male sexual partners. Nor will she question why she has to conform to rigid male-defined images of gravity-defying physical perfection whilst he can sport a face like a bag of spanners and still represent male desirability. Witness Sid James and the bevy of male actors from *Carry On* films where the nearest character to a traditional male sex symbol is invariably played by Jim Dale, and Benny Hill's comic finales where he's chased by hordes of scantily clad bimbos. However, we must also take into account the ironic self-awareness which much of this comedy displays. It is precisely the incongruity of a figure like Benny Hill arousing the attentions of women in this way that makes the sketches comical. Benny Hill, Sid James, *et al.* are ironic caricatures of male libido, representatives of a collective male fantasy which will never be realised outside the comic narrative. This allows for the free play of fantasy divorced from notions of polite behaviour, acceptable sexual mores and the reality of male sexuality which invariably fails to live up to its mythical status and expectations of unerring potency.

Other incongruous sexual pairings include Tom Ewell and Jayne Mansfield in *The Girl Can't Help It* (Frank Tashlin 1956) and Sid James and Barbara Windsor in the *Carry On* cycle. The comic pairing of the unattractive man with the over-determined, sexy woman can be interpreted in a number of ways. First, men like Sid and Tom offer points of reassurance for the male viewer: that unattractive men are capable of attracting the most desirable women and that men really do not have to try too hard with their appearance. They certainly do not need to match the physical prowess of the female object. In many such cases, women are comic objects and largely the butt of the jokes whilst the male subjects generate verbal and visual humour around the figure of the woman, particularly her innocence and her lack of awareness of the effect she has on men. However, we also need to understand the function of stereotypes and how comedy can articulate fears and insecurities, as well as desire and lofty status. Alternatively, we can read the overstated blonde as the ultimate threat to heterosexual male desire in that she represents a confrontation, in a grossly exaggerated form, with all that he is supposed to desire. She is the ultimate heterosexual male fantasy writ large. But rather like the ways in which the penis can never live up to the myths surrounding the

phallus, there are strong implications that the male comic subject will be unable to live up to a confrontation with the mythological object of collective male fantasy, whether this be Jayne Mansfield, Marilyn Monroe or Barbara Windsor. In other film and TV genres, the male subject might possess a phallus, but in comedy he only has a penis. So, understood from this point of view, the powerfully mythological and over-determined blonde, even devoid of her own libido and subject status, is the ultimate threat to masculine potency.

Employing a loose psycho-sexual framework to map issues of comedy and gender helps to understand the psychological basis for representations of men and women and the ways in which comedy can articulate psychologically determined patriarchal fears and desires. But we also need to take account of how stereotypes exist and change at particular social and historical junctures and the factors which have influenced and affected sexual relationships in recent history, and, ergo, their representation in comedy and popular culture.

Any examination of shifts in comic address, comic modes and forms over the twentieth century needs to take account of shifting agendas around patriarchal masculinity, of crises in heterosexual monogamy, the institutions of marriage and the family and, ultimately perhaps, of a mutable but fundamental incompatibility between male and female sexuality. During the 1970s and 1980s, coinciding with increased female equality, sitcoms such as The Dustbinmen, On the Buses and the Confessions films feature archetypal attractive females who are the passive and willing objects of unattractive masculine attention. A clear example of popular comedy articulating fears around the 'threat of feminism' and women's entry into the work place can be found in the 1971 film spin off from the series On the Buses (directed by Harry Booth). Here the comedy is derived from the inappropriateness of women taking jobs as bus drivers, whilst men are involved in industrial action regarding overtime. The narrative reflects 1970s industrial relations and anticipates the later recession and 'winter of discontent'. However, the women drivers are depicted as monstrous, excessively butch and ill-mannered characters: overweight, unattractive, unfriendly and clearly coded as lesbians. These are contrasted with the dolly-bird 'clippies' and sexual libertine housewives like 'Turn-around Betty' a character who lives entirely in flimsy negligees and performs sexual favours for the male bus drivers (Reg Varney and Michael Robbins) in her home by the bus terminus. Numerous sight gags are constructed around legs and breasts, with mini-skirted young clippies descending the bus or depot stairs whilst Stan and Jack stand at the bottom looking up and growling 'Whoaaa' to each other.

Popular comedy of the 1970s also provided us with the *Confessions* series of films, in which the singularly unattractive Robin Askwith scores with numerous young dolly-birds, whose only functions are to appear scantily clad and to make giggly sexual demands on the Jack the Lad hero. *Confessions of a Holiday Camp* (Norman Cohen 1975), for example, places Robin Asquith as the camp manager about to judge a beauty contest in as many unlikely situations involving near-naked girls as possible, all of them trying to trade sexual favours in return for a victory in the contest.

In these films, men are invariably unattractive, behave badly and, aside from the occasional ribald comment, have to make no perceptible effort to attract women. Women are divided into sexually available and ingenuous dolly-birds who 'will' on the one hand and those who 'won't' (or rather, those with whom the hero wouldn't want to) on the other. Their function is entirely peripheral to the narrative, other than to provide sexual titillation for a male audience and gratification for the male protagonist. However, it is oversimplistic to interpret these films merely as a 1970s aberration; as a backlash against a perceived militant feminism and the associated threats of female empowerment and the entry of women into the workplace. In particular, these films need to be understood generically in terms of their relationship to other forms of soft porn and sexual exploitation which proliferated in British film production at a time when the industry was at the lowest point in its history. As such they provided a low-budget, quickly produced product with a relatively safe return on investment from box office. They were produced to compete with home entertainment at a time when television was considerably less liberal and still perceived as middle class and middle brow. In other words they were designed to attract mass popular audiences back to the cinema or at least to stem the haemorrhage away from it. The television series were also designed to appeal to a mass working-class audience in the ratings war between the BBC and the Independent television channels (ITV were responsible for *On the Buses* and *The Dustbinmen*). The point is that popular television and cinema help to construct as well as reflect sexual identities, and matters of gender and representation cannot be examined in isolation from the economic, social and industrial contexts in which they were produced and disseminated.

If the image of masculinity is the starting point for much of this debate, this is because masculinity has traditionally determined femininity. The image of the woman fills the space of his desire and his fantasy. She also represents that which he is not. Without subscribing wholly to the depressing notion that there is no such thing as female, only non-male, it is nevertheless more revealing in comedy to use the masculine as the

starting point for examination as it is here where the majority of comic subjectivity continues to reside.

In trying to understand the construction of femininity in comedy as a function of masculinity, we need to adopt a two-pronged approach to mapping out masculinity, femininity and gender relations. First, account must be taken of successive and historically specific crises in patriarchy, of insecurities regarding masculinity and social power brought about by shifting gender relations and of economic and political threats to the traditional patriarchal roles of men. Gender relations and the ways in which we understand ourselves as sexual subjects in relation to and reflected by the media have shifted dramatically during the twentieth century. Second, if we acknowledge that masculinity has been the defining force behind the production of much popular comedy, then we need to consider ahistorical (but nevertheless related) psycho-sexual crises and proclivities in male sexuality. These include anxieties around impotence and declining sexual prowess and the omnipresent need for heterosexual masculinity to disavow homoerotic desire and to suppress the feminine and bisexual drives in male sexuality. Comedy is a crucial form for expressing issues and discharging anxieties around gender and identity. Its intrinsic anarchism allows for the expression of desires which cannot legitimately be expressed in 'serious' cultural modes. It can facilitate the parading of that which is normally unspoken or suppressed. Cross-dressing and heterosexual camp humour, for example, can be read as legitimate ways of expressing and, ultimately, discharging masculine desires around bisexuality and feminine identification. Laughter and mockery are themselves often a means of disavowal.

Generic distinctions in comedy also need to be taken into account and, whilst boundaries between forms are invariably slippery and at times unhelpful, a framework for analysis needs to be imposed at the outset. Consider the differences in the forms and content of comedy created distinctly for male and female audiences, for example. Although homosocial social groupings are increasingly rare, as even the bastions of men-only entertainment such as Working Men's Clubs now admit women, much traditional popular comedy assumed a male subject/female object status quo. Male-orientated comedy has traditionally involved male scriptwriters and features male protagonists and subjects in a universe which is understood primarily as masculine. This can be compared to comedy created primarily for female audiences. Largely, though by no means always, this is scripted by women. In this category are the more recent female stand-ups like Jo Brand, Rhona Cameron, Jenny Eclair and raconteurs such as Victoria Wood and female-orientated TV sitcoms such as *Absolutely Fabulous*

(November 1992–95, BBC2/BBC1) that take female subjectivity for granted. This is not to suggest that male comic scriptwriters are unable to write comedy for women with a female address (that is, those with an address directly to women) and vice versa. Willy Russell wrote *Shirley Valentine* (Lewis Gilbert, 1989) which was a massive success with female audiences, for example. Nor can simplistic gender divisions be mapped in isolation onto an overview of comedy that fails to take other factors into account; such as shifting audience and entertainment trends, the heterogeneity of popular audiences which are further divided by class, race, region, sexuality and so on. Not to mention resistant and against-the-grain readings which marginalised audiences invariably make. Gay and lesbian incorporation of certain film and television texts is an example of the historical specificity of certain kinds of reception. More recently, 'Queer Culture's' celebration of certain camp stereotypes such as Kenneth Williams and Charles Hawtrey in *Carry On* films is an appropriation specific to the late 1980s and the 1990s.

There are also issues and questions around the extent to which traditional comic modes of gender representation (i.e., pre-1985 to suggest a rather arbitrary date) have been imported into the post-alternative period of British comedy. Are there radically different comic forms, gags and agendas to suit recent 'enlightened years' and has 'political correctness' engendered new and different gender representations? Or, alternatively, does comedy simply rework a set of basic ideas, themes, gags and agendas into contemporary guises?

If, as it is often argued, all comedy needs a victim, then can comedy ever be totally immune from offence and be truly 'politically correct'? Comedy is forever reinventing its victims, the butts of its jokes. One set of victims is supplanted by another, certain forms and types of comedy become marginalised or outcast in certain quarters. The key differences between traditional and 'alternative' comic modes are often that some targets are more or less acceptable than others – mothers-in-law, plump ladies, newly-weds, skinny spinsters, old hags, nagging wives, busty blondes and butch lesbians are no longer the ubiquitous popular targets. This is partly because audiences have themselves fragmented, with the result that a much broader range of subject positions are catered for.

In trying to ascertain whether certain stereotypes and gender-related comic representations are intrinsically funny (large breasts, small penises, fat ladies and so on) we need to examine the endurance of these aspects over different historical periods and comic forms. The question remains to what extent do contemporary post-alternative comics and comic forms work within pre-existing frameworks and traditional stereotypes and to

what extent have they created a radically different humour which avoids having sexual difference as a primary point of departure?

There are a number of overarching questions to be addressed at the outset when considering gender, sexuality and recent comedy. Feminist film theory since the 1970s argues that women in mainstream cinema are coded to-be-looked-at (see Mulvey, 1975, 1981). Put simply, they have traditionally occupied object rather than subject positions in narrative cinema. Whilst the male subject propels the narrative forwards, when the woman appears the narrative thrust is put on hold to allow space for her visually sexualised performance and the erotic spectacle associated with her. Likewise, audiences for popular cinema have been conceived as heterosexual and male, with the female spectator struggling to find a suitable subject position in which to accommodate her own sexuality and desires. If this schema is adopted across the representational and performing arts, and despite a certain amount of revision it is still a widely accepted theory, then we must ask to what extent is the objectification of women universal and transhistorical, and to what extent is her objectification compatible with her ability to create humour as a subject in her own right? In other words can women be simultaneously sexy and funny and how do they negotiate the split between object and subject? In a recent tribute to Marti Caine, for example, comedian Ken Dodd claimed that 'she achieved the impossible for a woman, to be both beautiful and funny' (*A Tribute to Marti Caine*: BBC 1 1996). These sentiments were echoed by Des O'Connor and Bob Monkhouse in the same programme. Indeed Marti Caine was an interesting case in point, combining a showy glamour with an earthy, often self-deprecating humour.

> It's true. I was a bit much as a kid. I remember once my mother took me on a bus and when the conductor came for the fares he said to my mother, 'Do you know, missus, that's the ugliest kid I've ever seen. That's a 'orrible child'. And me mum said, 'If you're going to talk about her like that, I'm getting off this bus'. And the conductor said 'I wish you would, that kid's frightening the passengers'. And the man sitting next to us said, 'Quite right', and that was my dad. So me mum said, 'Ignore 'em Gonzo' . . .
>
> (*Heroes of Comedy: A Tribute to Marti Caine*: BBC 1 1996)

The combination of a highly sexualised stage appearance (clinging, low-cut evening gowns and a beautiful face and figure) with a working-class accent and a mildly bawdy repartee (which involved a considerable

amount of clowning and physical humour) is unusual in a female stand-up. However, much of Marti's humour involved putting herself down. Her ego is very clearly diminished in her act, thereby averting the threat of a beautiful object who threatens to transcend her status as butt of the joke and assert her subjectivity, her power and dominance as a comedienne, a dichotomy negotiated and exploited by Mae West in 1930s Hollywood.

In classic Hollywood cinema, the object/subject dichotomy faced by female stars was condensed in an exaggerated form into the figure of the dumb blonde: the apotheosis of woman as object. Women such as Harlow, Monroe and Mansfield, for example, coded as objects of sexual contemplation *par excellence* are traditionally stooges or the 'feed' for humour generated by the male protagonist. There are, however, important points of resistance. The star personas of these women enabled them to transcend their lowly textual positions. Revisionist feminist film studies also assert that the women were talented comediennes in their own right struggling within a system that could not contain them. In terms of her narrative position the dumb blonde was never that dumb and possessed significant narrative power. To denigrate these stereotypes with a superficial political or feminist critique for failing to articulate progressive images of women is to fail to understand the function of comic stereotypes and the endurance of particular comic types. What's more, it fails to distinguish between the stereotype, with its specific narrative functions (particularly within non-realist and stylised genres such as comedy and horror), from a material reality. Also, comic stereotypes circulate within a very sophisticated contract between audience and text. Nevertheless, the question of whether a woman can be both sexy and funny as a subject in the comic universe in which she functions, still needs to be addressed and the dumb blonde is an interesting case in point here where we might also examine the ways in which she incorporates an omnipresent awareness of her physicality and sexuality into the comic material that she performs. Mae West is a good example of a comedienne who had a strong awareness of her own sexuality and used this as a basis for much of her comedy. Nevertheless, the female performer on stage or celluloid is forced to confront and acknowledge her own physicality and sexual appeal (or lack of it) from the moment that she appears. Joseph C. Rheingold, quoted in Richard Dyer's examination of Marilyn Monroe, articulates the woman's dilemma: 'The denial of the body is a delusion. No woman transcends her body' (Dyer, 1987: 19). The extent to which this body/sexuality awareness is woven into female comic material is a question for debate. Victoria Wood, Marti Caine, Jennifer Saunders, Joanna Lumley, Jo Brand and others

all use costume, masquerade, clothes, style and a general body-consciousness within their comic material, whether it be a TV sitcom like *Absolutely Fabulous*, or as a vehicle for stand-up comediennes like Jo Brand and Victoria Wood. With a determined awareness of their physicality, these comediennes attempt to escape objectification by placing their bodies and their sexuality at the centre of their humour (*Absolutely Fabulous's* obsession with costuming, Joanna Lumley's slim, elegant tart is explicitly contrasted with Jennifer Saunders plump gawkiness; Jo Brand's constant references to eating, body size and her own refusal to accept norms of sexual desirability, for example). Such female generated comedy which places the woman as physical object at its centre enables women comics to invert their objectification by turning objectification into the subject of their comedy.

Female performers in film, television and the live arts are judged *a priori* by how they look and are invariably measured against a scale of sexual appeal determined by the patriarchal hegemony of the culture in which they function – overwhelmingly this is white, heterosexual and western. Women cannot simply appear. Body shape and size, dress, face, looks and beauty are primary issues for women to deal with and on which they will invariably be judged. Her appearance as object determines her reception and the female body is a compound of sexual signifiers which override the woman as subject. Large breasts carry very different sexual connotations to small ones, irrespective of the woman to whom they belong. Likewise weight is a key issue. Women cannot simply be fat or slim without being judged as a sexual/asexual object. Fat carries very different meanings on women than on men where it can be a signifier of good living, masculine excess, a manly beer consumption and so on. On women, fatness precludes desirability and connotes the absence of sexuality. Jo Brand, for example, makes much of her weight and derives humour precisely from the incongruity of a voracious sexual appetite forced upon the hapless males of her imaginary comic sexual encounters. Questions need to be asked about the extent to which male comic performers need to negotiate issues of physicality in similar ways. Roy 'Chubby' Brown for example uses his plump physique as an intrinsic part of his comic persona, but never does this preclude his consistent references to his own sexual prowess nor is his sexual desirability questioned in his comic performance. Quite the opposite in fact, and the way in which a comedian like Brown dresses and looks is recast primarily as an idiosyncratic trademark in the way that Max Miller became associated with his garish, baggy costumes. The issues that a female comedian faces in relation to dress and body are different from the outset as she is judged

primarily as sexual object which she then has to negotiate through the performance and content of her humour. The male stand-up is much less likely to have his object/subject status determined by what he looks like and as such has a much wider range of creative possibilities and control regarding costume, appearance, age, physical type, dress and performance style. If a male comic wears a baggy costume, he's a clown if a female comic does likewise, she's hiding fat. The signifiers around male costume and performance styles are very different from those attached to the female. The enigma of the female body and female sexuality becomes the overriding issue.

Male comics can therefore adopt a broader range of physical personas, masquerade, clowning and physical humour which enables them to avoid simple sexual objectification. Unless they court particular modes of sexually explicit performance, then they are unlikely to encounter the same degree of sexual objectification experienced by female comics.

Physically 'anarchic' behaviour, body shape or dress in women performers can be read, often quite justifiably, as a struggle for liberation from the rigid and delimiting range of sexual object positions available to them. Jo Brand, for example, makes her physical size an explicit aspect of her humour in a way which Bernard Manning, Roy 'Chubby' Brown or any other bulky male comedian has rarely been inclined or, more importantly, obliged to do. By acknowledging her bulk and adopting a self-mocking attitude, Jo Brand anticipates and deflects a negative audience response to her size. This leads into issues around comic content and the ways in which women comics tend to incorporate gags around appearance, looks and sexual appeal into their comic agendas. Locked into a battle for control of meanings circulating around their bodies, concerns, fears and desires relating to their appearance are inevitably central to feminine subjectivity and female humour. This tendency has survived intact through traditional and alternative comedy and is still very much in evidence in 'alternative' comedy, in the routines of Jo Brand, Dawn French and Jennifer Saunders for example. This implies the persistence of myths around the female body and the trans-historical desire for the woman to conform to notions of physical beauty. Even in the post-alternative era, female comics are still very much aware of the narrow range of appropriate female physicality and the penalties for not conforming to the ideal. Comediennes like Victoria Wood adopt a tone of mild self-deprecation with an acute awareness of their own physical shortcomings, measured against the ideal woman and invariably not making the grade. Women's relationships to their own bodies and related insecurities are a pivot for a lot of female comedy generated by women and aimed at female

audiences. It taps into fears around the pressure for women to conform to very narrow parameters for acceptable female physicality: shape, age, weight and appearance. Comedy offers women a way of articulating and ultimately discharging fears around a lack of sexual attractiveness when measured against these impossible ideals. In other, non-comic modes of performance – in theatre, cinema, dance and television – women are still expected to conform to certain physical ideals. Comedy is perhaps the one arena in contemporary culture where physical shortcomings can be translated into cultural capital. Here the power of the female comic is her ability to denigrate herself and to beat patriarchy at its own game. Comedy with its essential anarchism is perhaps the most appropriate tool to mock canonical attitudes towards the female body.

Humour touching on issues relevant or unique to women such as menstruation, childbirth, contraception, diet, and relationships will inevitably form a specific female address that many contemporary female comics desire. Comedy derived from these feminine issues essentially marginalises men and can be understood as a way of empowering audiences of women who have traditionally been peripheral audiences in popular entertainment. The Working Men's Club circuit, the cinema, the variety stage and other arenas in which popular and working-class comedy has circulated over the decades, have traditionally assumed or solicited audiences of heterosexual men. In this light, the exclusivity of women's comedy can be understood as part of a backlash in popular entertainment for women that includes male strip shows and groups like the Chippendales which extend the traditional 'hen party' celebration of female exclusivity and sexuality in the absence of men. Such forms of entertainment arguably empower women by overturning traditional, notions of sexual display by putting the male body explicitly on parade for female consumption or by creating a feminine community by acknowledging issues common to women. It is only relatively recently that live and television comedy aimed specifically at female audiences has entered the mainstream. And, as with the majority of popular culture, a heterosexual masculine address is assumed as the norm and deviation from this towards women and 'other minorities' an aberration.

Recent theoretical enquiry around popular British humour, Carry On films and male performers such as Frank Randall, The Crazy Gang and George Formby for example, sets out to understand their bawdy humour in terms of social anarchy – a kick at polite society and high culture. Andy Medhurst writing about Carry On films in Carry On Camp refers to Mikhail Bakhtin's distinction between the classical body of high culture and the grotesque body of the carnival:

they [Carry On] display a commitment to bodily functions and base desires that will always render them irreducibly vulgar, inescapably Not Art. (Intellectual aside: Bakhtin's distinction between the classical body of high culture and the grotesque body of the carnival might be relevant here.) Art, after all, can't or won't realise that dignity, solemnity and an existential smile might not be enough to help us make sense of life

(Medhurst 1992: 16)

So how do women performers fit into the Bakhtinian universe where comic representations of the body can be understood in terms of their origins in medieval carnival and humour, where lower bodily functions such as lust and greed are celebrated as essentially liberating? For there are many implications for representations of the feminine within Bakhtin's schema. For example, Bakhtin refers to a system of grotesque images of the female body: copulation, pregnancy, birth, old age and physical disintegration. In particular, an obsession with female reproduction, wombs and the proximity of life to death in medieval imagery:

In the famous Kerch terracotta collection we find figurines of senile pregnant hags. Moreover, the old hags are laughing. This is a typical and very strongly expressed grotesque. It is ambivalent. It is pregnant death, a death that gives birth. There is nothing completed, nothing calm and stable in the bodies of these old hags. They combine a senile, decaying and deformed flesh with the flesh of new life, conceived, but as yet unformed . . .

One of the fundamental tendencies of the grotesque imagery of the body is to show two bodies in one: the one giving birth and dying, the other conceived, generated and born. This is the pregnant and begetting body, or at least a body ready for conception and fertilisation, the stress being laid on the phallus or the genital organs. From one body a new body always emerges in some form or other!

(Bakhtin 1965: 25–6)

Bakhtin's work, whilst offering invaluable insights into the history and function of the grotesque in folk cultures, fails to differentiate between gender specificities or to question why the female body is represented through its procreative functions (wombs, breasts, genitalia) as the agent of both birth and death. Whilst the Bakhtinian analysis sees such gross

representations as a backlash against canonical doctrines of the church, high culture and polite behaviour, we also need to question how within the carnivalesque the female body is subjected to different representations from the male and what these might mean beyond a simple cultural, ecclesiastical and social anarchy. In other words what are the psychic mechanisms at play here? What fears and desires are being expressed by the female grotesque and how do these relate to enduring images of the female grotesque in contemporary comedy and culture?

WOMEN, SEXUALITY AND THE COMIC FEMININE IN TRADITIONAL BRITISH COMEDY

While medieval comedies employed female grotesqueries, old hags in the throes of childbirth, Elizabethan comedies derived humour from cross-dressing and mistaken sexual identities. Pantomimes have relied upon the Dame, a man in drag and a Best Boy, a woman masquerading as a young man. Comic stereotypes which transgress sexual binaries and 'normality' abound in the history of popular carnival and comic performance. In twentieth-century theatrical farce, radio and music hall, sexual disguise, cross-dressing and sexual innuendo have formed a basis for a substantial proportion of popular British comedy. The fat ladies, hen-pecked husbands, honeymoon couples and busty bimbos of seaside postcard culture are a playful poke at the traditions of heterosexual monogamy: marriage, restrictive gender roles, the mismatch between male and female sexual desire and the impossibility of its fulfilment. They also articulate a particular traditional, bawdy and essentially working-class form of humour which is socially anarchic when pitched against its polite middle-class counterparts and essentially risqué in a society which is rigid in its sexual and social mores. Here again we can use Bakhtin's differentiation between canonical, classic and high culture on the one hand and popular, folk and street culture on the other.

In terms of the anarchic function of popular bawdy comedy Andy Medhurst has noted the importance of the seaside context of much British popular comedy, particularly in relation to *Carry On* films:

> *Carry On* films are like holidays (the boarding house and fry-up ones not the discover-the-unexplored-secrets-of-Patagonia monstrosities), or works outings, or coach trips, or any other kind of piss-ups where indulgence and irresponsibility offer temporary escape from everyday tedium.
>
> (Medhurst 1992: 16)

In other words, such humour offers 'time out' from polite behaviour and a shift into the carnivalesque spirit of holidays, sexual and social liberation. But if the bawdy sexual innuendo of picture postcards and Carry On films represents the anarchic spirit associated with a release from the everyday tedium of work and a 'regression' into the carnivalesque underbelly of heterosexual monogamy where base desires are given a voice and men have licence to pursue the objects of their lust, we are still left with a question mark over the articulation of female desire and sexuality. Where are the spaces for the representation of female sexual desire?

In popular British film, television, variety and stand-up comedy, women as comic objects have predominantly occupied two key stereotypes: the sexually desirable busty blonde such as Barbara Windsor in the Carry On cycle, or the hordes of nameless dolly-birds in Benny Hill's sketches and the execrable Confessions series of films during the 1970s, or the tyrannical mother-in-law/harridan/over-sexed spinster of the female grotesque. Both sets of stereotypes are constructed in the image of heterosexual masculinity and both represent threats to a fragile masculine potency. The first by her excess of sexual desirability and the attendant male fears of being unable to satisfy her desire and sustain arousal, and the second by her absolute lack of sexual desirability and the reverse fear of being able to attain arousal in the first place. The female grotesque is perhaps the most interesting and complex of the two basic stereotypes, including as she does, male impersonations of women by such as Les Dawson, Roy Barraclough, Norman Evans, as well as female stand-up comics and variety artistes such as Hylda Baker with her sidekick, 'Cynthia'.

There are a number of characteristics which these representations share. First, the female grotesque is well past her prime and youth is a prerequisite for female desirability. Age – i.e. over 30 – makes her ripe for caricature. She's also coded as unattractive, often in the extreme, but, more importantly for the purposes of comedy, she fails to realise the lowly status of her sexuality and insists on pursuing male sexual conquests. Anna Karen as Olive in On the Buses with her thick spectacles, unattractive face and figure is an example of this type. The nagging wife is also usually working class, possibly with frustrated petit bourgeois aspirations, such as Yootha Joyce as Mildred in George and Mildred. George is inadequate both sexually and economically in being unable to fulfil his wife's aspirations to a more bourgeoise lifestyle. The female tyrant is usually a wife, mother-in-law or spinster and is definitely not single by choice. She's sexually frustrated with a libido in inverse proportion to her declining sexual appeal. If she's married, she pesters her husband for sex and invariably places impossible sexual demands on her long-suffering spouse. The

pickle-munching Olive (*On the Buses*) is locked into a permanently frustrated attempt to persuade her husband to have sex with her in a complete comic reversal of the traditional male/female dyad, where it is invariably the man who has to cajole an unwilling wife or girl friend into sex. Her excessive demands, her constant put-downs and incessant nagging undermine his ego and libido and render him sexually impotent. In this kind of sitcom, the marital bed becomes the site of constestation where the woman is desperate to seduce, persuade or nag her reluctant spouse into sex. He invariably resorts to the traditional female excuse of a headache. The interesting question raised by these meek male protagonists is 'how do such impotent and ineffectual images of masculinity offer points of identification for male audiences'? More often than not, their female counterparts (Olive or Mildred) are simply butts of the jokes and as such offer little or no possibility for female audience identification. One possible answer to this is that the reluctant and ineffectual Georges of popular television sitcoms offer a seductive alternative to the pressures of patriarchy: a kind of reverse fantasy in which the male can legitimately be an absolute underachiever. Though conveniently the excuse for his impotence is the presence of an ever-demanding harridan as a partner, and under these circumstances the male audience is obliged to question 'what man would want to perform his conjugal duties?'

THE MOTHER-IN-LAW

The mother-in-law figure is a classic comic icon, a consistent butt of male humour from the range of verbal jokes which circulate around her to her representation by comedians such as Les Dawson, who became known for his mother-in-law gags. Often Dawson integrated these into his comic monologues about marriage, poverty and working-class hardships where domestic necessity meant that the newly-wedded couple were obliged to live with the wife's mother. Here the figure of the mother-in-law as an interfering critic of the subject's inability as husband/father/patriarch is made explicit. In these instances she becomes the scapegoat for the impossibility of achieving patriarchal perfection. She is the block to his potency, the thorn in his side and a commentator who constantly reminds him of the fragility both of his position as head of the household and, *ipso facto*, of patriarchy in general.

> The wife's mother is outside in the car. I would have brought her
> in but I've lost the keys to the boot. To add to my trough of woe,
> she came to live with us three months ago. As soon as I heard the

knock at the door I knew it was her because the mice were throwing themselves into the traps . . .

The wife's mother has many things that men desire . . . muscles and a duelling scar

She's so fat, she doesn't have elastic in her knickers . . . its Swish rail

For Christmas I brought her a fireside chair . . . unfortunately it fused

(Dawson 1985: 182)

The question which needs to be asked is why is the wife's mother (and significantly not his mother) such a potent figure for comic caricature? There are a number of possible interpretations for this. The wife's mother is often a lone surviving matriarch, having outlived her spouse to become, in a male-defined comic universe, a frustrated old battle-axe. As an older woman, whose domestic and sexual functions of childrearing and servicing male desire have long since ended, she has a lowly status in patriarchy. In search of a new role for herself as a lone, older woman, she is often coded as 'interfering'. But domestic necessity often dictates her continued, if antagonistic, relationship to the husband.

In a Dawson monologue from *Sez Les* – reproduced on *Simply Les* (Yorkshire and Tynetees Enterprises video 1993) – Dawson is leaning on a piano on the studio/stage and talking about the importance of a home of one's own.

Like so many couples when I first got married, we had nowhere to stay. We couldn't afford a place of our own, so we had to live with the wife's mother. And I can honestly say, we were there for over six months and I only fell out with that woman three times . . . morning, noon and night.

I wouldn't say we didn't get on but they wrote a television series about our relationship. It was called 'Mission Impossible'. She didn't have tonsils, she had a fan-belt. Everything I touched she'd play holy hell. She'd stand there and stare like a frustrated moose. She'd fold her arms like two sides of gammon, a mouth like a workhouse oven. She'd say . . . [gurns, folds his arms and starts imitating his mother-in-law's voice] 'Don't you touch anything. You leave things alone. For instance, you leave that television set, its mine, it's paid for, it's not rental. I'll select the

programmes, I'll switch it on and off, not you. Don't you just turn the immersion heater on when you feel like it willy, nilly. Immersion heaters cost money. It's two kilowatt. I'll put it on, you just give me two day's notice. And another thing, don't you think you can go in the kitchen and put the kettle on when you feel like it. That's an expensive kettle. It's a Russell Hobbs from the Catalogue . . .

Much of the comedy in the above revolves around Dawson's comic performance of a gurning, toothless old harridan for which he developed a highly effective and evocative shorthand (arms folded under the bosom, a toothless gurn and head turning from side to side to check for other listeners). But there are other important points of recognition relating to class and the obsession with purchases, brand names and the ubiquitous 'catalogue'. So whilst comedy is derived largely from its gender representation, this is by no means the entirety of comic meanings contained in the above.

The mother-in-law's survival is also testament to the longevity of women who traditionally outlive their spouses. But as a loose cannon she's a challenge to the new head of the household, i.e., the comic subject (in this case Les Dawson) or the husband. For these reasons she destabilises patriarchy. The challenge for supremacy of the household, and ergo, ownership of the woman/wife/daughter becomes redefined as a battle between the younger patriarch and the older matriarch who's now an encumbrance on the married couple. The mother-in-law who maintains close links with her married daughter also represents a threat to patriarchy, her continued presence poses the possibility of a matrilineal alternative in which power passes from mother to daughter rather than father to son. Close mother/daughter bonding also arouses jealousy and suspicion and close female bonding is invariably a threat to male supremacy. In another example of mother-in-law humour from a Bamforth picture postcard a curvaceous young honeymooner gleefully telephones her mother from the bedside telephone whilst her new husband lies utterly exhausted next to her. The dialogue reads 'You were right, Mum, women are the stronger sex!' There are a number of interesting points to be made about this gag. First the newly-wed man is physically inferior and considerably less attractive than his mate. He is clearly inadequate to the task and cannot match the woman's voracious sexual appetite. Whilst she is the graphic representation of female physical perfection, a buxom blonde ingénue with an hourglass figure and pouting lips, he is the epitome of male unattractiveness – skinny, with no muscle tone, and a rotund stomach. The question

which arises from this example of saucy postcard humour (and there are many based around honeymoon gags) is how does the emasculated figure of the man offer any point of identification for a male subject? How can the heterosexual male position himself within the gag unless he harbours masochistic fantasies in relation to the dominant and more perfect female therein? Second, there's the structuring absence of the wife's mother who still exerts a post-nuptial bond with her daughter in gloating over the sexual inadequacy of her daughter's new spouse. The mother/daughter relationship in this case functions to comment upon the emasculation of the male, having already predicted his sexual inadequacy. The gag clearly sets up the male as a victim of female sexual voracity in the face of a mother/daughter relationship in which the absent mother still exerts power.

The mother-in-law is also traditionally a harsh critic of her daughter's new partner: as a husband, breadwinner and patriarch, who is usually compared unfavourably with the deceased or absent father. She thus elicits masculine insecurity about his worthiness as head of the household. If we are to question why it's the wife's mother and not his, then the Oedipal trajectory would suggest that his relationship with his mother is sacrosanct and based on desire rather than loathing. However, the repressed and unspoken problematic in the mother/son relationship may be transferred onto the mother-in-law/son-in-law dyad. The older matriarch also anticipates his own wife's looks, physique and personality in the future. Witness the old male adage that 'if you want to know what the woman will look like in the future, just look at the mother'. So as a vision of his wife in the future, the mother-in-law also represents a constant reminder of his declining potency and sexuality.

'HYSTERICAL RECTOMIES':
THE COMIC FEMALE GROTESQUE

Comic female impersonators offer interesting insights into the masculine construction of, and fascination with, aspects of femininity. They tend to divide into two sets: some construct a glamorous if over-determined drag with the feminine accoutrements of jewellery, make-up and lavish costumes. They have a feigned elegance and adopt parodic exaggerated feminine mannerisms. Others represent the harridan, the older woman with coarse facial features, voice and body. The first set includes performers such as Danny La Rue, Hinge and Brackett, Jerry Desmond and Sid Field and Barry Humphries's alter ego Edna Everage. The second set ranges

from the likes of Norman Evans with his over-the-garden-wall female gossip in the 1940s, through Dick Emery's parodies of inelegant 1970s womanhood, to Les Dawson's celebrated Ada Sidebottom and his later partnership with Roy Barraclough's 'Sissy' in the 1980s. Pragmatically, what determines the end result for cross-dressers is the physical material that they begin with. Male performers with refined features and slim figures invariably produce a more elegant, attractive femininity than the rugged, dissipated looks of Les Dawson or Norman Evans. So on this level, at least, their representation is less of a love/hate relationship with a particular type of femininity, but rather a battle with obstetrics. That is not to suggest that these two stereotypes do not carry significant and very different meanings, but what unites them as representations is a fascination with the non-male and a desire to know, understand and exchange position with – in other words to become – a woman.

The theatrical stage has for centuries offered a legitimate arena for men to parade publicly as women, as in the medieval carnival, where bisexual, transvestite or anarchic desires could be legitimately discharged through cross-dressing. As the majority of theatrical drag is linked to comedy or pantomime, bisexual desires are further discharged through parody. Hence most heterosexual female impersonators (i.e., those not part of gay, camp and drag-queen culture) are understood as ridiculing rather than celebrating the feminine.

Many of these representations share an obsession with gossip, health, the menopause and hot flushes and the empty minutiae of everyday life, from Norman Evans' garden-wall routines to Les Dawson and Roy Barraclough's Sissy and Ada, discussing 'hysterical rectomies' and suppositories in the doctor's waiting room.

A Les Dawson and Roy Barraclough sketch in a doctor's waiting room in 1983 illustrates the point;

Ada (Dawson) backs out of the Doctor's surgery and shouts.

. . . 'Thank you Doctor. A' the suppositories the same length?' . . . spots Sissy (Barraclough) and sits next to him. 'Well, well Sissy' . . . [sits down with legs akimbo, hair in curlers and dress riding up above his knees] . . . 'fancy seeing you at the Doctors. Is it the same trouble?'

Sissy: [affronted]. 'Whatever do you mean?'

Ada looks around, gurns and points and mimes: 'Woman's trouble'.

Sissy looks away in disdain. Ada: 'Last year when you said you might 'ave to 'ave an hysterical rectomy'. Sissy: [patting hair and feigning an effete manner], 'No, no, no. No it's not that, that cleared up after the man-ip-ul-ation. I was just thinking you looked a trifle wawm . . .' Ada: 'Well lets face it, I'm at a funny age. I wouldn't tell another living soul this of course . . .' [Looks around to check that no one is listening] 'I'm approaching the change.'

Sissy: (exclamation), 'Approaching the change! From which direction?'

And the following is a monologue from Norman Evans in 1950 (*Heroes of Comedy*, Channel Four, 1997)

[Norman with head, shoulders and elbows perched over a brick wall, forearms like Popeye, in a spotted 'frock'], '. . . Ooooh, I say, have you really? Y'know I haven't been well meself because . . .'

Ave yer? You mean? [looks from side to side, gurns and mimes something exaggerated but indistinct].

'Well it will make you feel a bit worried, won't it.'

'Well, Y'know, I haven't been well meself, because . . .'

'I haven't honestly . . . I keep pegging along y'know . . . With me? Well y'know, I keep aving them . . . [looks around to check whether anyone is listening] . . . hot sweats y'know. Ooh it does take it out of you. These men they don't . . . they don't know what it's like . . .'

'No, y'know, he's the same . . .' [gurns and points to the side]

[slips and hits her bosom on the brick wall]

[massaging bosom] . . . 'Aagh. Shame . . . that's given me a belt, I'll ave to watch meself that's the third time on the same brick this week . . .'

(*Heroes of Comedy*, Channel Four, 1997)

On one level, these representations can be understood as a celebration of female solidarity and survival. They illustrate a fixation with aspects of femininity which are unknowable to men: dropped wombs, large bosoms and hot flushes. Norman Evans's older matriarch is, after all, a powerful

figure: working class, unrefined but, above all, the pivot of the family and a pillar of pre-war terraced-house communities. This is the world of out-side toilets, large families and no mod-cons. The women who survive this into middle and old age are inevitably tough, unrefined and unattractive, but, most importantly they are survivors. As such these women are rep-resented by toothless, gurning faces, huge, powerful forearms folded to support ample and heavy maternal bosoms with a constant vigilance for eavesdroppers when imparting juicy gossip to one another. This is a women-only universe, in which the likes of Nellie Wallace and Lilly Morris in the 1930s, Norman Evans in the 1940s, Hylda Baker in the 1950s and 1960s and Les Dawson and Roy Barraclough in the 1970s and 1980s developed the archetypes. Much of this humour was directed at a working class audience, and although it uses the working-class matriarch as the butt of the joke, that does not preclude these images from con-taining comic pleasures for women. There are points of recognition and indeed the stereotype has a base in certain 'truths'. As such they transcend simple notions of sexist stereotyping.

The question that still needs to be addressed, however, is why are older women intrinsically the object of much male-generated humour? There is undoubtedly a certain mystery around the menopause which is translated into a comic parody of declining femininity: hot flushes, hormone imbal-ances, expanding figures and 'female trouble'. The ageing woman, stripped of her sexual attractiveness, is also one who threatens male potency. At a time when his sexual prowess is also going into decline, her appetite (in comic contexts) remains voracious, bearing out the old adage that whilst men hit their sexual peak at eighteen years old, women reach theirs at forty. So his fear of being unable to satisfy the voracious woman transfers the blame for his declining potency onto the figure of the woman and her exaggerated unattractiveness. His impotence then becomes the direct result of her physical repugnance and she is the excuse for his sexual decline. But she is also the mirror which he holds up to himself to reflect his own descent into middle and old age. Male crises in diminish-ing potency can also be used partly to understand the opposite archetype to the nagging wife or ageing harridan; namely the hordes of young dolly-birds that pervade the comic sketches of Benny Hill, Freddie Starr, Les Dawson, the Carry On and Confessions films and so on. These nameless, scantily-clad young women signify his over-inflated and distorted sense of his own attractiveness and his massively potent alter-ego. However, their exaggerated femininity and their incongruous pursuit of the unattractive older man (usually the male subject) take these sketches beyond simple wish-fulfilment into the realm of self-mocking parody. Les Dawson's

excessively ugly alter-ego Cosmo Smallpiece with his catchphrase 'knickers, knackers, knockers' was a parody of rampant male sexuality which turned the archetype in on itself as a repugnant comic critique of excessive male libido, whose object of desire is destined to be forever out of reach.

Female sexuality is closely associated with procreation. Large breasts and 'child-bearing hips' signify sexual attractiveness for example, but when procreation is no longer an issue, then femininity too becomes a parody of itself. When the accoutrements of femininity, once so desirable, are no longer functional in the sense of eliciting male sexual arousal, they become obsolete, parodic and repulsive to the male. Female sexuality, understood only as a function of male desire and isolated from its objective of eliciting and servicing that desire, becomes redundant and the prospect of a sexually desiring woman is unthinkable and ultimately threatening. In the male comic universe, this threat is translated into the kind of female stereotypes above. Older femininity, then, has its sexual threat disavowed through comic parody. It is also 'safer' for male comics to parody older women without implying a predilection for homoerotic rather than heterosexual attraction. Mocking the sexually desirable young woman may imply the absence of a 'normal' heterosexual response to an attractive female. Masculine fears of female sexuality and desire in general may also be safely transferred onto the older woman who becomes coded as the tyrannical mother-in-law, the spinster hag or the nagging wife: in other words, the sexually redundant and therefore totally redundant object of past desire.

The question remains: why should particular aspects of femininity be such fertile ground for comic parody? From an early age in our culture, we learn to treat breasts as comic objects; the fat, bosomy lady is the butt of the seaside postcard jokes and saucy humour, for example. So is there something intrinsically funny about the female form in its exaggerated state with large breasts, buttocks and thighs when it becomes a parody of heterosexual desire? Desirable femininity is indeed a masquerade relying on the maintenance of a fragile physical decorum: of cosmetic fakery, upholstery and physical support, corsetry and prosthetics. But its construction thus is precisely to conform to a notion of male desire. If femaleness is a construct, it is also denatured humanity: constructed in the image of heterosexual patriarchy and put on an impossible pedestal from which it is easy to knock down. For this reason the so-called dumb blonde roles given to the likes of Jayne Mansfield, Marilyn Monroe and, latterly, Pamela Anderson are simultaneously the ultimate in male heterosexual fantasy and also ripe for parody, comic abuse and loss of dignity.

Understood from this perspective, comic abuses of female stereotypes become sublimated critiques of patriarchy. For indeed it is patriarchy itself which put her where she is, constructed in its own image, and it is patriarchy which then knocks her down. Whilst masculinity is also a construct, this is understood as the norm, with femininity a perverse deviation. Mocking the woman is also a way of disavowing her threat to masculinity, to freedom, to control, to order – all that masculinity holds dear and needs to maintain in order to shore itself up against all the odds.

BIBLIOGRAPHY

Bakhtin, Mikhail (1965) *Rabelais and His Universe*, Bloomington, Indiana: Indiana University Press.

Dawson, Les (1985) *A Clown Too Many*, London: Elm Tree/Hamish Hamilton.

Dyer, Richard (1987) *Heavenly Bodies: Film Stars and Society*, Basingstoke: Macmillan BFI.

Fisher, John (1994–5) *Heroes of Comedy*, London: Channel Four.

Jacobson, Howard (1997) *Seriously Funny: From the Ridiculous to the Sublime*, Harmondsworth: Viking.

Jacobson, Howard (1997) *Seriously Funny*, London: Channel Four.

Medhurst, Andy (1992) 'Carry on Camp' *Sight and Sound* August pp 16–19.

Mulvey, Laura (1975) 'Visual pleasure and narrative cinema' reprinted in Tony Bennett, Susan Boyd-Bowman Colin Mercer and Janet Woolacott (eds) *Popular Television and Film*, BFI/Open University, 1981 pp 206–15, London.

Mulvey, Laura (1981) 'Afterthoughts on *Visual Pleasure and Narrative Cinema* inspired by *Duel in the Sun*' *Framework* Nos 15/16/17 Summer pp 12–17.

Orwell, George (1941) 'The Art of Donald McGill', reprinted in Sonia Orwell and Ian Angus (eds) *The Collected Essays, Journalism and Letters of George Orwell: Vol. 2 My Country, Right or Left 1940–3*, London: Secker and Warburg.

5

CERTAIN LIBERTIES HAVE BEEN TAKEN WITH CLEOPATRA

Female performance in the *Carry On* films

Frances Gray

Or – for as the genre developed, the more subtitles they seemed to acquire – how the *Carry Ons* critical reputation masked a lively interest in the way England changed over twenty years: or, how bringing the body into comic collision with major social institutions led to some of the most positive images of women available in British cinema, and how actresses made the most of them: or, how humane sexual comedy and 1970s commercialism made hopeless bedfellows. I begin this account with *Carry On Cleo*, rather than attempting to examine the films chronologically, because it seems to me to embody the paradox of the series: 'certain liberties', as the opening credits solemnly inform us, were certainly taken with female characters like Cleopatra – to construct them as sexual objects: but liberties were also available to the actresses who played them to be far more creative.

Julius Caesar goes to consult the Vestal Virgins. He is confronted by a man in drag, who announces cryptically, 'I'm a eunuch – virgins are off.' He withdraws, flustered, to find his own men advancing on him with drawn swords. He turns to the camera with an emotive flap of the arms and wails, 'Infamy! Infamy! They've all got it in for me!'

This is perhaps the most quoted joke in the twenty-eight films of the *Carry On* canon. It's also clean, funnier heard in relation to its temporal context, and springs from free improvisation on the set. (Its authorship became a lively matter of dispute in a *Guardian* correspondence some thirty years later during the run-up to the 1995 *Carry On* festival at the Barbican.) It effectively contradicts the prevailing mythology of the *Carry Ons* as one-joke movies: endlessly repeated variations on the theme of sexual innuendo, for which the market disappeared with the advent of newer freedoms of sexual representation in the late 1960s and 1970s. 'It made no sense to intimate what was actually on display' was Andrew Higson's

diagnosis of their decline (Higson, 1994), while Andy Medhurst dated the beginning of the end from a precise moment: 'After Barbara Windsor's brassiere had at last burst (in *Carry On Camping*, 1969), where was the humour in teasing about the possibility of such an occurrence?' (Medhurst, 1986)

It might be disingenuous to counter Medhurst's bare bosom with the row of male bottoms exposed in *Carry On Constable* some nine years earlier; but this flippant rejoinder might prompt a closer look at the groundbase of both critics' understanding of the notion of 'innuendo'. It appears to be a variety of what Freud called 'smut' (Freud, 1976); that is, a transaction in which man is in control as both audience and subject; the woman is present as passive victim of sexual aggression. The aggressor makes it plain to his audience that he is imagining, and forcing the woman to imagine, a sexual act which will be forever deferred in fact, but whose verbal form can be endlessly elaborated and enjoyed to her discomfiture. The desired female's embarrassment is classically depicted on the postcards of Donald McGill: the deep blush, the 'glow' of discomfort symbolised by slanting dashes around the face, the improbable proportions of breast and buttock as if the secondary sexual characteristics were themselves swollen with excitement or, perhaps, with its repressed cousin, shame.

The *Carry Ons* have frequently been likened to this art form, for instance by Marion Jordan (Jordan, 1983). Indeed, the blurb for the *Cleo* video hypes its 'seaside postcard humour' as a major selling point. *Cleo*, like the majority of its stablemates, offers up female bodies to the male gaze and the male snigger – for example, the scantily dressed bath attendant who scuttles off as Charles Hawtrey leers 'You can play with my duck.' But to accept the analogy completely is to dismiss the flexibility and inventiveness of the performers, especially the women performers, in a constantly changing world. Postcard images are frozen. They have no movements or inflections but depend only on the exchanges and gestures they enshrine. The watchword of the *Carry Ons*, on the other hand, was improvisation. Their overall project was to send up institutions: the army, education, the National Health; this later embraced movie parodies and, in the 1970s, cashed in on the nostalgia boom to mock the lavish costumed television series (*The Six Wives of Henry VIII*, *The British Empire*, *Upstairs Downstairs*) which celebrated both our colonial past and the increasing availability of colour TV. The title of one film, *Carry On England* (1976) might have served for the whole series. Anything that preoccupied the nation was seized upon and enshrined in a *Carry On* in the space of about six weeks.

Cleo suggests that this could be a complex process. Ostensibly, the object of parody is the 1960s Hollywood epic, specifically Joseph

Mankiewicz's *Cleopatra*, an impression reinforced by the use of its aban-
doned sets. These are gleefully contrasted with the bits of anonymous
common around Pinewood which the *Carry Ons* favoured for all outdoor
sequences regardless of period or geography. However, *Cleopatra* itself was
more than just an overblown example of a currently popular genre; it pro-
vided a stage on which the changing sexual attitudes of the 1960s were
acted out. Its stars, Richard Burton and Elizabeth Taylor, conducted what
the media constructed as 'the most public adultery in the world' (Bragg,
1988), about which even the Vatican felt compelled to make statements.
Despite inevitable comparisons between the performers and the 'doomed
lovers' they played, it became apparent that Burton and Taylor were not
tragic figures. Vatican notwithstanding, they were never subjected to the
ostracism that had wrecked Ingrid Bergman's Hollywood career when she
lived with the married Roberto Rossellini ten years earlier; rather, the
public was disposed to enjoy the stories of their extravagances, the dia-
monds, the yacht moored offshore so that they could avoid quarantine for
their assortment of dogs. Burton and Taylor might, like their historical
counterparts, connote excess, sexual pleasure and luxury, but this time it
did not all end in tears. Divorce was to become easier, in the 1960s, and
the contraceptive pill was to change the ways in which sexual activity and
its consequences were understood. Public sympathy, on the whole, was
with Burton and Taylor as the vanguard of the new mores.

In Britain this sympathy was reinforced by their image as a metonym
for the upsurge of middle and working class confidence in the 1960s.
Taylor might be a Hollywood princess, but she was also an English girl
who had beaten the Hollywood system and made millions; Burton was the
son of a miner who had conquered Oxford and the posh British stage
before winning both Taylor and film glory, a forerunner of the new
wave of British actors whose charisma was inseparable from their regional
and working class origins. These images affectionately underpin the 'lib-
erties taken with Cleopatra'. Amanda Barrie is a product of Swinging
Londinium rather than Ancient Egypt; her maquillage-sooty eyes and pale
lipstick owes less to antique paintings than it does to the cheap and
cheerful version of Taylor's *Cleopatra* make-up marketed by Boots, a look
you could meet at every discotheque in the country. Sid James' beat-up
boxer's face and Cockney-South African accent mock Burton's ravaged
beauty and Celtic vowels and trail faint wisps of Jimmy Porter. In their
super-luxurious settings spiced with the odd proletarian note (Cleo wears
a candlewick bath cap) Cleo and Mark Antony (or 'Tone') are simultane-
ously glamorous and ordinary. Not only does this reflect Burton and
Taylor, but the ordinariness links them to Hengist and Horsa, the dogged

working-class cavemen (*sic*) of *Cleo*'s slapstick subplot, and hence codes them as figures with whom the audience should identify.

Their glamour also makes it plain that these are the figures with whom our specifically sexual sympathies should lie. Thus they are distinguished sharply from the other leading character, Julius Caesar (Kenneth Williams of the aristocratic nostrils and the strangulated vowels), who is equally unable to cope with his 'small majority' or the prospect of a night with Cleo. Caesar's posh voice and Latin tags ('A sick transit, Gloria', he remarks to his slave at sea) suggest the Old Etonian clique from which a large part of the Tory cabinet had been drawn; specifically, his English catchphrases ('You've never had it so good', and 'the wind of change') connote the then Prime Minister Harold Macmillan, self-styled Last Aristocrat, stabbed in the back by colleagues after his cabinet was rocked by sexual scandal. The Profumo affair of 1963 threw the Burton-Taylor adultery into interesting relief: while the public tolerated and enjoyed the latter, they increasingly resented paternalism from a government whose ministers, according to the tabloids, shared call-girls with Russian attachés or attended parties wearing only a lace apron. By parodic juxtaposition, *Cleo* was able to capture a moment in the nation's thought-process about sexual values.

It is, above all, Amanda Barrie's performance that gives the moment its specificity. There are moments when she mocks the husky-musky, vampish Cleopatra of every multi-million dollar epic since Theda Bara: she languishes on couches, slithers out of the bath to reveal discreetly chosen areas of flesh, then punctures the image by crashing her snaky headdress into Mark Antony's panting face. But her performance also reflects her Chelsea girl makeup; it is youthful – not childish, like Shaw's Cleopatra, but the product of 1960s' hyping of youth and youth culture. She is slightly gawky, anticipating the vogue for pubescent skinny models like Twiggy; her manner is flip, a little vague, her eyes wide as if she has been up all night at a party. She personifies the media construct of the period, the dolly-bird: that is, the independent, sexually available girl; the girl with no visible marks of class, dressed by boutiques rather than chainstores or *haute couture*, speaking a carefully cultivated downmarket accent, the girl with flatmates rather than a family to define her, a trendy job rather than marriage plans. The reality was something of a con trick: the pill put new sexual pressures on women and the trendy jobs seldom proved stepping stones to real responsibility and power. Barrie, however, offers a subversive hint of what might be possible. While she gives full weight to the bimbo side of Cleo ('My servant is a mute, and he cannot talk either'), she opts for a different delivery of the lines in which she bargains with Antony:

CLEO: I've been thinking.

TONY: You do!?

CLEO: No no no, really, I've been thinking about all the things we could do together . . .

TONY: That makes two of us.

CLEO: . . . if you were emperor . . .

Barrie could choose to vamp this up, or she could continue in bimbo vein and allow Cleo to appear cunning. She does neither; her delivery is carefully bland and enigmatic; the result is that while her sexual power over others is apparent – Antony faints as she steps out of the bath – we are kept guessing about her ability to ironise and control her own body and the way it is viewed. The only real losers in the film are those, like Caesar, who cannot come to terms with the waywardness of the body at all. There are happy endings for all who can roll with the punches – like Horsa, who survives not only the rigours of the female gaze at the Marcus and Spensius Slave Emporium but his subsequent branding with the initials of his owner, Willa Claudia. ('They're making a convenience of you', remarks Hengist.) But Barrie's Cleo, triumphant in the last clinch as Tony hurtles fully clothed into the bath to join her, not only connotes the victory of sexual desire but offers a definition of sexuality which involves female pleasure without the sacrifice of power.

CARRY ON UP THE WELFARE STATE

While Cleo is perhaps the most satisfying single female role in the series, at least two aspects of the *Carry Ons* offered the woman performer relatively attractive comic opportunities. First, there was the policy of sending up institutions. The quickest way to make fun of any institution is to bring its rules and rigidities into conflict with the vulnerability and waywardness of the body. This of course involved sexual comedy which, given the target audience, meant heterosexual comedy. Women had therefore to be present in the institution in reasonable numbers – but this meant in turn that they had to be shown pursuing careers. While films like *A Kind of Loving* and *This Sporting Life* showed a new boldness in the exploration of women's relationships, it was rare for them to be depicted in the workplace and even rarer to see them exercising power there.

The image of the *Carry On* career woman was largely established by the series' predilection for the National Health Service, the subject of no less than four films. Its attractions were obvious. In 1959, the year of *Carry On Nurse*, it was new enough to be topical. The hospital setting opened up

endless possibilities for undress and lavatory jokes to impact on rigid hier-archies. Throughout, however, there remained an overt respect for public medicine; in Nurse, for example, patients sing the praises of free treatment and the one character who chooses to pay fees is mocked for his snobbery. In this context the one thing that the films could not do was to violate the popular image of the nurse as underpaid angel of mercy. While they may occasionally drop things it is taken for granted that nurses do a wonder-ful job. It happens to be a job in which they are the perpetrators rather than the victims of physical indignities. The blanket baths and bedpans they administer with brisk competence continually deflate the men who attempt to seduce or intimidate them with reminders of their own cor-poreality. And, occasionally, this process becomes conscious. At the end of Nurse the most captious and demanding patient, played by Wilfrid Hyde White, has a flower substituted for a rectal thermometer. The placing of the incident immediately before the final cut codes it as a comeuppance for which there can be no reprisal, and the quizzical smile of the matron implies approval. The joke lies in the fact that the 1950s censor couldn't possibly allow these nice *ingénues* from the Rank charm school to tell Hyde White where to put his daffodil − but they are free to exploit and parody acts legitimated by their 'angel' status.

Professional competence was to become a regular feature of women's roles in the series and not only in the 'nurturing' professions; they acted as policewomen, army doctors, cabbies; they ran their own businesses, ruled Egypt, travelled west to avenge dead fathers and explored the east-ern reaches of Empire without a chaperone. While James Bond's women had two choices, bed or dead, Barbara Windsor played a real spy in *Carry On Spying*, cheerfully turning Bond values topsy turvy as the most compe-tent member of a team constantly getting into scrapes caused by her boyfriend's insistence on 'protecting' her. While female characters might get custard pies in the face, fall into puddles or lose their clothes in a chase sequence, it was taken for granted that they worked on equal terms with men. Occasionally settings forced the films to raise, albeit gently, the sub-ject of their right to do so. To wring every possible frustrated-bridegroom joke out of the situation in *Carry On Sergeant* (Bob Monkhouse has been called up on his wedding day) it was necessary to manoeuvre his new wife into close proximity to the barracks; when the film was released in 1958, post-war pressures on women to remain at home and release jobs for men were only just beginning to lift; the media still solemnly debated whether married women should 'go out to work'. His bride, however, (Shirley Eaton) promptly joins the NAAFI as a canteen helper.

Carry On Regardless, a string of slapstick anecdotes about an odd-job firm,

had little expository time to spare. To engineer a meeting between its unlikely cast of characters, it opened in a labour exchange. In the 1960s, these buildings routinely corralled the sexes and the work available to them. To get the whole cast in the same room, it was necessary to provide a burst of subversive energy from the main female characters, Liz Fraser and Joan Sims; anticipating the Sex Discrimination Act of 1975 they simply crashed into the men's section announcing that they had a right to the better jobs available there. (And, presumably, since one of the staple jokes of the film was Esma Cannon's muddling of job allocations, the agency anticipated the Equal Pay Act of 1970 as well.)

CHARACTER PARTS OR STARS?

The second major benefit for actresses lay in the series' improvisatory, company-based approach. Europe had always shown a healthy respect for improvisation; the commedia dell'arte troupes, who entertained in France and Italy from the sixteenth to the eighteenth century and beyond, allowed Harlequin and company to devise their own lines. British comedy has always tended to be writer-centred, a tradition clearly seen in British television. Its staple is the eccentric, anarchic (male) character at odds with the forces of (largely female) domesticity and convention; 'created' by a single writer or writing partnership, this figure may be explored and enriched across several series, ringing the changes but retaining an essential consistency. It is a pattern which has served many British actors well (and one with its own mythology of cautionary tales such as the downfall of Tony Hancock when he abandoned the Galton-Simpson partnership). If it relies on types, the opportunities it affords the actor are so varied we are scarcely aware of a typology at work. (Compare, for example, the roles of Rigsby in Eric Chappell's Rising Damp and Albert Steptoe in Galton and Simpson's Steptoe and Son: both could be described broadly as a dirty old man, but both are so individual that such taxonomy seems pointless.) For women, however, largely stranded in supporting roles, one dragon wife or bimbo is pretty much like another. For it has long been the assumption, as Lesley Ferris points out, that women play themselves (Ferris, 1990). The body of the actress is a convenient device on which meanings can be projected: dumb blonde, mother-in-law, tart with heart of gold; and it is rare for these meanings to enshrine contradictions or subtleties. The comic skills which she brings to bear on the stereotype are assumed to be instinctual, aspects of a 'self' she offers for consumption. If she is judged as anything beyond sexual object it is as foil for the more conscious skill of her male counterpart (Gray, 1994).

The *Carry Ons*, however, were not interested in consistency of charac-
terisation or plot. Jokes existed in the moment rather than in relation to
an overall pattern – there's no room for Willa Claudia, for instance, once
her monogram has made its point. They might be improvised by the
actors, several of whom had developed off the cuff skills in revue and vari-
ety. Performers were free to make decisions as long as it didn't hold up the
shooting. Barbara Windsor, for instance, recalls that she decided to play
her schoolgirl character in *Camping* with a Roedean plum in the mouth, but
on the first take 'I drew back and screamed, "Get aht of it . . ." from
then on I was lumbered with the old Windsor rasp' (Windsor, 1990). The
characteristic *Carry On* structure was a tenuous plot expounded through a
series of comic events; like *lazzi* (the set-piece routines and jokes which
were the stock-in-trade of the *commedia dell'arte*), each of these little events
showed off the talents of a particular performer or set up a punchline that
might have little relation to character.

This was to prove liberating for women performers in particular.
Although there was a generous use of stereotypes, the freewheeling gags
could cut across their confines. A female role of any substance was liable
to contain enough inconsistencies to resist the imposition of a single
meaning. However closely she might match up to a physical stereotype, it
was not possible to make simple identification between actress and role.
The episodic gags continually foregrounded her – and hence her skill –
as performer. Joan Sims, for instance, has a set-piece in *Regardless* in which
she attends a wine-tasting and moves in minutes from pleasantly tipsy to
roaring, handbagging drunk. It's a precisely observed piece that would not
be out of place in revue or in a one-woman show, like those of her con-
temporary Joyce Grenfell, specifically designed to show off the performer's
versatility. And we are expected to enjoy it in these terms. When the
episode is finished it does not accrue to her character at all – there is no
suggestion that she is a drunk, or even irresponsible.

As the series developed a team of regulars grew up. One of the pleasures
of watching a *Carry On* was to see familiar faces in new roles. This further
undermined any possibility of identifying actress and stereotype. Instead,
stereotypes were largely replaced by the actresses themselves. Three in par-
ticular, Hattie Jacques, Joan Sims and Barbara Windsor, became closely
identified with the series. Windsor, in fact, despite only nine appearances,
has often been considered the figurehead of the *Carry Ons*. While they were
– especially Jacques and Windsor – recruited to conform physically to
'seaside postcard' images, their roles allowed them to exhibit highly indi-
vidual talents. All three had worked extensively in popular theatre and
variety. Windsor described herself as 'first and foremost a song-and-dance

lady' (Windsor, 1990) and her first major role was in Joan Littlewood's *Fings Ain't Wot They Used T'be*, where, like all Theatre Workshop actors, she was responsible for improvising and developing her own part. Jacques flourished in the radio comedy show *ITMA* and played opposite Eric Sykes and Tony Hancock; Sims appeared extensively in revue. This matched the policy employed in casting male regulars like Kenneth Williams. The distance between role and performer fitted the *lazzo* structure and offered specifically intertextual pleasures. Windsor might be stuck with the label coined by producer Peter Rogers, 'A body, a bosom and a joke' (Windsor, 1990) but the regular audience were watching her play a 'Windsor part' which might comment on or contrast with previous ones rather than a stereotype which happened to be played by Windsor.

A 'Windsor part' was invariably that of a sexually desirable woman, but despite the costumes that stressed her pin-up figure she could hardly be called an *object* of desire, simply because she was never passively available for contemplation. Her characteristic entrance had the self-assurance of a pantomime principal boy. In *Again, Doctor* she slips off a hospital blanket to reveal a costume consisting of three spangles with the absolute unconcern appropriate to her role as a dancer: there is no attempt at seductiveness. Jim Dale, by contrast, is so flustered he wrecks the X-ray machine. Rather than being invited to become the gazer at the gazed-at, we are watching Windsor as the incarnation of sexual energy. Attempts to render her passive with a look are constantly disrupted: for the characters, by slapstick punishment (James as Henry VIII gets drenched when attempting to watch her in the bath) and for the audience, by the spectacle of male discomfiture. Her occupation, whether dancer, nurse or highway robber, serves to underline that she is economically independent. She will choose to whom she will impart her sexual energy, and on what terms. One of the more refreshing assumptions in the majority of *Carry Ons* is that no means no; sex may not be very dignified, but it is fun for both parties or it doesn't happen at all.

Windsor continued to work in the series into her forties. While her casting was less flexible than, say, that of Sims, its recurrence over ten years carried with it its own sense of distance. In *Carry On Girls* she plays a professional beauty queen. Tiny, bosomy and middle-aged, she makes no attempt to resemble the extras in the lineup, chosen in conformity with 1970s taste. Rather, she chooses to stress her difference, strutting in leathers and a motorcycle helmet to be greeted by Sid James with 'Not now, sonny.' It makes specific the principal-boy element in her performance, always on the verge of breaking out of the screen to address or even organise the audience. The stylised playing is important as it serves

to bridge some of the contradictions of *Girls*. On the one hand the film offers an image that, since members of the women's movement disrupted the Miss World contest in 1970, had provided the media with a useful piece of reactionary symbolism: 'attractive' contestants menaced by 'ugly feminists' in woolly hats. Their plan in *Girls* is, predictably enough, called 'Operation Killjoy'. On the other hand, *Girls* offers a critique of male chauvinism, inviting audiences to laugh at the lecherous organiser, the wife-bullying mayor and the jealous boyfriend of one of the contestants, who respectively lose money, trousers and dignity. While the 'feminists' remain largely one-dimensional, their plan provides the most entertaining slapstick of the films, a battle with mud and itching powder; in this sequence the downtrodden wife of the mayor finally gets joyfully even by dropping him down a stage trapdoor.

What pulls these fragments together is Windsor's energy and ironic distance from her own role. In one *lazzo* she launches into a screaming cat-fight with another beauty queen in front of the local press, coolly emerging seconds later to discuss with James its value as a publicity stunt. The speed of this change stresses, first, the artificiality of the beauty world itself; second, it foregrounds Windsor as performer and projects the narrative into fantasy, setting up a carnivalesque atmosphere in which, for instance, Bernard Bresslaw can enter the contest in drag. This prompts a typical *Carry On* routine – one often delegated to the burly Bresslaw – with high heels and wayward bosom. It also causes Bresslaw's girlfriend, transformed into a beauty by a duckling-into-swan sequence over which Windsor presides, to defy his jealous strictures and compete, proclaiming, 'If he can be a beauty queen I'm damn sure I can.' This attractively surreal proposition articulates the idea that pleasure in one's body is available to anyone, and does not depend upon obedience to imposed stereotypes of beauty or correct behaviour. Comedies of the 1970s like *On the Buses* often laboured this very point on behalf of men by surrounding such unlikely heroes as Reg Varney with compliant 'crumpet': but for a woman to seize such a right – and to ally herself with the figure of Windsor who has clearly done so – is so rare in this period as to render the more reactionary aspects of *Girls* forgivable.

Jacques, a large woman, frequently suffered from unimaginative casting. In *ITMA*, for instance, she played a fat lady with a booming voice, although this did not suit her vocal range – and, when this didn't work, she was given the role of a fat child. In the *Carry Ons* her size was sometimes used in a clichéd way, to encode sexual unattractiveness, but more often it connoted simply authority, a trait which offered far more varied opportunities. In *Sergeant* her army doctor is briskly asexual, although

there's a certain poetic justice in a woman curing the hypochondria and timidity of Kenneth Connor and making him a fit mate for Dora Bryan, Shirley Eaton's NAAFI confidante. Her hospital matron role in *Carry on Doctor* involves an attempt to seduce Kenneth Williams as the snide Doctor Tinkle; here she undercuts the obvious image of large-woman-skinny-male; she uses a husky, Eartha Kitt voice, moves easily in flowing black lace and pours champagne with self-confidence. His protest, 'I was once a weak man!' is dispatched with 'Once a week's enough for any man' spoken briskly rather than with desperation. It is not surprising to see this pairing reprised four years later in *Carry On Matron*, this time with Williams as pursuer. The vitality of the Williams-Jacques partnership at its best sprang from the way they made use of their physical attributes, not for comic contrast but to stress what they shared. While Jacques' size gave her authority, so did Williams' snooty expression; they never allowed the audience to forget that, despite the indignity of bodily desire, they were figures of power, and, as matron and consultant, engaged in a power struggle between equals. If their public exchanges crackled with unspoken sexuality, their sexual ones carried a subtext of professional rivalry. They might get their comeuppance from people of their own sex – Jacques, for instance, gets a blanket bath from the outraged female patients in *Doctor* – but they brought a rare sexual dignity to the seaside postcard image they were required to present.

Perhaps the most interesting incarnation of Jacques was in *Carry On Cabby*. She plays Peg, the neglected wife of workaholic cabby Charlie (Sid James). She starts her own taxi firm, Glamcabs, which, as its name implies, employs pretty women. Her success is decidedly overdetermined. The girls may flash their legs to the camera – but to the gaze of Peg, not the customers; there is an innovative no-tipping policy and a sceptical attitude to the (male) shop steward who refuses to let the wife of one of Charlie's male employees take his place when he is ill. In the slapstick attempts at sabotage by the two rival firms, the women come out best: Jacques has a *lazzo* in which she responds to Charlie's hoax radio calls in a variety of voices, a more creative use of her vocal ability than *ITMA* ever offered. Glamcabs, it appears, depends for its success upon an alliance between female sexual charisma and female intelligence, and Jacques' performance undermines any simplistic attempt to polarise these qualities by stressing physical contrasts between boss and employees. She virtually throws away the one feeble joke about her size and concentrates on the opportunities afforded her to stress Peg's attractiveness: in a bubble-bath sequence, for instance, she pouts to the mirror in a mocking style that suggests she is secure in her own sexuality. This impression is reinforced when at the end

of the film Peg is reconciled to Charlie and announces that she is pregnant. Interestingly, in the light of her refusal to endorse the polarisation of professionalism and sexuality, what she does not say is that she will give up work.

Of all the *Carry On* regulars Joan Sims was the most resistant to stereotype. Her mobile face was usually contrasted with that of a blander *ingénue*; in *Regardless* she is measured alongside Liz Fraser for a modelling job and summarily rejected – although there is little appreciable difference in their figures. The mobility was at first largely occupied in showing bafflement as she coped with the physical world as a whole, setting the sluice on fire in *Nurse*, for example; but as the series went on it was men, rather than objects, with which she did battle. Sometimes it was in a stereotyped shrew persona, such as the nagging Calpurnia in *Cleo* or the seaside landlady in *Girls*. In many of the later movies, however, her role took on a certain complexity of image comparable to that of Sid James. James, as Paul Weller has demonstrated (Weller, 1994), gradually became the focus of audience identification as the embodiment of cheeky working-class sexuality, to the point when, balding, middle-aged and gravel-voiced, he stepped into the role of romantic hero – Scarlet Pimpernel, highwayman, king. The casting worked precisely because of its blatant artificiality, reinforced by the earlier incarnations of James as cabby or wide boy. Similarly, the middle-aged Sims took on roles that were both glamorous and highly dangerous to men. In *Henry*, she played one of the wives not recorded in the history books (Windsor was the other); rejected by Henry, she uses her sexuality to undermine his throne, vamping Wolsey and Sir Roger de Lodgerley (Charles Hawtrey) into various acts of treason. In *Cowboy* she had a stunning entrance as the owner of a saloon bar; she appears at the top of a staircase in glittering scarlet sequins and shoots the glass out of James' hand. Most interesting, perhaps, is her role in *Don't Lose Your Head* as the mistress of Citizen Camembert (Kenneth Williams); throughout the film she is constantly looking for a better marriage prospect and takes full advantage of her disguise as a French aristocrat to help the search. At the same time she renders aristocratic pretensions ridiculous. Her control of the extravagant clothes is masterly, while she parodies that extravagance by putting them to practical use, sweeping majestically out of the Bastille with Sid James concealed beneath her skirt. She demonstrates similar control of the posh accent. When Williams lets his suburban vowels slip, it codes him as a social climber whose heart is hardly republican. When Sims lapses into Cockney, it is in order to be satirical. 'Don't aristocrats *have* bottoms?' she complains after a bumpy coach ride. Williams' riposte, 'Surely you've heard of the London *derriere*?' may win on points, but his linguistic lapses

symbolise his failure to cope with his body. Sims, like Sid James' cockney Pimpernel, uses her slippages to remind the audience of her status as a focus of working-class sexual 'common sense'. She is not a 'heroine' in the way that James can be the 'hero'; she may sometimes lose her man to the *ingénue*; but she does have his capacity to treat the body as a source of pleasure and profit. She may lose either the pleasure or the profit, but she rarely loses both. (In *Girls* she and Windsor virtually divide James between them: Windsor opts for his body, rescuing him from irate councillors, and Sims pockets his ill-gotten takings.)

Windsor, Jacques and Sims shared equal status with the male members of the *Carry On* team. While there was a steady throughput of bland female 'extras' available to be gazed at, it was common for this gaze to be modified by the fact that the three 'regular' stars were cast as mentors – sometimes in an official capacity (Jacques' matron gives tacit permission for the floral arrangement at the end of *Nurse*) or simply through acts of kindness like Windsor's beauty advice in *Girls*. This hinted at a future for the younger characters with greater potential for subversion than is implied by the roles on offer to older women in both comic and naturalistic movies of the 1950s and 1960s. The dragon mother-in-law, withered spinsters and complaining grandmothers into which, it seemed, all women would eventually metamorphose, were defined solely through their sexuality, or lack of it. The authority of Windsor and Co. within their narratives enabled them to undercut and parody this definition for themselves and their juniors. The real future, however, was to be distinctly grubbier. The *Carry Ons* had trouble with sexual representation throughout the 1970s.

DECLINE AND FALL

I would argue that the problem lay neither in what was shown nor in the redundancy of 'innuendo'. Bursting brassieres notwithstanding, the amount of exposed flesh in the later films is not really much greater than in the black and white days; as for 'innuendo' in the sense of smutty puns and phallic allusions, these have never been solely substitutes for more overt images; an examination of every broad sexual comedy from *Lysistrata* onwards will reveal as many puns as the most buttoned-up *Carry On*. The real problem lay in an underlying definition of sexuality that gradually invaded the series as it invaded much of the popular media.

I would agree with Andy Medhurst that the rot began in *Camping*: but not with Windsor's bra, which seems to me a joke about bras, objects with an unreliable life of their own, rather than a joke about Windsor. It lies rather in the admission of Jacques as a lonely games mistress in desperate

pursuit of Kenneth Williams that she is still a virgin. Frankly, we don't want to know this. This film seems to be constructing the audience as the second male in Freud's analysis of 'smut' – the person in front of whom Jacques is embarrassed, the one invited to imagine her engaged in sex; we are consequently invited to mock and reject her. What is disturbingly unfunny is not that a character overtly desires sex, but that, suddenly, sex is something over which men have sole physical and ideological control.

This did not prevent the later *Carry Ons* from having funny moments. The more they imagined that they were being 'permissive', however, the less funny they became. Until 1969 or thereabouts, any sort of sexual activity was loosely encoded by terms like 'nookie' and by highly stylised images. Everyone knows how to make love in a *Carry On*. Both participants remain fully clothed. Then one takes a running start and leaps on top of his/her partner, with collapse of the furniture/the entire set optional. The attraction of this image lies in its lack of specificity. The audience may impose on it whatever meaning that, for them, corresponds to sexual pleasure; the only meaning of 'nookie' that is fixed is that it is a mutual pleasure. The more the films tried to spell out that 'sex' was taking place, the more 'sex' meant a commodity which men 'got' and women either gave or didn't give. 'We've got a couple of birds with prohibitions', lamented James in *Camping*; he 'gets' his girl at the end, but it's uncertain whether this is an endorsement of laddish presumption or a suggestion that less exploitative behaviour might have brought an earlier reward. We get little insight into the 'bird's' point of view. This was only to be expected in the year that saw the launch of the *Sun*, soon to splash a 'bird without prohibitions' onto page three for everyday consumption (Benn, 1988). Women consumers were not to be polled about their opinions on the subject until Clare Short's Bill in 1986 had led to uproar in the Commons. 'Sex', for the *Sun*, as for the *Confessions* movies which, Windsor points out, the *Carry Ons* felt pressured to imitate (Banks and Swift, 1987), became something men do to women, and this definition percolated through 1970s popular comedy.

This is clearest in the last gasp of the series, *Carry On Emmanuelle*. Ostensibly there is a potential for female subversion. *Carry On Emmanuelle*, like the movie it purports to parody, is about an ambassador's wife who, as the title song states, wants 'Good lovin': a free spirit. However, the plot problematises the idea of 'good lovin' with, literally, a vengeance. The eponymous heroine has only to catch a man's eye for sex to result – 'sex' being coded by a shot of a pair of panties with some emblematic article of male clothing. While there are innumerable shots of exhausted/satisfied males (including a parodic allusion to the football team fucked by the

original Emmanuelle), what is singularly lacking is any image of female pleasure. Instead, Emmanuelle's sexuality is treated first as sickness – we learn that her beloved husband has become impotent, and that she is 'desperate' – and then as something to be punished. The husband recovers and immediately substitutes fertility pills for contraceptive pills, resulting in a daunting array of babies in the closing shot.

Potential for subversion also appears at first to exist in the usual place in a *Carry On* – in the role of older, authoritative woman. Emmanuelle encourages the servants to describe unusual sexual experiences, and prompts a little *lazzo* from Sims about the joys of picking up men in a launderette. Out of this unpromising material Sims makes a witty parody of a striptease; fully clothed, she brings a likely man to boiling point by sultry glances over the tea-towels and underwear in the bagwash. The position of this sequence in the narrative, however, claws back its potential. For no apparent reason, Sims is not allowed to play it in the glamorous-older-woman mode she employed in *Cowboy* or *Henry*; instead, the film codes the sequence as distant flashback. Sims wears a 1960s wig and a terylene dress that shouts its date. This underlines a point we might deduce from the presence of the young and beautiful Suzanne Danielle as sole focus of present-time male desire throughout – that only young and attractive women are suitable objects for male consumption.

The film has clearly bought in to the notion of sex as commodity in the *Confessions* films. It continually alludes to sex taking place off screen and flaunts fragments of the female body. On the other hand, its queasy avoidance of nudity suggests that it wants to eschew their blatant self identification as soft porn. This did at least permit the *Confessions* to present themselves as escapist films, offering (men) an escape from the pressures of everyday life. *Emmanuelle's* coyness suggests it is clinging to its *Carry On* credentials as parody. But it is impossible to offer the escape of laughter by mocking an institution, like soft porn, that is itself escapist. It would be possible, of course, to mock the institution which makes soft porn. Arguably, the erosion of stereotype by the female regulars would suggest that given the chance to make a film called *Carry On Murdoch* they would deliver the performances of a lifetime.

It was, however, impossible. If the *Sun* helped to commercialise sex in the 1970s by presenting it as one of the rights of the consumer (Holland, 198) it has also, since then, liked to see itself as the instrument of Conservative electoral victory, proclaiming 'It's the *Sun* what won it.' *Carry On Emmanuelle* coincided with the Thatcher victory of 1979. Earlier films made it plain that, despite their occasional pomposity, institutions like the National Health or education existed for ordinary citizens. Kenneth

Williams might complain in *Regardless* that the Labour Exchange was inefficient for failing to find a job for a man who spoke six languages, but he did so in a context of high employment; by 1980 two million people were out of work. The patient who is aggrieved at having to wait an extra weekend for a bunion operation in *Nurse*, the civilised classrooms of *Teacher* in which Williams makes fun of corporal punishment, and even the shop steward in *Convenience* who gets smacked by his mum for one strike too many, all seem similarly anachronistic; they are all assuming that they own these institutions, that they will be heard – and that, if they are a little too big for their boots, that the institutions themselves will cut them down to size. By the Conservatives' third term, no member of a school, hospital or union could make this assumption. The enterprise culture undermined not only the *Carry Ons*' cheerful subordination of work to bodily pleasure, but also the image of male and female professionalism functioning in harmony – with interludes of 'nookie', perhaps, but without glass ceilings, exploitation, or fear that the profession itself would fall victim to 'management' or 'rationalisation'. The female 'regulars' had spent years developing every opportunity to be more than 'a body, a bosom, and a joke'. The liberties taken with the institutions at the heart of their comedy were to deprive them of those opportunities and the *Carry Ons* of their most distinctive voice.

NOTE

Carry On Columbus (1992) does not figure in this chapter. The main reasons for this are, first, that none of the original female stars were involved, and among the men, only Jim Dale, now old enough for the Sid James role as unromantic lead. Second, because it seems to have been conceived not as a *Carry On* but as a conscious homage to the original stars, many of whom are now dead. Its attitude to the tradition (part reverence, with almost discernible envy for team work not yet achieved by its very mixed group of stars, part send-up, without the confidence to treat the films themselves as an institution of the kind they parodied) sets it apart.

FILMOGRAPHY

Carry On Sergeant 1958
Carry On Nurse 1959
Carry On Teacher 1959
Carry On Constable 1960
Carry On Regardless 1960
Carry On Cruising 1962
Carry On Cabby 1963
Carry On Jack 1964
Carry On Spying 1964
Carry On Cleo 1964

Carry On Cowboy 1965
Carry On Screaming 1966
Carry On – Don't Lose Your Head 1966
Carry On – Follow That Camel 1966
Carry On Doctor 1968
Carry On Up The Khyber 1968
Carry On Again Doctor 1969
Carry On Camping 1969
Carry On Loving 1970
Carry On Henry 1971
Carry On At Your Convenience 1971
Carry On Abroad 1972
Carry On Matron 1972
Carry On Girls 1973
Carry On Dick 1974
Carry On Behind 1975
Carry On England 1976
Carry On Emmanuelle 1979

BIBLIOGRAPHY

Banks, Morwenna and Swift, Amanda (1987), The Joke's On Us, London: Pandora.

Benn, Melissa (1988), Page three and the campaign against it, in Feminism and Censorship, ed. Chester, G. and Dickey, J., London: Prism.

Bragg, Melvyn (1988), Rich: The Life of Richard Burton, London: Hodder and Stoughton.

Ferris, Lesley (1990), Acting Women, London: Macmillan.

Freud, Sigmund (1976), Jokes and Their Relation to the Unconscious, tr. Strachy, Penguin.

Gray, Frances (1994), Women and Laughter, London: Macmillan.

Higson, Andrew (1994), Renewing British cinema in the 1970s, in The Arts in the 1970s: Cultural Closure, ed. Bart-Moore and Gilbert, London: Routledge.

Holland, Patricia (1983), The page three girl speaks to women too, Screen, Vol. 24 no. 33, May/June.

Jordan, Marion (1983), Carry On . . . follow that stereotype, in British Cinema History, ed. Curran and Porter, London: Weidenfeld and Nicolson.

Medhurst, Andy (1986), Music hall and British cinema, in All Our Yesterdays: 90 Years of British Cinema, ed. C. Barr, London: BFI.

Weller, Paul (1994), Among Certain Classes: Class and the Carry On Films, Vaughan College summer school.

Windsor, Barbara (1990), Barbara, London: Arrow.

6

PUNCHING YOUR WEIGHT

Conversations with Jo Brand

Stephen Wagg

You cannot be too thin, or too rich.

The Duchess of Windsor

If the random selection I saw are anything to go by, 1990s come-
diennes are a brawling mob of beer-swilling, sex-hungry,
chocolate-gorging, lumpy misfits, struggling to find love, romance
and adventure in a world going increasingly mad. In short, they
are girls after my own heart.

Georgia Campbell

INTRODUCTION: COLLUDING, COLLIDING . . .

The principal details of Jo Brand's life and of her work as a comedian are
well known. She graduated from Brunel University and worked subse-
quently as a psychiatric nurse. She became an 'alternative' comedian
during the 1980s, initially using the self-deprecating sobriquet 'The Sea
Monster'. Gradually, reverting to her own name but maintaining the self-
deprecation, she developed a stage persona (see Chapter 4) that was
profane, sexually voracious, careless of the figure-conscious norms of
conventional female life and mocking of men. In the 1990s she came to
rival Victoria Wood as Britain's leading female comic, performing several
national tours and two series of her own show on Channel Four.

When I came to plan this book I already knew Jo Brand a little. During
the 1980s, I had occasionally compered local comedy shows and one of
them had featured her. (She, like most of the other performers on the bill
that night, now have, or have had, their own comedy shows on Channel
Four.) Later it transpired that she and I had a good friend in common and,
when we met at his wedding, I asked her to contribute to this book.
Initially, it was assumed that she would write for it but I felt, on reflection,

111

that a conversation, during which I could put a number of things to her, would be a better means of exploring with her the themes – comedy, politics, gender, the body and so on – that I thought it was important to explore.

There is, I think, a reason beyond mere personal convenience that, out of the 60 or 70 'mainstream' or 'alternative' comedians who now enjoy some sort of national prominence, I chose to talk in this way specifically to Brand. The reason is that, for good or ill, Jo Brand has perhaps a greater range of meanings for people than is the case for many comedians; when it comes down to it, though Bob Monkhouse, Rory Bremner, Ben Elton, Lenny Henry, Victoria Wood and others may each have a bigger public following, the nature of the political and social ideas that they evoke and, thus, the spectrum of reactions that they draw forth, are narrower and less faceted than they may be for Brand. I can illustrate this from the conversations I had around the time I met her, in the Spring of 1996.

When I mention Jo Brand to a class of mature students whom I am teaching on an evening degree course, there is a chorus of approval and, in amongst the various affirmations ('She's great', 'She's brilliant' and so on) the students, mostly women in their thirties or forties, quote her best known line for rebuffing hecklers; 'The reason I keep my weight up is so that tossers like you won't fancy me'.

Around the same time, a male academic of 40-odd tells me firmly: 'She's not funny. She's one-paced. She's got two lines – she's fat and she eats cakes'. I dissent politely from this judgement and, to support my case, recount a joke Brand has recently told about deceased FBI director J. Edgar Hoover in her series of *Through the Cakehole* (Channel Four, Spring, 1995). He smiles. 'That is funny', he concedes. I tell him another joke from her current repertoire, this time about women's football. 'Yes', he says, smiling again and shrugging, 'that's funny too'.

Within my own family, when I mention the forthcoming interview, my mother, in her seventies and devoutly conservative, pronounces Brand 'disgusting'; my brother, offers the amused but supportive 'I bet that'll be interesting'; and my teenage daughter asks about the possibility of complimentary tickets for Jo Brand's forthcoming performance at her university.

I discuss Brand with a group of first year undergraduates, mostly aged nineteen or twenty. Two female students respond immediately. One – slim, confident, with long black hair – declares: 'She's awful'; the other, sometimes ill at ease and generally less sure of herself, says: 'She's great'. A young male volunteers the familiar 'She hates men'. 'No she doesn't', I counter. 'Well', he replies, resorting to the currently fashionable 'laddish' irony, 'why doesn't she take a bit of trouble with herself then?'

After a pub gig in Nottingham, a blonde-haired young man with the looks of a lifeguard in an American B movie of the 1950s, calls into the dingy room where the artistes are clustered and, with slight embarrassment, asks Jo for a hug. They hug. I wonder what this might mean. Is it the gesture of a penitent male, now anxious to get in touch with his soft side? Or an already 'new man', eager to demonstrate solidarity? Or maybe it's male bravado: after a few lagers, he has bet his mates that he can do this. There is brief discussion of how the males in the audience received her material. 'They know I don't mean it', says Brand. I observe that the men sat next to me were pretty quiet and rather sheepish. 'Well,' counters the lifeguard, 'if they were as old as you [48, then] they were probably dead'.

In early 1996, 'FM', reviewing Brand's television show in the London listings magazine Time Out, advises readers that:

> It's amazing how Brand has managed to deceive so many people for so long. She built an entire career on the strength of two jokes ('Aren't I fucking fat?', and 'Aren't men fucking wankers?'). Offensive only because it's so boring.
>
> (31 January–7 February, p. 161)

The following week, the magazine is no more optimistic on this count, warning of,

> More desperately unfunny stuff from the desperate-for-some-new-material Ms Brand. Tonight there's the usual stand-up mixed with feeble sketches . . . and no doubt plenty of references to how fat, fat, fat the lady is . . . Preview tapes were unavailable.
>
> (Time Out 7–14 February, p. 161)

In early March, 1996, I buy Jo Brand's book A Load of Old Balls (Brand, 1995) in a Midlands bookshop. The young woman on the till says 'Do you know she's got another one out soon?' 'Yes,' I reply, 'she's still writing it', adding, by way of explanation, 'I know her a little'. 'Well, tell her', responds the woman, 'she's my hero'.

This spread of responses – from curiosity, admiration, perceptible warmth and even devotion, on the one hand, to moral condemnation, brittle discomfiture and testy consumer resistance on the other – places Brand in relation to the cultural politics of Britain in the late twentieth century. Comedians, increasingly, define us to ourselves and, within that, especially in relation to women, Jo Brand will, I think, have a greater role

in the making of identities than many who ply her trade. In the conventional stand-up comedy of post-war Britain, variously dispensed by the Max Millers, the Tommy Trinders, the Bob Monkhouses and the Bernard Mannings, women have been among the Others. In these male repertoires, they took their place alongside immigrants and skiving trade unionists, as mothers-in-law, nagging wives and glamorous young receptacles for male desire. This comedy, it's fair to assume, was a collusion with the majority of males who heard it and, perhaps, with many of the females. Until the late 1970s it was also, effectively, a monolith within popular culture, there being no comedy publically available that flowed from any different assumption. Today there is a cultural fragmentation within British comedy – left wing, female, 'laddish', black and gay comedians all now have a voice and an audience (Wagg, 1996) – and this fragmentation has brought more Others into play – men, for instance. Clearly, Jo Brand's act would not be viable if the resentment of men that many women feel had not reached a level of public visibility. Her comedy colludes with these dissatisfactions and collides with conventional notions of female beauty and decorum. Many males are happy with the idea that women should be more sexually aggressive. They are much less happy that this aggressiveness should be expressed by a woman whose appearance does not correspond to prescribed ideals of feminine appearance. In this latter sense, Brand is surely more genuinely 'transgressive' than most comedians.

CONVERSING

What follows are edited extracts of several hours' conversation. The conversation ranges over a variety of themes relating to Jo Brand's work. These include gender and femininity, the body, the relationship between comedy, politics and commerce and what I might call the dilemmas of transgression: the contradiction in her philosophy between an Appollonian desire for a better world and the Dionysian urge to rupture taboos emerges clearly. This she characterises as the conflict between the child and the 'grown-up', invariably within the same person.

[. . .]

sw: We were just talking about the circuit and the politics and the factions, and I was asking basically why you thought that the political comedy that prevailed in the eighties . . . died a death, and you thought it was something to do with the audience perhaps?

jb: Yes, well I think that audiences had decided in some way that they weren't that interested in it any more, to be honest.

sw: You think they ever were?

jb: I think some of the ones that went used to be but that sort of audi-
ence that went to alternative comedy and the ones that go now are
fairly different.

sw: In what way?

jb: Well there a much broader selection of different classes, if you like,
going now. I mean in the eighties it was, I suppose, a fairly elitist kind
of educated middle-class audience, and you still get people like that
going. But also, you get a lot of ordinary people who go to the
Comedy Store for a kind of night out. Friday and Saturday night, a
West End night out. Whereas Jongleurs still kind of retained some of
that kind of yuppyish audience, that they've always had.

sw: Yeah. But as I've said I do think the yuppie audience were there all
along. Just my feeling. For example . . . I talked to one of the early
Comedy Store performers, who was very conscious of the kind of
yuppie nature of his audience . . . I think this went for a lot of other
comedians as well. It wasn't so much whether your material was polit-
ical or not; it could be and then again it may not be. That didn't seem
to matter. It was the cleverness of it that mattered most, and people
like [Jeremy] Hardy have said, and people have said of him, it's a
good job he's good . . . because the audience actually don't like what
he's saying. They just like the way that he says it.

jb: I think there's something in that.

sw: And maybe for you too?

jb: That they don't like what I say, they just like the way I say it?

sw: That could be true of certain [people in your audience].

jb: [. . .] I think a lot of the audiences do like what I say. The women do,
certainly, you know. Because there's this sort of myth that women are
a certain way but in fact they're not at all.

[. . .]

sw: Do you get any kind of negative feedback from females in the audi-
ence?

jb: Yes I do. But the sort of negative feedback I get tends to be 'Don't put
yourself down so much'. And I get that from men as well. I get men
who say, 'Coo, you're gorgeous'. And I also get' Don't put yourself
down so. You're gorgeous' from women.

sw: Quite protective.

jb: Which is a sort of idealistic feminist kind of thing, I suppose . . . But
to me . . . well I think in an ideal feminist world, fat people and ugly
people would not be ridiculed. We'd all be accepted on the basis of

what sort of people we were inside, rather than how we were on the outside. But, you know, that sort of feminist utopia doesn't exist and I think you have to address the fact that it doesn't in one way or another. And that sort of putting myself down is so much a part of me I find it quite hard not to do it.

sw: Yeah. It struck me, thinking about that, that it might work in a slightly different way now. That what began as a kind of personal defensiveness in social situations . . . It's like you get your insult in first: before they are cruel to you, you are cruel to yourself. But you do have an enormously self confident aura. Which is quite a contradiction to that. The one thing that the public agree on, whether they like you or not, is that you do seem very self possessed, which more than compensates for any qualm about your appearance. It struck me that now it works in a slightly different way in the sense that it's, not an ingratiation, exactly, but a way of disarming the audience which makes it easier for your kind of comedy.

Whereas people like Ben Elton put people's backs up because of his sheer aura. What Elton seemed to me to try to do is to marry a kind of cheeky chappie, cockney, coster monger, kind of market trader type appearance . . . with a load of fairly kind of proselytising material.

jb: Yeah.

sw: And people became uncomfortable, not because they didn't agree with the substance but they didn't like the manner in which it came at them.

jb: Yeah. Well I think to some extent that's true but, then again, a lot of people did like it.

sw: Well sure, but in a way in the public debate it became the kind of defining characteristic of Elton, rather than . . . It just seemed to me that, that element of self deprecation makes it easier for you to do the things that you want.

jb: Yes, I think it does.

sw: [Something here] that you said in '94 sums it up very well. When it comes down to it you do want people to think about things beyond the normal stuff of consumption. Which is what most alternative comedians deal with. You know: 'Did you see this on the telly?' 'What d'you think of Arsenal?' You know that type of stuff its fairly narrow and that seems to me also to be the key to their success, a lot of these people – they come on to TV and radio as consumers.

jb: Yeah.

sw: And people want to know 'What did you think of this? What did you think of that?' You know, the *Fantasy Football* syndrome. Most TV

116

programmes – travel programmes, whatever – seem to have an alternative comic on board. You resist that partly because you, well . . . we were talking about women but it doesn't have to be women [quotes] 'A lot of women know or care more about the kind of kitchen Jane Seymour's got than about what's going on in Bosnia and I think it's fucking outrageous for women to be like that.' I presume you still feel that way?

JB: Oh very much so, yeah.

SW: So that cuts down a lot of avenues to you really. But some are still open. For example, you went on *Question Time* which I know you were quite chuffed about.

JB: I was very pleased, yeah.

SW: How did that come about?

JB: It came about because I'd mentioned in an article somewhere that it was something that I watched every week.

SW: Right, so you came in as a consumer?

JB: Yeah, [it was about my] top ten programmes and one of the producers just happened to read it and they'd changed *Question Time* and decided that they were going to have at least two women on the panel every week.

SW: Positive discrimination.

JB: Yeah. So they were looking for more women and I think when she read that she thought 'Oh well, here's another one we can try then.' So they did.

SW: And how did it go? I missed it, sadly, [although] I knew you were going on.

JB: Well it was terrifying to me because . . . a lot of the time I do behave like a child.

SW: How do you mean you 'behave like a child'?

JB: Well I'm sort of very childish in the sense that I kinda like to shock people with my act. Do you know what I mean?

SW: Is that childish, necessarily?

JB: Well, to some extent, it is because . . . I've always felt that you can kind of differentiate between . . . groups of people and a lot of people I know that are the same age as me I call grown-ups when in fact I don't think I am a grown-up, and neither are other people that I know. And that has do with a rather sort of . . . old before your time rather sort of pious kind of attitude that a lot of people my age have really. So I would tend to want not to be a grown-up and . . . have a go at those sort of false attitudes that I consider grown-ups to have, if you see what I mean. And to me *Question Time* is a grown-up

programme, whereas something like *The Word*, or anything that Chris Evans does, isn't grown-up, do you see what I mean?

sw: Yes.

jb: And to me it was, like, my first experience of being thrown together with the grown-ups really. And that I found . . . really, really hard. And . . . the other thing that I was terrified of was that gaps in my knowledge would be shown up.

sw: You see grown-ups as omniscient then?

jb: Of course, yes. Well grown-ups assume themselves to be and I . . . realise that's all very much an act on their part. But it still scared me a lot.

sw: Sure. I think these terms are very important, but they are also very fluid now, aren't they? I mean I'm listening to this and you talk about people your age which is forty-odd . . . Really you wouldn't have a job in a sense if what you just said was true because a lot of your audience is composed of people of your own age. And they are really up for this sort of stuff.

jb: Yeah, but they're not grown-ups to me. They're the same as me. I don't think I perform to grown-ups, ever.

sw: Well, I think that's interesting because in a sense that's another defining characteristic of alternative comedy. It's a kind of licensed irresponsibility.

jb: Yeah, absolutely.

sw: And it comes in all sort of shapes and sizes. Looking at a lot of alternative comics, basically what they've been allowed to be and to become [is] like ongoing students. I mean they talk the language of student life. 'Getting a shag', you know all that kind of stuff and the more successful they become the more they can be kitted out in it.

jb: Absolutely.

sw: For Baddiel and Skinner [of *Fantasy Football League*] you can kit out a whole mock up student flat with empty lager cans on the floor for them to feel at home in.

jb: And them in their mid-thirties.

sw: Well sure, because that's the way popular culture is going. There's more licensed irresponsibility around. And there are more people that are up for Chris Evans and *The Word* and whatever. And they're not all eighteen.

jb: Yeah.

sw: I personally think it is to do with the decline of high culture, and along with it the notion of public service. More and more people of a certain age are just pissed off with all that stuff. You know, the

government, and Bosnia and all that sort of business, why can't we have a laugh and get pissed? And alternative comedy seems to license them in that to a degree. It seems to talk to that kind of constituency a lot of it.

JB: Yes it does. But . . . there's also a very big side of some comedians, and of me, that is grown-up as well. Do you see what I mean?

SW: Yes.

JB: One kind of predominates over the other, really.

SW: But how does that kind of manifest itself – the predomination?

JB: In what sort of sense do you mean? In the way that I live my life.

SW: Well no. Not just you. I mean on the circuit. What evidence is there that irresponsible ones put the responsible ones down or prevail over them?

JB: I think . . . in the use of language using a lot of colloquial language – swearing and talking about rude things, which upsets the grown-ups really. I mean in that sense.

SW: But that can be read in different ways. There has been some considerable discussion about the language of alternative comedy. [An article I read recently in the *Guardian*] questioned the kind of liberal recourse to the work 'fuck'. And you were quoted quite extensively in one article because on the whole you thought it was a good thing because it was empowering.

JB: What? The word 'fuck'?

SW: Yes.

JB: I think the word 'empowering' should be taken out of the language. [Laughs]

SW: Surely not because of the idea of it, but because of the hypocrisy of it. No?

JB: Well, no. [It's] the slightly kind of smug self knowing element of it, I don't like. There are certain words. I am not applying that to you as an individual but I think it's a new slogan which actually means [. . .] I think it sets up a barrier. Because if you go to those people, you go to, like, a council estate in Peckham and say to all those black single mothers in Peckham: 'I want to empower you' they would all go: 'What the fuck are you on about?' . . . It creates a barrier rather than a communication. It's bloody stupid.

SW: Well, fair enough. Here's what you said: 'Stand up comedienne Jo Brand has been testing the limits of swearing for years. The temptation to swear profusely is at its worse, she says, when one's act is going badly. People will laugh when they hear the "f" word. We are so sexually repressed that an audience will snigger almost on cue. It's the

adult equivalent of bums and willy jokes. There's only one no and that's the "c" word. It's such an awful word because it's so tied up with misogyny.' You do say at one point that you counted the number of swear words [JB: Of 'fucks' in the act?] and it came to 93 and that this was not ideal. But then you did use the word 'power'. You said it gave the speaker a kind of power and I think that this ties in with other things that you've said. And, getting back to Foucault, it's against the grain. It's this licensed irresponsibility. All the social settings where people are not allowed to use this word. You can't use it at school and you're not encouraged to use it at home and stuff like that. But hearing somebody say in on stage it's . . . quite exciting.

JB: Yes, in some ways. I do think it breaks down that sort of veneer – to get back to grown-ups – that grown-ups have . . . I think that grown-ups are just like the rest of us. They just like to pretend to be more sophisticated. And everybody probably knows that when John Major's at home he says 'fuck'.

SW: So John Major's a grown-up. This is really a metaphor for something slightly different isn't it.

JB: Yeah, in some ways. You know that . . . grown-ups use bad language but, because they don't use it to you, they assume . . .

SW: Something to do with public and private . . .

JB: Yeah . . . some sort of superiority over you. Like again with my parents. I never heard my parents swear when I was a kid, but like now that they know I do and they've seen it on television they feel fairly comfortable about doing it. Not all the time.

SW: How do you feel about that?

JB: Well, I find it funny actually.

SW: You don't feel at all ambivalent given what you said about grown-ups?

JB: No, not really.

SW: No? So in your case its really has broken down in a concrete way the distinction or the gulf between a grown-up and a child?

JB: Yes.

SW: You've made children of your parents?

JB: In some ways.

[. . .]

SW: . . . about advertising . . . you were asked to advertise Flash and Vimto.

JB: Yeah, . . . I think it's wrong to attach yourself to a product and push that product for money. I think it kind of lowers you in some way.

SW: You said first of all it took away your soul and, by that, you meant

independence. You felt that you couldn't really look at an audi-
ence . . . you would be embarrassed to look an audience in the face
if you'd just been on telly doing an ad for like Ariel or Safeways. But
you know a lot of people who've done that. . . . Have you discussed
it?

JB: Well they have very different attitudes to everything from me. They're
not interested in politics or anything of that nature and they have
more of a terror of the future than I do. I'm not worried that when
all this comes to an end I'm going to be penniless you know.
Somebody like Harry Enfield is, so he's amassing as much money as
he can . . . That's the impression I get.

[. . .]

JB: I mean, a lot of comics have very little self confidence, you know.
SW: Do they?
JB: Oh god, yes!
SW: Why do you think that is?
JB: I think it's the reason they went into comedy in the first place.
SW: Which was?
JB: Well, there are lots of different reasons but [maybe] they felt in some
way alienated from other people, either by looks or by intellect or by
political opinion, or by their family or whatever.
SW: And this is a way of being loved?
JB: In a very basic sense I suppose it is, yeah.
SW: There is a very important point here which relates directly to what you
do, I think, and that is that comedians are required to be populist to
a degree. There's a point which you can't be a successful comedian
without being a populist, it's no use cracking stuff that people don't
laugh at. Therefore you have to have some kind of reliable route into
their subconsciousness . . . What do you feel about that?
JB: Well, I think yes, . . . you have to . . . broaden your material in a lot
of ways. Just because, as I said, people won't know what you're on
about, you know. And a lot of comics are quite happy about that
because we are consumers of that culture. So, therefore, they have the
same sort of reference points as everybody else. I mean, one example,
I once saw a fairly posh improvisation group get asked by an audience
to do Shakespeare in . . . a sort of *Eastenders* version and style.
SW: Yes.
JB: It was obvious that they knew Shakespeare back to front, but they had
never ever watched *Eastenders*. The only thing they knew was that there
was someone in it called Sharon and they had to rely on that one

joke . . . to get through it. So it's obviously in all our interests to be aware of what the most important culture reference points are. But, at the same time, if that's not satisfactory . . ., which it isn't, [you] experiment with going a bit more esoteric than that . . .

sw: Yeah, you have to know what your audience knows. There must be a pressure on every comic to feel what their audience feels, as well. Occasionally . . . people like yourself, . . . John Dowie, I remember . . . defy this. You come out with things . . . you sense your audience won't like. You sense that it will throw them. You had one in the last show [about] the bloke you can rely on is one whose wife has died. Did you know that, that would kind of throw them slightly?

jb: Yes.

sw: You used to have one, and you called it your testing-the-water joke. Is that consciously important to you?

jb: Not consciously, no. But . . . I find that I get pulled towards trying to get a reaction other than just laughing sometimes and that reaction would be 'Oh my god I can't believe she said that'. You know what I mean?

sw: Yes I do. But why do you want that? Because, as you said earlier on, laughter was the main thing and the main validation.

jb: Yeah. I think that's from a sort of female point of view, really. Which is . . ., like I was saying before, there is this attitude towards women which prevails in magazines and on the telly and if a Martian come down to earth and just had to watch telly and read magazines to find out what women were like he'd think that they were all blonde and 25 with big tits, you know. Because that is mainly what you expect on the telly. Also he would think they were never rude and always looked nice, they always deferred to men, a lot of the time. Obviously there are exceptions to that on television, but I'm saying that's the general essence of it. So I like not to be that . . .

sw: Yes.

jb: . . . I just like winding people up. Because I myself have been wound up so much in the past that I like the opportunity to get back at a few people by winding them up.

sw: Yes, but like I said earlier on, its something to do with self . . . and standing outside of what language and social expectation has somehow made you, and defined you as. [. . .] Yes, just getting back to the advertising. Not all the [comedians] who do advertising are apolitical [are they?]

jb: No. Nick Revell did an advert for Ford and his rationale for that was that if this advert was successful and more cars were sold it would

mean more work for the plebs on the production line. Which I thought actually was just a way of rationalising it.

sw: Yes, you said 'bollocks' when [we discussed] it before. But why? Some people would say that was fair enough.

jb: I would say that there is some sort of odd reasoning behind that, yeah. But the fact is that every one knows that the reason people do adverts is because of the huge amount of money you get for no work. And you have to acknowledge that really.

sw: But isn't there a qualm about advertising itself in there somewhere? I mean are you presupposing that advertising itself is not useful?

jb: I don't agree with advertising, no. Because I don't agree with competition. I agree with what George Orwell said about advertising which was 'advertising is the rattling of a stick inside a swill bucket' and that's what I think it's all about. So those are my own personal views about it. I don't like advertising anyway, let alone going any further into it.

sw: But it's so pervasive now it's almost like saying you're against the motor car. It's a difficult position. I say that as somebody who agrees [with you]. I think as a rationalist, I just wonder what's going on. People, who we know are getting paid to do this, coming on and saying something is good or even not bothering to say that it's good. Nowadays a lot of advertising is very oblique. It may not even mention the product. Again that's why comics are so good because they can come on and provide the necessary irony. Years ago we used to have solemn looking men in white coats coming on and announcing that this washing powder had been tested in the laboratory and was without doubt the best.

jb: And now we have Paul Merton coming on and taking the piss.

sw: Absolutely.

jb: But we all know that there is a serious and powerful message from the company that is pushing the product. So that superficial thing of being ironic and taking the piss means nothing to me at all. Because at the end of the day he is still getting paid for it. He's still selling a product on someone's behalf.

[. . .]

sw: One thing I've come across in reading this week is the way in which a lot of female comedy is appreciated as . . . a kind of self indulgence and it relates to what you say about how women are commonly perceived. That these programmes involve women clearly having a good time and not giving a toss who's watching necessarily. I came

across a review of *Wind Bags* [radio show by Jo Brand and Donna McPhail] which said that there was a nice kind of quality to it which had women saying what the hell they wanted and not caring.

JB: But I think women very rarely get the opportunity to do that, you know. You'll find that the vast majority of women won't actually be themselves, their true selves, when there are men around. They somehow kind of censor their speech and change their behaviour.

SW: In what ways?

JB: In that they will sort of defer to men. They will let men talk normally. They will lose some of their confidence about their opinions and they will be feminine rather than female, if you like. Be . . . slightly flirty or whatever. D'you know what I mean?

SW: I do. That makes your comedy so important, I think. In a way there aren't that many people doing what you do. You're clearly the best known, the most noted for this and, as I say, I did feel that the show you did in Leicester was a cross between being a gig and a rally, you know . . . I sat with my daughter who's very liberated and was chuckling away. She couldn't understand what was wrong with me. It wasn't that it wasn't funny. It was. It's just that I rarely laugh and I was . . . taken with the whole aura of it. That there was an interesting mingling of laughter and cheers which you said you enjoy, you relish. That put down line 'one reason I keep my weight up' which everybody knows now, but they just want to hear it again, I think there must be a sense, which clearly you share, to a degree . . . it's almost like you're doing it on their behalf. They live their lives constrained and those constraints aren't going to go away.

JB: Exactly. But I think what I do on stage is as much fantasy for me as it is for any other women. I mean, that isn't me. I don't live the life that I might refer to on stage. It's a fantastic life, you know?

SW: Sure, yes.

JB: And that is what the tabloids can't seem to understand. That's not really me. It's a bit of me. It's the bit of me that's very frustrated with certain things. But, you know, if I truly was a man hater . . . I would not see men, I would not work with them, you know. And it's such bollocks really – these things that they've created.

SW: But do you not think that the tabloids deal with fantasy anyway. [JB: Oh, absolutely.] They play one off the other. I mean everywhere you look there's a kind of fantasy version of what happens in the outside world. Fantasy football on the back page and there's fantasy breasts on page three . . . Fantasy [is] their stock in trade.

JB: You see, I think women suffer either way, you know. Whether they

look like me or Pamela Anderson. They're approaching a problem from different directions but it's the same problem, ultimately.

SW: Which is?

JB: Which is that men don't have any respect for women as people, on the whole. I'm not saying that as a blanket statement. A vast majority of men don't because they tend to view women [as an] object, you know. I mean, a friend of mine, who's just been in a series called *Call Red*, about a helicopter medical team, she's like the blonde . . . pretty doctor. And she's like going mad at the moment with the tabloids because they want her to be that fantasy; you know. Garry Bushell [columnist in the *Sun*] wanted her on his TV show to run in and revive him. With a sort of orange suit on and her doctor's bag. So she's being driven mad . . . she's being undervalued.

SW: Why's she being driven mad? Presumably she's having to do a certain amount of this. I mean, these things are mediated aren't they. Management will be pressing their clients to do this sort of thing, surely.

JB: Yes, she's being driven mad, not only by the media but by her agent as well.

SW: Because this is the name of the game: 'Hey we've got you on Garry Bushell. You should be pleased.'

JB: Yeah, she said 'No, I'm not doing it' . . .

SW: And she hasn't done it?

JB: And she hasn't done it but that is unusual because . . .

SW: . . . it's maybe a bad career move.

JB: Of course. That's right.

[. . .]

SW: Do you think in any sense there's a paradigm for women's comedy these days . . . a certain framework in which you have to operate if certain jokes are going to succeed? Certain angles on things.

JB: Yes I do. I think at the moment it's a sort of rudeness, if you like. Although, having said that, female comics do step outside that. French and Saunders, Victoria Wood. They're are not particularly filthy. But there's a filthy paradigm at the moment [that] in some ways takes in *The Girlie Show* as well. Although it's not meant to be comedy. I don't know if you watched it at all.

SW: . . . I caught three and a half minutes [which] was all I could stand. It's already been fed into the this kind of circuit of presentation and joke response . . . because the *Fist of Fun* had a piss take of *The Girlie Show*.

JB: Oh really, I didn't see that.

sw: . . . they had a little satirical made up *Girlie Show* with young women gesticulating at the camera, pointing at their chests and saying 'Tits'.

jb: [Chuckles] Yeah.

sw: Exactly like the real *Girlie Show*. This kind of hyper-reality. A lot of jokes are close approximations of the things that they [parody].

jb: Well. I think it's encouraging girls to be a bit moronic in the same way that some men are, to be honest.

sw: Yes.

jb: I don't agree with that. I'll probably get lumped in with them, though. Because they say 'shag' and because I say 'shag'.

sw: OK, so what's your defence? How do you differentiate yourself from them?

jb: Well, first of all, I would hope that I am funnier . . . I don't say 'shag' just to get a laugh. There would have to be sort of joke involved in it. Other than that, I don't have much of a defence really.

sw: It's an interesting thing to pursue because, ultimately, as I was saying, you're all part, as I see it, of the irony business. Ironists come in different shapes and sizes. Ultimately they're plying the same trade. I remember talking to one of the writers of *Alan Partridge*, which is a programme I greatly admire, and enjoyed even more the second time around. [At one point in the conversation, I said] 'What do you think about Chris Evans, because ultimately I think you're in the same business.' And he was quite outraged by that . . . It is kind of difficult isn't it?

jb: Well yeah, in some ways it is . . . But, well, this sounds rather vain, but I'd also like to think what I do's a bit more intelligent [than *The Girlie Show*] because there's like a big bit of me that does read the papers, read novels and read poetry.

sw: So you're not the child all the time?

jb: No, that's what I mean. That's what I was saying earlier, you know.

sw: You've got a sub category of 'adult childishness'.

jb: Yeah, absolutely, and there's also a big element of *The Girlie Show* that is about showing as much tit as you can, and that sort of thing. And that's not me either really. It's that kind of combination that we can be attractive sex objects, but we can be laddish as well. Whole problem with that is your normal sort of moronic bloke is gonna take the sex object and throw away the rest, really. So they might just watch it so they can see girls with short skirts with a lot of cleavage showing.

sw: Yes well, it seems to be part of the commodification of the whole thing. This is one of the reasons why a certain kind of alternative comic can have such a lucrative time of it now. That more or less

anything that is popular can somehow be made more popular and somehow more legitimate by ironising it. There is this alleged cult of 'laddishness' led by Skinner and Baddiel and all the new magazines which peddle all the things that Garry Bushell peddles, only with a slightly arched eyebrow and the tongue in the cheek . . .

JB: . . . and a degree from Oxford or Cambridge, or wherever.

SW: Well, I don't think that matters in Fantasy Football.

JB: I think it does. Can you imagine Garry Bushell presenting Fantasy Football? Wouldn't it be a totally different show?

SW: Well yes, but only because Garry Bushell is cerebrally challenged in a lot of areas.

JB: [laughing] He's in Mensa.

SW: Mensa represents the sort of intelligence that involves lateral thinking, doing crosswords and whatever. But I don't think he's too sophisticated about the way the world works . . . You don't have to [have gone] to Cambridge. It's the kind of streetwise media wisdom that you get from somebody like Danny Baker, who hasn't been to Cambridge but is in touch with certain areas of the youth market . . . If anything, going to Cambridge would serve as an impediment as much as anything. Just getting back to this paradigm, why do you think it is? Because some people would say it's the female equivalent to laddishness wouldn't they?

JB: Yes, I think it's part of a progression of female comedy in some ways. Women on the circuit do struggle for some sort of recognition which is strong rather than marginalising them – you know, looking nice in a show of four comics . . . And one of the ways to do that is to be fairly outrageous, if you like.

SW: You make it sound like a bit of a gimmick. Like something to make them remember. Don't you think it goes any deeper?

JB: Yes, I do think it goes deeper than that. But I think, to some extent, in the same way that the men are doing it, women are tailoring their act in some ways – I did as well – to suit popular demand, if you like.

SW: How do you perceive that popular demand? How do you work it out? Obviously you don't get letters from people requesting certain types of joke?

JB: No, you work it out from doing live performances. By looking.

SW: Seeing what works and what doesn't.

JB: It's not quite that simple. Some things will work in some places and not in others and, as you travel around the country, you get very different audiences in different places.

SW: What defines the different regions or a particular type of venue? You

talked about the Circus Tavern in Essex. You would never play the Circus Tavern, would you?

JB: Very unlikely. I would have though. In a way I'd like to, just to see what happens. In the way I'd like to do a working men's club as well, to see what happens.

SW: Occasionally that's been tried. [There was] a swap with Mandy Knight [an 'alternative' comedian]. She played a working men's club or a Circus Tavern type venue and a kind of mainstream comic played [an 'alternative' venue] in Palmers Green and the result, I thought, was a bit predictable. The mainstream comic stormed the club and Mandy Knight . . .

JB: . . . died. Yeah.

SW: Something that Jeremy Hardy said about playing the Comedy Store, which I know you've played a lot. It's like they're up for anything. They thought Hardy was great. They think you're great. But they think Jim Davidson was great as well. I think it goes to the heart of what you were saying earlier about this sense of naughtiness and devilry and childishness. They just don't mind who's taking the piss or out of what, so long as they take it well. Which makes it difficult terrain, I would have thought.

JB: In some ways, yeah. I see the Comedy Store as a certain sort of gig. You don't approach every one in the same way.

SW: Right . . . What sort of adjustments would you make then?

JB: I cut out anything that I thought they wouldn't understand. I'd keep it, very much, to one liners rather than routines.

SW: Wasn't it in the Comedy Store you mentioned Gorbachev and somebody said: 'Who's he?' You're sure it wasn't a terrifically ironic heckle?

JB: I don't think it was. You can normally tell . . . It wasn't at the time when he was like fading out. It wasn't like Who's-he?-We've-forgotten-him-already type of irony. And also I probably cut out anything that was, [contentious]. Like I've got a stand-up section about racism and about Bernard Manning. I probably wouldn't do that.

SW: At the Comedy Store?

JB: Yes. Just to make life simple for myself. I mean on some nights, I might have a touch of PMT and I'll say 'Fuck it, I'll do what I want tonight.' But then you have to be prepared to suffer for that.

SW: So, from what you've just said . . . this sexual voraciousness that is a strong element in your act, your stage persona – the kind of Janis Joplin of stand-up – that's something that in a sense you can rely on. There won't be gigs where that won't go down well.

JB: Yeah, pretty much. That will go down well everywhere.

sw: And with men and women?

jb: I think so, yes . . . I think people laugh in different ways. [There's something] I always used to do at the end of a set when I was in the theatre. If I got called back for an encore I used to say 'Well I hope all the women have enjoyed it tonight.' And I could see all the men sitting out there, with their girlfriends, thinking: 'I brought you out tonight to see Jo Brand as a treat. But I don't want any of this bollocks at home – you asking me to cook and that sort of thing.' And that used to get a big laugh. Because there was . . . an acknowledgement there, on behalf of the men and the women, in their partnerships, that 'Well we've seen her and the men have kinda . . . had the good grace to come and see her but nothing she says is gonna change anything.' Do you know what I mean.

sw: Yes, something that's coming across very strongly is that you do have a strong sense from the people that you meet and the experiences that you have that things haven't changed in the key relationships between men and women very much.

jb: No, I don't think they have.

sw: And that they're not likely to either, maybe. One thing that struck me listening to what you were saying earlier [is that] you create a kind of symbolic world in which the audience, through your routine, can strike back, in a way. Can have good laugh and a cheer and all the rest of it, whatever they do, because tomorrow . . . they are gonna be pretty much as they were. Given that they're also employed by men as well as married to them or going out with them or whatever?

jb: Yeah.

sw: And I guess, with job insecurity, things are going to get worse rather than better. Do you get feedback on that at all? It'd probably be a bit trite to come up and say 'You made me feel different' or whatever.

jb: Yeah, occasionally and I get letters that sort of say this as well.

sw: What sort of letters have you had?

jb: Well, I've had letters from women that, on the whole, have had fairly shitty lives. They've either said it's really nice for half an hour on Friday just to get . . . into that fantasy of fighting back. They've not actually said it in [as many words]. But that's how they come across, and I've also had a couple of times, women say to me that they got harassed by a bloke and they've used one of my put downs on them and that made them feel a lot better. That was lovely.

sw: [referring to another recent article] Who's your heroine?

jb: My heroine? Well I have fair few. Beryl Reid, Rachel Roberts . . . amazing.

sw: Tell me about [them].

JB: Well, Beryl Reid . . . at a time when, there wasn't much evidence of women being funny . . . and although she wasn't a stand-up, she was a character actress . . . she was very funny. Also, I just love that film *The Killing of Sister George*. I just think she did that so well and at a time when it was very controversial for someone of her standing to be in a film about lesbians. So I admire her in the same way that I admire Dawn French. Because I think she's a naturally funny person. If you talk to her you just look at her expressions and she makes you laugh.

[. . .]

sw: Rachel Roberts?

JB: Rachel Roberts. From a lot of points of view, I kind of identify with her. She wasn't very good looking and she . . .

sw: I thought she was, actually.

JB: Well, not in a traditional beauty sense. I personally thought she looked fantastic, as Janis Joplin did as well. People . . . male critics said she was ugly, that she looked like a horse. And she . . . suffered inwardly quite a lot . . . She had a serious alcohol problem. She was very out of control and was very badly behaved at parties.

sw: Under the table with a dog, it says here.

JB: Yes, that's right. Yeah. [Chuckles] That is like a totally outrageous thing for a woman to do . . . and I kind of admire that. I don't admire the fact that she did that to a dog. I admire the fact that she was so badly behaved really. Again, it goes with this thing that women are supposed to be demure.

sw: Yes, but that kind of leads back to the problem which you have and which you acknowledge: that it is a difficult position to maintain and define in a popular culture which is infatuated with bad behaviour of all kinds. Do you know what I mean?

JB: Yes I do. But infatuated with male bad behaviour. It's not infatuated with female bad behaviour . . . I . . . think in any sense at all.

sw: Well, its beginning to be. As we admitted, there is a paradigm for female comedy which is to do with filthiness and rudeness, and appetite of all kinds.

JB: Yeah, that's true. Yes, I suppose so. I don't think infatuated in the same way, though.

[. . .]

sw: [Some] people compete against other people in life. Whether they want to drive faster than them. Or have more money than them. I get the impression that you don't, but . . . do you compare yourself with other comics?

jb: Well, yes, I suppose I do really. I think that I do compete with men, but I don't compete with women.

sw: Why d'you think that is?

jb: Because I had two brothers, whom I competed with throughout my entire childhood, in terms of them constantly saying 'Well, we're boys, so we're better than you'. Not actually saying it outright, but that being the atmosphere. You know – 'We're tougher, we're quicker, we're brighter . . .'

sw: How does that play out now? Are you conscious of competing against male comics?

jb: No, but I do love hearing it when people say things like they don't even see me as a female performer, because I'm . . . as good as any male performer. I mean, that hasn't been said very often, but when you get to that stage where you know that the people who run the Comedy Store are happy for you to go on last on a Friday night late show, you think 'I can take on this audience with the best of the men, so I must have got somewhere'. To me it's not good enough to be a good female performer.

sw: How d'you mean 'take on'?

jb: Well, a Friday night late show at the Comedy Store is actually a battle. It's not really a performance.

sw: Battle of?

jb: It's a battle of wits. It's a battle of your power to control them over their wish to see you slaughtered [laughs]. I know it sounds awful, but it is like that.

sw: Why's it sound awful, because there's different ways it could sound awful?

jb: It sounds awful because a lot of people think it shouldn't be like that. Comedy should be a positive experience, where you go and you laugh because the comic's very clever and you go home, think 'What a lovely time I've had'.

sw: Who are those people . . . who would argue that?

jb: I think probably fairly middle class, educated people that don't go mad and get pissed too often.

sw: 'Grown-ups'?

jb: 'Grown-ups', yes.

sw: Some people would argue that's a man's view of the comedy business.

I recently read William Cook's book [Cook, 1994] and he quoted Addison Cresswell [a leading comedy entrepreneur] sounding like a character out of *Minder* – you know, south London wheeler-dealer – saying this was what comedy was all about: 'Getting up there and doin' the fucking business'. Some might say that's a bit masculine, even a bit New Right.

JB: Well, I think, to a certain extent, he's right, for a lot of stuff that you do. Because, apart from the clubs where audiences are polite and receptive and they listen to you, on a lot of occasions – not so much for me now – you are put in situations where you are at a big disadvantage when you start and it's a question of winning them over. Rather than starting from a positive standpoint where they have respect for you and they're prepared to listen and laugh at everything and be polite.

SW: I guess the subtext to this is some strands of feminism as I might perceive them. There must be women who say female comics shouldn't bother with all that beery, aggressive stuff, because it's basically male.

JB: Well, I think that's all well and good if your audiences are almost exclusively female, but they're not. Especially with venues like the Comedy Store, which is a very laddish environment, really. I mean there are male comics who refuse to perform there, and lots of women as well. But to me it was a bit of a challenge . . . to be able to do it. I had some challenges in my head and one of them was to do the Store. Or to do the Tunnel and get away with it.
[The Tunnel Club, situated near the southern end of the Blackwall Tunnel in London, is widely acknowledged to be the most difficult venue on the circuit – the 'Glasgow Empire' of alternative comedy.]

SW: What happened to you at the Tunnel?

JB: Well, I've done it five times. It was always a battle, but it always came down on my side in the end.

SW: How? What sort of problems did you face down there?

JB: One problem is that the audience tend to make a totally arbitrary decision, as one, whether they're going to support you or destroy you. So they've almost made up their minds before you come on whether you're going to be a sacrificial lamb or not.

SW: How does that manifest itself?

JB: . . . maybe 10 to 20 members of the audience will start up some kind of heckling. Or someone will start bah-ing noises, like a sheep, and everyone will join in . . . or they'll throw things. They'll decide: 'We're in charge here. You do what we say'.

SW: Sounds like they were mostly male.

JB: Yes. It had an atmosphere that was kind of dangerous and the audience

were almost as well versed in how to conduct it as the comics were in how to combat it. . . .

sw: The way you've described it, it sounds like an almost intractable situation. If they've decided in advance whether or not they're going to like you, how do you deal with that?

JB: It's kind of a competition . . . well, I did it once, when I'd just appeared on Friday Night Live. And I didn't have much material, so I had to use some of the stuff I'd done on Friday Night Live at the Tunnel. And the first line that I came out with, someone shouted out: 'Heard that on the telly' . . . so, out of pure luck, and I don't know why I did it, I kept repeating that line. I did it about twelve to twenty times. Just to wind them up a bit. It could have gone one way or the other. In fact, they really liked that I did it.

sw: What would you say your relationship was to other female comics?

JB: How d'you mean?

sw: What do they think of what you do? What do you think of what they do? Because you implied that it was less problematic, that you were more competitive with male comics. Albeit male comics in the abstract.

JB: Yeah.

sw: You're not competitive with specific male comics, but you're competitive with the idea of a male comic.

JB: Yeah. I'm competitive with the idea of a male, to be honest, comic or not. With women, no. I feel like I've always got on pretty well with the women on the circuit . . . people like Donna McPhail and Hatty Hayridge I see quite a lot. We phone each other fairly regularly. In the old days, when we all started off, because we were a fairly rare commodity we very rarely got to work together. You never saw a lot of female comics when you were working. There was one female comic who I had problems with . . . who I felt resented me a lot and therefore started saying horrible things about me to everyone.

sw: And the horrible things were, in effect, that you were no good?

JB: That I was crap, yeah. That I was boring.

sw: Boring in what way?

JB: Boring in the sense that I only talked about being fat and eating cakes.

sw: What d'you make of that. I ask because it seems to be a very widespread criticism – in fact, it seems to be the criticism of you . . .

JB: What I make of it is they probably haven't seen me . . . or, if they have seen me, they probably only picked up key words in, like, an hour long set. You're in danger: if you mention cakes twice, that can translate as 'Talked about cakes for an hour'.

SW: Yes, but it does raise the interesting question of why they're blocking off 99.7 per cent of the act.

JB: I think because they have their own agenda. That's what they want to think, so they will fit what I do into it.

SW: What is that agenda, d'you think?

JB: They don't like what I represent.

SW: Which is?

JB: Various things. One is an unattractive woman being allowed on the telly at all. [Another is . . .] that I'm a lesbian.

SW: Where do they get an idea like that when your material is so aggressively heterosexual?

JB: Because they haven't seen me. [Recounts a meeting with an actress, who told her: 'I really like what you do'. Brand had reciprocated and cited a particular film. The actress had replied that she'd have thought a TV series, in which she'd played a gay character, 'would have been more up your street'.]

SW: What about other objections to what you do?

JB: Grown-up objections to swearing and being a bit of a slob. Quaint old-fashioned ideas about how women should behave.

SW: How about closer to home, politically? Are you aware of questions raised by what you do by people closer to you politically – feminists or on the left . . . any problems there?

JB: Yeah. Several. One is I think quite a lot of feminists object to what I do because they don't think that women should put themselves down . . . and then there's the other idea that you don't go and be aggressive, like men are . . .

SW: How d'you respond to the first one?

JB: By saying, yes, in an ideal world they shouldn't. But it's not an ideal world, and pretending that it is to make it so, to me, will never work. And also that's just the kind of person that I am. That's my personality and I can't really avoid that. I understand what they're saying, and in a way I accept it, but . . .

SW: As someone who's seen you a number of times, it seems to be quite plain anyway that your stage personality is quite carefully . . . weighted, in the sense that you are self-deprecating, and also very powerful, by turns . . .

JB: Well, I've always felt that the putting-yourself-down stuff did give you a bit of a ticket to go on and lay into someone else. Also, it gets it out of the way. Because, as a woman, you know when you come on stage the first thing you're judged on is your appearance.

SW: Yes, as John Berger says in *Ways of Seeing*, men act and women

appear . . . I had an interesting conversation with some friends, mother and daughter. They like you in a qualified way. You make them uncomfortable some times. They say: 'She's always going on about her size and her weight' and I say 'Well, she is as she is. She wants to acknowledge that'. And one of them says: 'Well I can see how she is . . . I can see she's not Pamela Anderson'. They were clearly uncomfortable, and it seemed to me that maybe a lot of women feel undermined, in an ironic sort of way. One way and another they do take care of their appearance. They watch their weight and they have a certain way of going on, and your act, effectively, says: 'To hell with all that.' Have you ever had that sort of reaction?

JB: Yeah. Only from thin women.

SW: What do you say to it?

JB: I say: 'Come back and say that to me when you're fat'. Because there are varying degrees of how important one's appearance is to . . . women. To some women, it's everything. And I think that's tragic. I mean, I had a friend when I was in my twenties, who was absolutely gorgeous looking. She was stunning. And, when I met her, she's just getting towards 40, and she was getting a few crow's feet and a bit wrinkly. And her life was falling apart because of it. And I think that's absolutely tragic, because, when you're forty, you've got a good 30 years ahead of you . . .

SW: I notice you operate with a conventional notion of what's stunning and what's gorgeous. Or do you?

JB: Well, not necessarily. No, . . . I think that some people are gorgeous that other people think are absolutely horrible.

SW: But, when you were thinking of her?

JB: When I was thinking of her, conventionally yes, she was. And to me she looked lovely because she looked like a Greek statue, which everyone conventionally accepts as a model of beauty.

SW: Sure, but . . . you liked her as a person, as well . . . Because it seems to me that another judgement on women is that people run personality and looks together. They're often [assumed to be] the same thing. [Pause] Do you have any view on why women are fat? Have you read into it, for example?

JB: I've read bits and bobs. I've read *Fat is a Feminist Issue* . . .

SW: The central argument in that book, if I understand it . . . is that fatness in women is a kind of rebellion . . . What do you think?

JB: I think there's something in that argument, to be honest. The other argument is that it's protection, against the danger of being attractive

to men. But, then again, . . . I don't think it's the whole story. I think there are other aspects to it.

sw: Like what?

jb: Like you just like eating a lot and you don't like exercising . . .

sw: But very few people, if they were female, would eat and avoid exercise unaware of the consequences . . .

jb: No, that's true . . . well, there is this other thing as well, that dieting makes you fat . . .

sw: From very slender knowledge – [drawn] mainly from being the father of a female – [a girl's] sense of the importance of [her] own appearance sets in very early. I noticed . . . that boys, being conventionally uptight, would thump each other [when they fell out]. Whereas the girls would tell each other that they were ugly.

jb: Yeah . . . I think teenage girls have no idea how they look.

sw: This was when they were six or seven.

jb: Maybe it starts younger now. But I know when I was a teenager, I thought I was fat then. When, in fact, I wasn't at all. When I look at photos of myself, I think: 'God, I look fantastic there.' But I remember what I thought at the time about how I looked and it tended to be based on minimal evidence – maybe one or two people who made a comment at you in the street.

sw: It's more likely to be significant people, isn't it?

jb: Not necessarily, no.

NOTE

Many thanks to Cassie Wagg and Valletta Bayley who, between them, transcribed much of these taped conversations.

The quotation from the Duchess of Windsor, which appears at the beginning of this chapter, is taken from Margaret Greaves' book *Big and Beautiful* (London, Grafton Books 1990). Georgia Campbell's remark, which follows it, appeared in the *Guardian* on 23 August 1990.

BIBLIOGRAPHY

Brand, Jo (1995) *A Load of Old Balls: Men in History*, London: Pocket Books.

Cook, William (1994) *Ha, Bloody Ha*, London: Fourth Estate.

Wagg, Stephen (1996) 'Everything else is propaganda: the politics of alternative comedy' in George C. Paton, Chris Powell and Stephen Wagg (eds) *The Social Faces of Humour*, Aldershot: Arena Press.

THE STRAIGHT MEN OF COMEDY

Mark Simpson

In 1994 some US fundamentalist ministers decided to 'out' two much-loved characters from the PBS children's TV show *Sesame St.* 'Bert and Ernie are quite obviously gay lovers,' they declared. 'They cook and tend plants together and even share a bedroom.' By way of clinching the argument they added, 'Sometimes they even do a bit of sewing.'[1]

It must have come as something of a surprise to the millions of parents who consider *Sesame St.* an entertaining and innocent form of education for their kids, to discover that it had been promoting homosexuality all along. Needless to say, Children's Television Workshop, the makers of *Sesame St.*, were unhappy with this interpretation of the private life of two of their most popular stars and refuted the charge as 'ridiculous'. Later they issued a terse statement which stated simply: 'Bert and Ernie do not portray a gay couple and there are no plans for them to do so in the future.'

Of course, things are no longer that simple. In this media-literate age almost everyone prides themselves on their ability to 'read' 'texts' and uncover the 'real' meaning they contain. As evidence of this, even square old Bible-bashers are having a go – and poor *Sesame St.* is feeling the effects of their 'reading'. Now that the allegations about the 'true' nature of Bert and Ernie's relationship have been aired, who can watch Bert and Ernie curling up in their matching twin beds beneath a portrait photo of them arm in arm in quite the same way?

Actually this contretemps over the sleeping habits of male comedy duos is nothing new. There have been outings/readings before – from the other side of the political fence. The gay film critic Vito Russo, in his book *The Celluloid Closet*, claimed that the classic male comedy duo Laurel and Hardy were gay, pointing out that in films such as *Their First Mistake*, in which Ollie's wife sues him for divorce, naming Stan as 'the other woman', they exemplified the 'perfect sissy-buddy relationship, which had a sweet and very real loving dimension'.[2] He cites the French critic Andre S. Labarthe's observation that the classic silent short *Liberty* – in which the

fat man and the thin man escape from prison only to hurriedly pull on each other's pants by mistake and spend the rest of the film trying to swap trousers in alleyways, the back of taxis and even on a building site, but are always interrupted by shocked passers-by – offers 'to anyone who can *read* the unequivocal sign of unnatural love' (my italics).

Then, like now, many reacted indignantly to the suggestion that there could be anything 'filthy' or 'unnatural' in the relationship of two men who were taken to be the epitome of purity. 'There is something rather absurd about discussing this seriously at all', harrumphed the critic Charles Barr in his book *Laurel and Hardy*, insisting that because the pair had 'the minds of nursery children' it was only 'natural' that they should 'share a bed like nursery children'.[3] In other words, the fact that our heroes shared a bed was taken as the very sign of innocence itself.

Actually, as this piece of circuitous reasoning shows, the shared bed, *de rigueur* for Laurel and Hardy and many of the male comedy duos that followed them, from Jerry Lewis and Dean Martin to Morecambe and Wise, was the contradiction at the heart of the genre, managing somehow to accommodate the audience's curious ambivalence towards non-heterosexuality – both fascinated by it and loathing it. The shared bed signified both the innocence of the relationship – oh look, they sleep together, how sweet! just like brothers! – but also and at the same time (albeit held under the 'innocence' idea) its *queerness*. If this wasn't the case, if, as Barr *et al.* argue, their intimacy was only 'innocence', where would the gags come from? After all, we laugh at what we fear. (It is also worth remembering that Stan and Ollie both had screen wives, a fact which contradicts their 'innocence' and also further characterises their relationship as an irresponsible, possibly pathological rejection of heterosexuality, one that would most likely have been diagnosed by an orthodox psychoanalyst of that era as a perverse 'regression' or 'fixation'.)

Even in Laurel and Hardy's day (1920s to the early 1940s) the audience knew very well what two men in a bed could signify. And this is precisely why the shared bed was so popular, because through comedy, the audience could enjoy in a 'carnivalesque' fashion 'queer pleasures' – that is to say, the possibility of an Eros that was not ordered around reproduction and heterosexuality – applauding (while at the same time as deriding) a touching relationship between two men that would otherwise be branded unhealthy and unsavoury. In the 1940s and 1950s, Jerry Lewis's and Dean Martin's relationship had all the hallmarks of institutional homosexuality, with Jerry as the defenceless, immature ever-so-slightly effeminate young 'punk' seeking the 'protection' of his older, wiser, bigger roommate Dean (this in a post-war era when a large section of American

viewers must have been familiar with military service and its 'situational' homosexuality). In the 1960s, those British suburban family favourites Morecambe and Wise exhibited more signifiers of homosexuality than a Soho queer pub. In addition to sharing the same bed they were cardigan-wearing bachelors with a passion for Shirley Bassey and musicals, who lived in a spotless interior-decorated home, without even a housekeeper or maid to save their masculine reputation; Ernie was a vain wig-wearing playwright; Eric was obsessed with Ern's 'big fat hairy legs'; and one of their most loved sketches has them in dressing gowns making breakfast together.

Of course, the official point of these connotations is not to affirm or proclaim homosexuality but to raise the spectre of it so that it can be dismissed. Morecambe and Wise were not 'gay', but they weren't conventionally 'straight' either. The 'ticklishness' and the discomfort these images of queerness produce is always released (and denied) in laughter: How *absurd* it all is, thank god, the audience says aloud by laughing, and how absurd of me to think that there was anything funny *peculiar* about this, it says to itself, wiping the tears from its eyes.

However, now that homosexuality is so much more visible, and thus much more in the front rather than the back of people's minds, this disavowal is no longer sufficient (although, like all disavowals, it was never complete anyway). As David Ashby, the Conservative MP who shared a bed on a holiday with his rugby pal, discovered when he was 'outed' by the *Sunday Times* newspaper and his neglected wife, 'doubling up' with another man can no longer be presented as the sign of innocence itself – it only connotes queerness; that is to say, it *denotes* it. This is partly why it is no longer gay critics who 'out' comedy couples – but rather fundamentalist ministers who once upon a time would have been goggle-eyed at the notion that Jerry might be rubbing more than Dean's back at the end of the day or that Stan might suck more than his thumb in bed. Bert and Ernie don't even share the same bed, just the same bedroom. But such is the paranoia of an age when heterosexuality is much less hegemonic than it used to be, that the fact that two male puppets live together is taken by some as an irrefutable sign of deviance.

The flip side of the visibility of homosexuality is that relations between men are now so suspect, so scrutinised, so policed that the instant men betray any intimacy or 'unmanliness' they run the risk of being labelled gay and Other. In the past, when married life and the responsibilities which went with it was a fact that everyone submitted to, this was not so necessary – intimacy between men could, and did, frequently develop an erotic intensity which was hidden from the world and from each other by

the acceptability of homosocial attachments: it remained unnamed. Nowadays, when marital obligations are increasingly optional and 'alternative' sexual identities increasingly possible, this strategy is no longer so viable.

This is perhaps why contemporary heirs to Laurel and Hardy, such as Rik Mayall and Adrian Edmonson in *Bottom*, may live together and clearly be all that each other has in the world and fail to show any real interest in women beyond impressing one another, but are nevertheless sentenced by modern sensitivities to sleep in separate rooms.[4] Nor are they allowed any of the tender moments that Ollie and Stan enjoyed in between the nose-twisting and the foot-stamping; instead the spiteful spats are cranked up to full-blown sado-masochistic rituals; their violence is emphasised far more than their 'love'. This may, however, be as much a comment on disillusionment and a general decline in sentimentality as on the state of male-male relations. But for all this, Rik and Adrian do remain together and their tainted, twisted love survives in an equally tainted, twisted world.

Others are allowed shared bedrooms, but only if they make a 'knowing' display for the audience, which signals 'I know you know I know what this means'; 'irony' replaces 'innocence' and there is no longer any subtext – everything is 'read' for you in a deliberately vulgar fashion. This is exemplified in *Terry and Julian* (Channel Four, 1992), in which one very straight and one very gay man are made to share a single-bedroomed flat. The very first episode featured a gag based on the (mistaken) idea that Julian was masturbating under the covers while Terry looked on aghast: the fear of explicit homosexuality in particular, and perverse sexuality in general, raising its ugly head in male–male relationships appears to have been realised.

Terry and Julian also illustrates the strange contradiction of modern attitudes towards queerness, that while homosexuality has become more difficult to disavow as it has become more public, it has also become less scary – and therefore less funny. Hence *excess* is required from Julian Clary, forcing him to 'camp it up' with *single* entendres about warm hands on his entrance, to the point where he threatens to vanish in a puff of pink, fragranced, ironic smoke.

Previous comics whose homosexuality was signalled as part of the act, such as Larry Grayson and John Inman, were examples of the homosexual in an era – the post-gay liberation 1970s – when homosexuality was becoming more visible and more spoken about, but still something indecent when considered as a concept. Hence Grayson and Inman never declared their homosexuality, but merely alluded to it (their respective

catchphrases were, for Grayson 'My friend Everhard', and, for Inman, 'I'm free!'). This careful observance of connotation (also employed by earlier performers including Kenneth Williams and Frankie Howerd) and avoidance of denotation was naughty enough to make people laugh but didn't name the naughtiness, allowing the audience to disavow the idea that their star might actually relish performing the genital acts his demeanour signified. Julian Clary, as an 'out' gay comic in a much less sexually repressed era, spells out his deviance in neon lights and presents the audience with a kind of caricature of their idea of 'The Homosexual', allowing the (Channel Four) audience to laugh at themselves laughing at him.[5]

Beavis and Butthead also exhibits a knowing, playful irony (though not the characters *themselves*), this time the joke is at the expense of a whole *genus* of American males, represented by two teenage MTV addicted mid-western metal-heads who share a sofa instead of a bed (although they use it as one) and who are forever trying to assert their heterosexuality by miming sexual excitement whenever 'babes' appear and expressing contempt for 'wusses'; but so hysterically that it is always self-defeating. They are obvious virgins (as far as the female sex is concerned, although there is a faint suspicion that they may have indulged in 'circle-jerks' and 'willy-measuring' in the past) and even when they try to assert their heterosexuality vicariously when watching pop videos they frequently mistake male performers for female ones, and vice versa. Their favourite topic of conversation is butts – each other's, about which they are, *naturellement*, inordinately sensitive. Like the characters in *Bottom* (also, as the name proclaims, obsessed with the masculine *derrière*) they are spectacularly cruel to one another and forever talking about 'chicks'; but in fact have only each other. (The only other party we ever see generate a truly loving response from them is a heavily muscled young sadist who locks them in his boot and drives over rough ground: when they are let out of the boot, bruised and battered, red swooning hearts circle their heads.) While the profile of this group of American teen males is scathingly accurate, their 'homosexuality', like that of Rik and Adrian, is part of their humiliation and punishment for being so inept at being men, a kind of homosexuality by default, which contrasts with the usual male comedy duo scenario in which homosexuality is suggested as a kind of fond (if impossible) aspiration.

Knowing irony mixed with surrealism, however, makes it possible to stick closer to the original queer romance formula. Reeves and Mortimer have had a 'shared bed moment' on one of their Xmas TV shows. The shared bed had nearly visible quote marks around it and was explicitly 'knowing' in both its references (to Morecambe and Wise) and its possible

interpretation (as denoting homosexuality). Nevertheless what is most interesting about Reeves and Mortimer is the way that their act is based upon what is essentially a long-standing love affair between them, which is, beneath the noisy brashness and banter, quite clearly of the tender variety which has all but disappeared. They interact with one another with a casual intensity that is quite remarkable, and in a way that is perfectly harmonious, even, and perhaps especially, when they argue. In fact, hosting such quiz shows as *Shooting Stars* and appearing on chat shows together, they have become (along with Skinner and Baddiel of *Fantasy Football League* and the singers Robson and Jerome) an institution of (non-sexual) same-sex coupledom and represent the possibility of enduring partnerships at a time when such relationships are probably particularly difficult for many men to achieve.

And, like some of the great comedy homo romances, theirs is also a rather wistfully infantile affair, with their boy-boy love-fest conducted in an imaginary world with an imaginary language which excludes everyone else; but part of their appeal is based on the fact that everyone wants to join them in that snug little world. Of course, without the wacky surrealism, their relationship might take on a more definite, *sexual* meaning – which would render them Other. Just as important an alibi is the reassuring laddishness, nicely reinforced by authentic North-East accents. (The fact that Skinner and Baddiel – who apparently live together in real life – are brought together by their love of football, i.e. manly things rather than *men* as such, also legitimises their affair; the same goes for Robson and Jerome brought together in the TV drama *Soldier, Soldier* by the army.)[6]

Those sea-front perennials Cannon and Ball are also able to get away with presenting a boyish tenderness, largely because they are playing to an audience that is both working class and elderly: homosexuality is something that afflicts other classes, and other generations. In one of their most-requested 'serious' routines, Cannon serenades Ball with 'You are the wind beneath my wings'; Ball falls asleep and Cannon carries him off stage 'to bed'. The audience adore this because it allows them to enjoy the spectacle of two men behaving towards one another in the very way that homophobia forbids, or at least makes highly problematic for all men in the real world – i.e. loving – while at the same time conventionally repudiating the *wrong kind* of manly love. Hence Cannon and Ball reinforce the distinction between their 'pure' and 'innocent' masculine love and the travesty of it contained in homosexuality, with frequent jokes about 'poofs' and that dreary, meticulously bad impersonation of effeminacy which is designed both to ridicule homosexuals and point up how unable a real man is to perform 'poofiness', even when he tries.

But by far the greatest, most dangerous, most *passionate* queer comedy lovers ever to hit the screen are Ren and Stimpy, whose love-affair apparently breaks all the rules. Not only do they share a bed but they regularly demonstrate their intense affection for each other: Stimpy regularly showers Ren with sloppy, big-lipped kisses, and in the very first episode Ren pines for an absent Stimpy, weeping inconsolably and making a fetish out of his fur balls. That Ren is a Chihuahua and Stimpy is a cat should defuse the threat somewhat, but in director John Kricfalusi's hands this almost becomes itself something perverse. Their cartoon antics are even 'zanier' than Reeves and Mortimer but again this hardly comes across as a strategy to make them safe for the consumption of children (the target audience) but rather something that makes them even more disturbing – as one particularly fabulous episode, 'Nurse Stimpy', a kind of no-holds barred s/m 'Doctors and nurses', demonstrates all too well.

The queerness of the relationship between the floppy (but controlling) 'bottom' Stimpy and ruthless (but inept) 'top' Ren is simultaneously so explicit and so innocent that it is as breathtaking as it is endearing. In their regular bedtime ritual the back-flap on Stimpy's pyjamas pops open as he climbs into bed, prompting him to proffer his rear end and ask sheepishly, finger in mouth, 'Oh Re-en, could you button me, please?'

With its flagrant anality (Stimpy's 'first material possession' is his cat litter), our cartoon lovers, like all the best queer comedy romances, tap into the nostalgia and sense of loss adults and children feel for the anarchic unstructured infantile attachments and pleasures which they are required to abandon in order to grow up and take on responsibility (and identity). At times, *The Ren and Stimpy Show* seems to go further than this and become a glorious insane revenge on adult society; as in 'The Big Baby Scam', in which Kricfalusi's heroes, down on their luck, substitute themselves for a couple of babies so that they'll be pampered: 'I tell you man', says Ren, 'Babies have got it *made!*' (naturally the adults don't notice their children have been replaced by a cat and a Chihuahua).

How did Kricfalusi get away with it? How could chaste, respectable Bert and Ernie be fingered by fundamentalists when mad, bad and totally pervy American TV cartoon characters Ren and Stimpy escaped without censure? The sad fact is that in the end Kricfalusi *didn't* get away with it. After only two seasons, and despite enormous success, the US children's cable TV company Nickleodeon reportedly fired Kricfalusi because he refused to 'tone down' the content of his cartoons.

Ultimately, what makes the queer romance of comedy duos so appealing is precisely that it is so unconventional and that the lovers themselves are so thrillingly *unmanly*; after all, what could be more conventional than

being a man? In the end both the fundamentalists and the gay critics can claim that Bert and Ernie, Laurel and Hardy or any of the other male comedy duos are 'gay', but this 'reading' is almost to miss the point – which is that they are not straight (although, I suspect that neither fundamentalist ministers nor Vito Russo miss the point: both, for their own reasons, would like to pretend that what isn't one thing must be the other). As Charles Barr argued, these male-male romances are indeed 'innocent' and 'childish' – but only in the sense that they key into the audience's nostalgia for the easy and less repressed pleasures of infantile sexuality, which are innocent only of Oedipus and sexual differentiation, not of sexuality itself. Male comedy duos can play with queerness because they exist in a space which pretends not to know what 'homosexuality' is, or at least where this diagnosis doesn't apply since 'heterosexuality' doesn't really exist here either. Heterosexuality, American critic Judith Butler has written, is a comedy whose norms even heterosexuals find impossible to embody.[7]

The final punchline in this story of comic romance could be that male comedy duos are so funny and so popular because heterosexuality and homosexuality are the biggest jokes of all, ones, moreover, that we have to live with all our adult lives. Male comedy duos fascinate us because they both embody these 'jokes' and transcend them.

NOTES

(This chapter is adapted from one which appears in Mark Simpson's It's A Queer World (Vintage)).

1 Time Out, 'Sidelines'. 1994
2 Vito Russo, The Celluloid Closet (New York: Harper and Row, 1987), p. 73.
3 Charles Barr, Laurel and Hardy (Berkeley: University of California Press, 1968), p. 57.
4 It may be argued that in the past, especially around the time of Laurel and Hardy's films, i.e. just after the 1929 Wall Street Crash, shared beds may have been more common as an economic necessity (and Stan and Ollie did often portray homeless men looking for work). It has also been observed that the Great Depression of the 1930s, by making many men too poor to support families and forcing them to roam around the country looking for work, allowed some men to develop relationships as close and as loving as Stan and Ollie's (shades of the cowboy/Western fantasy). Interestingly, Morecambe and Wise apparently lived in the epitome of 1960s luxury – an era when the British working classes were being 'rehoused' from cramped 'slum' accommodation – but chose to sleep in the same bed. Their success and wealth allowed their characters to reject heterosexuality as it had to be lived by their audience.
5 Although there are limits to this explicitness, especially in the dicey business of crossing over into the mainstream, tabloid market, which Clary had begun to do. Hence his public shaming in the Sun et al. over the 'Sorry I'm late, I've just been backstage fistfucking Norman Lamont' gag. As any comic knows, it is difficult but crucial to be able to find the borderline of your audience's taste (i.e. what is acceptable) and tease it a little – rather than go crashing through it.

6 All these couples are, of course, jokers. The role of banter in male intimacy and friendship is extremely important; it provides both a competitive, i.e. masculine edge to the relationship as well as a useful way of making expressions of affection more oblique and less embarrassing (you demonstrate the closeness of your bond by 'taking the piss' out of one another).

7 Judith Butler, *Gender Trouble: Feminism and the Subversion of Identity* (London: Routledge and Kegan Paul, 1990), p. 122.

8

SUITS AND SEQUINS

Lesbian comedians in Britain and the US in the 1990s

Frances Williams

My mother made me a lesbian.
If I give her the wool, will she knit me one too?

A lesbian joke is no laughing matter. Or so urban myth would have it.
Public folklore promoted by the tabloid press decrees that lesbians, like
feminists, are people that the great British public are supposed to laugh *at*
and certainly not to laugh *with*. But today, this reactionary line is faltering
somewhat in the face of a new social reality. 'Alternative' comedy has
moved to take up a central space in British cultural life. Many of the
groups in society once considered marginal and politically threatening to
the status quo, have blossomed to provide some of the richest sites of
comedy. Women now constitute the expanding establishment in popular
comedy, with the likes of French and Saunders becoming increasingly
influential, while gay male comics have also crossed into a wider public
realm: Julian Clary tells provocative anal jokes on prime time TV while the
drag queen Lily Savage welcomes viewers to breakfast TV with discon-
certing aplomb.

Like Indians surrounding a corral of covered wagons, the politically dis-
possessed 'outsiders' are claiming their own comic territory at a pace,
shooting gags like well-aimed arrows. The cowboy with the punctured
stetson in this story is that most beleaguered contemporary figure, the
heterosexual male. His comedy has been forced to assume a shoulder-
shrugging tone of self-depreciation or else to retreat into aggressive
laddishness. It's either the self-conscious political-correctness of Ben Elton,
the crass 'men should know better' comedy of David Baddiel or the bald
misogyny of the old school stand-ups such as Jim Davidson or Bernard
Manning: the good, the bad and the ugly.

Straight men's comedy is defined by what it is not: it is certainly not

girlish, nor gay, and so holds itself apart, the pivot point against which everyone else is forced to take on the mantle of 'other'. 'Being white, male and middle-class is useless if you're a comedian', Eddie Izzard says sagely. 'Thank God I'm a transvestite.'[1] And as the more dead-pan Bea Campbell has pointed out, 'Women's comedy and lesbian comedy share the same niche: both start from a critique of straight men and what they have done to women.' 'Sex, love and passion', she asserts 'is their argument with society, with men, and it is their challenge, it is their identity.'[2] The 1990s have been called the 'decade of the queer comedian' and lesbian comedians are using both feminist and gay traditions to assert their own agendas more visibly and more confidently. In common with the two constituencies of gay men and strident straight women, lesbians share a sense of sexual taboo, often using obscenity and vulgarity in their work to draw attention to and undermine the assumptions of the classic straight male 'blue joke'. Sex and sexuality are the crux of their difference and the source of both shame and anger, affirmation and pleasure.

As the social and cultural visibility of lesbianism has increased dramatically in recent years, the lesbian comedy scene has likewise blossomed. This fact is reflected not only in the presence of a few pioneering lesbian comics in the mainstream but also in the emergence of a burgeoning cabaret scene in the lesbian community itself. American dyke comedians like Kate Clinton, Susan Westenhoefer and Lea DeLaria, and 'out' comics in the UK, Rhona Cameron and Donna McPhail, were playing to marginal audiences until relatively recently. Now they appear, in various roles, on prime time TV.

Some comedians have chosen to declare themselves lesbian while others have gone out of their way to disavow the tag, and there's been an interesting cross-fertilising of comic genres. The British actress and comedian, Sandi Toksvig, came out as a lesbian publicly in 1994 and began to play to lesbian audiences for the first time in her life after a long and successful career in the mainstream. She described her stand-up routine at Stonewall's 1995 Equality Show, which she wrote especially for the occasion, as 'a sort of gift to the community'. She approached the sauciness of her gay material with a self-deprecating irony: 'In Guildford, we don't even call our cats pussy.'

At the other end of the spectrum, the US actress and comedian (and pussy-galore *Playboy* model), Sandra Bernhard, attempts to elude any static sexual identity. Refusing to toe the gay establishment 'party line', she fiercely shuns the 'lesbian' label, insisting that she doesn't want to 'ghettoise' herself. Her performances elude easy categorisation and she tests, not always successfully, the expectations of her varied audiences. (She is said

to have once 'tenaciously endured the jeers of a Comedy Store audience'.)[3] Her reluctance to pin her own colours to any mast has led some to accuse her of being something of an empress without clothes . . . but no doubt Bernhard herself would insist that this would be to miss the point of her act. Whereas Toksvig's relationship to her gay audience was one of self-revelation, Bernhard has made a career out of artful obfuscation. Certainly, women who you could loosely call 'lesbian comedians' operate within conflicting social realities and contexts.

Alongside such developments in the mainstream, there has been a groundswell in grassroots comedy. Women such as Amy Lamé, Twinkle and Helena Goldwater are part of a new generation of performers who play cabaret venues on the lesbian scene in London and Manchester. Acts such as Sandra Bernhard's have heralded a whole new way of women performing gay male drag, influencing a younger generation of lesbian comic performers. They play with genre itself, rejecting traditional stand-up and one-liners in favour of the adoption of surreal characterisation and more fluid personae. As Julia Brosnan has pointed out, 'In the past, women often had to squeeze what they wanted to express into the very conventional straitjacket of stand-up cabaret, largely made up of gags, punchlines and spangly waistcoats. It's a very blokish genre.' Whereas now, lesbian performers 'have more freedom to create new forms out of personal experience'.[4]

In common with Bernhard, these younger performers also risk playing to mixed audiences, performing to art-house, clubbing and cabaret crowds. Amy Lamé, who describes herself as 'a gay man trapped inside a lesbian body', performed her first stand-up routine at the exceedingly serious Institute of Contemporary Arts, where, she said, you would normally expect to see someone 'eat a long strip of bacon and then kneel while screaming to a bare lightbulb'. Amy went on to conquer less self-consciously knowing venues, establishing the successful cabaret club night Duckie at the Vauxhall Tavern, the home of Lily Savage, and a place more used to gay male drag. It has now had to make room for the seemingly impossible: a new breed of women female impersonators.

All these recent developments are a reflection of the fact that in the 1990s, the political aspirations of lesbians and gay men have shifted their focus away from a leftist agenda and party politics towards something that's been described as 'cultural intervention' and subversion. 'Queer politics' opened up the way for some lesbian artists to explore their sexuality in less overtly didactic ways.

During the Thatcherite 1980s, lesbian comedians were to be found playing benefit gigs for campaigns against Clause 28[5] or 'women-only'

benefits. Working-class lesbian stand-up comedians, such as Julie Namara, acted as reassuring balm against the cold winds of social change, buttressing local community values. The Newcastle-based Hufty, whose humour ran along the fault line of class as much as of sexuality and gender, was proud to eat fish'n'chips in the face of Yuppie sushi. Her look was as blunt as her Tyneside vernacular: dressed in an overlarge man's suit, topped off by a shaved bald head, Hufty's gags were formulated in 'us' and 'them' terms and the relationship between this breed of dyke comic and her lesbian audience was one of assumed soldarity. (It's a sad reflection of the times perhaps that Hufty ended up in the early 1990s as the derided mascot of brutalist butch dykedom on the dire late-night TV youth show, The Word.)

During the mid-1980s, lesbian and gay politics changed dramatically. A new breed of lesbian and gay activists shifted the emphasis from municipal marches and rallies to the more idiosyncratic and confrontational tactics of direct action. In response to the Aids crisis and attacks on their political freedoms, gay and lesbian groups such as Act-Up and OutRage! brought a new theatricality and individualism to public expressions of anger and protest. As a result, the gay community itself began to fracture along 'conservative' and 'radical' lines. Decidedly 'in yer face', OutRage stunts were simultaneously aggressive and, to use the street vernacular of drag queens, 'FABULOUS!' Wit was employed as the deadliest weapon in their campaigns. Lesbian comedy began to reflect this new Zeitgeist, employing the fashionable sensibility of 'post-modern irony'.

For the purposes of this chapter. I've divided lesbian comedians into two schools of humour: those who take up the reins of the traditional 'stand-up' genre, previously the exclusive preserve of straight men, and those who take on a 'queer' positioning, often aping a gay male genre of parody, employing altogether a more camp sensibility and a looser style of comic performance. The former can be broadly characterised as the products of a strongly feminist background. The latter are more likely to describe themselves as 'queer' and align themselves politically with gay men and gay men's tradition of performance. As Bea Campbell points out, generational difference is important:

> the trail-blazing contemporary lesbian comics are the generation of thirtysomethings and twentysomethings who have inhabited a world already changed by the modern gay movement . . . their generation has come to confidence in a period of rapid depoliticisation, when politics as something beyond parliament has become, it seems to many young people, a thing of the past, but when being gay is a possibility and certainty for the future.[6]

All the lesbian comedians covered in this chapter tread these difficult paths between the agendas of both feminist and queer politics and notions of what constitutes the mainstream and the marginal: their comedy acts as the conduit of both subcultural resistance and participatory inclusiveness.

LESBIAN BLOKES IN SHINY SUITS

No lesbian comic encapsulates better the combination of these strands than Lea DeLaria. She has succeeded to an extent in 'crossing-over' into the mainstream while simultaneously declaring herself to be unrepentantly 'other'. She was the first 'out' comic to appear on the prime time TV programme in the US, the Arsenio Hall Show, and is currently making her way in Hollywood. 'I want them to respect me for who I am', she asserts. 'Fuck their acceptance. I don't need that to survive. We are not normal like everyone else. Otherwise they wouldn't be oppressing us.'[7] When she visited Britain for the first time, her act was too strong for some. Chat show host Clive Anderson agreed to talk to her on air and then backed out at the last minute when he saw a video of her performing. ('I think he's afraid of strong women', she told me after she'd heard the news, 'and I'll be sending him a letter to tell him.') Her unpalatability to the likes of Anderson is a measure of how the mainstream finds her both an attractive and repulsive proposition. They know she's got something, but they're not quite sure what to do with it. She tells the anecdote of one TV network executive who told *Time* magazine, 'Yeah, she's great, but what are we supposed to do, put her in a sitcom and cast her as a boy?'[8] They want to harness the creative energy of her anger but don't want to know where it comes from.

DeLaria herself is not ambivalent. Her loyalties lie, like her origins, firmly at the radical heart of America's lesbian and gay community. She talks of 'the need to locate our rage as a community' and sees herself as an agent for change. 'When I stand on stage and make them laugh, it's easier for them to hear the message be they straight or whatever. This is my way of making a statement, my way of making a speech, my way of changing the world.'

Anger is a central motivating force behind her act: 'My anger comes from not having enough sex, that's the first thing. I'm angry from being queer. Plus I'm Italian. We are an expressive people. Anger is a puny little emotion isn't it? I'm *rageful*.' Her relish for breaking social taboos is not confined to her straight audiences to whom she unapologetically announces herself as a 'bulldyke in a chinashop'. Some quarters of the 'lesbian community' get targeted too: 'these fascist feminists who say you are

not a good lesbian unless you eat humus! There's only one thing you have to eat to be a lesbian and it isn't humus.' Her critique cuts in all directions at once. She started her career on the lesbian feminist circuit, playing to women-only audiences, and as a result is well steeped in the mores of dyke culture, relentlessly poking fun at lesbian social orthodoxies and, more especially, their prudery around sex. On her first British tour, she revelled in throwing a large double-ended dildo around the stage, much to the uncomfortable glee of many in her audience. She is shameless and affirmative even in her most lewd moments, quite literally 'toying with the phallus'.

She 'gets away' with this brand of humour because the jokes are coming from someone who has matured as a comedian completely immersed in lesbian subculture: her parodies are mostly affectionate and knowing. She succeeds in opening up lesbian vulnerabilities to the laughter of a larger audience – for instance, in the case of dildo jokes, their sensitivity to the charge that deep down they really want to be men. She opens up the dyke Pandora box of delight and disgust. And she does it in front of men too (who are perhaps themselves the sufferers of the reverse paranoia of not measuring up to the symbolic phallus).

DeLaria successfully cleaves open dyke subcultural defensiveness and inward-looking protectiveness. This is in part a reflection of the increasing self-confidence of the 'lesbian community'. But it's also made possible by DeLaria's attitudes towards gay men. In line with the recent historical trend, she's a dyke who has moved onto common political ground with gay men. By addressing, often very directly, her gay male audience, she widens her scope to take on the whole edifice of masculinity. Straight men don't escape her notice either. She gets all the men in the audience to shout in unison, 'I am a lesbian.' This is the ultimate inclusive device. It brings them 'in on the joke', and enables them to accept more readily her lesbian reference points: we are all lesbians when we watch Lea DeLaria. This participatory manoeuvre simultaneously parodies, in a gentle way, the inclusive defensiveness of the previous epoch and posits lesbianism, albeit briefly, as the universal human condition.

In contrast, a comic such as Julian Clary employs the reverse process, singling out members of his audience in order to mock them. He enjoys using straight male scapegoats as the butt, not only for gay, but for straight women's laughter. But DeLaria is prepared to make peace with straight men as long as they acknowledge the centrality of lesbian desire. As DeLaria somewhat cheekily admits: 'I have nothing against penises. I just don't like them on men.'

She never neglects her essentially female identity and holds firmly to a

rigorous critique of male power. She has firm ideas on how her role as a lesbian comic is more difficult to sustain than that of her gay male counterparts. 'Gay men are allowed to be a lot more outrageous than lesbians because lesbians are women and women have to keep within this box of this normal way a woman is supposed to behave. And ladies don't spit and holler. Polite ladies don't say the F-word, much less in reference to the first lady.' DeLaria got into trouble for saying she'd 'fuck' Hilary Clinton in the same way Clary was lampooned for saying he'd 'fist' ex-government minister Norman Lamont. But in DeLaria's case, much of the criticism came from other women, horrified that she should sexually 'objectify' other women in this way. 'Words are meaningless symbols,' she explains, 'it's the ideas behind them that are harmful. That's why I say the word "fuck". As a person, I don't use the word, but on stage it's a political choice.'

She uses language to subvert notions of femininity and incorporate the potency of the male 'blue joke'. 'I fart, sweat and swear', she explains, 'because I want to change society's idea about how women ought to behave. I am into using words like fag, dyke, queer. I'm into challenging the concept of words.' DeLaria is explicit when she describes lesbian desire, adopting the vulgar vernacular of stand-up for her own inventive purposes. When DeLaria thinks of Madonna, she gets a 'wide-on'. She shares this habit with the British stand-up comedians (and 'out' lesbians), Rhona Cameron and Donna McPhail, both of whom are happy to admit that they 'shag girls'. Although less altogether brash than the American, they admit to adopting a blokish style of stand-up. 'I was quite fiery when I started out', Rhona says. 'I told stories about myself, but I also did the usual "fucking, drinking, shagging" jokes. And because I was a woman, and a boozy one at that, people liked my act.' Like DeLaria, she believes that 'people don't allow women to do the things on stage that men do'. As a woman, there's a pressure to explain something about yourself to the audience – why you're there, what kind of woman you are – whereas men can just get up and give their opinions about everything . . . My act is more of a male act.' Donna McPhail, described by Bea Campbell as 'laddish', explains why she thinks there are more men in stand-up than women: 'You're standing up in front of hundreds of people and saying "please like me" and you're showing off. That's why there are more men in comedy, because they are always encouraged to show off.' McPhail explains that when she began her career, 'there weren't that many good women comics around. So once you've learnt your trade it's easier. Once an audience see that you're funny, they relax and you can get more out of them than a man. Funny men are two a penny.'[9]

McPhail performs stand-up to mixed alternative crowds. The subject matter of lesbianism is usually an adjunct to her larger theme of sexual politics in general. It is a brand of comedy she shares with straight women – a comedy of complaint. (Her definition of post-feminism is 'letting a man open a door for you and then slamming it in his face'.) She introduces the subject of her own sexuality with some care. As William Cook pointed out when reviewing her show at the Edinburgh Festival of 1993, she 'has come clean about being a lesbian and consequently her stand-up has suddenly found its focus'.[10] But this 'focus' is by no means the core of her material. She adamantly refuses to call herself a 'lesbian comedian'; rather, she is a comedian who 'happens to be a lesbian', ambitious to stretch both her material and her audience.

As a result, McPhail employs some intriguing devices to get around the L-word dilemma, dropping it in in the middle of her act, rather than roaring in at the beginning, as DeLaria might. 'It can be scary when you are doing a big gig,' she admits. 'Although I'm out and I'm not that famous, I forget sometimes that people don't know. When I say that I'm a lesbian, you can feel a huge ripple through the audience. So I let the audience relax and enjoy themselves and then half-way through the show, when it's in context, I say, by the way, I'm a dyke. By then it's too late. They can't take the laughs back.' McPhail's 'Essex bloke' style is geared to a British audience and she mercilessly exploits English politeness, although she does admit to telling jokes that go too far for some: 'For instance, I'll say, who's this an impression of?: "Piss off you lesbian shite!" The answer? My mother last Christmas. Didn't work.'

This technique is shared by Rhona Cameron who explains how she drops the lesbian bombshell with careful precision: 'If I put the lesbian stuff before my material about relationships told from a general human perspective, then the audience would feel alienated and tense. So I tell this joke about how I'm going on holiday and how I don't want people to stare. I don't like people staring. And then, calmly, I say: "you'd think they'd never seen two drunken lesbians fist-fucking on the beach before". And at that point they laugh because it doesn't have to be true of me and because I've mentioned fist-fucking. It's just an easy way of introducing the subject and going on to talk about how my parents reacted to me being a lesbian.' She doesn't dwell on the subject however and 'quickly moves on'.

Both Cameron's and McPhail's lesbian material is the risqué element of an otherwise more traditional act that deals with the trials and tribulations of everyday existence. Cameron asserts that she 'can't see the point in "lesbian comedy"'. 'I only mention it in my act because I love other women,

sleep with them, and I'm just being honest about that. I'm not making a political point . . . I hate programmes like *Have I Got News For You* because we all know that politicians are wankers and that this country is shit . . . people use political satire to try and be "daring", but I think it's much more daring to be open about yourself on stage.' She'd agree, perhaps, with Frank Maya, the first 'out' comedian to appear on MTV, who says that 'Comedy is about really being truthful. People are hoping the comic will tell them everything. So how can you hide your love life? It just seems impossible.' Significantly, Cameron cites American rather than British comedy as her inspiration, mentioning the likes of Woody Allen and Roseanne, people who have succeeded, she believes, in 'talking about their feelings and drawing on areas of human life that we *all* dread or find frightening . . . in ways that we can *all* relate to.'

There's an interesting cross-fertilisation of style that takes place between American and British comedians and you could argue that lesbian and gay humour specifically springs from different traditions of comedy on either side of the Atlantic. Whereas British gay comedy has always been inextricably intertwined with drag, American comedy is less dependent on costumery and is more reliant on a rhetoric of self-revelation. There's a tendency towards debunking and sincerity, rather than studied exaggeration, that springs perhaps from the fact that comedy has developed as much through the medium of film and television as it has the theatre and music hall.

And as a result, there's a different relationship to being 'out' that's as much to do with style as content. In America, there's more of a liberationist approach – I am what I am – whereas in Britain, lesbian and gay identities are less overtly stated. Instead, deviant sexualities are manifest in the performing style itself as much as they are verbally expressed by the performer. British audiences are less likely to 'take their word for it', and more likely to suspend their disbelief, especially in relation to drag, where deliberate disguise allows for more ambivalent readings. The audience knows, but pretends not to know, in relation to both gender and sexuality. There's a complex conspiracy afoot.

For example, Stephen Leigh asserts that there is no lesbian equivalent of Lea DeLaria in Britain. He is disparaging of British gay humour which is, he says, mired in cabaret and drag. He believes that in the US, it's more 'politically inspired'. Although probably with more reference to gay male than to lesbian comedy, he asserts

> Pantomime costumes take precedence over political humour. It's a
> tradition born out of the nudge-nudge, wink-wink antics of a

generation like Larry Grayson, Kenneth Williams and Frankie Howerd . . . this approach has probably gone a long way to smothering any development of any real groundbreaking humour in Britain. We need a lot more comics with the bravery to just stand up and say,'I'm gay, I'm funny'.[11]

But if Cameron and McPhail are well placed on the British circuit to aspire to his slogan, they might change it around to read, 'I'm funny, I'm gay'. Cameron and McPhail do share a view of themselves in the world that fits Leigh's view of what constitutes the new wave of American lesbian and gay comedy: they are both unquestioningly and unswervingly 'out' in their acts. (The Glaswegain-born Cameron has also gone on record saying she wants the whole American Dream, complete with 'a body like Madonna's, a personal trainer, a therapist and a house by the beach'.) They have more in common with the canon of female American comedians than those of British gay male drag. As Bea Campbell says, 'What these women are not is camp. That's a boy thing. They're tough.'

And so there are tensions between the queer and 'lesbianandgay' liberation agendas about the purpose of gay comedy and the forms in which it is most transgressive. Leigh's line of argument ignores recent reclamations of old-style homosexual comedians, such as Larry Grayson, by revisionist queer academics. The prime exponent of this school of thought, Andy Medhurst, does not denigrate but celebrates this tradition of British cabaret and drag. He's revised the 'Gay Lib' view of Grayson, describing it as 'both arrogant and misplaced'. 'These days we're learning to respect the kind of queer past Grayson came from . . . a brave history of down-market provincial pansies who were such screamers that "coming out" (a largely middle-class invention) was hardly an issue.'[12]

Likewise, critic Mark Simpson belongs to a new generation of younger gay men who are cynical about the self-satisfied claims of modern gay culture. He's wary of it's insistence that a proclamation of one's 'outness' is an intrinsically liberating device. 'Homosexuality has become more difficult to disavow as it has become more public', he asserts. 'It has also become less scary and thus less funny.' Of male double acts such as Laurel and Hardy, Simpson points out how, 'reading them as "gay", even as part of a laudable part of an attempt to raise the visibility of homosexuality, diminishes the subversive potential of queer comedy romance'.[13]

Gay male cultural critics such as Medhurst and Simpson are not alone in questioning the assumption that queer and camp humour is less political, less culturally subversive, than 'gay lib' gags. A bandwagon of lesbian theorists, from Sontag onwards, have tackled the thorny issue of where

'camp' fits in to feminist discourses and shown how drag draws on women's own performance of femininity. And it's from this corner, coming out of a gay male tradition of cabaret, that a new breed of lesbian performers and comedians have emerged in Britain. Whereas the stand-up girls wear suits, this new variety wear their sequins with pride. . . .

GIRLS WILL BE GIRLS

It's fashionable in the 'queer nineties' for people to advertise themselves as the thing that they are not: it's become a positive virtue to shine with what Elizabeth Wilson calls the 'glittering depthless polish of the postmodern urban scene'.[14] Labels and categorisations slip their anchors and become part of the shifting yet glamorous landscape of kitsch parody.

The lesbian cultural scene is mutating at a pace, fuelled by the excitement offered by this new 'strap-on, strap-off' culture of appropriation and playfulness. In contrast to the earnestness of feminist academics before her, a quasi-feminist writer like Camille Paglia is more than happy to describe herself as 'a drag queen'. ('They said I was the love child of Dame Edna and Quentin Crisp.') Some will argue that Paglia is more of a lesbian comedian than a serious cultural critic. But she is undeniably symptomatic of the new breed of gender-bending appropriators intent on semantic slipperiness.

One of Paglia's heroines is the actress, performer and comedian, Sandra Bernhard, a woman she hails as 'the female Lenny Bruce'. 'Like a drag queen,' Paglia explains, 'Bernhard can defend herself without running to grievance committees. Whether lesbian or bisexual, she accepts and respects male lust without trying to censor it. And she knows that comedy is the best road to truth.'[15] Paglia asserts that Bernhard, through her various stage presences of 'bitch, stripper, whore, lady, fashion model', 'has re-joined stand-up to it's origins in Vaudeville, where music and comedy were brassily interwoven'. While Bernhard's mouthy monologues have a very American flavour, they are interspersed with songs. Paglia, although asserting Bernhard's 'completely American' female brashness, does also acknowledge her connection to the more European tradition of vaudeville and cabaret. Bernhard combines these strands in new and surprising ways as do a whole new generation of women on a new British queer cabaret scene. One such is Marisa Carr, who describes her work as 'somewhere between cabaret, live art and erotic performance', while the Manchester-based comic Twinkle does performances that are a cross between Coronation Street's Bett Lynch and Wonder Woman. Perhaps it's not altogether surprising that the force behind the main club night where these

women perform (Duckie, at the Vauxhall Tavern) is herself an American, albeit a disenchanted one, a girl who listened to the Smiths while growing up in New Jersey. Amy Lamé describes herself as a 'gay man trapped inside a lesbian's body' a label conveniently designed to make Havelock Ellis spin in his grave (the sexologist who asserted in the 1920s that lesbians were 'inverts', or men trapped in women's bodies). Amy explains how the label she chose to describe herself – 'a Lesbian drag queen' – caused so much confusion in people's minds. 'People didn't know how to take it. They were dumbfounded. They were saying things like "you must be a transsexual. You must be a bloke who's had a sex change and now you're a woman. Is that it?" And I'd be like, "Well, not exactly!"' She explains her thinking. 'There were lots of different layers to calling myself a lesbian drag queen. First and foremost, it was a piss-take of other lesbians because at that time, ideas about how a lesbian looked and behaved were still very strict and prescriptive. I'd constantly come up against the attitude of "we don't believe you're a lesbian". So when I'm in a dress, in pigtails, with lots of make-up and high heels, I'm saying, yes, I am dressing up as something else, but I am a lesbian at the same time. In the second instance, I was challenging gay men's stereotypes of women. Is a drag queen dressing up as a real woman? No!'

Although both drag devotees, Lamé shares this last reservation with fellow traveller Sandra Bernhard, who also has strong views on how gay men perform female drag. As Bernhard told interviewer Kevin Sessums in Out,

> It's such a bizarre phenomenon. I think, in a strange way, it's more comfortable for men to accept women filtered though a man, than it is for them to accept actual women. . . . I love drag queens as performers, but as figures who are saying something that we should be looking up to, well, I think that's a little insulting to women. Women themselves are not respected. Women do not get their fucking due . . .[16]

Lamé, however, does not see drag itself as misogynistic. 'I don't have problems with men dressing up as women. Obviously, it's caricature, not reality. But where there is misogyny is in acts where women are picked out of the audience and put down.' Significantly, Lamé's own personal drag is something she doesn't just perform on stage. This is in contrast to the likes of Regina Fong and Lily Savage who have very different male/female personas when in and out of drag. Amy wears gingham frocks, nerdy specs and ribbons in her pigtails both on and off-stage. 'That's because it's me!'

she explains. 'I'm not an actor, I don't have those skills. I don't want to be anyone else on stage, I just want to be myself . . .' This would seem to go against what male drag is about – where the flinging on of a wig can change a man's personality, releasing, as if by magic, both his feminine and aggressive sides. What does Lamé think of that idea? 'I don't think I have a repressed side. If I have, it would be as a repressed heterosexual housewife!' (Jam-making is a current preoccupation.)

But Lamé is more than just another drag artist, albeit one with a female double twist. Other than what she calls 'traditional drag', she cites other influences on her act like game shows and musicals. 'In terms of comedy, I would never describe myself as a comedian. I grew up in a family that was like Roseanne times three billion – my mother is Roseanne. So at home, I was always the one saying "You are so stupid, Shut up". I had this reputation for being very serious.' She is not, she says, 'a lesbian comedian'. She is rather, 'just a performer', adding that 'language hasn't caught up yet' with what she does – a combination of both political and comic genres. 'If I went out and did a serious show about the lesbian community's F-word – femininity – then no one would give a toss. That's why comedy is important and the melding of comedy with politics is important. It engages an audience in a different way. A lot of performers at Duckie mix up different ways of performing.' She gives as an example Marisa Carr, a Duckie performer whose act draws on 'everything from Marie Lloyd in old-style music hall mixed up with modern day prostitution'. As Carr herself explains: 'I'm very interested in vaudeville and if you look at early music hall, it was very anarchic and bawdy. It produced many powerful women and my show includes five of them, all of whom were cross-dressing bisexuals . . . People like Colette and Marie Lloyd who were really subversive and very sexual.' Carr draws on a showgirl tradition as much as that of comedy alone, a forum where powerful women were able to fuse sex with wit, song, quips and audience banter.

Another Duckie act, Helena Goldwater, also describes herself as a 'lesbian drag queen'. She draws on the powerful women from her own background to flesh out her high-femme stage persona. 'For me it's really connected with being Jewish. I base a lot of my characters on the wonderful women I grew up with – like my Auntie Hannah and Aunt Margie. They were really glamorous and I want to reclaim some of that in a feminist context. Although I look really over the top, it's not parody. This is who I am and where I come from and just because I'm a lesbian doesn't mean I'm disconnected from that.'

Both Carr and Goldwater combine past and present stands of vaudeville, cabaret and drag in fresh and highly personalised ways. They take on

female social archetypes, such as 'the sex-goddess' and 'the auntie', and rework that rich seam of comic material from a feminist perspective. As Andrea Stuart has argued in her book, Showgirls, hyperfemininity can give women a special power:

> More than ordinary women, she (the showgirl) understands fem-
> ininity as an act. Consequently, she is free, unlike most women,
> not to take femininity too seriously. She can, as the critic Gaylin
> Studlar writes, refuse 'to invest emotionally in her femininity and
> its assumed aim of attracting men', and achieves at times a dis-
> tance, perspective, even humour about her physicality that most
> women only envy.[17]

Taking material from both their own past and stereotypes from the dom-
inant culture, both Carr and Goldwater explore female authority figures
from their own unique viewpoints. Call it feminist or queer, it's definitely
political. According to Goldwater, 'I think that's in its nature. It's about
making a statement.'

As Lamé explains, 'Performance artists − if you can understand them at
all − are doing the politics without the comedy and stand-up were doing
the comedy without the politics. There's a new breed of performer that
does a bit of both, and a new audience too − an audience who want more
from their entertainment than just silly laughs or sitting at the ICA being
bored.' And as journalist Rose Collis has commented about Sandra
Bernhard's act, 'her idiosyncratic brand of stream-of-consciousness comic
serial commentary has always required its audience to put its brains as well
as its bums into use.'

This mixing of different forms of comedy and performance reflects the
spirit of the times and is what Lamé says she finds exciting: 'In terms of
performance now, really exciting things are happening − call it Millennium
fever − the breakdown of everything. Twenty years ago, you had your
drag queens and singers, you could mix a little bit. But now, gay per-
formers especially are at the cutting edge of what's happening, breaking
down and using influences from loads of different forms.' She rejects the
comedy of Cameron and McPhail, saying that it doesn't interest her, pre-
senting it as an old-fashioned approach. 'It's popular in America, but it's
never turned me on.' Although she concedes that 'humour probably over-
comes a lot and it probably does quite a lot of good', she goes on to
explain how 'I would hate to do stand-up in front of straight people,
making stupid jokes about coming out − like "Hello!", that was five years
ago!' 'Coming out' is not on Lamé's agenda as such, but neither is she in

any closet. Talking of Duckie, Lamé says that 'It's clear we're gay but it's said in a different way. It's not about getting on stage and shouting "I'm gay, look at me, I'm so funny." It's more subtle than that. Now you get performers, like Divine David, who rips shreds out of other gay comics who tell coming-out jokes to straight audiences. Divine David makes jokes about Bert Tyler Moore [a gay comedian on the 'alternative' circuit who also hosts Gaytime TV]. It's about gay people taking the piss out of each other. Which is great!' Lamé agrees that there's a cannibalistic variety of gay humour at work.

Those who reject the 'gay establishment' line, and who have gone beyond the 'nirvana' of coming out, are more willing to be publicly critical of other lesbians and gay men. Perhaps this is a reflection of the confidence and success, rather than the failure, of the modern gay movement's crusading openness. Other lesbians and gay men are treated as fair fodder for cutting humour. As Arlene Stein says in her chapter 'Style Wars and the New Lesbianism', 'Today, we've lightened up a bit. Witness the new lesbian comedians who convey a sense of lesbian life, warts and all, by constructing characters driven by anger, jealousy and revenge – as well as love and community.'[18]

One such example of this might be the Manchester-based comic-performer Twinkle. She started out life as a performance artist but later went on to adopt a comic persona that earnt her the label 'a lesbian Victoria Wood'. She takes an *Absolutely Fabulous* approach to what is essentially an English comedy of manners. She 'ramraided' some of the proceedings at Queer Up North's festival in 1995, her act testing the audience's capability for distinguishing real-life lesbian drama from impromptu pantomime. Wearing fluorescent frocks and wielding a giant water pistol, Twinkle is something of a 'lesbian bimbette'. 'I use Twinkle to live out some of the things that I think are funny about how lesbians behave on the scene,' Twinkle says. 'I'm not taking the piss, saying "You're all sad bastards, get a life." I'm saying, yeah, it's all fun, let's just look at it and laugh at ourselves and not be pretentious.' She sends up a whole generation of confident, clubbing, nineties lesbians. She successfully feeds the stereotype back to the original people who inspired her, making them laugh at themselves. 'There really have been all these lovely shiny dykes with their lovely silver tops and shiny hair and mobiles. And they're really loving the show, saying, "That's me, it's fab isn't it?"'

Although such exaggerated caricatures may not be that complimentary, there's a recognition of themselves in the performance that nevertheless delights. That's the kind of response that working-class middle-aged women used to reserve for the likes of John Inman and other pantomime

dames.There's an ambivalence in such forms of imitation and caricature that can be both critical and complimentary. It's worth noting here perhaps how English comedy in particular has a very strong tradition of caricaturing strong women, older women, powerful women. One thinks of Les Dawson's stern old ladies, or Hinge and Brackett; anyone wielding a rolling pin. But these days, women are actively reclaiming those comic stereotypes for themselves – witness the success of Mrs Merton. She's a young woman who plays an older woman. Like Barry Humphries' Dame Edna, she's a wolf in sheep's clothing: she renders that most innocuous of females, the suburban housewife, as a deadly force to be reckoned with. She adopts the seemingly harmless format of the cosy chat-show host and drops in references to outrageous sexual acts, keeping her plastic smile intact throughout.

Mrs Merton's real-life audience, often made up of authentic middle-aged women, revels in her cheekiness, both scandalised and delighted. The extent to which everyone 'gets the joke', especially the guests, is questionable. Mrs Merton, with her quintessentially prim persona, takes chat show parody one step further than Dame Edna ever could. Straight women are 'dragging up' as the kind of women usually performed by men. It's a new variety of double inflection. Women are not only creating their own interpretations of male drag, but actually 'dragging up' as gay men themselves. One of the aspects that has most delighted lesbian fans of French and Saunders has been their 'drag king' appearances. In these sketches, the entire make-up department of the BBC has been brought to bear on their appearance, turning them into fat, slobby, 'couch potato' blokes who hump the television when a gorgeous girl comes on. They parody the crass, sexist Sun reader, aping the most ridiculous and repulsive aspects of his behaviour. Significantly, these portrayals by French and Saunders coincided with the fleeting emergence in London of a lesbian 'drag king' scene. At the night club, Naive, lesbians dressed up as a variety of men, complete with moustaches, beards and 'packing' down their trousers. At turns both funny and stylish, frightening and downright strange, these male caricatures were part of what the Naive organisers claimed was the new exciting phenomenon of 'genderfuck'.

In line with the times, male behaviour in this 'drag king' context did indeed become something that could be treated as a joke (although not always). Women were parodying the behaviour of men who thought that they were already being tongue in cheek about their own excessive brand of 'male behaviour'. The 'new man' of the eighties had been replaced by the nineties 'lad' as the controversial male model. The more outrageous or sexist lad behaviour became, the more 'ironic' it was meant to be. Lad

magazine bible *Loaded* wasn't, we were told, *supposed to be taken seriously.* It was all a 'bit of a joke'. This was an effective defence against those who sought to critique lad behaviour because any objectors could be characterised as literal and humourless.

In line with all of this, there was a weird transmutation on the lesbian scene of the TV sitcom famously titled *Men Behaving Badly.* Girls started deliberately to ape some of the more unattractive aspects of male behaviour. As drag king and Naive organiser Jules says, when she's in drag, 'I do all the things that straight men can't do because they are supposed to be "new men". Dragging as men gives us the kind of freedom that women don't usually have – freedom to touch yourself, burp and fart and go "Corr . . ." at other women.'[20]

Another 'drag king' *aficionado*, the US-based Diane Torr, spent the summer of 1995 giving a series of workshops in Britain on how to make the physical transformation from female to male

> Nineties urban-gender bending is only the latest in a long line of transformations, but unlike them is no longer seen as an outward sign of identity. It's now fashionably understood as a way of performing gender, as an expression of the arbitrary nature of gender roles, which are reduced to no more than a set of clothes and a range of stylised behaviours.[21]

Certainly, when this theory was translated into practice, on the clubbing scene of Naive, it made for fun, games and lots of media publicity (something the Naive girls/boys milked for all it was worth).

It wasn't just the mainstream print media that cottoned on to the new fashion. In a comic context, these subcultural developments found mainstream expression in a variety of forms. Further to their 'couch-potato man' characters, French and Saunders made more intriguing drag king manifestations on prime time. In one sketch, they dragged up as gay men, campy clone hairdressers in contemporary Old Compton Street garb. (When asked what their new year's resolutions would be, French's character replied, finger on chin, 'Um . . . Satanism. And rough trade.') Perhaps this represented a friendly doffing of hats to the men who have always been ubiquitous in the entertainment industry. Certainly, both French and Saunders have publicly endorsed the gay rights agenda, supporting Stonewall and appearing at their Equality Show. It also delighted many gay men who took the imitation as a compliment (although whether they should have is perhaps more questionable).

Furthermore, gay men have been among the most ardent supporters of

Jennifer Saunders' hugely successful show, Absolutely Fabulous, reading Patsy and Edina as gay men, identifying with them as men 'dragged up' as women: here are men 'behaving badly', but as women. Gay men can identify with the female characters because their behaviour is so unlike female behaviour, which is regulated by strict conventions of 'taste and decency'.

In a way, we are back full circle to Lee DeLaria's views about how women's behaviour is more restrictive. Like Lea DeLaria, Patsy and Edina 'fart, swear, drink and sweat,' and behave in very unladylike ways. They break the rules. And so across a spectrum of drag manifestations, audience readings are becoming increasingly sophisticated and various. Here we have men acting as women who act as men. And women who act as men, acting as women. There's a fluidity in these complex cultural inflections that, as Amy Lamé says, reflects the 'Millennium fever' of the age.

Using both stand-up and drag, lesbians are struggling with conflicting discourses about what constitutes women's autonomous sexuality. Comedy by lesbians is fracturing in line with the increasingly complex interpretations of sexuality and gender roles present in society today. There is no longer any one remit, genre or audience exclusive to lesbian comedians, whose personalised styles of performance often utilise the tensions and incongruities between the form and content of their acts. Yes, they are women, but no, they don't always act like women are supposed to act. Yes, they stick within comic traditions, but they also innovate and break down forms of performance. And finally, yes, they do make their public laugh, but they also aim to surprise, confuse expectations and lend a sense of danger to proceedings. In the nineties, laughter not only authenticates collective 'lesbian' experience but also helps deconstruct dyke stereotypes – whether they be the homophobic caricatures of old or the 'positive role models' we have more recently created for ourselves. Lesbian comedy is both self-reflective as well as proselytising, a category that's set to implode as well as explode, slip it's own shackles and create new forms of expression and being.

NOTES

(All unreferenced quotes are taken from interviews with the author.)
1 Stephen Leigh, 'Send in the clowns', Attitude (October 1994), p. 26.
2 Beatrix Campbell, 'Funny peculiar, funny ha ha', Diva (April 1994), p. 16.
3 Rose Collis, 'Iron Lady', Gay Times (January 1995), p. 14.
4 Julia Brosnan, 'Fanny-tastic vaudeville', Diva (April 1996), p. 50.
5 Section 28 of the Local Government Act (1988) banned local authority employees – in practice, principally teachers – from promoting homosexuality as a 'pretended family relationship'.
6 Beatrix Campbell, 'Funny peculiar, funny ha ha'. Diva (April 1994), pp. 16–19.

7 Frances Williams, *Gay Times* (August 1993), p. 64.
8 Katie Sanborn, *Curve* (June 1996).
9 Cayte Williams, *Diva* (December 1995), p. 12.
10 William Cook, the *Guardian* (18 August 1993), p. 6.
11 Stephen Leigh, 'Send in the clowns', *Attitude* (October 1994), p. 26.
12 Andy Medhurst, *Gay Times* (February 1995), p. 4.
13 Mark Simpson, 'Straight men of comedy', *Attitude* (December 1994).
14 Elizabeth Wilson, 'Fashion and the postmodern body', in Juliet Ash and Elizabeth Wilson (eds) *Chic Thrills: A Fashion Reader* (University of California Press, 1993), p. 4.
15 Camille Paglia, *Virgins and Tramps* (Penguin 1994), p. 138.
16 Kevin Sessums, *Out* (September 1994).
17 From Gayla Stodler, 'Masochism, masquerade and the erotic metamorphosis of Marlene Dietrich' in Jane Gaines and Charlotte Herzog (eds) (Routledge 1995), p. 245.
18 Rose Collins, 'Iron Lady', *Gay Times* (January 1995).
19 Arlene Stein, *Out in Culture: Gay, Lesbian and Queer Essays on Popular Culture* (Cassell, 1995).
20 Frances Williams, 'Girls who wear moustaches', *Independent on Sunday* (17 September 1995), pp. 4–5.
21 Tina Papoulias, 'Self-made men', *Diva* (February/March 1995), p. 40.

9

'YEAH, AND I USED TO BE A HUNCHBACK'

Immigrants, humour and the Marx Brothers

C.P. Lee

We have room for but one language here and that is the English language, for we intend to see that the crucible turns our people out as Americans and not as dwellers in a polyglot boarding home.[1]

> Thus stated Theodore Roosevelt in 1919, spelling out the avowed aims and intentions of American domestic language policy.

What's got four wheels and flies?
A garbage truck!

> The Marx Brothers, *Horse Feathers*, 1932

So much for legislating the most amorphous and misleading of things – language.

It is my intention in this chapter to demonstrate how the immigrants to the USA at the turn of the century empowered and protected themselves through verbal displays, particularly in the field of comedy, and specifically in the work of The Marx Brothers and their writers. I will close the piece with a reappraisal of the state of American 'ethnic' comedy today, and I might even draw some conclusions if I can find some chalk.

One of the many facets of humour has always been its ability to be used as a defensive weapon – 'That great spear of humour', as it was described by the American jazz comic, Lord Buckley. Even within the darkness of the Holocaust oral accounts tell of jokes shared and created and preserved within the hell-on-earth of Hitler's camps. Small wonder that in Czechoslovakia under the Communist regime, political jokes were known as 'tiny revolutions', the telling of which could result in imprisonment or worse. For immigrants to the New World, the situation was compounded

by the problems inherent in coming to grips not only with a new, incomprehensible language that had rules and structures all of its own, but with a totally alien culture and hegemony based on WASP (White Anglo-Saxon Protestant) principles. WASP culture was, moreover, prepared to use legislation to enforce its control over the way people spoke, and therefore, by implication, how they would think and behave.

> Put it on the penultimate Jameson, not on the dipthonic.
> Groucho Marx, *Animal Crackers*, 1930

Sadly for Theodore Roosevelt (at any rate) his dreams of a single unifying Amero-English language couldn't possibly have taken into consideration the combined efforts of The Marx Brothers and their cohorts' gleeful delight in deconstructing, mangling and massacring their adopted tongue.

Presently, I will examine how three Jews pretending to be a harp-playing mute, an Italian con-man, and a motor-mouthed shyster could cross over from the ethnic melting pot and establish a rich vein of absurdist humour that found favour not just with the American public as a whole, but with international audiences as well. (I have a bizarre memory of watching Duck Soup, dubbed into French, in a sleazy flea-pit in Marrakesh – the audience laughed there as well.) First, though, let us very briefly set out the circumstances into which they were born. Ellis Island off Manhattan was the holding pen for the countless thousands of immigrants who arrived in the New World from Europe. They came from Ireland, England, Russia and Poland; from Sweden and Italy and France; from all corners of the Old World to the New. They sought a place where they would be free of poverty, pogroms, famine and prejudice – the factors that had caused them to leave their countries of origin. What greeted the majority of them on their arrival was a more subtle, inherent racism and an atmosphere of discrimination, aided and abetted by a frightening new culture whose linguistic absurdities and reliance on petty bureaucracy would mar the lives of the immigrants and their children for years to come.

English as a language contains complexities and ambiguities like any other, and this piece is not intended as a semiotic analysis, but picture yourself for a moment as a non-English speaker trying to come to terms with a simple phrase such as 'to lay the table'. What seems straightforward at first, when scrutinised through Alice's looking glass, actually has a variety of connotations involving chickens, sexual intercourse and cutlery.

An example of Anglo discrimination and language is the story of one young boy who arrived at Ellis Island from Russia. Unable to pronounce

his real name, the authorities at immigration control made him take the name Samuel Goldfish – doubtless hilarious to the officials and a source of amusement to them and their buddies for a while. For the young man it represented a growing source of embarrassment as he slowly acquired enough English to realise why people laughed at him when he introduced himself. It wasn't until several years later that he was able to change his name to Goldwyn. The rest, as they say, is history.

From the top of the Statue of Liberty you could survey the masses as they struggled for survival in the Brownstone tenements of Hell's Kitchen, the Bronx and the Bowery; Little Italy near Carmel and Broadway; and St Mark's Place for the Polish and Russian Jews. Here were millions of people teeming through the streets of the new ghettos of the New World. These people brought with them their cultures and practices, their own prejudices and codes and slowly, but surely, as the first generations of children were born, to be followed by the next and the next, came the cross-fertilisation and assimilation that accompanies migration. Despite the attempts of Roosevelt and his like-minded social engineers, however, there was room enough for more than one language. Artists and writers such as Isaac Bashevis Singer and Edgar Ulmer could and did earn their livelihoods working for the Yiddish theatre and cinema almost exclusively. Italian, Polish, German and Irish social clubs flourished, as did newspapers and magazines. The levelling of the language was not to be achieved easily, if at all, but the Marx Brothers had a darn good try at it.

GROUCHO: Put it in a box Jameson. Mark it Fra-gilly
ZEPPO: Fra-Gilly?
GROUCHO: Look it up in a dictionary Jameson. It's under 'fragile'.

<div style="text-align: right">*Animal Crackers* 1930</div>

For the first generation of immigrants in America, the world was more often than not a bi- or multilingual polyglot. Fired with a burning enthusiasm to succeed, these children of the dispossessed endeavoured to carve their way into the free market economy of the burgeoning capitalist Republic. Acquisition, or control, of the primary language was an essential ingredient for success. This was even more so in the world of entertainment where large-scale success was dependent on crossing over to the broad American public as a whole. Whilst there is no denying that survival on a limited scale could be achieved working within a strictly ethnic linguistic market, fame and fortune was only obtainable within the wider spectrum of the American cultural world. With the advent of radio, and 'talkie' movies, Amero-English became, as it were, the lingua franca (in

the way that Roosevelt envisaged) of the United States, and a fully functioning ability in the language became the necessity.

In a permanent state of crisis, mini-language communities adapt and survive. For some the route to survival is the creation of a patois. For others it is the adoption of the dominant language community's structures, codes and rules, which are then subverted into argot or slang – West Indian patois dialects, or American Black street talk, 'jive', being two cases in point. No language can remain static, and it is my contention that the English of The Marx Brothers is that of a dominant tongue filtered, mediated and regurgitated through the consciousness of an essential ethnicity of perception. In the case of Morrie Ryskind, George Kaufman, S.J. Perelman, George M. Cohen, Al Shean, Nat Perrin, The Marx Brothers *et al.*, English becomes a ritual sacrifice slaughtered on the altar of comedy, and this point can be demonstrated as follows:

> We must remember that art is art. Still, on the other hand, water is water, isn't it? And East is East, and West is West, and if you take cranberries and stew them like apple sauce, they taste much more like prunes than rhubarb.
>
> Groucho Marx, *Animal Crackers*, 1930

So where did the funny people come from? To be precise, the young Marx brothers were brought up in a variety of Brownstones clustered around 100th and 6th in the district of Harlem, though at the end of the nineteenth century this was a warren of different ethnic ghettos, not the primarily Black one we associate with Harlem today. However, the poverty of the present was the overriding constraint of the past, and it was into penury they and their contemporaries were born, and free of which they fought all their lives to remain. This fear of poverty recurs over and over again as the driving force that fired the creative engines of these enthusiastic young (and subsequently not so young) artists. To break out and achieve was the ambition of most young Americans of whatever stock; the dream was theirs for the taking. Why, even Presidents had been born in log cabins, or, like the Roosevelt clan, were descended from original Dutch settlers, but whoever heard of a Jewish President? Or an Irish one, or an Italian? It would take until well into the twentieth century for limited achievements to be made on these fronts. In the meantime there was always the stage.

Minnie and Sam were the brothers' parents; he, a French speaker from Alsace, Minnie from Germany. The household grew up speaking Yiddish and German at home, English at school. Groucho always regretted not

having learnt French, but the eternal presence of the archetypal Jewish matriarchy held dominance in the domestic world of the Marxes: Sam, an oft unemployed tailor, was relegated to a back-seat position in the raising of the boys, and their subsequent careers. According to Groucho, 'He spoke a low German that my mother had taught him. That's the kind of German they speak between Germany and Holland because that's where she came from.'[2] To complicate matters he also had to learn a dialect called Platt Deutsch, because most of his customers in New York spoke that. It therefore comes as little surprise to discover that some of the earliest routines in Groucho's career were as a dialect comic specialising in a German accent. A record of this survives in the live recording of his 1972 Carnegie Hall concert where he performs a rendition, in dialect, of a song popular on the New York Vaudeville stages at the turn of the century, entitled, 'Ve can't keep de volves from de door'.

The genre of dialect comedy was a style of comedy popular at the turn of the century until, interestingly enough, the advent of talkies when its potential as a comedic device became less used. It's still around today, though in a much mutated way. In the UK recent examples would be Harry Enfield's Stavros character, the Greek Cypriot take-away owner and Lenny Henry's portrayal of the elderly West Indian Siphus, speech thick with patois, a comic triumph that succeeds because it can cross so many cultural boundaries.

We must take care not to dismiss dialect comedy as a device that relies solely on getting laughs by poking fun at the way the comic represents an immigrant's struggle with language. It is, or was, much deeper than that, in that it would allow material that probed dominant cultural traditions and foibles. It could question values and allow contemporary practices to be ridiculed by observation, or at least have gentle fun poked at them.

In this sense its success was twofold. Audiences could on the one hand share with the comic a sense of delight at the absurdities of everyday life within a specific cultural milieu, and on the other, delight in the parodic representation of the performer. Yiddish audiences would recognise the 'Volves' that Groucho couldn't keep away from the door, as the Woolfs, an immigrant family. The Woolfs are portrayed as 'schnorrers', Yiddish for professional beggars who would make demands on people's hospitality on the Sabbath when no one could be turned away. 'Yoks', or non-Jews, would identify with the punning signifiers couched in the semi-bilingual phraseology of the dialect comic, representing a universality of comic meaning inherent within the text. The unifying allegory of poverty is the coded reference, signifying that it's hard for us all without having to put up with this as well, and bringing together all the different ethnic groups

in the comic's audience, without needing directly to translate, explain or subtitle the text.

I will refer later to the problems of dialect comedy in this our post-modern world, but I would argue that early in this century they represented a reference point that brought together, rather than discriminated. The genre may appear problematic, but it is in no way intended as racist. Rather than being divisive, it acts as an agent of cohesion, awaiting recognition, agreement and unity as we can see from this extract.

GROUCHO: White man red man's friend! White man want to make friends with red man's brother!

CHICO: And sister too.

INDIAN: Beray! Beray! Kulah! Kulah! Cocho! Rodah! Nietzsche! Pardo.

GROUCHO: Are you insinuating that the white man is not the Indian's friend? Huh! Who swindled you out of Manhattan Island for $24?

CHICO: White man.

GROUCHO: Who turned you into wood and stood you in front of a cigar store?

CHICO: White man.

GROUCHO: Who put your head on a nickel and then stole the nickel away?

CHICO: Slot machine.

<div align="right">Go West, 1940</div>

In the early 1900s Harpo, Groucho, Gummo and Lou Levy were corralled by Minnie Marx to be a singing act called The Four Nightingales. 'We would sing what were popular songs of the day – until we sang them.'[3] It was in this act, which later (circa 1909) became The Six Mascots (because they were paid by the head) that they first tried out comedy, with Groucho as a German errand boy. By 1910 Minnie had persuaded her cousin Al Shean, who was half of the phenomenally successful Vaudeville double act, Gallagher and Shean, to write a 'proper' comedy act for the Mascots, and this became their first legitimate revue entitled Fun In High Skule. The second half of the act was called 'Mr Green's reunion'. Groucho played the teacher as a German, originally named Greenbaum, Gummo played the 'hebe' (Jewish) school kid, and Harpo, who at this point was still speaking on stage, played an Irish school kid called Patsy Brannigan. Here follows some of Gummo's, Harpo's and Groucho's original Fun in High Skule dialogue (imagine it with accents).

GROUCHO: If you had ten apples and wanted to divide them between six people what would you do?

GUMMO: Make applesauce.

GROUCHO: What is the shape of the world?

HARPO: Well I don't know

GROUCHO: Well, what shape are my cufflinks?

HARPO: Square.

GROUCHO: Not my weekday cuff links. The ones I wear on Sundays.

HARPO: Oh, round.

GROUCHO: Alright, what is the shape of the world?

HARPO: Square on weekdays, round on Sundays.

Fun in High Skule, 1910

Chico Marx was eventually persuaded to leave his job as a sheet music plugger in Pittsburgh and become part of the act, Lou Levy left, Groucho dropped his accent, Harpo dropped the use of words altogether, Gummo joined the army when America entered the First World War and Zeppo, their youngest brother, took his place. Now known as The Marx Brothers, where did the Italian one (Chico) come from? Well definitely not Italy for a start. There isn't one instance in any Marx Brothers' movie where he uses anything other than cod, Italian-sounding noises (with the exception of 'Getta your tutti frutti icecream' when he flirts with a real Italian in *A Day at the Races*, 1937). The ability to sound like an Italian, or Irish, or German, or whatever, had been developed during childhood owing to the simple necessity of crossing streets. If you were suddenly in a different ethnic neighbourhood, and it often went by house number, let alone blocks, then you could be in for some serious trouble unless you could bluff your way out of it. In the same way that contemporary street gangs like the Crypts and the Bloods in Los Angeles divide up territory – and heaven help you if you're wearing the wrong colours as you try to pass through them – so it was in New York one hundred years ago. Chico Marx had this ability to pass chameleon-like through the ethnic danger zones and fifty years later, when playing nightclubs, he still thought of audiences in ethnic terms. 'We didn't think there'd be anyone there but the Cohens and the Levys', he said of performing one Ash Wednesday, 'but when I looked out at the tables I saw nothing but the McCarthys and Raffertys.'[4]

During their transition from Vaudeville to Broadway, The Marx Brothers dropped the German and Irish dialect angle, but stuck with the Italian. It's my contention that they also retained another essential component of their comedy – their 'otherness'. This is an 'otherness' built around language. To paraphrase the feminist critique of Lacan's post-Freudianism, they (in the feminist case, women; in this case, the immigrant) are excluded by,

not from, language. This combination of 'otherness' and language emerges, through their natural comedic skills and that of the battery of writers, as a guerrilla war waged against the 'cultural and linguistic decorum'[5] of the dominant language community. Ultimately, they are the linguistic equivalent of Sacco and Vanzetti, Joe Hill, Emma Goldmann and the IWW (Industrial Workers of the World), launching their 'spear of humour' in celebration of their 'otherness' at the constant signifier of class and power in their celluloid world, Margaret Dumont.

Margaret Dumont was the eternal straightwoman of the act, a dowager grande dame, ploughing gamely on through a world of anarchy, like a pocket battleship at the Battle of Midway, totally at sea. She had come from a relatively well-to-do background, was widowed and left with no money so she turned her well-groomed talents to the stage. She always played the same part, a rich, pompous, upper-class widow. Audiences liked seeing her humiliated. The Marx Brothers obliged.

> She didn't understand half our jokes. She always kept saying to me 'What are they laughing at?' . . . I used to explain all the jokes to her. She was a serious woman. . . . Once we took all her clothes off on a train we were travelling on. You could hear her screaming all the way . . . to where the engineer was blowing the whistle. She screamed and screamed but she loved it just the same. We took all her dignity away, both on and off the stage.[6]

> I was told they needed an actress with dignity and poise, to lend legitimate dramatic balance to their comedy. After three weeks as Groucho's leading lady, I nearly had a nervous breakdown. He pushed me about, pulled chairs from under me, broiled steaks in the fireplace of my apartment, put frogs in my bath, made my life miserable on the stage and off. But I don't regret a minute of it. I just love those boys.[7]

The battlefields where the 'Marxist' conflicts took place reflected the ideological war of words. Mrs Rittenhouse's country mansion, an ocean liner, an exclusive sanatorium, an Ivy League college, a presidential palace, are places not generally accessible to the mass of people the Marxes were fighting for.

MARGARET DUMONT: Rufus, what are you doing?
GROUCHO: Fighting for your honour. Which is more than you ever did!

Duck Soup, 1933

The glory of Margaret Dumont lies in the fact that her faith in rules, order and logic ensures that she will return time and again for the put-downs and goosings meted out to her in film after film, scene after scene, line after line. The problem is that anarchists can only exist where there are rules to be broken and language can only exist if we agree to abide by the rules. The Marxes' linguistic war of liberation refutes the theory that language exists for communication. They defy logic and grammar in a way that can leave the viewer gasping for air, so fast is their ability to transmute orderly, normal sentences into mind-boggling impossible absurdities.

GROUCHO: Now, what is it that has four pairs of pants, lives in Philadelphia, and it never rains but it pours?
CHICO: Atsa good one. I give you three guesses.

<div align="right">Duck Soup, 1933</div>

Yet their ultimate triumph surely lies in their ability to draw the absurdity to an utterly logical resolution. The triumph of the imbecile – the idiot savant – irrefutable, illogical and golden!

GROUCHO: Now, let me see. Has four pairs of pants, lives in Philadelphia . . . is it male or female?
CHICO: No, I don't think so.
GROUCHO: Is he dead?
CHICO: Who?
GROUCHO: I don't know. I give up.

<div align="right">Duck Soup, 1933</div>

To further their comedic ends The Marx Brothers occupied three geopsychical spaces within the language community from which they were able to launch their anarchic attacks on the conventions of language and behaviour. Groucho is the 'intellectual' of the trio: quick-witted, fast-talking, he controls the speech situation.

GROUCHO: How much am I paying you fellas?
PROFESSORS: $5000 a year. But we've never been paid.
GROUCHO: Well, in that case, I'll raise you to $8000. And a bonus. Bring your dog around and I'll give him a bonus too.

<div align="right">Horse Feathers, 1932</div>

Chico, a self-imposed exile, dwells on the fringes of the dominant language community, where he 'does battle against the language of

Shakespeare and Milton armed with only one weapon: unyielding literalness.'[8]

MINISTER OF FINANCE: Something must be done! War could mean a prohibitive increase in our taxes.
CHICO: Hey, I got an uncle lives in taxes.
MINISTER OF FINANCE: No, I'm talking about taxes – money, dollars.
CHICO: Dollars! There's a where my uncle lives. Dollars, Taxes!

<div align="right">Duck Soup, 1933</div>

Here in the twilight zone of Chico's consciousness there ain't no such thing as a Sanity Clause and a levee on a map is where the Jews live. Chico and his ilk are why the verb 'to queue' has left Amero-English; it's too ridiculous to spell or learn how to pronounce – it's much simpler to use 'wait in line'. His verbal duels in the movies are a language war in microcosm, the eternal battle of the plain speaker up against the Latinate ruling class culture.

GROUCHO: Do you know what an auction is?
CHICO: Sure. I sail here on the Atlantic auction.

<div align="right">The Coconuts, 1929</div>

Between Chico and Groucho reality becomes quicksand.

Completing the triumvirate we have Harpo, the brother who abandoned speech altogether in favour of noises and gestures. This is reducing communication to its most basic, primitive level and this is the realm of the Shaman.

HOBO: Say, Buddy, could you help me out, I'd like to get a cup of coffee.
Harpo removes a steaming cup of coffee from inside his coat and hands it to the bewildered looking Hobo.

<div align="right">Horse Feathers, 1932</div>

We're entering the world of magic here and also that of Levi-Strauss and *bricolage*.

> Together, object and meaning constitute a sign, and within any one culture, such signs are assembled, repeatedly, with characteristic forms of discourse. However, when the bricoleur re-locates the significant object in a different position within that discourse, using the same overall repertoire of signs, or when that object is

<div align="center">174</div>

placed within a different total ensemble, a new discourse is con-
stituted, a different message conveyed.[9]

But what better example of *bricolage* can we have than Harpo himself? A
Vaudeville comic who, bored with parroting gags runs around a lot
instead, blowing a horn and making faces, and then is suddenly pro-
claimed, by no less a critic than Alexander Woolcott of the *New York Times*,
as one of the greatest pantomime artists of the age.

In the Judaic system of Magick known as the Kaballah, all words res-
onate with power, and this power can be concentrated in order to effect
changes in reality. I'm in no way implying that the Marxes, or any of their
writers, were employing Talmudic Magick in their routines; on the con-
trary, all the evidence indicates that their upbringing was, if anything,
agnostic. What we do find in common with other cultures, though, is the
knowledge that words and language systems have the power to ingratiate,
anger, deflect, cajole, etc. A case in point is the Trinidadian tradition of
Calypso. Here we have a Black cultural phenomenon that uses the language
of the 'master' for purposes of empowerment. First noted in the middle
of the nineteenth century in a form known as Kaiso, musicologically it
stems from the African genre of praise or insult singing, traces of which
can be found in contemporary American Rap. Assuming the basic root lan-
guage of the slaves was Hausa or Yoruba, it's possible to trace the genre's
development into French Creole, then as the English began to dominate
the West Indies we can follow the decline of Creole, its subsequent meta-
morphosis into patois – for instance 'they mouth' instead of 'their
mouths'. The Calypsonian would use patois in ordinary social circum-
stances, but on stage, doing battle with other singers in the large Calypso
tents, would use strictly regulated English. Calypso singer Lord Executor
claimed the change to English was introduced in 1898 by a Calypsonian
called Le Blanc.

> From abolition to ninety-eight
> Calypso was still sung in its crude state
> From French to English it was then translated
> By Norman Le Blanc who became celebrated
> Then it was rendered grammatically
> In oration, poetry and history.[10]

An imperalist tradition of compulsory education provided patois-speaking
children with the equivalent bilingual capabilities of their contemporaries
over in North America.

Calypsonians have often been accused of being intoxicated by language. Singers who could extemporise on the spot were highly praised and regarded. Calypso wars could often last for days before one singer was finally declared the winner and made the Calypso King, leader of the annual carnival. What is of interest is that they chose to do it in English, not creole or patois. Why?

Throughout history warriors in various cultures have believed that eating the heart of a courageous enemy imbues them with the slain foe's power. It is not too hard a leap to see the analogy in their taking the conqueror's language in the same way. There is another aspect to this argument of linguistic transubstantiation, that of beating the master at his own game. If we assume the generally acknowledged position of patois, creole, dialect and slang to be in some sense a defensive agency, reliant on exclusivity, a language that shields the user community from literally non-comprehending outsiders, then the effect of a patois speaker suddenly switching to the dominant group's language has an air of mastery all in itself. It means that they can comprehend you, but you are unable to comprehend them. The traditional Irish greeting of 'Good morning, sir' to an English landlord takes on a completely different meaning if you are aware that in a west coast Gaelic dialect, 'sir' actually is 'sor' and means 'louse'. Effective use of the dominant group's language is just one of many ways of bringing about those tiny revolutions.

WHITMORE: Just a minute Mrs Upjohn. That looks like a horse pill to me.
GROUCHO: Oh, you've taken them before.
WHITMORE: Are you sure, Doctor, you haven't made a mistake?
GROUCHO: You have nothing to worry about. The last patient I gave one
 of those to won the Kentucky Derby.

A Day At The Races, 1937

Before moving on to a wider discussion on ethnic comedy, it's time to examine the concept of 'Jewishness' in relation to American comedy. Why did so many Jews become writers or performers? I would argue that in relation to the Marxes and their contemporaries it was more to do with it being a viable option for escaping the teeming ghettos of the New World. There is indeed a tradition of Jewish humour, but then there is Celtic humour, or Mexican humour, or any other blend of humour you care to find. I would also be reluctant to claim that the Marxes or Perrin, Benny, Kaufman and the rest of them were in any way exclusively Jewish, in the sense of a modern Jewish comic like Jackie Mason. I would say they were people driven by demons who were

capable of seizing the *Zeitgeist* of their time and transforming it into a cross-cultural event that had strong resonances for all participants in the great American dream.

What is interesting to note here is a survival mechanism adopted by European Jewry in the nineteenth century, that of carrying your trade in your head. Living in geographical areas noted for the frequency of their pogroms against Jews, it became apparent that you had to be ready to leave your home at a moment's notice if you wanted to avoid being killed. More often than not you'd have to leave all your possessions behind you. This meant that if you were a tradesman or a skilled craftsman you'd more likely than not have to start again completely from scratch, acquiring stock, tools, premises, etc. How much more advantageous for you if you carried your trade in your head, like a doctor or a lawyer. That is why, it has been argued, Jews set such great store on their children doing well in education. Could this then possibly be a factor in the preponderance of Jewish artists in the entertainment business earlier this century?

Another answer to that question can be gained by looking at the population figures for New York which is where the Marxes *et al.* almost all hailed from. By the early twentieth century there were whole districts occupied by single ethnic groups, and one of the largest of these were the Jews. By the middle of the century there were more Jews in New York than there were in Israel; in essence they were numerically the greater group, so *ipso facto* more Jews would be entering the entertainment business. It is also worth bearing in mind that there was no Hollywood until two decades into the century; New York was the place for theatres, magazines, newspapers, actors, writers, singers, comics, etc. It was the hub of the American entertainment industry. It was from this crucible that the Brothers emerged to gain international fame throughout the 1920s and 1930s. Then, as with all things, their fame as a unit declined.

What happened to the Marx Brothers as a team was that they simply grew out of date. What had been perfect cinema fare for Depression audiences was considered too unsophisticated for post-war tastes. Perhaps the truth lies in the observation that the world was becoming as absurd as the Marx Brothers. In his book *The Marx Brothers. Their World of Comedy*, Allen Eyles quotes from a study of anti-Communist Senator Joe McCarthy. It reads like the description of a Marx Brothers' script:

> McCarthyism was, among other things, but perhaps foremost among them, a headlong flight from reality. It elevated the ridiculous and ridiculed the important. It outraged common sense and held common sense to be outrageous. It confused the categories

of form and value. It made sages out of screwballs and accused wise men of being fools.[11]

What then of ethnicity in American comedy? In terms of mass communication, TV, radio and film, and so on, artists until the 1960s, generally speaking, passed over open declarations of race or religion. Danny Kaye, George Burns, George Jessel, Eddie Cantor, Jack Benny, et al., even the early stage act of Bill Cosby, all avoided problematical areas. They tended to see themselves primarily as performers and entertainers, not as social commentators or proselytisers. Where this did begin to change was in the 1960s and is simultaneous with the emergence of various movements inspired by the Liberationist and Civil Rights activists of earlier in the decade, which included such diverse elements as Black Pride, Gay Pride and the Native American Movement.

There had, of course, always been exclusively ethnic comics operating in small nightclubs and holiday resorts like the Borscht circuit in the Catskills outside New York (Woody Allen, amongst others, played there), but now, here were people emerging with acts based almost exclusively on material taken from ethnic experiences, and openly celebrating them. Nor, again, was this an exclusively Jewish domain; Richard Prior came along and almost single-handedly (pace Dick Gregory) led the way for the next generation of young Black comics like Eddie Murphy. What is more significant about this postmodern multiplicity of discourses is the arrival on the US comedy circuit of openly racist, sexist and homophobic performers like Andrew Clay, known for a while as 'The Dice Man', whose phenomenally successful HBO Cable shows in the late 1980s were justified on the grounds of freedom of speech, guaranteed under the Constitution.

I'm making no comparisons whatsoever between 'comics' like Clay and former Rabbi Jackie Mason. Mason tells jokes that sometimes send up his faith and race, but he offers them to us all as a celebration of his particular 'otherness'. Clay and his poisoned ilk with his Nuremberg-rally style of delivery where his 'fans' would chant and punch the air in unison offers only prejudice and hatred as the ground-bed of his so-called humour. Clay has come under attack from a variety of well-meaning and not so well-meaning groups and this is where we can begin to see a problem with the original subjects of this study, The Marx Brothers. In this postmodern, politically correct age, where DWEMs (Dead White European Males) are being lined up for reappraisal, can aware, intelligent, thoughtful people find the sight of a Jewish con-man, a guy with a fake Italian accent playing it stupidly for laughs, and a vocally challenged underachiever,

amusing? In the opinion of this writer, of course we can! The Marx Brothers were, and remain, brilliantly funny.

The Marx Brothers represented all immigrants and used the dominant language of America as a weapon of protection for all its inhabitants. For theirs was a humour that crossed all barriers and was possessed of a universality that not only crossed cultural boundaries, but time as well.

GROUCHO: Hello – I must be going.

Animal Crackers 1930

In conclusion, I will paraphrase an anecdote that Groucho Marx was fond of quoting. It demonstrates quite clearly the fundamentals of ethnicity and goes a long way to proving the maxim that while you can take the boy out of the ghetto, you can't take the ghetto out of the boy.

In the 1920s two friends of The Marx Brothers were walking along 5th Avenue. The first one was Otto Kahn, a patron of the Metropolitan Opera. The second was Marshall B Wilder, a hunchbacked scriptwriter. As they walked past a synagogue Kahn turned to Wilder and said, 'You know, I used to be a Jew'. And Wilder said, 'Yeah, and I used to be a hunchback.'[12]

NOTES

1 Peter Farb (1974) *Word Play: What Happens When People Talk*, London: Jonathan Cape.
2 Richard J. Anobile (1974) *The Marx Brothers Scrap Book*, London: W.H. Allen, p. 15.
3 Ibid., p. 20.
4 Adamson, *Groucho*, p. 17.
5 Farb, *Word Play*, p. 31.
6 Anobile, *The Marx Brothers Scrap Book*, p. 75
7 Allen Eyles (1969) *The Marx Brothers: Their World of Comedy*, London: The Tantivy Press, p. 161.
8 Farb, *Word Play*, p. 31.
9 J. Clark 'The skinheads and the magical recovery of the working class community' in S. Hall (ed.) (1976) *Resistance Through Rituals*, New York: HarperCollins. For a more detailed analysis of bricolage, see Dick Hebdige's *Subculture – The Meaning Of Style* (1979, Routledge) where the author uses it to examine the Youth Culture surrounding Punk and Reggae.
10 Keith Warner (1982) *The Trinidad Calypso*, London: Heinemann, p. 29.
11 Eyles, *The Marx Brothers*, p. 156.
12 Anobile, *The Marx Brothers Scrap Book*, p. 77.

10

'WHERE EVERYBODY KNOWS YOUR NAME'

Open convictions and closed contexts in the
American situation comedy

Paul Wells

Making your way in the world today takes everything you've got.
Taking a break from all your worries sure would help a lot.
Wouldn't you like to get away?
Sometimes you want to go where everybody knows your name,
And they're always glad you came.
You want to be where you can see, troubles are all the same.
You want to be where everybody knows your name.

Theme from *Cheers*. Words and music by Jody Hart Angelo and
Gary Portnoy. Copyright © BMG Music Publishing Ltd
for the United Kingdom and Eire.
All rights reserved. Used by permission.

Jody Hart Angelo and Gary Portnoy's signature tune to the phenomenally successful American sitcom, *Cheers*, provides an apt summation of some of the codes and conventions of the American situation comedy. David Marc has suggested that 'sit-coms depend on familiarity, identification and redemption of popular beliefs' (Marc, 1989: 24) and this agenda is clearly endorsed in *Cheers'* opening lyrics, which acknowledge the pressures and anxieties of the contemporary world, and suggest the utopian comforts offered by the collective support of a like-minded community. *Cheers* is based in a Boston bar, which provides security and pleasure for a motley cross-section of local society whose 'troubles are all the same'; troubles which are ultimately shared and resolved, with a requisite degree of goodwill, good humour and overt sentimentality. Throughout its history, the American sitcom has created similar models to *Cheers*, and has in itself become a genre dedicated to offering the popular audience a space to

empathise with particular situations, rehearse a variety of responses, and find similar kinds of resolution. It is this process that this chapter will attempt to define and assess, moving from sitcom's antecedents in radio right through to popular contemporary examples of the genre like *Roseanne* and *Friends*.

However, the sitcom, in providing a context for an expression of personal and domestic agendas, does not merely operate as a melting pot for psychological and emotional struggle or glib, easily rationalised solutions. Rather, despite its apparent veneer of comic innocence, and liberal-democratic consensus, the sitcom, in the words of Darryl Hamamoto, 'has offered oppositional ideas, depicted oppression and struggle, and reflected a critical consciousness that stops just short of political mobilisation' (Hamamoto, 1989: 27). This is an important observation, and begs the question of how the sitcom has achieved this openness of socio-political conviction, and yet maintained its status as television's most popular genre. I hope to demonstrate that the sitcom creates comic structures which legitimise the expression of a variety of politicised agendas, and, consequently, the creation of a multiplicity of possibly contradictory discourses. These discourses take place, however, within closed contexts which appear to contain the implications and effects of these debates. The situation comedy can provide a legitimate context where, within apparently conservative and consensual limits, complex, sometimes subversive discourses may be rehearsed. Significant ideas and issues are addressed in seemingly innocent and trivialised parochial situations, but are engaged with and resolved in a symbolic way through the mediation of comic exchanges and events. In many senses, the sitcom is the most appropriate site for these small acts of political and ideological 'smuggling', and this is central to the genre's endurance and constant rejuvenation in the American context.

The American sitcom has progressed in a number of respects, which reflect aspects of change in American culture. At the same time the makers of US sitcom were constantly attempting to engage an audience and maintain it in the face of commercial pressures, political lobbying, and unpredictable variations in popular taste. The sitcom focuses on the very humanity of its characters and stories in a way which laughs at, rather than dwells upon, life's vicissitudes, and, it is this light-hearted, 'people-centred' approach which gives the genre a broad appeal, accommodates many different kinds of audience, and most importantly, brings an innocent, common and timeless 'feel' to the situations. Thus, the comedy as it is played out in these situations masks many of the political dimensions which inform the programmes and which are essentially the chief thematics of the genre.

It is clear that the writers and producers of the sitcom achieved their acts of 'smuggling' through the necessity to maintain the fundamentally reactionary (but evidently successful) formula of the sitcom, while finding areas of development which corresponded to new cultural agendas. From the outset of American broadcasting, commercial imperatives dictated that programmes had to be popular in order to achieve and maintain a large consumer audience (see Comstock, 1991). Consequently, once particular models of programming were provenly successful at the commercial level, their structures, conventions and modes of address were sustained, repeated and imitated. Todd Gitlin notes, for example, that this has been achieved through various *recombinant* strategies: that is, strategies that recombine elements of a successful programme in a different way, suggesting 'if a spinoff exploits success by transferring a character, a copy exploits it by reproducing a formula' (Gitlin, 1994: 69). I wish to argue, however, that the genre, despite its many inflections and styles, is progressive, because it consistently uses comedy in the negotiation of personal, moral and sociopolitical issues, and uses its recombinant features to reflect the effects of increasing social fragmentation and cultural destabilisation. I will now address some of these ideas in relation to the evolution of the genre.

Radio Days

Early radio comedy was characterised by Vaudevillian models of entertainment, and was mainly informed by comic songs and the patter of double acts like 'The Happiness Boys', Billy Jones and Ernie Hare (Wertheim, 1979: 11). The first major innovators in the field of radio sitcom were Freeman Gosden and Charles Correll, who grew up in the South, and wrote and performed *Sam 'n' Henry*, about two Southern Blacks, prefiguring the later format of *Amos 'n' Andy*, the extremely successful sitcom that properly established the genre as a radio form. Debuting in 1926, *Sam 'n' Henry* drew most of its humour from the established stereotypes of the Blackface minstrel shows, and cast its two lead characters struggling to adjust to a new life in Chicago after leaving the South. These legitimised jokes about indolence, ignorance and naivety in Black character had been the staple of White entertainers such that the wide acceptance of these patronising comic caricatures was not open to question.[1] Leaving the *Chicago Tribune* affiliated radio station, WGN, Gosden and Correll joined the Chicago *Daily News* affiliated station, WMAQ, in order to attain national distribution of recordings of their show. Forced to change the name of their show because of copyright laws, Gosden and Correll created *Amos 'n' Andy*, and having found early success across the country, came to the

attention of William Benton of the Lord & Thomas advertising agency. He suggested that the programme should be sponsored by Pepsodent and offered it to NBC for national broadcast.

The show was an immediate success, mainly because it remained topical and found its first major subject for comic interrogation in the Wall Street Crash of 1929 and the subsequent depression years. Amos and Andy's failed get-rich-quick schemes were comic commentaries on the profound poverty and hardship suffered during the depression. Such humour offered solace to an audience who empathised with the hope that things might improve, and with the implied critique of those who had failed to govern effectively. Simultaneously, however, the programme patriotically foregrounded its fundamental belief in the nation's traditions and its ability to recover through the accepted virtues of family and community. In one show, Amos gave the following speech:

> Times like dese does a lot o' good 'cause when this is over, which is bound to be, an' good times come back again, people's like us dat is livin' today is goin' to learn a lesson an' dey know what a rainy day means. People is done always used de repression 'I is saving up fo' a rainy day' but dey didn't even know what dey was talkin' about. Now, when good times come back again people is gonna remember all dis an' know what a rainy day is – so maybe after all, dis was a good thing to bring people back to dey're senses an' sort a remind ev'rybody dat de sky ain't de limit.
>
> (Quoted in Wertheim, 1979: 44)

Warning against complacency and profligacy, the speech addresses the key political issue of government and consumer spending in the much more universal and colloquial terms of everyday exchange. Even something as devastating as the Depression is seen in optimistic terms: that is, as a period of suffering which was caused by wilful indulgence and mismanagement, and, as such, may be something which can be learned from and avoided again. Here is a political and moral lesson, offering perspective and insight, but within the innocent confines of exchanges between two social (and racial) misfits estranged in an urban context. This 'backwoods' sensibility also featured in the characters of *Lum 'n' Abner*, played by Chester Locke and Norris Gough, though it was less insightful, and more prone to literal jokes and extended routines based on misunderstanding. The pair did not venture often into the city environment. This country/city tension informs the themes of rural alienation and simple perception of later television sitcoms like *Green Acres* and *The Beverly Hillbillies*.

The Radio Boom of the late 1920s and 1930s meant that by 1935 over 70 per cent of American homes had a receiver, and that radio performers became *national* stars, providing models for the listener to endorse and aspire to. *Amos 'n' Andy* was a programme readily acknowledged as popular entertainment which, in NBC announcer Bill Hay's words, offered 'a homey philosophy that attacks life's problems in a way that interests, amuses, and in so many cases helps' (Wertheim, 1979: 47). The sitcom did more than entertain; it initiated a framework of exchange that has prevailed throughout the genre's existence, namely, the *Therapeutic Discourse* (see White, 1992) – a quasi-philosophical exchange about the personal and political meanings of everyday life in the domestic scenario, enabling characters to engage in acts of symbolic *confession*, prioritising their own perspectives and the need for personal redemption. Inevitably, this kind of exchange found echo in the audiences who listened to (and later watched) sitcoms, who empathised with characters and situations, and were offered scenarios which rehearsed their own anxieties and concerns, but in a way which also afforded them the relief of humour. The sitcom represented and enjoyed the pleasures and pains of domestic relationships, but one of the early consequences of sponsorship was the necessity to appeal to listeners and viewers with large disposable incomes, and most particularly, what may be understood as a WASP (White Anglo-Saxon Protestant) middle-class audience. Inevitably, early sitcoms, therefore, reaffirmed middle-class family values, an agenda which has consistently informed the genre, and generated some of its key tensions.

Fibber McGee and Molly and *Vic and Sade* were the first major radio sitcoms to engage with the politics of the small-town household in the American mid-west. *Fibber McGee and Molly*, played by Jim and Marian Jordan, and written by Don Quinn, played out its social agenda in the American tradition of 'Tall Talk'. As historian Daniel Boorstin notes:

> Tall talk described the penumbra of the familiar. It blurred the edges of fact and fiction. Discovered and established by urgent need and quick consent, tall talk was a language without inhibitions. It did not grow, it exploded from a popular demand for modes of speech vaguer, less clear-edged, more ambiguous than the existing language provided. It responded to the newness and uncertainties of the New World. It was the language of Community before Government: of people who first shared experiences and purposes, and only later legislated about them.
>
> (Boorstin, 1988: 290)

It was also a language that leant itself to comic purposes. The exaggeration and ambiguity of tall talk was intrinsically amusing in the sense that its claims were excessive, but it also had the consequence of throwing the limitations of the real world into further relief. It became the language of ambition and endeavour in contexts which would not necessarily support such certainty. It thus became the language of the inept egotist, a comic stereotype best epitomised by Jack Benny or Bob Hope. Quinn's character, 'Fibber' McGee, was a braggart and a liar, but his persona remained good-natured and appealing. His boastfulness was continually exposed and undermined, but McGee was never seen as anything but well-meaning and lovable. Implicit in the tall talk of *Fibber McGee and Molly* was hope, and the desire to succeed, but couched in terms which expressed the fervent belief of human endurance and liberal-democratic consensus. As Arthur Wertheim suggests,

> During that time of widespread bankruptcy, unemployment, and poverty many Americans bore a feeling of personal inadequacy and internal shame for failure. A listener whose self-image was low readily identified with the egotist, who, despite constant ridicule, maintained his vain traits and delusions. The great radio comedy hero was the loveable fall guy or fool whose affectations derived from traits common to all of us.
>
> (Wertheim, 1979: 219)

Fibber's tall talk epitomised his folksiness, and included slang catchphrases like his euphemism for swearing, 'dad-rat the dad ratted', and the show's trademark use of the extended comic tongue twister. As the show developed, Fibber became more accident prone and blundering, especially in his ever cluttered hall closet (an opportunity for funny sound effects), and his exaggerated claims sat uneasily with his failings, producing a greater degree of comic sentiment. Fibber, in many ways, anticipates one of the enduring stereotypes in sitcom, the white male, working-class, buffoon, best represented by William Bendix in *The Life of Riley*, Jackie Gleason in *The Honeymooners*, Archie Bunker in *All in the Family* and Homer in *The Simpsons* (see Butsch, 1995).

Molly was Fibber's ever suffering, ever tolerant wife, who essentially played the straight role to her husband's excesses, but had a gentle, knowing humour of her own, commenting on his ineptitude. The couple lived in a house called 'Wistful Vista', a name which conjures the nostalgic (reactionary) yet optimistic (progressive) feel of the programme, and the endearing appeal of the (real-life) husband and wife team. *Fibber McGee and*

Molly was essentially based on comic slapstick, but *Vic and Sade*, written by Paul Rhymer, which premiered in 1932, prioritised more character-based, dialogue-centred humour, making small talk the focus for much of the comedy. Vic and Sade Gook became a vehicle for Rhymer to satirise social aspiration, using Vic's often surreal and cynical humour, or Sade's modes of gossip and exaggeration to undermine those with power and status – chiefly, their local mayor. Moreover, the show looked to the details and idiosyncrasies of ordinary life to show the kind of humour inherent in having a personal and unusual perception of the world. Vic's view of love, for example, is characterised by his incongruous use of everyday materials to describe the vagaries and illusiveness of the emotion:

> You may wear it on your head like a gauntlet glove: you may throw it to the four winds like canned salmon; or you may rub it in your hair like potato peelings. In the end it always narrows down to the same thing – vanilla.
>
> (Wertheim, 1979: 250)

Quite what this description amounts to is uncertain, but it nevertheless draws together a number of surreal strands to humorous effect, deliberately misusing words and misinterpreting events. This 'mangling' of language characterised a great deal of radio humour, especially in the Vaudevillian cross-talk exchanges of George Burns and Gracie Allen in *The Burns and Allen Show*, and Jane and Goodman Ace in *Easy Aces*. These shows operated as quasi-sitcoms, in the sense that the couples inhabited a particular place and were sometimes concerned with domestic scenarios. But this soon gave way to a kind of humour that only partially reflected everyday events and more specifically operated as 'a routine' subject to its own narrative laws and conditions.

The cross-talk tradition was to inform other radio sitcoms like *Duffy's Tavern*, which anticipates *Cheers* in being an ensemble comedy set in a bar (where the eponymous Duffy never appears), and *The Bickersons*, which prefigures *All in the Family* and *Roseanne* in its barbed blue-collar cynicism, and a certain degree of quarrelling which isn't underpinned by affection. Vaudevillian cross-talk was a close relation to the 'wisecrack' monologue, characterised by simple observations and one-liners, ultimately perfected by Jack Benny, Fred Allen and Bob Hope in their radio shows. Indeed, this type of humour became the dominant mode of comedy, even if it was sometimes couched in familiar sitcom scenarios. The key difference, however, is that these scenarios were not sustained, and relied on the star persona of the performer to inform the humour. The sitcom more

properly evolved into a genre determined by character comedy predicated on domestic issues, and epitomised by a show like The Aldrich Family. The son in the family, Henry Aldrich, established a stock figure, that of the well-meaning child who gets into trouble despite all his best efforts to help. This character recurred in television sitcoms like The Adventures of Ozzie and Harriet (Ricky) and Leave it to Beaver (Wally and Beaver).

Television was soon to absorb a number of models of programming established on radio. The new phenomenon saw rapid growth. By 1952, over seventeen million TV sets were located in American homes, and advertisers and sponsors, the financial backers of all the top radio shows, perceived a ready market opportunity in the early years of the new medium. Television comedy largely divided into two significant strands which absorbed the dominant radio models. First, the Vaudevillian strand, which recovered the visual and physical comedy (so prevalent on the variety stage, but unviable on radio), and combined it with wisecrack humour. This is, perhaps, best exemplified by Milton Berle on Texaco Star Theater. Second, the Situation Comedy strand, which established the character-led, family-centred mode of behavioural humour. This was not the comedy of 'gags', but the comedy determined by a recognition of, and the identification with, human traits and foibles. The self-absorbed, self-contained scenarios of Amos 'n' Andy, Fibber McGee and Molly, Vic and Sade and The Aldrich Family provided a model by which the common aspects of American 'folk' culture could be played out in relation to the bigger picture defined by American political and commercial culture. These programmes were based on the idea of a familial or community-orientated space negotiating its own moral principles and convictions in the light of changing social agendas. This model has survived throughout the history of situation comedy, changing only in matters of emphasis and self-consciousness.

'What a revoltin' development this turned out to be!'

In 1953, William Bendix replaced Jackie Gleason as Chester Riley in The Life of Riley. Gleason had seemed uncomfortable in the role since its inception in 1949. Bendix, however, epitomised the bumbling, good-natured, blue-collar father, constantly making mistakes, and hollering 'What a revoltin' development this turned out to be!', which quickly caught on as a popular catchphrase across the country. In retrospect, his comment may well be seen as an appropriate summation of the early fate of the sitcom on television in the late 1940s and early 1950s. Programmes like The Life of Riley, The Aldrich Family, The Goldbergs and Ozzie and Harriet were predominantly informed by comic sentiment; the humour emerged out of reassuring

scenarios in which the family was constructed as an economically secure, domestically settled, socially aspirant unit, subject only to easily resolvable situations and problems. Such shows merely endorsed the dominant codes of responsible social citizenry. Little of this was funny in the way that the gender conflicts, surreal inventions, or verbal flights of fancy that informed the radio sitcoms had been; rather, it was amusing. In other words, the comedy of behavioural humour, in endorsing a social status quo, and reasserting dominant cultural formations, principally the dominant role of the father, rendered much of the comedy itself banal. The purely aural dimension of radio had legitimised imaginative scenarios, and implicitly encouraged the audience to revel in both the empathetic and subversive possibilities offered up by the various situations. The literal aspect of television sitcom fundamentally reduced this level of engagement, and in doing so, delineated a different style of comedy which was less socially disruptive or intrusive.

Father Knows Best premiered in 1954, transferring from radio, on which, significantly, it had been called Father Knows Best? The Andersons, who featured in the programme, became a paradigm for the all-American family: largely unflawed, morally and socially responsible, loving and caring; an appealing role model for aspirational families in the 1950s. Interestingly, the universal conception of the Anderson family is supported by the location of their home in Springfield. There are numerous towns called Springfield in the United States, and clearly, the show's creators envisaged the fictional Springfield as an American Everytown; a particular vision of small-town America, later parodied in the Springfield of The Simpsons. Father Knows Best, though, is a significant development in the sitcom because it took up the idea of the Therapeutic Discourse as part of its implied agenda concerning the determination of a model for effective parenting. As Susan Sackett has noted, 'Jim Anderson was actually employed – rare for TV fathers of the '50s; he also didn't bellow or rule with a fist of iron. He and his wife Margaret tried to set examples for their children' (Sackett, 1993: 88). This liberal agenda chimed with some of the new theories concerning parenting advanced by Dr Benjamin Spock[2] but, more importantly, it served to endorse and naturalise particular codes and conventions which both defined 'the family' structure and models of appropriate behaviour. Jim Anderson (Robert Young), was the benevolent patriarch at the top of the hierarchy, venerating his wife, Margaret (Jane Wyatt), as the emblem of 'Momism', and the epitome of the 'domestic goddess', later to be dismissed as a relevant model of maternity in the construction of motherhood in Roseanne (see Rowe, 1995). The Anderson children, Betty (Elinor Donahue), James (Billy Gray) and Kathy (Lauren Chapin), were essentially

acquiescent, mature and entirely sensible. This apparently perfect model of family life offered American audiences a utopian myth set in the suburbs – more significantly, it provided a context in which the artefacts which defined the perfect home could effectively be sold to the American middle classes (see Haralovich, 1988).

The sitcoms based on an essentially behaviourist model aspired to a code of naturalism. The show which was the genre's most immediate and enduring success, however, sought to use the domestic scenario for modes of 'situation slapstick'. Debuting in 1951, I Love Lucy, featuring Lucille Ball as a suburban housewife married to a Latino bandleader (her real-life husband, Desi Arnaz), played out various narratives in which Lucy engaged in numerous routines involving physical gags, costumed clowning and implausible disguise. These brilliantly executed 'riffs' – constantly gorging chocolates on an ever accelerating factory conveyor belt; becoming increasingly drunk as she consumes an alcohol-based health-food product during the numerous rehearsals for a commercial, or impersonating the antics of Harpo Marx – serve to mask the ideological framework of the programme. Patricia Mellencamp has argued that this kind of narrative uses humour in the spirit of containment, casting 'dissenters' like Lucille Ball, and indeed, Gracie Allen, as contented housewives-cum-Vaudevillians, frustrated with their entrapment but ultimately contented with their designated social position (see Mellencamp, 1986 and 1992). Equally, one could view Ball (and Allen) as using these comic modes for subversive effects. The war had provided new models of outlook and behaviour for women, which had made the institution of marriage much more vulnerable in the post-war period. Clearly, therefore, there was a desire in some quarters for ideological re-entrenchment, but, despite the promotion of paternalism and the quasi-deification of the passive domesticated wife, gender roles had irrevocably changed. Lucy's comic antics are essentially a symbolic mode of empowerment in which she controls and reconstructs her body in terms which give her complete physical freedoms and/or parody patriarchal codes. Though this is seemingly contained by the closed context of the established gender order, the open conviction of Lucy's position is the comic narrational device which carries the most social and moral certainty. Her invention, imagination and initiative essentially redefine every previously 'male' space. Her anarchy is something laughed with by women, laughed at by men, the latter naively assuming that the social order will inevitably stay the same when it is changing before their very eyes. It is probably one of the key reasons why I Love Lucy endures in syndicated reruns worldwide. The more gender power relations have changed, the more Lucy seems pioneering and relevant.

Lucy's rebellion is not merely confined to the domestic space, but plays out her desire through consumer culture, by her occasionally over-whelming desire to shop (Mellencamp, 1992: 324). This establishes a useful ambivalence in the sense that such behaviour inevitably meets the requirements of sponsors and advertisers, but it also threatens to exploit and redefine the home environment for different purposes. Faced by the notion that domestic space might be redefined as female space, the sitcom turned its attention to the working environment, both as a site for the implied extended family, and as a mechanism by which to reflect the con-struction of the television world. This first occurred in The Dick Van Dyke Show, which debuted in 1961. This inward-lookingness with regard to the medium was in many senses prompted by the recognition that television itself was becoming a social preoccupation, and prompting important social debates. Appointed as Chairman of the Federal Communications Commission by John F. Kennedy, Newton Minow, addressing the National Association of Broadcasters, in the same year as The Dick Van Dyke Show first aired, stressed that when television was bad it constituted 'a vast waste-land', and that a committed viewer would only see

> a procession of game shows, violence, audience participation shows, formula comedies about totally unbelievable families, blood and thunder, mayhem, violence, sadism, murder, western bad men, western good men, private eyes, gangsters, more vio-lence, and cartoons. And endlessly, commercials – many screaming, cajoling and offending.
>
> (quoted in Comstock, 1991: 27)

David Marc suggests that The Dick Van Dyke Show works as an oasis in this vast wasteland because it directly corresponded to Kennedy's New Frontier ethos (Marc, 1989: 84). Formalising the implied aspects of 'show busi-ness' as they had occurred in shows like The Adventures of Ozzie and Harriet (Ricky's budding career in Rock'n'Roll) or I Love Lucy (Desi Arnaz as a bandleader; the Mertzes, the Ricardo's neighbours, as retired vaudevillians), The Dick Van Dyke Show wished to show the inner workings of television from a writer's perspective. Based explicitly on the experiences of comedy writer and performer, Carl Reiner, later the director of successful film comedies like Dead Men Don't Wear Plaid (1976), the show first emerged as Head of the Family, a pilot sponsored by JFK's father Joseph and featuring Reiner himself in the lead role. Initially, the programme did not receive favourable responses, and was revised by Reiner in association with Sheldon Leonard, producer of successful variety-led sitcom vehicles like The

Danny Thomas Show and The Andy Griffith Show, who suggested, much to Reiner's displeasure, that the lead role of Rob Petrie be recast with Dick Van Dyke, who won the role over Johnny Carson, later renowned for his successful talk shows. Marc suggests that this ploy may have been based on the idea of diluting Reiner's 'jewish' agenda in the show, and heightening WASP orthodoxy (Marc, 1989: 98). It is certainly the case that Rob Petrie, and his wife, played by Mary Tyler-Moore, were constructed in a way that more explicitly recalled yet updated the WASP sitcom family of the 1950s. A college graduate, Rob Petrie plays out liberal-consensus politics in regard to his work colleagues, but embodies more progressive agendas in his tastes and preferences. Rob and Laura are clearly identified as a modern couple in the sense that they recognise the culture and they are part of and contribute to, endorsing the civil rights movement and encouraging discourses about equal opportunities in the workplace and the need to provide for the disadvantaged in society. The most important difference in The Dick Van Dyke Show from sitcoms like Father Knows Best was that commercial agendas were being coupled with overt concerns about aesthetic and cultural preference, rather than merely domestic concerns. These adult agendas were more specifically adopted in the 1970s when the sitcom sought relevance, but not before the late 1960s had brought more of what Minow described as 'formula comedies about totally unbelievable families'.

'If television is America's vast wasteland, the Hillbillies must be Death Valley'[3]

Extraordinarily popular sitcoms, like The Beverly Hillbillies, won little critical favour, but in representing a backwoods family newly engaging with an alien urban setting, the programme reflected the culture of rural areas, which increasingly were populated by television stations. New audiences in these areas took advantage of the availability of cheaper TV sets, and enjoyed a greater degree of consumer spending. A proliferation of what Hamamoto calls 'supernatural sitcoms' (Hamamoto, 1989: 60), also emerged in this period, and included Bewitched, My Favourite Martian, The Munsters and The Addams Family. Similarly, a series of military-centred sitcoms, following on in the spirit of The Phil Silvers Show from the 1950s, characterised the schedules, ranging from F Troop to Hogan's Heroes to Gomer Pyle, U.S.M.C. It is no coincidence that these sitcoms are entirely predicated on fantastical scenarios. Simultaneously, they operate as easy escapist entertainment, but also as self-evidently 'safe' texts that are seemingly unconnected to the traumatic decade of social upheaval in the United States. The fantasy frameworks of these sitcoms are essentially the closed

contexts in which open convictions are expressed in playful metaphors, half-appeasing cultural expectation, half-'smuggling' subversive discourses. In many senses, for example, military sitcoms offered nostalgic comforts and distraction from America's involvement in the Vietnam War. Likewise the very 'otherness' of monstrous or magical families only proved that the WASP , middle-class liberal consensus, was proving increasingly unstable. It was increasingly recognised as ideological and socially oppressive in marginalising certain groups, and as perpetuating the myth of an economic prosperity not shared by many of the population.

The Munsters and The Addams Family, in their delirious reversals of social orthodoxies, represent an inversion of the morally and culturally naturalised sensibilities of their middle-class neighbours. This echoes the implied 'White Trash' aspects of The Beverly Hillbillies, who innocently undermine the establishment, and it anticipates the aggressively Blue Collar contempt actually voiced in Roseanne. Herman Munster, and his family, for example, are anachronistic and inappropriate in a way that gains comic purchase through the manipulation of generic expectations. Essentially the very middle classness inherent in a sitcom played out on purely naturalistic terms and behaviourist recognition, is thoroughly undermined, and sometimes negated, by the imposition of generic types which have no place in that context. The very incongruity of a family of monsters behaving as if they were a normal, suburban middle-class family, inevitably offers a critique of social orthodoxy. The gothic trappings attendant to both The Munsters and The Addams Family have their own generic meanings, and thus revise the meanings inherent within the environment which they ultimately inhabit. The pursuit of pleasure (experimenting in the lab, playing a round of golf, etc.) is a key characteristic of both families, especially as it is couched in unusual pursuits and the ease of their supernatural powers.

This issue is crucial in Bewitched in which Samantha, played by Elizabeth Montgomery, can perform magical feats. Though only using magic when absolutely necessary (in her desire to be 'normal'), Samantha is empowered in a way which can both maintain the social status quo and privilege particular needs for her husband, Darren, and daughter, Tabatha. Interestingly, this tension between maintenance and progress, a central tenet of the Kennedy outlook, echoing The Dick Van Dyke Show, essentially collapses liberal interventionism and conservative notions of self-help into an indistinguishable whole. This is perhaps unsurprising when one considers that dominant social groups sought to maintain traditional structures in the full knowledge that previously marginalised groups were mobilising in the light of changing political agendas and new legislation. For example, Kennedy formed the Presidential Commission on the status of

women. This led to the Equal Pay Act of 1963, and the subsequent formation of the National Organisation For Women (NOW), which championed the rights of women in all contexts. This, however, now worked principally from a revisionist view of the role of women from the middle-class: seen as no longer passive, but educated and formulating a mode of proto-feminism. Bewitched operates as an apt metaphor for female transgression in an increasingly destabilised patriarchal context. Darren, though he would like to think that his authority prevails, knows that his wife is enpowered in ways that ultimately make his assumptions at least, naive; at worst, obsolescent.

As Ella Taylor has noted, this implied mobilisation against the complacencies and orthodoxies of the middle-class was at the cost of other kinds of representation, chiefly 'the virtual disappearance of working-class family comedies' (Taylor, 1989: 32). In the post-Kennedy era, there was increased political activism linked to the rise of feminism, a radical youth culture, and the zenith of the Civil Rights movement. This progressive activity consolidated a process of new democratisation, with the inevitable consequence of increasing social fragmentation: social differences – male and female, young and old, white and black, blue collar and white – were now heightened. If humour had previously operated in a way that assumed that the audience all shared the same perspective on the joke, now the idea was that comedy should engage with the topical, and should reinforce its agenda through the satirical. In 1968, there emerged the first of what Hamamoto has termed the 'ethnicom' (Hamamoto, 1989: 91). Julia, featuring Diahann Carroll as a widowed nurse – her husband had died in Vietnam – took an assimilative rather than antagonistic view of a Black person in an ostensibly White culture. The programme made the tacit assumption that Black culture was equably absorbed within mainstream society, and adopted a liberal tone in its race agendas. The following telephone dialogue between Julia, and her employer, Dr Morton Chegley, played by Lloyd Nolan, serves to illustrate this point:

JULIA: Did they tell you I'm coloured?
CHEGLEY: Mm, what colour are you?
JULIA: Why, I'm negro.
CHEGLEY: Oh, Have you always been a negro, or are you just trying to be fashionable?

The humour here is double-edged. It clearly draws attention to the idea that Black people have been marginalised from particular occupations and roles, but makes its joke arguably at the expense of the necessarily high

public profile of the Civil Rights movement. The joke serves as a good example of the sitcom's uneasy transition from the personal and domestic domain to the public sphere. Once more attempting to rationalise the conservative against the liberal agenda, the programme appeases popular audiences, but fails to create a progressive discourse in regard to race issues.[4]

Watershed of wit

Arguably, the commercial interface with the American sitcom has operated partially in a censorial way, inhibiting the overt discussion of ideas and issues that might seem detrimental or inappropriate to the sale of particular products. Clearly, sitcoms needed to strike a tone of optimism and vitality rather than one which was in any way cynical or downbeat. Ironically, it was a shift of emphasis in broadcasting policy in relation to advertisers that legitimised a different and more progressive approach to the sitcom in the 1970s. As Taylor notes, 'what mattered was less how many people tuned in than how much they earned and were willing to spend on consumer products' (Taylor, 1989: 44). With the emergence of a *demographic* approach to the age, sex and income of specific targeted audiences, so emerged particular kinds of programming which recognised different interest groups, and echoed new discourses in society. These audiences constituted markets which chimed with the splintered social groupings of the post-Kennedy era. Corresponding to this shift of commercial interest was a period of aesthetic and political programming that Thomas Zynda defines as a watershed in American television (Zynda, 1988: 126).

Three groundbreaking sitcoms were produced in this time – *All in the Family*, *The Mary Tyler Moore Show* and *M.A.S.H.* – which essentially redefined the genre. Norman Lear's sitcom, *All in the Family*, was at the top of A.C. Neilsen audience ratings list for five years, and simultaneously recovered working-class representation in mainstream television comedy, while redefining its comic signature as abrasive rather than good-humoured bluster. Archie Bunker (Carroll O'Connor), course, bigoted, yet somehow good natured, provided an ambivalent role model that some audiences laughed *with* (endorsing his insensitivity and racism), and some audiences laughed *at* (recognising the ironic critique implied in his excessive attitudes) (see Vidmar and Rokeach, 1974). *The Mary Tyler Moore Show*, featuring Mary Tyler-Moore as a career-minded, single woman, working for Channel 12's *Six O'Clock News* team, was a radical departure from previous female-

centred sitcoms, in the sense that it privileged the proto-feminist issues in a distinctly *social realist* context. Tyler-Moore, playing a very different role from that of her passive housewife, Laura Petrie, in *The Dick Van Dyke Show*, was not constructed in a specifically comic way. This was not the comedy of 'gags', but the humour of the therapeutic discourses, often played out in ways which Mary would mediate the agendas of her boss, Lou Grant (Ed Asner), and her friends, Rhoda (Valerie Harper) and Phylllis (Cloris Leachman), all of whom later became stars of spin-off series (see Feuer, Kerr and Vahimagi (eds) 1984). The open convictions expressed in *The Mary Tyler Moore Show* were predicated predominantly on the new freedoms available to women in attempting to determine their own destinies. If *All in the Family* was concerned with the dysfunctional family attempting to deal with the social changes that were impacting upon their perception of the world, *The Mary Tyler Moore Show* was an example of those, particularly women, in the vanguard of creating new models of social existence. The comedy in both ultimately emerges from the self-evident incongruities of past and present.

M.A.S.H., produced by Larry Gelbart, was perhaps the clearest embodiment of a countercultural sensibility in its coded anti-Vietnam war stance. Set during the Korean war, in a Mobile Army Surgical Hospital, the series maintained a tension between anarchy and tragic *gravitas* over its 255 episodes and eleven-year tenure – three years longer than the Korean war itself! 'Hawkeye' Pierce (Alan Alda) made such observations as 'The thing you learn out here is that insanity is no worse than the common cold', aptly summarising not merely the essentially homogenising ambivalence of the wartime experience, but also the new conditions of the sitcom. M.A.S.H., like *All in the Family*, uses the comic mechanism of the satirical one-liner to explain and explore the contemporary condition. In M.A.S.H., such lines comment on the amoral universe of the real conditions of war rather than the heroic myths of gung-ho right-wing ideology. Gelbart successfully translated the ethos informing Robert Altman's original film version of M.A.S.H. to the television context. Altman stressed, 'when we had the choice, we always chose the joke that was in poorer taste, because we figured that nothing was in poorer taste than the war itself'[5]. When 'Hawkeye' lists the invaders of Korea, he cites the Russians, the Chinese and the Americans, only to use studied bathos by concluding, 'and appearing this week, Professor Jerry Colona', reducing the war to the status of a comic variety act, and implicitly satirising colonial ambition. No one is free from ridicule in M.A.S.H. Reassuring a patient, Hawkeye says, 'President Truman gets gas. They just don't print it in the papers.' This line is particularly representative of the M.A.S.H. style in that it undermines any

mode of authority or ritualised procedure, either through incongruity or through recourse to the lowest common denominators of human experience. To compound its irony, M.A.S.H. even makes jokes *about* insensitivity – a surgeon, for example, is described as having 'the same light touch as a German jazz band'. The amoral context creates immoral comic address, enabling the programme to make a comprehensive critique of a government victim to the illusory notion of a necessary war. Zynda summates M.A.S.H.'s relevance and popularity:

> the appeal of Hawkeye and the other surrogates for the American character, survived the roller-coaster political shifts of the 1970s and 1980s, through Nixon, Ford, Carter, and Reagan administrations. Its final episode, in February 1983, a few months after the dedication of the Veterans Memorial and mid-way through the first Reagan administration, drew a 60 rating and a 77 share, making it the most viewed series telecast ever.
>
> (Zynda, 1988: 130)

Audiences were increasingly identifying with the sitcom as a model which provided both entertainment *and* the discussion of important social issues. In an interesting test case for particular advocacy groups, *Maude*, featuring Beatrice Arthur, latterly of *The Golden Girls*, dealt with a scenario in which the 47-year-old Maude discovered herself to be pregnant and opted for an abortion – a story-line which Kathryn Montgomery suggests, 'tested, as never before, the boundaries of acceptability for programme content' (Montgomery, 1989: 28). The numerous advocacy groups which lobbied for or against the representation of serious issues like abortion in such programmes inevitably began to affect the agendas of both broadcasters and advertisers alike, and in the mid-1970s, the reinstallation by the US TV networks of a prime time family hour (an agreement to pursue greater propriety in prime time scheduling) significantly reduced the creation of radical sitcoms, and implicitly endorsed a backward-looking agenda. *Happy Days*, a sitcom that epitomised the desire to revisit the ideological certainties of the 1950s, was soon top of the ratings.

BACK TO THE FUTURE

The sitcom in America essentially reached the zenith of its popularity in the 1978–9 season, when nine out of the top ten rated programmes were sitcoms, including *Happy Days*, plus its companion programmes from the Garry Marshall production stable, *Laverne and Shirley*, *Angie* and *Mork and*

Mindy, the latter featuring Robin Williams. Though not the first to impro-
vise material within the narrative context of a sitcom, nor the fist to use
modes of stand-up address in such a vehicle, Williams often played out
topical agendas through these free-wheeling imputs, and anticipated the
rise of the stand-up comic within the sitcom in the late 1980s and 1990s.[6]
Also featured in the top ten were M.A.S.H., All in the Family, Taxi, Three's
Company, and its spin-off The Ropers. By the 1983–4 season, however, only
one sitcom – Kate and Allie – featured in the top ten, and the popularity of
the genre seemed to have run its course. Kate and Allie, innovatory in its
reconstruction of the family unit as the combination of two women
divorcees and their children, was also, however, a return to the same rec-
onciliation of liberal and conservative tendencies found in the 1960s
sitcom. Kate (Susan Saint James) often pontificated on the value system of
the counterculture, citing her own activities as a student, for example, in
recommending a sit-in at her daughter's school. Allie (Jane Curtin) firmly
trod the conservative line, however, especially in the disciplining of her
children in the predominant absence of their father. Indeed, the pro-
gramme is a good example of the ongoing use of the therapeutic discourse
as an educational tool in models of good parenting. Both Kate and Allie are
good parents and hold down taxing jobs. Further, they merge these agen-
das when they start their own successful catering business. Kate and Allie
anticipates what might be seen as the saviour of the genre in the early
1980s – The Cosby Show – in its favouring of scenarios which had implied
aspects of teaching and learning about contemporary issues.

The Cosby Show, featuring Bill Cosby as Dr Cliff Huxtable, was essentially
a Black middle-class version of Father Knows Best, recalling patriarchal hier-
archies in the family unit, and playing out situations in which the
children came to terms with the seemingly irrelevant details and large-
scale issues of growing up. Like Julia, The Cosby Show takes an assimilative
position on race issues, but places its emphasis on socially responsible,
humanist, educational initiative within each episode as its overt purpose,
fully endorsed by social psychologists and educational experts. This
approach was fully initiated and developed by Cosby himself, and was
perceived as a model which contributed positively to society, resisting
more cynical and irreverent models like The Simpsons (see Bianculli, 1992:
174–83). The success of The Cosby Show may be largely attributed to its
empathetic codes of recognition and its overt conservatism in returning
to traditional parenting, and to the promotion of the skills required to be
successful in American life. The very first episode of The Cosby Show fore-
gounded this when Cliff Huxtable does not accept his son Theo's excuses
for poor grades, nor his plea for love in spite of his lack of achievement.

Huxtable merely sees this as indolence, lack of ambition and a misrepresentation of his son's potential; he says that this is unacceptable, and should be corrected with harder work and application. Ironically, the very last episode of The Cosby Show was aired on the day when the verdict of the Rodney King trial provoked race riots, and America witnessed the most intense display of Black dissatisfaction with the White social order and the kinds of conservatism played out in The Cosby Show, only available to those with middle-class economic security and social status. Ronald Reagan's favourite sitcom, Family Ties, also endorsed this secure value system predicated on small-town American values, and the aspiration to self-made wealth and social success. Alex Keaton, played by Michael J. Fox, once more assumed the role of the progressive conservative in the face of his parents' ex-hippy, liberal tendencies. Only with the emergence of Roseanne were the fundamental assumptions of the middle-class sitcom once again challenged.

Kathleen Rowe has argued that Roseanne Barr profoundly violates established codes of feminine decorum, physical orthodoxy and patriarchally determined roles and functions for women in 1990s society. She does so by redefining the relationship between received notions of female beauty and the actual conditions of personal resource which inform their construction (see Rowe, 1995: 50–91). The 'fatness', 'slobbishness' and 'contempt' which characterise her stand-up persona of the 'Domestic Goddess', and further compounded in her sitcom role of Roseanne Connor, are the direct consequence of blue collar disempowerment and disenfranchisement. They are thus used as the tools by which to criticise middle-class values, the social construction of motherhood, the oppression of women, and the notion of a folksy nostalgia for a mythic golden age. As Rowe suggests, Roseanne's achievement is considerable because she has represented the supposedly unrepresentable in being 'a fat woman who is sexually "normal"; a sloppy housewife who is also a good mother; a loose woman who is tidy, who hates matrimony but loves her husband, and who can mock the ideology of true womanhood yet considers herself a Domestic Goddess' (Rowe, 1995: 91). This radical agenda is also popular and has clearly resonated with a viewing audience who recognise the kind of dysfunctionalism which supposedly characterises the Connor family in Roseanne as both natural and normal in a high percentage of American families. Though hardly idealistic or utopian, this model offers reassurance because its comedy is predicated on the sense of achievement in spite of overwhelming struggle and little overt progress. Life goes on, and becomes funnier the more the absurdity of trying to succeed materially and socially is heightened with each effort. Roseanne, whilst being a socially realist text

of sorts, is also a black comedy of the absurd because it recognises irresolvable destabilisation over the inappropriate didacticism of *The Cosby Show*.

The 1990s have in many ways been characterised by this key tension, half-resolved in the barbed revisionist view of senior citizens in *The Golden Girls*, or the 'Mary Richards' mode of feminism played out in the Candice Bergen vehicle, *Murphy Brown*, but half-resisted in the post-feminist, mock-macho of Tim Allen in *Home Improvement*, or the nostalgic engagement with the rites of growing up in the 1960s in *The Wonder Years*. Probably the most significant development, however, is the rise of the stand-up comic as the defining persona of the sitcom, and the self-conscious, self-reflexive deconstruction of the genre in programmes like '*It's Garry Shandling's Show*', *Seinfeld*, *Dream On*, *Eerie, Indiana* and *The Larry Sanders Show*. The intervention of the stand-up mode of address, or the self-conscious construction of narratives which assume that the audience has a collective knowledge of sitcom characters and conventions, has led to a systematic redefinition of the sitcom as a closed context. Garry Shandling, for example, can operate as a stand-up comic and a sitcom character in one episode, sometimes directly speaking to the audience and revealing all the mechanisms by which the show is constructed, and sometimes being in character playing out the anticipated narrative. The ideological flux thus made possible by the breaking of both televisual rules and generic conventions further destabilises any coherent political position, except one directly attributed to the authorial voice. This 'voice', whether it be Shandling, Seinfeld, Margaret Ho in *All American Girl*, Brett Butler in *Grace Under Pressure* or even Roseanne Barr in *Roseanne*, is always challenged by competing discourses, which enable the viewer to engage in a variety of interpretations.

The sitcom, therefore, though always a progressive genre in many respects, has maintained a model which promotes open convictions in the most democratic way possible by resisting the enduring conventions of the closed context. Even in the freshest and less radical of contemporary sitcoms, like *Friends* and *Ellen*, competing discourses are maintained by the use of social groups composed of individuals with different personal interests and socio-cultural investments instead of socially determined families, locked in predetermined ideological frameworks. Though the genre is still commercially driven, and arguably still predominantly middle class, it is clear that both implicitly and explicitly the sitcom has done much to challenge and dissolve old boundaries by laughing at their very existence.

NOTES

1 For a full discussion of the race issues surrounding *Amos 'n' Andy*, see M. Watkins, *On the Real Side: Laughing, Lying and Signifying*, New York and London: Simon & Schuster, 1995.
2 In various editions of Dr Spock's *The Common Sense Book of Baby and Child Care*, he endorses the view that a woman should not attempt both to be a mother and maintain a career, because it may affect her children psychologically. Spock clearly views the paternal role as one of breadwinner, but also as the moderator of the extent and intensity of the mother–child bond. Essentially, the father determines the codes of household conduct in order to maintain his relationship with his children, given that the dominant role of nurturer is acknowledged as the mother's fundamental purpose. This model clearly echoes those represented in many sitcoms of the 1950s, and indeed, early 1960s.
3 The quote comes from an unsourced television critic, cited by Susan Sackett in her analysis of *The Beverly Hillbillies* in *Prime Time Hits*, New York: Billboard Books, 1993, p. 114.
4 For a more developed discussion of the sitcoms based on military sources, see Hamamoto, 1989: 54–9; also for issues concerning the 'ethnicom', see Hamamoto, 1989: 87–112, and Aniko Bodroghkozy's essay, 'Is this what you mean by colour TV?: Race, gender, and contested meanings in NBC's Julia', in G. Dines and J.M. Humez (eds), *Gender, Race and Class in Media: A Text Reader*, Thousand Oaks, London and New Delhi: Sage Publications, 1995.
5 From an interview with the author, March 1987.
6 The phenomenon of the role of the stand-up comedian within the sitcom context is discussed more fully by Paul Wells in *Taking Liberty: Situation Comedy and the American Way*, London: Leicester University Press, 1998 (forthcoming).

BIBLIOGRAPHY

Bianculli, D. (1992) *Teleliteracy*, New York, London *et al.*: Simon & Schuster.
Boorstin, D. (1988) 'Tall-Talk': Half-Truth or Half-Lie?', in D. Boorstin, *The Americans: The National Experience*, London: Cardinal Books, pp. 289–96.
Butsch, R. (1995) 'Ralph, Fred, Archie and Homer: Why television keeps recreating the while male working class hero', in G. Dines and J.M. Humez (eds), *Gender, Race and Class in Media: A Text Reader*, Thousand Oaks, London and New Delhi: Sage Publications, pp. 403–13.
Comstock, G. (1991) *Television in America*, Newberry Park, London and New Delhi: Sage Publications.
Feuer, J., Kerr, P. and Vahimagi,T. (eds) (1984) *MTM 'Quality Television'*, London: BFI.
Gitlin, T. (1994) *Inside Prime Time*, London and New York: Routledge.
Hamamoto, D. (1989) *Nervous Laughter: Television Situation Comedy and Liberal Democratic Ideology*, New York: Praeger.
Haralovich, M. (1988) 'Suburban Family Sit-coms and Consumer Product Design: Addressing the Social Subjectivity of Homemakers in the 50s', in P. Drummond and R. Paterson (eds), *Television and its Audience*, London: BFI.
Marc, D. (1989) *Comic Visions: Television Comedy and American Culture*, Boston: Unwin/Hyman.
Mellencamp, P. (1986) 'Situation Comedy, Feminism and Freud: Discourses of Gracie and Lucy', in T. Modleski (ed.), *Studies in Entertainment: Critical Approaches to Mass Culture*, Bloomington and Indianapolis: Indiana University Press, pp. 80–99.
—— (1992) *High Anxiety: Catastrophe, Scandal, Age and Comedy*, Bloomington and Indianapolis: Indiana University Press.

Montgomery, K. (1989) *Target: Prime Time: Advocacy Groups and the Struggle Over Entertainment Television*, New York, Oxford et al.: Oxford University Press.

Rowe, K. (1995) *The Unruly Woman: Gender and the Genres of Laughter*, Austin: University of Texas Press.

Sackett, S. (1993) *Prime Time Hits*, New York: Billboard Books.

Taylor, E. (1993) *Prime Time Families: Television Culture in Post-War America*, Los Angeles: University of California Press.

Vidmar, N. and Rokeach, M. (1974) 'Archie Bunker's Bigotry: A study in selective perception and exposure', *Journal of Communication*, 24(1): 36–47.

Wertheim, A. (1979) *Radio Comedy*, New York and Oxford: Oxford University Press.

White, M. (1992) *Tele-Advising*, Chapel Hill and London: University of North Carolina Press.

Zynda, T. (1988) 'The *Mary Tyler Moore Show* and the transformation of American comedy', in J. Carey (ed.) *Media, Myths and Narratives*, California: Sage, pp. 126–46.

11

CRINGE AND STRUT

Comedy and national identity in post-war Australia

John McCallum

A great deal of Australian comedy, in cabaret and stand-up performance, in the mainstream and alternative theatres, on television and in the cinema, has been about an ambivalent relation to authority. All comedy is to some extent about power, involves elements of aggression and malice, and is often rebellious or debunking. It therefore seems an ideal form in which to explore issues of authority in a society that, since the mid-1950s, has been engaged in a process of decolonisation and which, during the same period, has become one of the most culturally heterogeneous in the world.

Since the 1950s, and more markedly since about 1970, there has been an extraordinary upsurge in performance and television comedy. To some extent the increased activity was associated with periods of renewed nationalism both in the 1950s and the 1970s, but its growth has been so large and fast that nationalistic feeling alone is not enough to explain it. I am not proposing to explain it here, although factors such as increased material affluence and the growth to maturity of the post-war generation of 'baby-boomers' are obviously important.

What follows is not a sociological analysis of Australian comedy but a selective critical commentary that focuses on social readings of the work of four of the most popular and influential comic performers or groups of performers. These are: Barry Humphries, especially his most famous character, Edna Everage; Garry McDonald's main character, Norman Gunston; Paul Hogan, especially his character, Crocodile Dundee; and the team of multicultural performers who created one of the biggest stage successes of the 1980s, *Wogs Out of Work* as well as a spin-off television series, *Acropolis Now* and a stage sequel, *Wogarama*.

Each of these has had an enormous popular success, playing long runs in large venues to theatre audiences, in the case of Humphries and the

Wogs Out of Work team, and to huge popular television and/or cinema audiences, in all cases. Everage and the *Wogs* team had their initial success on stage. Gunston and Hogan's early character, 'Hoges', started out on television. Dundee sprang into being fully formed in the major commercial movie that bears his name. In all these cases such popular impact, by itself, would warrant our attention.

More importantly, however, each of these popular successes has provoked widespread commentary and debate in the media and has been taken, with some ambivalence I shall suggest, into the hearts, minds, living rooms, playgrounds, offices and tea-rooms of the nation. In each case the impact of this comedy has been widespread and out of proportion to its box-office or ratings success. I shall be arguing that this may be because in each case the comedy touches, in one way or another, on a vulnerable social nerve. Questions are at stake here concerning difference and power, the negotiation of complex social positions and relations, and different ways of reading the work available to a large heterogeneous audience.

THE AUSTRALIAN CONTEXT

Australia's position as a once-colonial society, continually looking over its shoulder at its erstwhile imperial masters, as well as its position now as a multicultural society, with different groups continually looking over their shoulders at each other, is the key element in this discussion. Everage and Dundee have had a significant impact outside Australia, which in turn has had an effect with their Australian audiences, and Gunston has also played comedically with Australians' attitudes to American and English imperialism. The *Wogs* team have appropriated some of the comic forms of the other three and reinterpreted them in terms of divisions within Australia.

These four are, as I have said, the most popular and successful exponents of a new comic style in Australia that has had a great impact during the last three decades. In order to place them in some sort of perspective it will be useful to give a brief historical sketch of the period.[1]

An active tradition of vaudeville and music hall comedy in Australia, dating back to the mid-nineteenth century, began to die in the 1920s and 1930s with the rise of the American movie industry and the Hollywood studios' vertical integration of the economies of production and distribution, which had a profoundly depressant effect on Australian film and theatre. The decline continued with the introduction of television in 1956, and the at first gradual but eventually triumphant success of imported American and English television comedy. Australian work continued to thrive on television into the 1960s in a series of Tonight Shows that

produced a great deal of live comedy, but eventually the local traditions succumbed to the pressures of the overseas product.

There had been a revival of nationalist pride in the 1950s, associated in the theatre with a new wave of working-class realist drama which was original but which paralleled the new American and English drama of Arthur Miller and John Osborne. At this time Barry Humphries was a small-time actor in a touring repertory company who created Edna Everage to entertain his fellow actors on the bus between towns. The suburban comedy of recognition which he was creating in the early versions of characters such as Edna and Sandy Stone was eventually to have a huge impact in the new wave of middle-class satirical drama and theatre of the late 1960s and early 1970s. He left Australia, however, in 1959, and although he has kept returning in a series of solo shows since then, and has had considerable further influence through television, film, books and comments in the media, his popularity in Australia has been influenced by a perception that he has for many years been more interested in English audiences.[2]

The late 1960s and early 1970s saw the beginnings of a sudden and enormous growth in Australian-produced arts and entertainment. Edna herself said, on many occasions, that one of the good things about living in Australia was 'all those wonderful cultural renaissances we're always having'. A new wave of small-venue cabaret sketch-based comedy began in Melbourne during the 1970s and was to grow to have a profound effect on Australian popular entertainment. It was overtaken in theatres, cafés and clubs in the 1980s by stand-up, but not before it had escaped its origins and become a major force in television. Norman Gunston first appeared on public television, and was based in Sydney, and so is something of an anomaly, but his type of satire of the provincial aspirations and anxieties of suburban life helped pave the way for the new-wave comedy's success on commercial television in the 1980s.

Meanwhile in the early and mid-1980s the stage tradition of alternative cabaret was moving into television and being taken over in the live performance venues by a new wave of stand-up comedians, many of whom were then themselves taken up by some of the new television shows and given national exposure. This is no place to go into the history of this popular comedy boom, except to say that its tone was a mixture of the zany, the larrikin and the satirical and that the upsurge of activity sparked a great deal of public debate over what it meant to say that the new comedy was 'Australian'.

The stage success in the 1980s of the new ethnic comedy embodied in the *Wogs* team's work was reflected in a new interest in the comedy of

minorities or marginalised groups who had been excluded from the theatrical new wave of the early 1970s – a comic theatre which had celebrated the rebelliousness of a generation of white, middle-class Anglo-Australians against English and American models.

The alternatives also flourished. Women's comedy is recorded, if not analysed, in Wendy Harmer's popular book, *It's a Joke, Joyce*.[3] Gay and lesbian comedians have found stages and had some impact through the huge growth since 1978 of the Sydney Gay and Lesbian Mardi Gras and its increasingly high-profile accompanying arts festival. There has also been a number of successful comics who have used different speaking positions in ways which either challenge or inadvertently reaffirm the prejudices of the dominant culture – according to the position one takes about the oppositional nature of comedy. Aboriginal comic Ernie Dingo did 'blackfella' jokes during the 1988 anti-Bicentennial celebrations, moved into television as a comedian, and is now a mainstream presenter of 'lifestyle' programs. Steady Eddy is a very successful comic with cerebral palsy who has made a career for himself doing routines about being handicapped. In these and other cases the public debate, within and outside the minorities from which these performers come, has been concerned with issues of political correctness, 'selling out' and the role of the oppositional comic who joins the mainstream. These issues surfaced at a more popular cultural level in the work of the *Wogs* team.

Attempts to define the Australian identity', comic and earnest, have been endemic in Australian life throughout the last 200 years. Since the 1890s, in the years leading up to Federation in 1901, and particularly since the 1950s, when to a great extent the 'bush' legend of the 1890s was (re)constructed, there have been continual attempts to establish exactly what, it was hoped, would be unique, special or distinctive about Australian history, culture and society, and to set this up as defining a position in relation to the imperial centre.[4]

These attempts at national self-definition may be divided very broadly into two groups: those which looked inward and sought distinctiveness, and those which looked outward and sought a validating authority from the centre. Australian cultural life has, to a large extent, swung between periods of self-conscious nationalism and periods of respectful internationalism. In comedy, thought of in terms of the aggressive laughter which has a bonding role in the exclusion of the out-group and the creation of in-group solidarity, and its correlative, the self-deprecating laughter which has a role of self-definition in relation to the out-group, these alternating periods of nationalism and internationalism have obvious significance.

The debate about the 'Australianness' of the comedy boom of the

1970s and 1980s took place with these broad parameters. One of the greatest television successes of the 1980s, The Comedy Company, was based in the rediscovery of some of the comic stereotypes of suburban Australia which Barry Humphries had started to explore in the 1960s.[5] Another, Fast Forward, was based more on an appropriation of the mass culture of the centre, in a series of parodies of the high-budget commercial television which was coming in from overseas.[6]

Edna Everage specialised in the suburban comedy of recognition, until she went abroad and began to perform it mockingly for English audiences. Norman Gunston dealt with the outward-looking comedy of a cringing culture with its eye on the imperial masters, turning it around, for Australian audiences, into a form of ironic appropriation. Paul Hogan employed from the outset the stereotypes of the old nationalist traditions of self-assertion. The Wogs team were working in these performance traditions, but they turned the power struggle of their comedy inwards to challenge the solidarity of the colonial in-group.

AUSTRALIAN SELF-MOCKING HUMOUR

A great deal of popular humour since the mid-1950s has been about the feelings of displacement, migration and otherness which are a large part of the social and personal experience of all Australians. Australia is a society made up of transplanted people, with also a dispossessed indigenous population whose joking is as much about rootless alienation as is the joking of the various waves of their dispossessors. Initially these waves were English and Irish, but later, by turns over the last 200 years, they were Chinese, Mediterranean, Eastern European, Middle Eastern and South East Asian. The patterns of humour have been varied but a recurring one has been humour about the experience of not being at the centre of your parent culture. The anxiety which this causes has been a great source of comedy.

The Anglo-Celtic tradition is that Australian humour is very dry, laconic, self-mocking, cynical and irreverent.[7] A great deal of it is in fact as lively, voluble, self-conscious, reverential and conservative as humour anywhere, but the tradition remains strong. What is in fact operating in Anglo-Celtic Australian humour, and repeated in the recent Italian, Greek, Arabic and Vietnamese Australian humour, is a mixture of defiance and apology for being there.

These comedians' invasion of the volatile space opened up by comedy – their techniques, comic devices and structures, and many of their actual jokes – is similar to the comic performance strategies obvious in the

humour of any oppressed, marginalised, rebellious or resistant group. Many of the joking strategies discussed here are evident in the traditions of Jewish, feminist and gay comedy. I am concerned here with the ways in which these strategies operate in post-colonial humour.

Much Australian humour is a type of comedy of embarrassment, or as Nadia Fletcher has put it, in relation to the theatre, a Comedy of Inadequacy. In Fletcher's argument this sort of work ironically celebrates internalised feelings of inadequacy in a form that challenges the standards of adequacy imposed by a dominant cultural centre. In the Australian Anglo-Celtic tradition this celebration is mockingly built on the embarrassment that Australians feel when they are confronted with European, and especially English, culture – the culture which at first authenticates emigrant experience and which is later abrogated in times of defiant nationalism.

A distinguishing feature of such humour, therefore, is its mixture of self-deprecation and aggression – of apology and defiance. Europe, and perhaps the United States, are cultural centres which define Australians as marginal, but Anglo-Australians now have plenty of other cultures to patronise and marginalise in turn, and the list grows and becomes more complex with each new wave of immigration. It is a phenomenon in contemporary Australia that much racial prejudice, and joking, is directed from one immigrant community to the next to have arrived. Thus, to localise a famous lyric by Tom Lehrer: the Irish hate the Italians, the Italians hate the Lebanese, the Lebanese hate the Vietnamese, and everybody hates the Blacks. The Blacks are, of course, the primary dispossessed. Depending on where you find yourself in this ladder of submission and aggression this sort of laughter can say to the centre, 'you can laugh at us', and to the margins, 'we can laugh at you'.

In some of the examples discussed below – Gunston, Edna and Dundee – both the self-deprecation and the aggression are reflected back to the centre. At this level the humour says, 'we can laugh at us, and this will disable you, by denying your authority, so that we can also laugh at you'. The paradigm joke here is the old worker's line, pathetically defiant: 'You can't fire me, I quit.'

COLONIALS STEP OUT

Anglo-Australian comics Gunston, Everage and Dundee differ in their approaches but each has taken up a form of the centre – respectively the media interview, the celebrity talk show and the adventure movie – and placed an inadequate parochial hero at the centre of it, in order to take

over and subvert the authenticating strategies of the central model. Before discussing how these characters have grown as post-colonial appropriations of international media forms let me introduce them as they originally walked onto the stage.

The oldest is Edna Everage – a comic creation who from humble beginnings has grown to become an awesome and terrifying figure in the social psyche of Australians, partly because she has directed so much of her maniacal energy at English audiences, whose approval was a major obsession of the Australian public to whom Edna first directed her attention. She has been around now for 40 years. She began life as a simple revue character created by the young Barry Humphries in Melbourne in the mid-1950s, when he was a touring actor trying to entertain his fellow actors in the back of the bus.

Her first appearance in the public record was as a simple housewife.[8] Humphries and his range of characters, including Edna and the quintessential old suburban husband, Sandy Stone, were then part of a wave of questioning of post-war material comfort and complacency which Australia experienced during the long, quiet, smug years of the Menzies conservative government – years in which Australia sat back and lived happily off the fat of the land, marketing natural resources for a living and tending their cars, their gardens and their children, in that order, on the weekends – in the land of the long weekend. The 1950s were years which appeared to be so idle and easy that they created a myth of Australia as a land of mindless, sunny contentment.

Edna represented then a type of suburban ordinariness which Humphries exploited satirically, with an influence that was felt throughout the 1960s and 1970s when that ordinariness came increasingly to be challenged by a society which was moving further and further away from its 1950s construction. His move to England, where the fifties image of Australia seems to remain alive to this day, was perhaps inevitable. Edna, and another colonial character created by Humphries for the English market, Barry McKenzie, flourished there, and were eventually joined and then superseded by Noeline Donaher, the 'real life' construction by an English television crew who came out to the colonies in 1993 to retrieve a very British image of Australian suburbia for a documentary soap opera called Sylvania Waters.

In her initial colonial incarnation Edna's humour lay in the catalogue of suburban values and commonplaces that she represented. Some of her monologues and songs were so mundane that they read like Sunday newspaper advertising supplements. Such is Humphries' comic genius that the old saw that some performers can read out the telephone directory

and get laughs was illustrated beautifully. In those days she had simply to mention gladioli – the tawdry flowers which in later years became the great phallic symbol of her aggression – to get an easy laugh of recognition.

Edna became famous, however, and, being the sort of character she was, it went to her head. She grew by degrees from being a simple suburban mum to a 'housewife superstar' and later a 'megastar' whose talk show attracted international guests. Like Noeline she loved every minute of it and as her fame grew her suburban ordinariness assumed extravagantly surreal proportions, to which I shall return.

Norman Gunston had similarly humble beginnings, and although he never became a star abroad he did travel there to interview other stars of the sort which the Australian public has always admired and wanted to read about and watch on television. He was from the outset utterly inadequate – the world's worst television 'personality'. In his mock-role as a famous Australian Tonight Show host he interviewed the likes of Muhammed Ali, Rudolph Nureyev, Paul McCartney, Keith Moon and, unsuccessfully, Richard Nixon, and sent the tapes back home in a series of programs that created delicious, cringing embarrassment for his Australian audiences. His naivety and gaucheness, combined, as with Edna, with an aggressive refusal to be ignored, created some excruciatingly awkward moments in which embarrassment was mixed with sudden moments of country-mouse triumph.

Gunston started out in the mid-1960s as a minor character – a nerdy cub reporter – on a popular television program, The Aunty Jack Show, which, half satirically and half in celebration, revelled in Australians' fear of provincialism and colonial remoteness. The show made great play with a town called Dapto, which stands in relation to its nearby industrial centre, Wollongong, much as Wollongong stands in relation to Sydney, and much as – and this was the point of the show – Sydney stood then in relation to London, New York or Paris. Gunston was a Wollongong lad who could patronise Dapto but who became a half-cringing, half-aggressive sycophant in the face of the big world outside.

One of his running gags was that he desperately wanted to be offered a 'fabulously well-paid cigarette commercial'. This was a reference to a series of television advertisements fronted at the time by Stuart Wagstaff, one of an old breed of Australian television personality whose public image was to be more British than the British. Wagstaff was urbane, suave and sophisticated in precisely the way in which Gunston was not, with his whining accent and comic trademark patches of tissue on his chin where he'd cut himself shaving. ('You ought to use an electric razor,' said

American soap star Sally Struthers. 'I do!', he replied.) Gunston aped Wagstaff in a series of parodies in which he too tried to offer cigarettes to beautiful women in sophisticated nightclubs, but kept failing abysmally.[9]

Paul Hogan was, according to the media mythology, a humble bridge-painter (the Sydney Harbour Bridge, of course) who launched his career not with a show of his own, nor even as a minor character in someone else's show, but, literally, with a series of fabulously well-paid cigarette commercials. He too parodied the urbane Wagstaff style, conducting the Sydney Symphony Orchestra in evening dress. As the camera pulled back he was revealed to be wearing, below his immaculate dinner jacket, stubbies (cheap rough beach shorts) and thongs (rubber sandals of the type that Americans call 'flip-flops'). 'Let 'er rip, Boris,' he said, as he handed the orchestra back to its real conductor. The advertising message was that colonials could do all this high-art stuff if they wanted to, but that they didn't need to take it all too seriously as long as they had a Winfield cigarette hanging off their lip.

The complexity of Edna, Gunston and Hoges, in their original form, revolved around their combination of colonial naivety and ironic rebellion. Each had great comic appeal for Australian audiences, but only in the context of their confrontation with the world outside. Each in a different way travelled there and appropriated spaces of the empire. By 1989 Edna would be filling that great centre of English theatrical culture – the Theatre Royal, Drury Lane – with its first solo show in 350 years.[10] Gunston brought home his videos, as Australian tourists for generations have brought home snapshots of themselves in front of Buckingham Palace or the Statue of Liberty. Hogan, when he became Crocodile Dundee, waved his famous knife at hoodlums in the streets of Manhattan and climbed over the backs of commuters on the New York subway like a good Aussie working dog moving over a mob of sheep in the drenching yard.

THE COMEDY OF INADEQUACY

There are, however, important differences in the ways in which these characters operate at the boundary between national self-hatred and self-assertion. The mixture of malice and sympathy in them varies according to which side of the boundary they fall. Edna falls on the side of self-hatred, and is created with more malice; Dundee falls on the side of self-assertion, and is created with more sympathy; and Gunston walks the line and does not fall – which makes him the most interesting for the purpose here.

The distinction between Gunston and Everage, on the one hand, and

Gunston and Dundee on the other, is for Australian audiences partly a question of how they are positioned in relation to those external sources of power, to that generic 'abroad' which for Australians is the reference point for all comparison. Each performer, in differing degrees, is awkward, inept and colonial. To different extents and in different ways they have all gone on to conquer the source of embarrassment, without ever becoming more 'adequate' by the imperial standards they are mockingly embracing.

McDonald never made any attempt to play to audiences outside Australia. Gunston's success was that his Australian audiences knew that his overseas victims were not aware that he was a parodic character. The comic pleasure, and pain, lay in the excruciating embarrassment of watching their bewilderment at this gauche colonial fool.

Sometimes they were delighted with him, as was Sally Struthers, for reasons which may not be a source of pride but which were a source of comfort. She responded with great warmth to the innocent simplicity and pleasantness which is one way in which colonial characters may find their position in relation to the centre. Paul McCartney, tipped off by an aide after an initial moment of confusion, was aware of the parody and attempted to meet it, therefore inadvertently giving Gunston an opportunity to defeat him in comic badinage, which in turn gave the audience the vicarious pleasure of colonial victory. (Gunston shut Paul up by turning to Linda McCartney and saying, 'That's funny, you don't look Japanese.') Keith Moon, by the extremity of his reaction ('Piss off, you Australian slag!', he said, before pouring a bottle of vodka over Gunston's head) provided an opportunity to enjoy a grimmer type of triumph. It is exactly the sort of arrogant behaviour Australians expect from the English, albeit expressed in this case in the house style of a famous rock'n'roll bad boy. The range of different responses which Gunston managed to provoke reflected the whole range of possible confrontations between the colonial and the coloniser, and therefore the range of different emotions which Australians feel about their confrontation with 'abroad'.

With Humphries the pain of embarrassment was magnified by the fact that he had actually emigrated, and by the more genuine streak of malice in his characterisation of Edna. As with Gunston it was particularly painful that she was so blissfully and aggressively unaware that her colonial airs and graces were so inadequate, but also satisfying that her success was so complete. The development of her character is particularly important.[11] Her early comic routines were, as I have said, satirical hymns to the mundanity of drab everyday Australian life, and, as satiric spokesperson, she was very drab herself. In this role, as she attempted, in the nicest possible way, to avoid having a 'tinted person' as her billet during the 1956

Melbourne Olympic Games, Edna grew as an often cruel parody of the life and aspirations of women in the sprawling suburbs of Australia's big cities. In her beginning a great deal of the comic malice with which her character was conceived was directed against these Australian women, rather than against the more cosmopolitan figures who became her and Humphries' targets when she grew to become the self-proclaimed megastar of the 1980s.

Edna's rise to megastardom has taken 40 years, during which time she has aged and grown as a character in response to the popular success of Barry Humphries' performance of her. In other characters Humphries has expressed a great deal of satirical scorn about Australian nationalist aspirations, but there is no doubt that Edna's ascendancy has itself become part of those aspirations. Australian audiences enjoy, perhaps ironically, Edna's success.

There is an ambivalence in Humphries' own attitude to this colonial triumph – the ambivalence of an urbane cosmopolitan who takes his material from the parochialism of his origins, but takes his formal inspiration from the advanced art of his time. It was Humphries' great achievement, during the late 1950s and the 1960s, to bring to bear on local realities a perspective which drew on the then advanced modern work of Beckett and Pinter, and to realise, when many other more narrowly nationalist writers were attempting simply to represent Australian life through the conventions of well-made realism, that appropriating European culture meant appropriating its avant-garde rather than its traditions.

In addition to this there is a comic collusion that Humphries offers his audience which often excludes the character he is playing, but which sometimes, in Australia at least, that audience is disinclined to accept. For Australian audiences Edna has an appeal of which Humphries himself does not seem to approve.[12] He satirises her provincialism and triviality but does so with an extraordinarily ebullient character whom Australian audiences like and do not always read ironically. English audiences may take easy pleasure from the stereotype that since the 1960s has taken over from the more subtle study of suburban experience which Humphries produced when he was still working in the country from which he used to draw his material.

By the 1980s Humphries' appropriation of international forms had reached past the avant-garde to embrace one of the great forms of modern international media culture – the glamorous celebrity chat show. Edna's television shows of that time, An Audience with Dame Edna and The Dame Edna Experience, had different versions in England, Australia and the United States, using different 'international' stars in each country. She mocked the whole

notion that any star could be as international as she, while never letting go of her essentially provincial personality. When the stars appeared she sycophantically harassed them, scarcely letting them get a word in. In each show she had at least one well-known guest whom she never allowed onto the set.

Edna's consummate control and disdainful power over these public figures is a form of colonial domination which might be more satisfying for Australian audiences if they could believe that Humphries shared their delight in her triumph. The irony that lay behind her original appearances has disappeared beneath a chaos of glamorous showbiz effects which ape the commercial forms so well that the parody and the original become almost indistinguishable. The big glamorous shows ceased after those produced in the United States failed to create an impact in that culture in which, to the Australian eye, the most extreme parody never quite matches the excess of the shows which are taken seriously.

This leads us to *Crocodile Dundee*, played by the first Australian comedian to become a Hollywood movie star. Humphries made one attempt at the satirical colonial appropriation of the Hollywood adventure film, in a movie created for one of his most grotesquely obscene characters – *Les Paterson Saves the World*. It was not a success, partly because it lacks respect for the conventions of the form which it parodies. Hogan, on the other hand, has so much respect for the model form that many Australian audiences were unable to read *Crocodile Dundee* as ironic.

The character from which Dundee was developed, 'Hoges', was a simple proletarian with a rough vernacular style who took on and mocked by his own pure unsullied example the pretensions of the high and mighty, in a tradition that had little to do with the knowing comedy of McDonald and Humphries and much to do with a simpler celebratory tradition of national self-congratulation. For Dundee Hogan added to this type many of the features of an Australian national mythic character, well established since the 1890s – the tough, laconic outback hero – in order to create an internationally appealing character who could go to New York and take on the Yanks with the authority of a great pioneering legend – a legend as much American as Australian – behind him.

The scene in the first movie in which Dundee, in all innocence and naivety, flourishes what is supposed to be his good Aussie bush knife in the face of a New York mugger, is well known in Australia for its celebration of colonial self-confidence, but it is virtually impossible to distinguish Dundee's knife from a Bowie knife, or his brash provincialism from the provincialism of any cowboy confronting urban New York. Mick Dundee has many charms, not the least of which is his casual ability

to deal without fuss with New York street punks, but no one really believes in his colonial authenticity.

Of these three, and leaving aside for the moment Edna's early local success, Gunston was the most interesting because he played most dangerously at the crucial border between colonial cringe and self-assertiveness. He was so innocently gauche and yet so effective in debunking the pretensions of his victims that he created between the two emotions a gap in which Australian audiences could find exhilarating and dangerous humour.

WOGS WORK NOW

One of the most extraordinary recent successes in Australian theatrical comedy has been the phenomenon which began in Melbourne in 1987 when Nick Giannopoulos and Simon Palomares launched a late-night show at the 150-seat theatre, Universal Two: *Wogs Out of Work*. The show had many similarities with the larrikin Melbourne style of performance of the early 1970s, and at first it appeared to be a minor, politically correct, ethnic extension of the alternative comedy and cabaret boom of the 1970s and early 1980s.

The new self-consciousness about multiculturalism in Australia in the 1980s had been reflected in the television spin-off of the cabaret boom, in an enormously successful character created for the popular show, *The Comedy Company*: 'Con the Fruiterer'. Con was an ethnic (Italian-Australian) stereotype performed by an Anglo comedian, Mark Mitchell. The character had roots in a tradition of Italian-Australian humour dating back to the 1960s when the first post-war generation of European migrants, many from Italy, had established themselves in suburban greengrocers' shops. In the 1960s a series of humorous books, purporting to be the memoirs of an Italian immigrant named 'Nino Culotta', who was utterly confused by the bizarreness of Anglo-Australian culture, had a huge popularity. They were in fact written by an Anglo-Australian writer named John O'Grady, and were read at the time more as a satire from an outsider's perspective of 1950s and 1960s Anglo-Australian culture than a genuine record of immigrant experience.[13]

Wogs Out of Work employed similar stereotypes but turned out to be special, particularly in the context of the argument here. For a start the shows were written, produced and performed, for the first time by people who took a new pride in calling themselves 'wogs', which was an important authentication, in the politics of multiculturalism, of their comedy of recognition.[14] In various seasons, transfers, tours and television spin-offs

the simple, affectionately satirical comedy of cultural difference which was the *Wogs* team's hallmark had an enormous popular success, and in the different audiences to which it was directed, and the different stances which it has taken, it has been a highly provocative variation on the Anglo comedy of the alternating cringe and strut.

The crucial issue is, again, one of readership and address. The initial show at the Universal Two, says Giannopoulos, attracted middle-class Anglo yuppies, but gradually the working-class wog kids discovered it and took over the audience.[15] The show transferred to the Universal One (400 seats) and then to a much larger popular venue, the Athenaeum, where it played to full houses for ten months – a very long run for an 'alternative' show. Eventually it reached mainstream, predominantly middle-class audiences in the series, *Acropolis Now*, broadcast on public television. This was clearly a type of comedy which was variously readable.

At this point I would like to return to the issue of comedy as a form of self-definition in the creation of in-group solidarity. In a society which, like other Western societies, has become increasingly concerned in recent years with 'political correctness' this is a controversial issue, the negotiation of which has given rise to a number of comic strategies, especially, as I have argued in the case of the Anglo-Australian comics, ironic or pre-emptive self-deprecation. This is one of the basic strategies of the *Wogs* team. In different degrees and in different ways Humphries, McDonald, Hogan and the *Wogs* team all play a sophisticated game of comic irony: it is virtually impossible to read their humour with any certainty. As commercial performers they operate within the discourses of power, but they also mockingly embrace a self-deprecating style: it is never quite clear how confident the mockery is. Any attempt to read the level of irony that they are employing inevitably implicates the reader: the more you read their jokes ironically the more the aggression in them is turned back on you.

This strategy makes it possible for the colonised to join in the public laughter of the powerful and to find a stance from which they may quietly laugh back – to use what Homi Bhabha calls the 'sly civility' of the colonised. In the comic negotiation of power you may be aggressive or submissive, but are most interesting when you are both at the same time. Self-mocking jokes work because they can be read both of these ways. They complicitously offer an easily accessible reading to general audiences used to the form, and a covert reading strategy to anyone who cares to look for it. In such cases the doubleness of irony is doubled again through these ambiguities. How knowing is the work? It is sometimes impossible to say.

When the *Wogs* team made jokes about flash macho Greeks, then one

butt of the joke is the Anglo creators of the original comic stereotype, of wogs from the ethnic suburbs with their instantly recognisable emblems of group identification – open shirts and gold chains, hotted-up purple Monaro cars and the rest of it. A great many Greeks and Italians in the Sydney suburbs of Enmore, Marrickville and Leichhardt really do wear open shirts with gold chains, and they wore them proudly to the performances of *Wogs Out of Work* at the Enmore Theatre. These performers were appropriating a comic type created originally within the dominant culture, and at the same time creating a comedy of recognition for new ethnic audiences.

This neat splitting of the multicultural image means that multicultural audiences have opened up a space for themselves – the liminal space of constructive irony which Linda Hutcheon describes as the obverse of the marginal space of deconstructive irony.[16] In this space they are then free to turn round and read old-fashioned Anglo-Australian representations – such as Con the Fruiterer – as sympathetic and subversive if they want to. Mary Coustas, one of the original *Wogs Out of Work* cast and since then a successful solo comedian, has said that she does.

In the television spin-off of *Wogs Out of Work*, *Acropolis Now*, the appropriation of a mainstream space for mock-complicitous humour reached out to a much wider audience and, inevitably, the different possible reading strategies offered become less easy to separate out into different audiences. It would perhaps be going too far to suggest that large numbers of everyday Australian television audiences were reading the program as a subversive appropriation of mainstream television by an ethnic minority, but, for what was presumably a culturally mixed audience, the show, in Nick Giannopoulos' phrase, at least 'made the wog thing more accessible'. 'We don't mind being on the cover of *TV Week*', he said.[17]

Wogarama was a follow-up stage show, after the success of *Acropolis Now*, which repeated the style and much of the substance of the earlier show, but which brought it up to date in terms of multicultural politics by including an Aboriginal (Denise Kickett) and a Vietnamese (Hung Lee).[18] One of the features of the show was its use of ethnic put-down humour between the different races represented. A Greek and an Aboriginal traded insults of the type which each used to receive from the dominant Anglo-Australian culture. Gerard Matte argues that the ethnic use of forms and styles of the Anglo-Australian tradition renders the phrase 'multicultural humour' invalid but, as I have argued here, the appropriation of those older forms is precisely the point. Matte quotes Giannopoulos referring to Hung Lee as a Vietnamese Paul Hogan, and suggests that Hung Lee is therefore not a truly multicultural comedian, ignoring that the fact that he

looks Vietnamese but sounds like Hogan is the whole point of his humour.[19]

A more overt example of the appropriation of an old Anglo form by a new wog comedian is the return of the by then middle-aged Norman Gunston to commercial television in 1993 and the role which Mary Coustas played in the series. I have argued that in the 1970s Gunston operated, at least for white middle-class audiences, by exploiting the Australian cultural cringe in a funny and comically dangerous way. He was an essentially young gormless character, whose youthful naivety reflected the naivety of 1970s Australian neo-nationalism. It seemed doubtful, when his return was announced, whether his character could survive in middle age without some sort of monstrous transformation, such as Edna Everage underwent in her middle age. Indeed, it didn't survive — it no longer worked, and the overseas interviews on which Gunston had built his fame were tired and forced, especially since all the stars now seemed to be well aware of who he was and to be playing along with him. A few episodes into the new series Garry McDonald became ill and the show, which was broadcast live-to-air, was taken over for a night by Coustas as 'Effie', her wild, young, inner-city Greek-Australian character. It was suddenly obvious that the reason Gunston was no longer working as a character was not simply because he was middle-aged but because his vulnerability was no longer interesting. In the 1970s the ineptitude of a young colonial incompetent from Wollongong had been funny and pathetic. By the 1990s it was very difficult, as we contemplated the personal failings of an inept white middle-aged middle-class male character, to react with delighted comic surprise. It's what you would expect. Effie, on the other hand, was exactly right for the comic function of the role Gunston used to fill. She is an over-the-top, self-confident, young character whose whole self-presentation is based on the irony of her consciousness of her marginality and her brashly aggressive refusal to let it bother her. Her obsession with her elaborate hair and her self-made wog-glam clothes is the nineties equivalent of Gunston's obsession with his media image and getting his 'fabulously well-paid cigarette commercial'. She made audiences cringe and cheer for her at the same time, as Gunston used to do. If she were not conscious of her marginality then she wouldn't behave as if she didn't care.

This is an example of what I mean by doubled irony. Effie knows that she is just a wog sheila and is happy to be one, but the brashness of her behaviour is scarcely a sign of relaxed self-confidence. She celebrates and at the same time mocks her ethnicity and thereby creates an irony which, in Hutcheon's phrase, launches a challenge and also admits a loss. Her irony allows her to address and at the same time slyly confront the official

discourses of Anglo ethnicity and the hegemonic discourses of commercial television.[20]

In 1994–5 Effie travelled the world to record a series of mock-interviews of the kind that Gunston had done twenty years previously. The pilot program which was to have used these was never screened. In late 1995 Coustas announced that she was moving to New York, where she felt her character worked and where there was more professional opportunity. This was more than thirty years after Humphries first took Edna to London for similar reasons.

For thirty years the most successful popular comedy in Australia has exploited feelings of inadequacy which are a very real part of the way in which Australians see themselves. It is unlikely that comedy ever really changes social attitudes but this humour may be considered subversive or oppositional to the extent that it offers different readings of its ironies. None of the performers considered here is at all technically or professionally inadequate. Each is a highly skilled professional entertainer. Humphries is arguably one of the greatest comic performers this century.[21] Each performer discussed here employs inadequacy as a performance style and so challenges, from a post-colonial or multicultural point of view, what the concept of 'adequacy' really entails. Who sets the standards? The English, the Americans and the Australian white middle class do, of course, as do, in other types of comedy, the gentiles, the men and the straights. The skilled performance of a mock-failure to meet those standards is the essential performance strategy in all the comedy I have been describing.

A concluding example is Los Trios Ringbarkus, a comic duo (Neill Gladwin and Stephen Kearney) in which the technique is so pure and simple that the strategy is brilliantly clear. Their name is the first of the ironies.[22] They were the first Australian comic cabaret act to have a major success abroad, at the Edinburgh Festival. When they received the 1983 Perrier Award they claimed, with typical colonial panache, never to have heard of it. Their act, in various forms on stage and television, was always the same. Their 'gimmick', when the curtain rose or the lights went up, was that their characters had absolutely no idea why they were there or why all those people were looking at them. But they accepted the form imposed on them. In their bumbling attempts to improvise something for the audience to watch they performed an extraordinarily skilful series of routines and pratfalls in which everything went hopelessly and very messily wrong. They were the ultimate colonial failures. Their shows consisted almost entirely of glorious clowning of a type that goes back to the bumbling servants of the Aristophanic tradition, but they always remained

218

colonial Australian idiots, who triumphed finally in their discovery that imperial English and American idiots had set the rules and that the rules made no sense.

NOTES

1 Much of the account which follows is based on personal experience. A popular account of this movement is given in Richard Harris, *Punchlines: Twenty Years of Australian Comedy*. Sydney: Australian Broadcasting Commission, 1994. A survey of women's comedy is given in Wendy Harmer, *It's a Joke, Joyce*. Sydney: Pan Books, 1989.
2 A convincing argument concerning the enormous effect which Humphries' early work had on the dramatists, satirists and performers of the late 1960s and 1970s is given in Nadia Fletcher's unpublished doctoral dissertation, 'The Theatre of Inadequacy: A Study of Humour in Twentieth Century Australian Theatre'. University of New South Wales, 1989. See Part II, pp. 206–301.
3 See above. Harmer herself was one of the leading stand-up comics of the 1980s and hosted an innovative live television show, *The Big Gig*, which was a great success for the public network, the Australian Broadcasting Corporation.
4 A good account of this search for national identity is Richard White, *Inventing Australia: Images and Identity 1688-1980*. Sydney: Allen & Unwin, 1981.
5 This was broadcast on the Ten Network, beginning in 1988.
6 See Harris, *Punchlines*, pp. 137–8. *Fast Forward* was first broadcast in 1989 on the Seven Network.
7 The term 'Anglo-Celtic' elides a recently important distinction, in Australian cultural debate, between the English and the Irish influences, but it is still used, as it is here, to refer to the original convict settlement of the continent, and to distinguish that from those more recently imported traditions of Australians with Non-English-Speaking Backgrounds (NESB) – referred to by some of the comedians as Nesbians.
8 This and several of Sandy Stone's monologues are reproduced in Barry Humphries, *A Nice Night's Entertainment: Sketches and Monologues 1956–1981*. Sydney: Currency Press, 1981.
9 All the interviews referred to are reproduced on a videotape, *The Gunston Tapes*, produced and marketed by the Australian Broadcasting Corporation. There were many other examples.
10 The show was called *Back With a Vengeance*. The season is documented in John Lahr, *Dame Edna Everage and the Rise of Western Civilisation: Backstage with Barry Humphries*. London: Bloomsbury, 1991.
11 See Fletcher, 'The Theatre of Inadequacy', Part II, for a very useful discussion of Humphries' place and influence in Australian culture, and the effects of his emigration on the reception of his work in Australia.
12 Compare Fletcher, 'The Theatre of Inadequacy', Chapter 7.
13 The first such publication was John O'Grady, *They're a Weird Mob*. Sydney: Ure Smith, 1957.
14 The comic appropriation of the word 'wog' by Nesbians (see note 7) was similar to the appropriation of the word 'blackfella' by some Aboriginal Australians, and of the word 'dyke' by lesbians, or, in the USA, of 'nigger' by African Americans. In comedy this is a generally accepted political gesture, but the question of who is allowed to use the terms is still highly sensitive.
15 For details on this and some of the commentary which follows see 'Mary Coustas and Nick Giannopoulos', pp. 204–15 in Murray Bramwell and David Matthews (eds), *Wanted for Questioning: Interviews with Australian Comic Artists*. Sydney: Allen & Unwin, 1992.
16 Linda Hutcheon, *The Politics of Postmodernism*. London: Routledge, 1989. See Chapter 1.

17 Bramwell and Matthews, *Wanted for Questioning*, pp. 213, 215. *TV Week* is the leading popular magazine guide to television. No demographics are available for the audience of *Acropolis Now*.

18 A video documentary on the work of Hung Lee is Steve Westh's *What's So Funny?*, Video Products Pty Ltd in association with The Australian Film Corporation, 1995.

19 Gerard Matte, 'Cultural war and the fate of multicultural comedy', *Australian Journal of Comedy* 1/95: 81–2, 84.

20 Linda Hutcheon, *Splitting Images: Contemporary Canadian Ironies*. Toronto: Oxford University Press, 1991, p. 15.

21 This is Lahr's claim in *Dame Edna Everage and the Rise of Western Civilisation*.

22 'The ringbarked trio'. 'Ringbarked' is the word for a tree which has been killed by having its trunk cut around near the base. 'Los Trios' suggests the endless touring circus and musical acts from Europe which have toured Australia since the nineteenth century.

12

'SERIOUS T'ING'

The black comedy circuit in England

Stephen Small

INTRODUCTION

Although the most common stereotypes of black people held by non-blacks in Britain is of them as 'performers', the images that almost invariably come to mind are those of athlete, musician, or dancer.[1] There are few perceptions or stereotypes of black people as comics, which in part is explained by the relatively small number of blacks in the country, their infrequent forays into the realm of public comedy, as well as the general marginalisation of comedy as an area of interest. Consequently it comes as no surprise to learn that there is virtually nothing written about professional black comics in Britain, especially black stand up comics. The main work that has been done about black people and comedy is about 'racist' humour; there is also some work on blacks in situation comedies (Gray, 1986; Husband, 1988; Jones and Dungey, 1983; Pines, 1992). And, of course, a few biographies of Lenny Henry. Where humour and comedy have been analysed by non-blacks, it has almost exclusively been about non-blacks and has been generally indifferent to the black presence (for example, Powell and Paton, 1988).

Despite this, the number of black professional comics has increased dramatically since the end of the 1980s, and there is now an established circuit of comedy shows performed by black professional comics largely in London, but also with forays into the other key cities with black communities – Birmingham, Manchester, Liverpool, Nottingham, Leicester and Bristol. This circuit was given a kick-start by the tour of 'The Posse', a group of black men seeking to circumvent their marginalisation on television, as well as the tours by the Bibi Crew, a group of black women comics. Interest has also been raised by the success of Channel Four's *The Real McCoy* which aired for the first season at the start of the 1990s, with several follow-up seasons. Several of these performers have become well known in the black community – Felix Dexter, Curtis Walker, Geoff

221

Schumann, Robbie Gee, Eddie Nester, John Simmit, among the men; Angie Le Mar, Felicity Ethnic, Llewella Gideon, among the women. There is a considerable entourage of others in the wings, doing supporting acts, and waiting to surge on the national scene themselves, such as Aymer and Powell, Rudy Lickwood, Richard Blackwell and Roger Dee. For the most part, these comedians perform before blacks, though there are small numbers of non-blacks who attend as well. A series of journalistic articles and interviews has begun to document this circuit (Jolaoso, 1993; Coley, 1994; Lindsey, 1994).

This chapter offers a preliminary assessment of black comics and the professional circuit within which they work, with a primary focus on black professional stand-up comics. It does not provide an analysis of related activities of professional comedy, such as black plays and pantomimes, though many of the comics discussed are actively involved in those performances. Rather, it offers some contextualisation of the experiences of black comics within the framework of the institutionalisation of black comedy – on the professional circuit, on television, and in the press. The analysis is carried out in light of some of the work done about British black comics' African-American counterparts in the United States (Watkins, 1994).

A focus on black professional comics offers several opportunities for an analysis of issues centred on resistance and control, black authenticity and hybridity, and gender relations and representations. It also raises issues about the institutional infrastructure of black community organisations, and about the extent to which black culture is reproduced for blacks, as opposed to non-blacks. Questions like these have been asked in detail about other aspects of black culture, including music, religion and film where black culture continues to be a major focus of sociologists, cultural studies theorists and literary specialists (Gilroy, 1987, 1993; Rose, 1994). Very little of this work has focused on black comedy, but where it has been analysed, it has usually been about the United States (Watkins, 1994). An examination of black comedy in Britain can address many of these issues.[2]

PROFILES OF BLACK COMEDIANS

The black comedy circuit is not currently organised in a way that enables us to obtain a precise figure of the number of black professional comics in Britain. Some comics are full-time, others part-time and few are able to make a full-time wage from comedy alone. Bearing these constraints in mind, it is possible to offer the following broad generalisations. There are

clearly more men than women; more African Caribbeans than Africans; and most of the comics were born or have spent a lengthy period in Britain. I was able to identify at least thirty-five active comedians, whose names appeared in the black newspapers, posters and leaflets that advertised the shows. In addition, it seems that there are at least another twenty who are relatively new to the circuit.

Black comics reveal a variety of styles. Some adopt one particular style and seem to sustain it at most or all of the shows; others have a variety of styles which are adapted according to the event. All comics are required to demonstrate versatility, as they are called upon to perform in a variety of different shows and formats.

Stand-up comics

These performers begin with a set list of jokes, apparently scripted beforehand, and they go out on stage with the intention of telling the jokes, one by one. Though they share a common approach or technique, they perform in quite different ways. Among the men, Leo X Chester is distinctive here with suit, black bow tie, immaculate grooming – a member of the Nation of Islam, his act offers the most manifest influence of the United States. This is not comedy but 'Edutainment'; that is, entertainment with an educational purpose. Chester has described his performance as 'education for empowerment through comic entertainment'. Says Chester, 'I want to uplift the spirit even while I bring a serious message about our future on the planet' (Bartholomew, 1995: 3). Angie Le Mar is the outstanding woman stand-up comic with an ability to hold the audience captive from start to finish, and a razor-sharp wit, reeling off joke after joke, occasionally picking on people in the audience, weaving them into her seamless flow of humour. Her repertoire overwhelmingly revolves around women, especially black women, and stereotypes about them. But she, like other comics, is able to tap into experiences that resonate so well with members of the audience, that she has the crowd in stitches. She once proclaimed to a woman in the audience, 'I see you've bought some gold, dear! Looks like you bought it at Ratners [Ratner once called his products 'crap' in a televised speech]. Don't worry dear, some people can wear cheap stuff, but I can't . . . but it looks good on you!'

Curtis Walker, invariably billed as the best black stand-up comic in Britain, was confident, even arrogant, highly capable and, in general, a master at reading and working his audience. At the start of one show he asked men in the audience to shout out, then women in the house to shout out, and when he saw more women than men, he began to criticise

men as liars, cheats, and adulterers, thus winning over the mostly female audience right away. He frequently made black men the butt of his jokes, whatever the audience composition, suggesting they are lazy and good for nothing, spending their entire day walking back and forth across Brixton high street stopping cars dramatically, arrogantly and loudly, as a means to affirm their power. Despite his attacks on men, both men and women found the jokes amusing, particularly because he was able to tap into local knowledge (the names of streets and pubs, times of days, and the concrete experiences of audience members when they were younger).

John Simmit describes his style as 'a collection of controversial anec-dotes' rather than a series of 'did you hear the one about . . .' jokes (Jolaoso, 1993: 25). Simmit is comfortable with a range of topics. Glaz Campell offers a completely different style, joking around topics applica-ble to all and sundry, reminiscent of Tommy Cooper, but delivered, necessarily, with his own flair and distinctiveness. He wins the crowd over, not with bravado, ego or confidence, but via an endearing self-depreca-tion: 'I went into a shop to buy a suit. I said can you show me the cheapest suit in the shop, the guy said, hold on a minute, I'll get you a mirror' or 'Me and my wife were lying in bed last night . . . I was lying to her, she was lying to me! "I can't remember the last time we made love," I said to my wife. "I can," she said, "that's why we're not making love . . .".' His deadpan humour makes you want to get out of your seat and slap him across the face for his sometimes corny, usually clichéd impudence. But it's impossible to do so, because his humour slaps you across the face, and has you rolling over in your seat.

Other stand-up comics include the well-established Junior Simpson (who in addition to his joke routine offers a very compelling imitation of a Bajan accent), Ismael Thomas and, new to the scene, Ruth Harper, whose appeal to women is bound to please, with her hearty front-line attack in the battle of the sexes. One of her key lines for the shows I attended was 'Big up for the '90s girls. You can tell the difference between a '90s girl and a '90s man, because the '90s girl has a different address from her parents.'

Mimics and impressionists

Among the men, Felix Dexter is the archdeacon of this style, with a range of generic and specific characters, such as Samuel Benjamin, the West Indian underground ticket inspector: 'Children today have no respect, no respect. You can't even ask them a simple question, a simple question like "Where you think you going you nasty, dutty [dirty] looking likkel

[little] tief? [thief]" Yes, dem get all upset.' Or his impression of a Nigerian:

We are all brothers, we are all brothers, don't get me wrong, but you West Indians, I don't understand you . . . don't you West Indians understand that you are not wanted here in England. You make trouble at Notting Hill carnival. You make trouble at the airport at Christmas [a reference to the plane full of Jamaicans, many of whom were denied access to Britain during Christmas 1993] and you don't know how to be polite when selling food in a shop. Me buy some food and I am waiting and waiting! Waiting and waiting! Waiting and waiting! By the time the food comes I forgot what a bloody ordered in the first place.

This is all articulated with an impressive Nigerian accent, inflection and facial gestures. But Dexter is also adept at performing the generic black minister and the white-working class skinhead racist. Geoff Shumann also ranks as one of the top impersonators, with impressions such as Barry Fright (for Barry White), Ghanaian Greg, Conan the Barbadian, Darcus Howe, and ragga girl Ballencina Babycham.[3]

Marcus Powell, although primarily performing as part of a double act (Aymer and Powell) also does impressions, in particular an inimitable character, Roy Diamond, a 1950s-type West Indian immigrant, claiming to be the first black comedian in Britain, hardened in the pubs and clubs of England into a culture of cigarette smoking, beer and whiskey drinking. Dressed with white hat, flowered shirt, tie and suit, Diamond told his jokes with a philosophy earned in the university of life, and an appreciation of the inadequacies of human behaviour. His first statement: 'When I came out tonight, the manager of the show told me don't do no profanities tonight, Roy, this is a family show! Fuck off you bastard, I told him, its not my fucking family.' And then, nonchalantly, 'By the way, I just want to let you know that I am available for children's shows.' He continued, sadly, 'My wife left me, y'know (sigh) . . . yes she left me' [with sad face and wide eyes until the crowd said 'ahhhh!' and he responded 'I don't want your sympathy, I want sex. . . . Yes, she left me for my best friend [pause]. I don't know who he is, but since he took her off my hands, he is my best friend.' Feigning drunkenness, stumbling back and forth, unsteady on his feet, his persona was that of the old sage, with simple but wise common sense, based on self-evident principles, instead of high-fallutin' intellectual ideas. 'Who said the pen is mightier than the sword? If someone attacked me in a dark alley I wouldn't want to fight them with a pen.'

Charles Tomlin is also a good mimic, his range of characters based primarily on Jamaican archetypes, such as the 'back-a-bush-country bwoy', the equivalent of the English yokel, who is backward and thus amazed at the advances of industrial and technological society, and the apparent complexities associated with its organisation. He went from the countryside in Jamaica to the town (that is, Kingston) and when told to go wash his hands, did so in the toilet bowl, while praising how advanced they were because they had running water.

Among the women, Felicity Ethnic appears unequalled, with an extensive list of characters including Big Titty Pearl, the stalwart of the black family; Bigga International, the proverbial London Ragga man, Sheila Culture, the working-class white Londoner; as well as several elderly Black women, including Mother Culture, the repository of black sagely knowledge. Lewella Gideon also has an impressive array of characters, which she tends to perform according to scripts, rather than stand-up.

The double act X-Elle (from Bradford) are also mimics with a variety of characters, including two elderly black cleaning women, Myrtle (pronounced in an exaggerated Jamaican fashion – MYRKAL) and Enid, who did a very matter-of-fact routine, covering mundane topics like cleaning, children, underwear and even characters based on northern working-class white women. Their pronounced, even exaggerated, northern accents, are bound to please the largely southern audience. There is also Collette Johnson, who performs, among other things, numerous characters from the popular television show *Eastenders*.

Double acts

Robbie Gee and Eddie Nestor are the champions here; most frequently the comperes of shows, they are the masters of spontaneity. They begin with a minimalist script, but their forte derives from their ability to interact with the audience, by finding themes, issues and topics that resonate with particular audiences on particular nights. Eddie told me. that there are certain themes that generally work well – relationships between the sexes, or family relations – but some themes just arise and can be exploited. Gee and Nestor are not the only ones who use this format; I was unable to see Jefferson and Whitfield, veterans of the double act, but was able to see both Aymer and Powell and X-Elle, who are among the most promising actors at the present time. Aymer and Powell go through several routines, including a 'straight man, funny man' series of sketches. Most notable, though, is the fast-style, back-and-forth exchange of words.

ORGANISATION OF THE BLACK COMEDY
CIRCUIT

A formal institutionalised black comedy circuit is a very recent creation, emerging only in the 1990s. Prior to that time, says Gary Coley, black comics 'had to make do with the bedroom mirror, told a few jokes at weddings, or, if they were really lucky, they'd get an unpaid "newcomers spot" at the mainstream comedy club' (Coley, 1994). Perceptions of black comics among non-blacks in the 1980s were limited to Charlie Williams, Kenny Lynch and Lenny Henry. Blacks were even absent, or excluded, from the so-called alternative comedy scene of the late 1980s. The first black comedy shows began in 1991, with 'Friday black comedy night' shows at the Tabernacle in Ladbroke Grove, the Albany Theatre in Deptford and the Brixton Village in Brixton (Coley, 1994). That year also saw the establishment of the 291 Club, which led to an increase in the number of black comics, and the growth of other clubs and venues. Miles Crawford, Beverely Randell and Charlie Hanson were central here, basing the 291 Club on the popular 'Live From the Apollo' in the United States (Coley, 1994). The 291 Club attained 'cult status' but had many destructive elements, as individual acts were made to sink or swim. Crawford developed a show in central London which reduced the pressure and gave the acts a chance to develop and grow. John Simmit established the Upfront Comedy Club, based in the Midlands, after being turned down by Birmingham Arts Festival when he attempted a black comedy event. Simmitt has also been instrumental in bringing over black professional comics from the United States. These early efforts have been joined in the last couple of years by several other organisers.

At present there are several main organisers, and a series of smaller ones. One is the Upfront Comedy Club, established and organised by John Simmit, which comes the closest to a national organisation. While the other organisers do run shows outside London, only Simmit systematically attempts to reach audiences across the entire country. The Upfront Comedy Club comes with its own flags, posters and logos – an image of a black man resembling the research assistant in the mad scientists sketch on the muppet show – and holds shows regularly across the country, including London. Simmit (named thus as a play on his parent's pronunciation of 'Smith') is one of the veterans of the circuit. A second is 'Dark and Ugly' managed by Sarah Moore with Eddie Nestor and Robbie Gee as the main acts. 'Dark and Ugly' hosted a number of shows in London, as well as Birmingham. A third organiser is 'Street Cred' by Geoff Shumann, again with him as the main act. There is also POWER (People Organised and

Working for Economic Rebirth): based in west London and closely connected to the Nation of Islam, sharing the same offices and many personnel, this is an economic black community empowerment organisation. Among its objectives are the establishment of black businesses of various kinds. POWER events are markedly different from other comedy shows and closely resemble black community educational events.

Black comedy shows take place at a variety of venues across London, and across the nation. Many of them are established venues for comedy, for example, at the Comedy Store in Leicester Square club. Others take place in mainstream performance theatres – for example, the Hackney Empire and the Greenwich Theatre in London, the Alexandra Theatre in Birmingham, The Neptune Theatre in Liverpool and The Phoenix in Leicester. These venues tend to hold one-off shows at different times throughout the year. Closely related are venues in multi-racialised neighbourhoods such as The Albany in Deptford.[4] But most shows took place in black community centres or halls such as The Base in Camberwell Green, The Tabernacle in Ladbroke Grove and the Yaa Asantawaa Centre near to Paddington station. Several new organisers were appearing on the scene at the time of the research, with shows appearing in Tottenham.

The shows themselves took several different forms. Some followed a stand-up comic format, with one person compering, and introducing each act, with the artists going through his or her list of jokes. A second format entailed shows being organised around a theme – for example, 'edutainment' or 'sex'. A third format involved cabaret, in which stand-up comics told jokes, or performed sketches, but were accompanied by other artists that would sing, dance or do drama.

Most people in Britain would regard Lenny Henry as the most successful black comic in the sense of having achieved a national reputation and been given frequent exposure on television. None of the black comics that I researched had achieved this level of success. Many of the comics would undoubtedly define themselves as successful, given the obstacles to black comedy – the lack of precedent outside the United States, the stereotyping and tokenism of the non-black comedy circuit towards black comics, the small size of the black community to offer support, and so on. At the same time, however, many black comics do feel marginalised. They feel black comedy is stereotyped around Lenny Henry, as if one black comic is enough, and that it is pigeonholed as lacking variety. Many feel that opportunities have been constrained by white priorities, and handcuffs, and are keen to ensure that blacks maintain control of what appears to be a burgeoning market, and a product that has the power to challenge the successes of 'alternative comedy'. For example, John Simmit, an

enthusiastic and committed comedian and organiser, is the foremost advocate of the need for black comics to consolidate an infrastructure that would enable them to expand and develop. He exclaims:

> I'd like to think that with the way Black comedy is going we will be able to create and own our own circuit so that if and when the boom comes and goes, there will be something long-lasting on the ground which we are doing on our own terms.
>
> (Jolaoso, 1993: 25)

These views were expressed strongly in my interview with Simmit. One aspect of building a strong foundation, said Simmit, was the need for black comics to analyse their circumstances and engage in a critical assessment of them. This would facilitate development through reflection and action. Geoff Schumann was also insistent about the need for blacks to consolidate and control their shows. But while Schumann was wary of the opportunities of television, Felix Dexter felt the way forward was to break into television.

It is clear, too, that the black women experienced many aspects of marginalisation, given their small numbers, and the sexist attitudes pervasive in England generally, as well as within the black community. Sheba Montserrat, a comic who performs largely though the medium of poetry, felt that women faced particular obstacles and constraints, particularly if they tried to experiment with a range of characters and content. Black audiences do not allow the kind of latitude for experiment that white audiences allow, she said, in part because white audiences are much larger. Despite this resistance, she strives to be creative in her work.

One indication of marginalisation is reflected in the venues in which most black comedy takes place. Overwhelmingly this is in black venues and community centres, very infrequently in large theatres outside the control of the black community. It is also clear that only a tiny handful of comics can make a full-time living by doing comedy alone. Most of those I talked to made it clear that they were doing a range of things to earn a living with many, even most, working full-time jobs.

Audiences

Black comics play to a variety of audiences. The majority of shows that I attended had audiences that were predominantly black, some almost exclusively black, with most of the non-blacks being white.[5] While such shows might be called 'multi-racialised', I think they are best described as having

black audiences, because the numbers of whites present are negligible, the performers respond primarily, often exclusively to black people, and the whites are ignored, or singled out for some jibes. On the couple of occasions that I attended performances in which the audience was more clearly non-blacks, some stylistic differences were evident. Comics were less likely to use patois, or dialect, much less likely to raise issues concerning racism and hostility, and certainly not likely to pick out whites and use them as the butt of jokes. I suspect that this is common practice.

In the shows that I attended the majority of the audience was also female. This varied from a little over 50 per cent to close on 90 per cent (estimates of audience size based on a head count at the start, during the intermission, and at the end). Every artist with whom I raised the question invariably said that the majority of the audience are women. They offered several reasons for this, the primary one being that whereas black men are more likely to go out to the pub and drink, black women want to go out, dress up and have a good time. Black women were more responsive to comics, more likely to engage in a running commentary with the comics, and go on stage when invited. In part this reflected the larger number of black women in the audience, but also there was a greater willingness on their part to engage in the discourse for the fun of it.

Comics made variable attempts to interact with the audience. Comperes would usually single out members of the audience for jokes, or comments; some would bring them up on stage and make fun of their dress, or hair. Sometimes audience members would receive prizes. At the comedy show in Nettleford Hall, West Norwood, Geoff Schumann handed out whistles to the audience at the start of the show and they were encouraged by the performers to whistle at certain junctures. Of course, some individuals whistled whenever they felt like it. The noise was overwhelming – it was collective euphoria and participation. In addition, shirts and half bottles of rum were handed out and the audience encouraged to repeat over and over again the name of the show's sponsors – Appleton's Rum – but this was done 'tongue-in-cheek'.

Comics often identified white members in the audience and singled them out for jokes. They would be called foolish, or arrogant, for coming to a black event, or mocked. Early on in one show Schumann informed the entire audience, that if they didn't want to be embarrassed they had better sit at the back of the audience. He added, 'White people can sit where they want, I will find them and embarrass them anyway', to a laugh from the crowd. In nearly all of the instances that I observed, the individuals took the jokes with a smile, even a laugh, though many

undoubtedly felt uncomfortable. At a show in Leicester, Curtis Walker went much further. After making several jokes about a white man that appeared to be drunk in front of the audience, the white man argued this was not good for 'race relations' and Walker allowed himself to be drawn into a twenty-minute dialogue on this issue. He finally defended himself by arguing that white comedian Jim Davidson had singled out black people for the butt of his humour so now it was the turn of white people to endure it.

THE CONTENT OF BLACK COMEDY

The vast majority of comics, on most of the occasions that they performed, covered a broad range of topics. Black comedy covers a wide range of areas from the immediate and mundane to the abstract and philosophical. There is some evidence of explicit political content in the work of some comics, but most avoid the explicitly and immediately political, except, perhaps, to make fun in a very apolitical way of some key politicians such as John Major or Margaret Thatcher. But many of the jokes told, or the situations addressed, do reflect concern with political issues generally, especially when they touched upon issues like racism, immigration and policing. The majority of comics confined their topics to issues and situations that would be familiar mostly to, or known only to, the black community. Some of the time they addressed topics that would be of general knowledge, regardless of the racialised identity of the audience. At other times many of the topics drew extensively upon knowledge of and familiarity with the black community, for example growing up with black parents, the black churches, music, food, etc., as well as general attitudes towards white people. Sometimes, this was done using language that non-blacks would find difficult to comprehend, literally; or using words that had comic connotations more fully appreciated by black people familiar with the language. Several comics told me that black audiences like their comedy to be pointed, and 'straight up', rather than abstract and philosophical.

A distinct area of comedy is 'Edutainment'. This entails content that is designed to raise consciousness, especially black consciousness, and to provide social commentary and critique. The overall goal is to use humour and comedy as a means to stimulate cultural and personal introspection. Although I would argue that many of the comics spoke to issues that were consciousness raising, in so far as they challenged racialised hostility and practices, this type was more explicit and sustained. By far the leading exemplar is Leo X Chester, a member of the Nation of Islam, and a

person whose own transformation compares, in no meagre fashion, with the personal transformation of Malcolm X (having spent a lengthy period in prison, and undergone substantial personal change). Others include Kwaku, and, intermittently though increasingly, Geoff Schumann.

I have found it useful to organise the material in the following categories: the reproduction of black culture; social commentary; gender relations and representations. Social conformity and social resistance are also very evident, and I address these two themes in the following section.

Affirmation and reproduction of black culture were achieved in a variety of ways, but largely by articulating jokes relating to aspects of black culture known and experienced, fondly, if ambivalently, by members of the audience: black food and cooking; black music and dance, black religion, and growing up with strict, disciplinarian parents; black women's hair styling; and, of course, dealing with the stereotypes, inanities and stupidity of white attitudes towards blacks. Felix Dexter characterised the differences between black and white churches, the former loud, involved and energetic, the latter quiet and timid; Richard Blackwell performed the antics of a young boy being scared as he went home after staying out all night, and the experience of being beaten once he got there. Angie Le Mar was outstanding in her representation of black culture, especially as it was reproduced by girls and women, for example, around hair and hair stylists, as well as dating and child-raising. It was also common for comics to characterise the differences between Jamaicans and other Caribbean islands. Gee and Nestor were the best here, the former from Jamaica, the latter from St Kitts, and they played off the inter-island rivalries without the animosity or virulence that sometimes accompany them. Gee mocked St Kitts for being small: 'I went to a street in St Kitts, I don't know which street, I think they only have one street!' Nestor mocked Jamaican arrogance about having spread Jamaican culture across the world – 'Yes, Jamaicans are everywhere. There is not a jail in this world which doesn't have a Jamaica in it!'

Black culture to these comics meant black Caribbean culture, and only a couple of comics made any systematic and explicit reference to other dimensions of black culture such as West African. Both Dexter and Schumann did impressions of West Africans. No comics made reference to African American culture in this way. For the couple of African comics on the circuit – Wara and Toju – black culture meant African culture, Zimbabwean for the former, and Nigerian for the latter. Wara talked of the stereotypical notion his white teachers had that he could play cricket, despite the fact that he had never played it in his life; Toju articulated the educational obsession of West African parents, and exaggerated their fears

232

that their children would imitate Caribbean behaviour, especially if speaking patois.

One final way in which comics reproduce black culture is by speaking to the ways in which non-blacks seek to imitate and appropriate it. For example, several jokes concerned assertions of the inability of whites to dance, or play sport, and their feeble attempts to copy blacks; or their inability to cook – 'salt and pepper, for whites,' said Leo X Chester, 'is seasoning'. Chester also spoke of David Rodigan, a white DJ who specialises in Reggae music, calling him 'Rodigan Crusoe', he also criticised those who regard Apache Indian as the best performer of Reggae music. John Simmit, after a newspaper announced a new discovery by white people in Africa, raised the issue, 'How come whites always find their way into "Darkest Africa", and the locals don't even know where it is? Do white people have a map, or what?' Rudy Lickwood proclaimed, 'How is it that all these liberal whites claim they are so open-minded by telling you "some of my best friends are Black!"? I don't believe them . . . there isn't enough Black people in this country to go round!'

Dexter is perhaps the most versatile in the topics upon which he draws for social commentary. From politics and John Major, to policing and the National Front, he taps into contemporary political issues and currents. Other comics raise issues around work, education and more mundane topics like shopping. Social solidarity and unity is implicit, often explicit, in the jokes of many comedians. Chester is the most notable, insisting that blacks should buy black products, work together, and give one another a chance to help one another. One aspect of social commentary speaks explicitly to stereotypes of white behavior and attitudes. Comics comment on various aspects of racism, hypocrisy, inadequacy, and fumblings around white behaviour. Angie Le Mar's material almost exclusively concerns male/female relationships, attacking men (how easy it is for women to fake orgasm) and mocking, sometimes mildly or sarcastically, even caustically, black women's anxieties, for example, insecurities around dating men (putting on make-up, being overweight, farting, dealing with the new girlfriend of their ex-boyfriends). Le Mar draws heavily on, and thus reproduces, the stereotype of black women as bitchy, competitive, self-centred rivals. Chester rebuked black women for wearing miniskirts, saying that the road traffic accident rate goes up when they do so.

One final comment can be made about the content of black comedy: this concerns the language of delivery. A constant theme characteristic of the comics studied is the movement between what might be called 'standard English' and patois or dialect. All comics demonstrate the ability to do that, and most do it frequently and self-consciously. Others seem to do

it haphazardly. Some speak almost exclusively in one or the other. This interplay of language codes is also evident in interactions with white members of the audience. On some occasions, fun is made simply around the idea that whites would have difficulty understanding patois or dialect. For example, they would be asked if they understood particular phrases, or terminology, and at times translations would be offered. A good example of this occurred at a show in Leicester Square where Charles Tomlin identified a couple from Texas and spent much of the evening offering translations of single words and phrases. Charles Tomlin: 'In Jamaica we usually se "fe" when it means "its yours", for example, "fe him house" means "it's his house" or "fe him money" means "it's his money". So me go to a toilets which said "female", but get ina trouble.'

EVALUATING BLACK COMEDY

What I want to suggest here is that black comics are mediators of cultural codes and forms, and critics of key aspects of the social order. Comics highlight and challenge the racialised hostility prevalent in British society, while reassuring black people of the validity of their grievances. But comics also reproduce a range of normative cultural attitudes and practices among black people, and they challenge any divergence from this, especially around attitudes and practices held central to the cultural repertoire. In doing this, they reproduce a number of stereotypes around black community behaviour (as well as stereotypes of whites and women). However, they do occasionally suggest the problematic nature of such codes, while even sometimes encouraging their transgression.

Nearly all of the content of black comedy involves social commentary on a range of day to day topics, heavily skewed towards topics familiar to, and central in, the experience of the black community; from broad topics like politics, policing and immigration, to more immediate issues of family, work, the battle of the sexes, food and shopping. In this way, humour is used to articulate concerns and grievances, register indignation and protest, as well as suggest alternatives to the current institutional order. Central to this is a critique of the racialised social order in Britain, of racialised hostility and the many obstacles and anxieties that it poses for black people's aspirations to survive and succeed. At the same time as this racialised social order is subjected to critique, the black community's ability to thwart hostility and subvert control is affirmed.

Much of this comedy reproduces expectations of normative behaviour, reinforces cultural codes and requirements, by asserting its authenticity, appropriateness and desirability. Jokes emphasise the authenticity and

integrity of black culture and reaffirm appropriate modes of behaviour and demeanour – where to live, who to date, how to dress, do your hair, what to eat, what music to listen to, political values to subscribe to, and the like, are all articulated in varying ways. Schumann mocked the accent and behaviour of television celebrity Mr Motivator and said he was an 'NQB'! (Not Quite Black!) who tried to appease white folks with an exaggerated black accent. Mr Motivator, said Schumann, was one of these 'coloured chaps' we see on television all the time. Others joked about children's television presenter Andy Peters, that he sounds white because he has 'no bass in his voice'! Junior Simison asked why Alan in *Eastenders* does not take on a more challenging role – for example, playing a black part in a film. At the most extreme, and Leo X Chester best exemplifies this, the audience is told pointedly: 'Don't drink, don't eat pork or chicken'; Ruth Harper's joke is 'the only thing a white boy is good for is to introduce me to a black man'. This racialised moral chastisement, at its extreme, is what analysts of other aspects of black culture (particularly music and education) have called 'policing the boundaries' of black culture (Gilroy, 1993). It is here that we see most clearly black comics as mediators of cultural codes.

But if social control is pervasive in the cultural repertoire of black comics, then resistance to what I call 'racialised iron cages' is also evident in black comedy, though it is far less common. Here, I am not talking about resistance to racialised hostility in its more obvious manifestations of verbal abuse, prejudice, discrimination and violence. Rather, it is about challenging stereotypical, expected, even required actions, attributes and behaviour by blacks – that they must 'look black', 'talk black', 'act black', and date or marry black. For example, Sheba Montserrat raised the issue of public sexual mores, asking modestly, 'how is it that blacks can "wind up" (dance lasciviously) in a dance hall just like sex, and no one says nothing? But if whites kiss in public, black people go crazy. Blacks kissing in public is against the rules.'

Felix Dexter offers the best, and most consistent example here, as time after time he raises issues, explicitly and implicitly, about these normative expectations. One of his frequently used scenarios concerns him saying 'Why do we have to be called black comedians? Why not comedians? I know I'm black. I don't have to be told every day that I'm black. Black people don't wake up in the morning and say, 'B'woy me is a black man, y'know, me better have ackee and salt fish and buy *The Voice* and listen to Reggae today.' The audience laughs with him, as if in support, but it's not clear that they share his spirit. Not only does Dexter joke about these issues, but he challenges the audience directly, playfully mocking them. One of his most insistent examples concerns differences between black and

white comedy, where he talks about a 'dog licking its balls', or about 'fucking, and cleaning my cock with my girlfriend's toothbrush', or 'wanking' and how blacks don't like to hear that kind of thing. For black people this is 'slackness', a Caribbean term, originally used with reference to some of the lyrics of Ragga artists from Jamaica, meaning indecent, obscene. But Dexter is not content simply to mention the point, he develops it, adding layers of lewdness to it, pushing his audience further than they want to go, almost condescendingly.

Comics addressed other types of moral order and constraint. An outstanding example of challenging the moral status quo occurred with the performance of a skit called 'Romeo and Julian' by 'The Posse'. It featured two men in tights, clearly homosexual lovers, in a scene based on Romeo and Juliet. Designed to push the hypocrisy of homophobia, the scene drew mixed, and loud, reactions. Eddie Nestor, who had been involved in the organisation and performance of the tour said that The Posse as a whole had received substantial criticism as well as strong praise for the scene.

Much of the humour around gender plays upon and also reproduces the sexist stereotypes pervasive in British society and the black community. Just about every black comic, male and female, told several jokes relating to the 'battle of the sexes' – dating, romance, beauty, sexuality. They did so in different ways, and while most reproduced sexism, others consciously strove to challenge it. Toju, a young artist, took this to its extremes, with a tirade of crass and vulgar jokes – women who claim to be shy but have sex in every conceivable position; women with big breasts end up old and fat and saggy, who can wrap their breasts around their neck, tie them in a knot and use them as a scarf. This drew sighs from the audience, and booing. He then imitated a 'shy' woman by lying on the ground, with his legs up in the air, pointing to between his legs and saying 'put it there, put it there'. The following week, comic and writer Gary Coley pointed out in his column that if Toju wanted to go far as a comic he needed to learn that it is not advisable to tell crass sexist jokes at the best of times, but especially not in an audience that is 90 per cent female (Coley, 1995: 34).

Again there were examples of challenges to the gendered status quo. One of Angie Le Mar's themes centred on how women could trick and deceive their men, to acquire money and presents. In particular, she would describe how easy it is for women to fake orgasms, to maintain their man's ego. In a different vein, Eddie Nestor performed a sketch based on linguistic patterns familiar to African Caribbeans, in which a macho and egotistical character narrated how he invited out a woman, wined and

dined her, seeking to impress, and eventually expected to have sex. As he described the unfolding of the evening, each time his date said how impressed she was by his style and sartorial splendour, and his fancy car, he would assert 'me knooooow!' But after she refused to succumb to his advances, he proceeded to force himself on her, and he ended up in prison for rape. He asked, reflectively, 'do you know what happens to a man in this circumstance?' And, before the audience could answer 'jail' he uttered, with head turned down, 'me knooooow!'

Authenticity and hybridity

All black culture in Britain is clearly hybrid, but the idea of hybridity on its own does not indicate the extent to which different components of diverse, even divergent cultures, are incorporated to create a new configuration, a new composite. Black cultural forms owe their origins and key aspects of their current formation to diverse diasporic roots in the Caribbean, the United States and Africa (Ramdin, 1987; Oliver, 1990). They owe a great deal, sometimes unacknowledged, to non-African sources across Britain and the United States (Fryer, 1984). This is true, for example, in music, religion, food and clothing. These different aspects of black culture all reveal traces of a distinctly British nature but to varying degrees. What I want to suggest is that black comedy is more distinctively authentic, in the sense of building more directly, more explicitly, more self-consciously upon the experiences of blacks in Britain, than for blacks elsewhere in the diaspora. Its content is more clearly preoccupied with British issues and concerns, its modus operandi characterised by an incessant vacillation between accents – Jamaican or Bajan (Barbadian) and the localised English, often with a regional accent (e.g. South London, or Birmingham). In this way, black comedy in Britain owes less to its diasporic contributions from elsewhere; it has broken out of its African, Caribbean and North American diasporic origins, and has created its own genre.

It remains to be said, however, that while it is unique to Britain, black comedy is biased a great deal towards the south of the country. The majority of comics are from the London area, and most of the shows take place there. There are several exceptions to this – with performers from Birmingham, Yorkshire and Luton, but even these performers feel the pressure to move to London, and many of them have. The content of the shows reflects this geographical bias, and there is an implicit assumption that black life in England and black life in London are one and the same thing. This is not appreciated by black audiences outside London, though

some capitulations are made. Black comics have not yet taken the opportunity to build a distinctive following by playing on the idiosyncrasies of local issues and identities.

It is difficult to find many aspects of black culture in Britain that are not in large part borrowed from black culture in the United States. This is true in music and education, in religion and language, in dress and even food. On the surface, black comedy seems patently unaffected by this borrowing. With the exception of Leo X Chester, none of the material owes a great deal to the USA either in content or form. And while Chester's attire is distinctly Nation of Islam, the content and delivery of his jokes owe more to his socialisation as an African Caribbean in England. None of the comics has a distinctive style reminiscent of any of the most well-known African American comics, such as Richard Pryor, Bill Cosby, Eddie Murphy or Redd Fox; and although Rudy Lickwood bears a striking resemblance to Eddie Murphy, his own confident and distinctive style bears little resemblance to his lookalike. Several comics say that they have been influenced by the United States, but not in ways similar to other aspects of black culture. Geoff Schumann says he wants to control black comedy like African Americans control their institutions; the 291 Club was loosely inspired by the 'Live At the Apollo' shows; John Simmit has brought African American comics to Britain. But none of this has led to the manifest presence of African American culture in black British comedy in ways that it is present in other aspects of black British culture, such as music or dress.

What kind of comedy and for whom?

The majority of black comics perform for black audiences that have a full understanding of the black experience in Britain, a familiarity with its many nuances, and an ability to understand the black British versions of patois and dialect which articulate these experiences. While most of the comics could be understood, literally, by non-blacks, to an extent that they would understand their jokes, a fuller appreciation is possible only by those immersed in the black experience. In interviews and discussions, several comics said they did not want to change their comedy, or to dilute it, in order to appeal to non-black audiences. The most obvious exemplar of this type of humour is Charles Tomlin, who portrays himself as the authentic Jamaican country bwoy, who comes from so far back-a-bush that his patois is as impenetrable as the foliage and fen in the Cockpit country. His presentation of material has white people grasping for their 'teach yourself patois' books.

It is useful to note that there is a certain cathartic value to be had from

engaging in culturally exclusive humour, that is, over and above the symbolic act of cultural affirmation. This catharsis occurs in the act of doing to whites what they have been doing to blacks for centuries – mocking, marginalising, ignoring, even despising. So, also, the comedian can use poetic licence to chide and chastise whites in general and racists in particular for this mistreatment of black people. The cathartic effects are especially beneficial given the relatively small size of the black population in Britain (and its overwhelming concentration in England).

Institutional infrastructure

The black comedy circuit is small; the funds available for comics far from abundant; the venues available for black comedy, few in number; the audiences needed to sustain comedy, limited in supply. Many comics must sustain other jobs or work to make ends meet. In addition, the comics are often responsible for the organisation and promotion of each event. When I interviewed Eddie Nestor early in July 1995 he was frustrated and overworked because, he told me, the posters and the radio advert for his upcoming show at the Hackney Empire ('Sex Rated') had not gone out. He had worked the previous Friday at the Albany in Deptford, and then from 12.00pm until 8pm at the Hackney Festival, Hackney Downs. I then saw him, with Robbie Gee, handing out flyers for their show when I attended 'The Black Woman's Guide to the Black Man' that evening at the Hackney Empire.

Like other blacks who produce culturally inscribed commodities – from food and music, to artefacts – black comics are competing against one another for the attention of a small audience. In order to consolidate and expand black comics need continually to develop new material, as well as finding new venues in which to perform. New material is necessary to keep the interest of the audiences who regularly attend black comedy, as well as to attract other audiences. If new material is not developed, neither the existing audiences nor new ones can be sustained. Those who attend black comedy frequently become familiar with the jokes and routines and have come to expect more creativity and innovation, especially after watching the same performers over and over. I discussed this issue with a couple of black women at one comedy show who indicated that they came every two weeks to a comedy show and were beginning to get a little concerned over how often the same material was used. Yet, if comics wished to attract non-black audiences, distinctive changes would have to be made, and this, I believe, would make the comedy less attractive to black audiences.

CONCLUSION

The professional black comic circuit in Britain is of recent origin. It is organised around a national network of small clubs and venues, many of them in black community centres, with shows occasionally taking place in larger theatres. Most shows take place in and around London. These shows are attended overwhelmingly by blacks, though sometimes black comics play to mixed audiences, even to private parties that are mainly white. The majority of black comics are African Caribbean men, but some of the women have national reputations and followings. They reveal a variety of styles, some being stand-up comics with a series of jokes; others being accomplished actors and mimics with a repertoire of characters, voices and scenarios; there are also double acts. Black comedy is overwhelmingly concerned with two broad areas: general issues which have a resonance with the lives and experiences of all people (employment, education, family, battle of the sexes, politics, music); and the characteristic features of black culture, the experiences of different sections of the black community and the idiosyncrasies of black life in Britain. The two areas are closely related – the former is saturated by references to the uniqueness of black people's experiences in these institutional realms, and the latter is overwhelmingly articulated with a symbolism and subjectivity which would be lost to those without experience grounded in the black community.

Like all Creoles, black comedy in Britain plays upon its syncretic heritage of black and white, local and foreign, Caribbean, African and, to a lesser degree, African American. It thus combines and merges diverse diasporic sources, as well as many from an array of nations (primarily England and the United States) that have little to do with black diasporic life. This is also the case with other elements of black culture, like music, religion and politics. But unlike other aspects of black culture which continue to be shaped so directly and explicitly by black culture from other diasporic locations, especially the United States, black comedy in England is more clearly locally grown. This comedy clearly owes it primary substance and articulation to the realities and history of the black presence in Britain, to the patterns of immigration and settlement, housing, work and education, to resistance and resilience; not to mention the ambivalences and conflicts within diasporic communities – between African Caribbeans and Africans, as well as between the diverse island nationalities of the Anglophone Caribbean. Black British comedy traces its roots to the diaspora and the continent; but the fruits on its branches are more clearly the result of its home-grown fertilisation.

It seems inevitable that the basic structure of the black comedy circuit will remain intact, and that black professional comics will increase in number. They will certainly build upon their successes, as a second generation of comics learns from, consolidates and expands, with their own creativity, on the successes of the first. Black audiences want to hear from black comics in a style and cultural repertoire that resonates with their own experiences and attitudes and they will continue to offer support. In this respect, the future looks promising. But it seems unlikely that it will expand in any significant way, without a distinctive change in its character, for two reasons. First, I don't believe that there is a sufficiently large enough audience demand to enable it to expand in its current form, to any great extent. The relatively restricted opportunities for making a living as a professional comedian and the small size of the black community in Britain militate against this possibility. Second, it is clear that the lure of money and limelight for the most versatile and accomplished of black comics, will lead to greater incentives to develop styles and content that will be amenable to larger, that is, non-black audiences, and will lead to them performing in different venues. Some of them may manage the juggling act of doing both types of venue, both types of audiences. The skill and linguistic versatility of many black comics suggest their ability to maintain this type of cultural schizophrenia – but most will not.

Nor is it clear that control of the black comedy circuit will remain in the hands of black people. If the circuit proves to be more lucrative there is the distinct likelihood that it will be appropriated by non-blacks, probably in a fashion similar to how Hip-Hop music has been appropriated in the United States (Rose, 1994). The current organisers are determined to maintain control, but they are also performers and may be lured away by other opportunities. In any case, they are few in number, face more immediate and pressing problems, and cannot begin to match the resources of non-black competitors. It is thus far more likely that structural and institutional factors will overpower the resolve and determination of individual blacks.

Black comedy in Britain is in its infancy. The circuit is limited in scope but with a strong foundation. The performers are small in number but growing, with skill, vibrancy and enthusiasm. Overall, black comics in Britain reveal both heart and soul. It is the heart of those who fight with spirit and determination against odds that they know outnumber them; it is a soul which reveals the playful anger of underdogs whose parents have caught the last boat from the colonies before the dam closes to block an imagined tidal wave.

NOTES

1 The word 'black' in this chapter refers to people of African and African-Caribbean origins, including those who are of mixed origins with whites (usually called 'mixed-race'). The term 'non-black' refers to anyone other than this group, but primarily means white people. For an outline of the rationale underlying the use of this terminology, see Small, 1994. This chapter is primarily about England, and the vast majority of black comics are based in England. But reference is sometimes made to 'Britain' because this is the national boundary.

2 The information for this chapter is drawn from several sources: observations at 20-plus comedy shows in London and across Britain; interviews with black comics and producers; and a range of published secondary material.

3 'Ragga' refers to one type of Reggae music, sometimes called dancehall music, which has a distinctive following of young people, with distinctive attire. The stereotype of a 'Ragga' girl is one with short, dyed hair, usually blonde, gold teeth, gold chains and rings, denim jeans and jackets, with extensive rips.

4 For an in-depth discussion of the concept of 'racialisation' see Small, 1994.

5 It is clear that there are some occasions on which black comics perform for audiences that have a relatively equal number of non-blacks in the audience, and even shows in which the audiences are predominantly non-black. Felix Dexter made it clear to me that he performs in such situations, and often does private parties in which the majority are not black. He also performs in locations – such as Plymouth or Warrington – in which there are very few black people, and thus the audience is not black. He makes several jokes about this. Robbie Gee and Eddie Nestor also perform in venues where there is a large proportion of non-blacks present, for example, the Hackney Carnival.

BIBLIOGRAPHY

Bartholomew, Roy (1995) 'The power of black humour', Observer Review, 5 July, pp. 1 and 3.

Coley, Gary (1994) 'We did it our way', The Voice.

—— (1995) 'Gary's Coley's comedy column', The Voice, 20 June, p. 34.

Fryer, Peter (1984) Staying Power: The History of Black People in Britain, London: Pluto Press.

Gilroy, Paul (1984) There Ain't No Black In the Union Jack: The Cultural Politics of Race and Nation, London: Hutchinson.

Gilroy, Paul (1993) The Black Atlantic: Modernity and Double Consciousness, London: Verso.

Gray, H. (1986) 'Television and the New Black Man: Black male images in prime time situation comedy', Media, Culture and Society 8: 223–42.

Husband, Charles (1988) 'Racist humour and racist ideology in British television, or I Laughed till you Cried', in Chris Powell and George Paton (eds) Humour in Society: Resistance and Control, Basingstoke: Macmillan Press.

Jolaoso, Ronke (1993) 'Serious Business', The Voice, 27 April, p. 25.

Lindsey, Emman (1994) 'Laughing all the way to the bank', The Weekly Journal, 8 September, p. 9.

Oliver, Paul (ed.) (1990) Black Music in Britain: Essays on the Afro-Asian Contribution to Popular Music, Milton Keynes and Philadelphia: Open University Press.

Pines, Jim (ed.) (1992) Black and White in Colour: Black People in British Television Since 1936, London: British Film Institute.

Powell, Chris and George Paton (eds) (1988) Humour in Society: Resistance and Control, Basingstoke: Macmillan Press.

Ramdin, Ron (1987) The Making of the Black Working Class in Britain, Aldershot: Gower.

Rose, Tricia (1994) Black Noise: Rap Music and Black Culture in Contemporary America, Hanover and London: Wesleyan University Press.

Small, Stephen (1994) Racialised Barriers: The Black Experience in the United States and England, New York and London: Routledge.

Watkins, Mel (1994) On the Real Side: Laughing, Lying, and Signifying, the Underground Tradition of African American Humor that Transformed American Culture from Slavery to Richard Pryor, New York: Simon & Schuster.

ACKNOWLEDGEMENTS: I would like to thank Gary Coley who introduced me to several black comedians, and offered indispensable insights into the nature and history of black comedy in Britain. Thanks also to Shaun Deckon, who carried out a number of interviews, and undertook observations at comedy shows. Finally, thanks to Julia Sudbury who provided detailed comments on a draft of the chapter.

NOTE: This chapter has been written on the basis of research carried out between summer 1994 and summer 1995. The black comedy circuit is in a period of rapid development and it is likely that some of what I say here will have been overtaken by the development of events.

13

'THEY ALREADY GOT A COMEDIAN FOR GOVERNOR'

Comedians and politics in the United States and Great Britain

Stephen Wagg

I'm goggle-eyed from watching the convention. Until TV, nobody knew the caliber of the clowns governing the country. It's impossible to observe these chowder heads in action, with their funny hats and balloons, without feeling sure we're destined to go the way of Rome, Greece and big-time vaudeville . . .

Groucho Marx, in a letter to Goodman Ace, 1960

This chapter examines the relationship of comedians to political processes, in Britain and the United States, over the last fifty or sixty years. It is primarily concerned to interpret the *actions* that comedians have taken in the realm of politics, or in relation to politicians, although it also tries, where appropriate, to relate their professional work – their comedy material, routines and suchlike – to the political life of their respective societies. But I want, if possible, to tie any political analysis of individual comic texts to the time and place in which these texts occurred: clearly comedy is conditioned by, reflects and, perhaps, seeks to challenge particular sets of political circumstance. Necessarily, I will have more to say about comedy and politics in the United States; this is because, as I will argue, American political culture has been more populist than British political culture, and for longer, and this has made for a greater and more sustained involvement of comedians in US politics. Ultimately, though, the same processes will be seen to be at work in both societies, trends well established in the United States as long ago as the 1940s and 1950s having become perceptible in Britain by the 1980s.

LOOKING FOR AMERICA: COMEDY AND
POLITICS IN THE UNITED STATES FROM THE
1930s TO THE 1960s

The American sociologist C. Wright Mills once lamented that, in the United States, 'A man who can knock a small white ball into a series of holes in the ground with more efficiency and skill than anyone else thereby gains social access to the President of the United States.' This, he suggested, was the cultural hallmark 'of a society that makes a fetish of competition', wherein the mass media celebrate 'the movie stars and the Broadway actress, the crooners and the TV clowns simply because they are celebrities' (Mills, 1959: 74). Such a society is, paradoxically, based heavily upon social class, with a strong ideology of the openness of these classes, and there is within it a widespread abhorrence of status division: nobody, in principle, is better than anyone else. Thus, initially, any person occupying a position of social or political eminence would have from time to time to demonstrate a 'oneness' with ordinary folk and popular culture. Golfers, crooners, comedians and so on were a means to this end: they were fellow meritocrats, whose success was a manifestation of the popular will, and their friendship betokened an apparently democratic culture in which high office did not disdain the pleasures of the multitude. Comedians were especially important in this context. They, after all, submitted themselves most regularly to public scrutiny and failure to judge popular opinion correctly, and the consequent absence of laughs would mean that they didn't work. As Hollywood showbusiness correspondent James Bacon once observed of Bob Hope and George Burns:

> In the old hoofing days of vaudeville, if you didn't come across you were pulled – you might be fired in the matinee and not do the evening show. It was a life or death existence. So these guys are hungry comedians; they're still hungry; not for the job – hungry to make good.
>
> (quoted in Thompson, 1982: 121–2)

What turned old vaudeville comedians like Bob Hope and George Burns into celebrities was radio. A number of comedians, including Hope, George Burns and Gracie Allen, Milton Berle, Eddie Cantor and Jack Benny, had popular radio shows in the States during the 1930s and these shows all had corporate sponsors. Hope, for example, was sponsored regularly by Pepsodent toothpaste; Benny represented, among others, Canadian Dry

Ginger Ale and General Foods; Eddie Cantor's radio show was called the *Chase and Sanborn Hour*, after the coffee company that employed him; and, in the early days of radio, big commercial corporations and their agents trawled vaudeville for as many comedians as they could find. Once they had their sponsors, the comedians were, inevitably, bound in what they said both by the wishes of their employers and by the anticipated attitudes and prejudices of a large and diverse audience. Moreover, once in post, these comedians had a battery of writers working for them, whose job it was to determine what might tickle this vast audience and what might not. In this context, therefore, no firm distinction could be made between the writing of jokes and the writing of advertising copy; indeed Cantor's writers were provided by J. Walter Thompson, the advertising agency (Cantor and Ardmore, 1957: 215).

All this is important to note, I think, for two reasons. First, the great American comics should not be seen as free-floating individual gadflies, wisecracking against convention. Although they were often genuinely funny people, capable of creating spontaneous amusement at social gatherings, their principal work was in relation to mass consumption and, specifically, to maintaining the visibility of key consumer goods in the marketplace. Theirs was the crucial task of determining 'what would play' and what wouldn't and, in this context, they tried to identify social trends and to follow them, rather than to lead such trends or to defy them.

Second, therefore, the much-extolled Jewish origins of many of the leading US comedians of the inter-war period matter less than might be thought. Cantor, Benny, Burns, The Marx Brothers, Milton Berle and Phil Silvers, to mention only a few, all came from Jewish homes but none of them were especially conscious of their Jewishness and it informed little of their humour. Harpo Marx, for instance, describes an early gig by the Marx Brothers being received in silence by an audience, including a number of their relatives, that were hoping for jokes in Yiddish (Marx and Barber, 1985: 146); and Benny's daughter recalls 'Daddy wasn't a "Jewish comic". . . . He rarely if ever did Jewish humour or told Jewish jokes' (Benny and Benny, 1991: 163). The point, for Benny and the others, was that they had to concoct, and to purvey, an 'American' humour, 'ethnic' or sectional humour being perceived as 'unAmerican' and, thus, bad for business. (These comedians nevertheless all faced anti-Semitism both in their private and their professional lives. They belonged to the Hillcrest club in Hollywood, because other clubs would not admit Jews and, for young Jewish comedians, there was always work in the 'borsht belt' of hotels in the Catskill mountains, because Jewish holidaymakers were unwelcome in other resorts.)

The central logic of this culture, for the comedians who inhabited it, was that notions of 'America' and 'the people' took precedence over 'politicians' and 'government'. In an often aggressively egalitarian society elected representatives should never forget who put them in office. America had never had an aristocracy and, thus, no concept of class ascription. Jokes which reiterated the humanness of leading political figures, and punctured any pretension on their part, would likely go down well in a predominantly undeferential culture, where, formally speaking, people were not required to 'know their place'. Thus, for example, when President Coolidge came to see the Marx Brothers in *Cocoanuts* on Broadway in the mid-1920s, Groucho Marx 'stepped to the footlights, eyed the President for a moment, and then said "Aren't you up past your bedtime, Calvin?"' (Marx, 1954: 96). Groucho was a liberal, a registered Democrat and an activist in the Actors' Guild but, although Coolidge was a Republican, this remark had nothing to do with party rivalry. It was a device simply for the puncturing of presidential dignity and, as such, it invoked 'America'.

Comedians during the immediate pre- and post-war eras generally avoided criticising politicians *as* politicians; they concentrated on an increasingly institutionalised irreverence. The comedian Red Skelton, for instance, was invited to the White House in 1940 to entertain at President Roosevelt's birthday luncheon:

> Midway through the proceedings, Red interrupted a Presidential toast by grabbing FDR's glass. 'Careful what you drink, Mr President', he warned. 'I once got rolled in a joint like this.' Roosevelt roared appreciatively, and until he died always insisted that Skelton emcee the annual Presidential birthday luncheon.
>
> (Marx, 1979: 3)

Phil Silvers was asked to perform a similar task for President Eisenhower at the Statler-Hilton hotel in Washington in 1954. 'First', Silvers remembered, 'we were all cleared to make sure we had no leftist connections.' At the performance:

> I walked onto the stage and looked over the audience: President Eisenhower, Vice-President Nixon, the Cabinet, Congressmen and Senators, most of the Supreme Court. Everyone was there except John Foster Dulles, who was stuck in some weary negotiations in East Germany. Well, I'd come a long way from Brownsville, so I took a good look. About fifteen seconds — an eternity. Finally, I

turned to Mr. Eisenhower: 'My God, who's minding the store?'
Ike liked that. It was a knee-slapper.

(Silvers and Saffron, 1974: 201–2)

These jokes reveal, and celebrate, a social and political distance; Skelton
and Silvers function here as court jesters to an elite. The presidency
becomes, symbolically, a 'joint' and a 'store' – the language, respectively,
of downtown and small-town America. Ultimately, though, the presidency
is the President's business; these wisecracks bring the stamp of popular
approval to that – he and his people will know how to 'mind the store'.

Indeed, this notion that although politics was for politicians, that ordi-
nary folks or their spokespeople should be allowed to poke a bit of
good-natured fun at the whole business produced a spoof presidential
campaign in 1940. Gracie Allen, one half of the popular comedy duo
Burns and Allen, ran in 1940 for the 'Surprise Party', visited several major
cities and held a mock-convention in Omaha, Nebraska over four days in
May of that year. Allen campaigned with charmingly nonsensical slogans,
such as 'Down with commonsense. Vote for Gracie' and guested on other
comedy shows to press her candidacy. This worked as a multiple promo-
tion: Burns and Allen were able to mount a national celebration of their
radio show; once again there was corporate sponsorship – from companies
such as Mars and Union Pacific Railroad, who provided Allen's campaign
train; and the town of Omaha was boosted as a place of commerce.
Omaha ran a traditional seven-day carnival, called 'Golden Spike Days'
around the convention, and a local banker on the organising committee
told Variety (8 May 1940): 'Visitors to a city, entertained with a good
show, will return to that city again for shopping, business transactions and
even for permanent residence. Good will follows good entertainment and
good business follows good will.' No one could better describe the polit-
ical economy of US comedy during this period. As George Burns
acknowledged many years later, the 'Gracie for President' campaign
expressed the standard distance between politics on the one hand and
comedians and ordinary folks on the other:

Neither Gracie nor I were interested in politics. . . . Gracie had her
own opinions about current events, but she was never vocal about
them. We never publicly supported any political candidates or
made fund-raising appearances for them, although we were often
asked to.

(Burns, 1990: 187)

This was partly because, despite their conspicuous success, Burns (a Jew) and Allen (an Irish Catholic) were in practice still marginal to 'mainstream' American society, despite the reforms of the Roosevelt administrations in the 1930s (see Carroll and Noble, 1979: 350–1):

> The only politicians Gracie ever cared about were the Kennedys. Not because she agreed with their policies – she may have – but because they were Irish Catholics. Gracie was very proud of her heritage, and the thought that an Irishman could be President of the United States absolutely thrilled her.
>
> (Burns, 1990: 187)

This shouldn't be taken to imply that no comedians were able or prepared to engage with political issues. For example, the memoirs of Eddie Cantor show his close involvement in Democratic politics and his sophisticated appreciation for Roosevelt's 'New Deal'. Cantor knew the tough ward politics of East Side New York from his youth, campaigned actively during the 1930s and 1940s not only for Democratic candidates but for particular social policies and perspectives. He enjoyed a political friendship with Al Smith, a Catholic and mayor of New York who was the Democratic candidate for the presidency in 1928 and actively supported Franklin Roosevelt for a third presidential term in 1940:

> I remember when he first became President, there were so-called race riots in Harlem. The newspapers called them 'race riots'; but when La Guardia [mayor of New York] sent Morris Ernst to investigate Ernst found that these people had broken into stores, yes, into groceries and bakeries, but they did not take money, they did not touch a safe, they were stealing food. Morris said to me, 'Eddie, how far is Harlem from here?' I lived then on Central Park West and Seventy-fourth.
>
> 'About twelve minutes.'
>
> 'There was a revolution twelve minutes away from your house.'
>
> I mentioned this one day to Mr Roosevelt. He said: 'Eddie, I wish you and all the other comedians would lay off jokes about boon-doggling [skiving]. When you put a shovel in a man's hand, even if he's leaning on that shovel. he hasn't got a gun in his hand sticking it into your back.'
>
> (Cantor and Ardmore, 1957: 195)

This account is, of course, well within the political consensus built by Roosevelt during the late 1930s and shares his aim, expressed in 1935, to 'save our system, the Capitalist system' (Carroll and Noble, 1979: 342) but it departs from the populism favoured by most comedians at the time: every so often, they would be asked why they didn't run for office themselves and their reply was usually some variant of 'I couldn't work for that kinda money' or 'They already got a comedian for governor'. (The tradition of the comedian's spoof campaign, incidentally, continues. The US comic Pat Paulsen has run for the presidency since the 1970s, most recently in 1996. His manifesto for 1996, available on the Internet, consisted of the same sort of populist fun as Gracie Allen's back in 1940: 'Slogan: United We Sit/Pro-Choice: Yes and No/Foreign Aid: We Don't Want Any . . .' and so on.)

Politicians, for their part, were happy to reciprocate this populism, paying public homage to comedians and joining them in pomposity-puncturing rituals. By the 1950s, this might take place on TV – as, for example, in 1959 when ex-President Truman agreed to appear on *The Jack Benny Show*. Benny, a friend of Truman's since the mid-1940s, recalled the negotiation prior to the broadcast. 'The show will be dignified,' promised Benny. 'Don't make it too dignified, Jack,' replied Truman (Benny and Benny, 1990: 246). But this populism had an uglier dimension and the same decade saw ample warnings to entertainers not to involve themselves in politics outside of these rituals. In September 1953, Lucille Ball, at that time star of the popular TV situation comedy *I Love Lucy*, was called before Joseph McCarthy's House Un-American Activities Committee to answer the charge that she was a Communist sympathiser. (Her grandfather, who had brought her up, had been a Socialist.) Ball, in her defence, countered with the benign, dippy populism of Gracie Allen: when asked if she was familiar with the term 'Criminal Syndicalism', she answered: 'No, but it is pretty. What does it mean?' Later she assured the committee: 'I have never been too civic-minded and certainly never political-minded in my life' (Arnaz, 1976: 246, 248).

It was possible, however, for one comedian at least, to embrace this populism and nevertheless to play a manifestly political role in United States history over a considerable period. This comedian is Bob Hope and, because the period of his political prominence is also the period when the fundaments of mainstream American comedy and its relationship to politics came under severe threat, he merits a short case study.

BOB HOPE: HAWK OR OWL?

Bob Hope was born in England in 1903, his family migrated to the United States and he became a naturalised American citizen in 1920. Biographical details such as these should not be overstressed, but Hope has had both the white Anglo-Saxon Protestant ethnicity that most American comics of his generation lacked and the émigré's eagerness to embrace the culture that took him in. For more than four decades, between the mid-1940s and the early 1980s, Hope was close to the presidency; for much of that time he worked for the US government, chiefly as an entertainer of troops in the various theatres of wars being waged by the United States (see Hope and Martin, 1974); and throughout his career he has practised a brand of comedy that an increasing number of observers have seen as right-wing. He himself has often refuted this charge, claiming to be interested in politics, but not partisan. 'I am called a right winger', he said in 1971, 'because I know the president and played golf with the vice president. . . . But I have known six presidents . . . I believe in our country' (Thompson, 1982: 142). As with so many of his contemporary comedians he has recognised the professional mileage in puncturing the dignity of office, by kidding its holder: 'The White House is always the place, because one of the greatest formats of comedy is turning down dignity. So we always work on the White House and whoever is in it' (Thompson, 1982: 191). Hope, of course, kidded the presidents at their own invitation, Truman being the first president to invite Hope to perform at the White House in 1945.

The key to Hope is corporate America. Hope was the corporate comedian *par excellence*, who did not so much deliver lines, as audiences. Aside from presidents queuing up to have him puncture their dignity, Hope functioned as a one-man dispenser of cheeky, egalitarian all-Americanness and, as such, attracted a huge range of sponsors during his career. By the late 1960s, he had become a corporation himself, being estimated to be one of the fifty richest men in the United States and the only one of that number from showbusiness (Thompson, 1982: 196). As early as 1938, Hope employed eight full-time joke writers; by the early 1970s his writers' payroll alone was $750,000 a year (Hope and Shavelson, 1990: 29; Morell et al., 1973: 30).

Hope became known as 'the GI's comedian' and did his first troop concert at an air-force base in California in 1941, shortly before the United States entered the Second World War. He did so as an American patriot, but this patriotism was always commodified. After the Japanese attack on

Pearl Harbor the same year, Hope called on his radio show for listeners to support the president in this national emergency. He went on: 'Every hour of work that is lost through illness pushes victory just a little further away. . . . Avoid wet feet, drafts and watch your throat, because that's where illness often starts. Gargle with Pepsodent antiseptic regularly' (Hope and Shavelson, 1990: 83–4). Pepsodent went on to sponsor broadcasts of the Bob Hope radio show from US army, navy and marine bases until 1948, when Lever Brothers took over (Hope and Martin, 1954: 189). The wartime appearances brought new commercial possibilities for Hope. In 1948 he

> had decided that, when radio and filming commitments allowed, he would start taking paid theatre dates again. His reasoning was simple – there was gold in them thar returning servicemen. The shows were a tremendous success: as Bob had astutely forecast the dischargees who had heard him on radio overseas flocked to see him.
>
> (Thompson, 1982: 77)

The same year, Hope accepted an invitation from the Secretary of the Air Force to perform a concert for US troops involved in the Berlin airlift and thereafter put on shows wherever US troops were deployed. The costs of these shows were generally split between the US Defense Department and Hope's sponsors, who were usually paying for a TV special to be made out of the performance. One such TV special was even made in Moscow in 1958, with Russian acts, as a showbusiness accompaniment to the cold war summit between Eisenhower and Krushchev (Hope and Shavelson, 1990: 213–36). Through the 1950s and early 1960s, from Anchorage, Alaska to Subic Bay in the Philippines, Hope seemed sure-footed in his comic address of America's enlisted men. 'Hope becomes the mind of the GI's' said one observer. 'His quips and wisecracks originate from the same frame of reference as theirs' (Morell et al. 1973: 225–6). But Hope found in Vietnam in the late 1960s that this frame of reference had shifted and might, possibly, be disintegrating.

On a visit to Vietnam, Hope had initially made the mistake of declaring himself a 'hawk', when feeling among GIs, his purported constituency, was moving strongly against the war. Then, in 1970, at Camp Eagle, a base north east of Saigon, his material was received mostly in silence by 18,000 American soldiers. He and his writers had at least acknowledged that the troops now favoured marijuana above alcohol, and jokes about this went down well: 'I hear you guys are interested in gardening here –

our security officer says a lot of you are growing your own grass.' But a crack about World War Two ('That was the one without the pickets'), and prepared routines about homosexuals and Women's Liberation drew no response. Officers and their wives were booed, some military policemen climbed on stage with a banner reading 'PIGS FOR PEACE' and a number of black GIs, who had given clenched-fist salutes throughout the performance, got up and left. Hope now pronounced himself, and his audience, 'against war'. Raquel Welch, who accompanied Hope on a subsequent trip to Vietnam, remembers him doggedly giving out ball game scores to men with horrific injuries (Thompson, 1982: 142–4). In between times Hope came to London to compere the Miss World contest of 1970, only to have it disrupted by feminists throwing flour and rotten tomatoes. Bemused, he said later, 'You'll notice about the women in the Liberation Movement – none of them are pretty, because pretty women don't have those problems' (Thompson, 1982: 159).

The problem for Hope was that the perpetual quest for the dominant ideology of 'America', in which he and his writers were engaged, had apparently reached a fork in the road. The generalised other – male, white, heterosexual, anti-Communist, uncritically patriotic – to whom his comedy had invariably been directed, could no longer be relied upon. Hope's America, always contested, was now manifestly not the only America. As Todd Gitlin has observed, in the United States 'there were by 1968 two nations that wanted to obliterate each other' (Gitlin, 1994: 61).

Hope, of course, continued to support Republican administrations; he acted as an unofficial emissary of the US government to North Vietnam in 1971 and with Vice-President Agnew and, subsequently, President Ford he continued to celebrate the exclusive, white country-club ethnicity of the American golf course, teasing the country's top politicians, as he had always done, about their lack of prowess at the game (Eisenhower, he had once suggested, had forsaken golf for painting, which involved him in fewer strokes). This kidding, of course, continued to emphasise the ordinary, mortal nature of the nation's leaders – although, crucially, not in the political realm. However, when the Democrat Jimmy Carter, a politician at least cognisant of social movements of the left, was inaugurated as president in 1977, Hope was not invited, nor was he asked to perform for the new President. He retaliated with a string of jokes at Carter's expense which were considerably more acerbic than his usual presidential fare, many of them being aimed at Carter's dissolute brother Billy. Carter relented and invited Hope to the White House the following year (Thompson, 1982: 188), but the relationship between politics and comedy in the United States had by then begun to fracture beyond Hope's understanding.

For Hope, politics, as he understood it, was part of 'the American way'. Just as the theologian Will Herberg argued that having a religion, whatever it was, was part of being American (Herberg, 1960), Hope, a Republican who had nevertheless performed benefits for the Democratic Party, believed that to be a Republican or a Democrat, and always to kid the President was, similarly, a part of US ethnicity. What his comedy failed to acknowledge was that huge swathes of American society lay outside of this political and cultural consensus. These swathes became increasingly militant during the 1960s, and they had politics, and comedians, of their own.

GETTING HIP: POLITICS AND AMERICAN COMEDY AFTER VIETNAM

The principal social movements in the US society of the 1960s, of which politicians and comedians alike were ultimately obliged to take account, were: the student protest movement, based on university campuses and organised largely around opposition to US military involvement in Vietnam; the hippie counterculture, which was strongly libertarian and flourished in the cities of the West Coast; the Civil Rights movement, of African Americans and white sympathisers; and the women's liberation movement. The relationship between comedy and politics here is complex, as this necessarily brief account tries to make clear.

In the late 1950s and early 1960s, a number of new comedians emerged on the club scene of the North, the headquarters of which was in New York's Greenwich Village. These comedians were, again, drawn mainly from social minorities: Jews, like Lenny Bruce, whose stage act included a lot of Brooklyn Bronx Yiddish (Bruce and Benenson, 1976: 177): blacks, like Bill Cosby and Dick Gregory; and women, like Joan Rivers. The comedy of these various artists had different nuances, but it had in common a libertarian thrust: Bruce and the other comedians in this milieu challenged the standards of taste and civic decency by which Hope's generation of white comics had been content to abide. Bruce's material tended to be sexually explicit and profane in relation to ethnic and religious taboos, while his contemporary Mort Sahl was drily dismissive of mainstream American politics and popular culture: in a routine of 1960, he referred to Mickey Mouse as a 'rodent' and speculated that Mickey's big ears might be a mutation caused by fall-out from the nuclear tests currently being carried out by the US government (Sahl, 1960). The constituency of Bruce and Sahl was made up of the young, the liberal and the college-educated in the Northern cities; this audience was dubbed the

'white hipsters' in some intellectual quarters because their interest in jazz, rock'n'roll and, now, sexually explicit comedy was seen as borrowing from black culture (Watkins, 1994: 303).

Certainly, outside of the mass media, black American comedians in the 1950s, notably the popular Redd Foxx, generally used 'blue' material, because this is what black club audiences generally wanted. In media culture during this period, the most prominent representations of black people in comedy were *Amos 'n' Andy*, a radio show of the 1930s that transferred to TV in the 1950s and 'Rochester', a black manservant in the Jack Benny Show. In the 1930s *Amos 'n' Andy* was popular with white politicians of the right, such as Herbert Hoover and Huey Long, the populist governor of Louisiana, who himself took the nickname of 'Kingfish', a character in the show; when CBS announced a TV version in 1948, both President Truman and Dwight Eisenhower, then still a general in the US Army, are said to have made casting suggestions (Watkins, 1994: 278, 307). But 'Amos', who was slow, and 'Andy', who was scheming, drew complaints of stereotyping from the National Association for the Advancement of Coloured People; 'Rochester', the subject of similar complaints during the 1930s, was in the 1950s TV version made more independent-minded by Benny's writers, and now traded sardonic quips with his boss.

This trend was followed by the new black stand-ups, although they differed in style and political orientation. One, Bill Cosby, while not insensitive to the politics of 'race' ('Could you imagine the first black president of the United States?' he asked his audiences in the early 1960s. 'And the For Sale signs up and down Pennsylvania Avenue?') chose to develop a style that drew on social similarities, rather than perceived racial differences, in US society. He argued:

> I'm tired of those old jokes about stereotyped Negroes. You know what I mean? I don't miss *Amos 'n' Andy* . . . my humor comes from the way I look at things. I am a man. I see things the way other people do . . . A white person listens to my act and he laughs and he thinks, 'Yeah, that's the way I see it too.' Okay. He's white. I'm Negro. And we both see things the same way. That must mean that we are *alike. Right?* So I figure this way I'm doing as much for good race relations as the next guy.
>
> (Smith, 1988: 55–6)

Dick Gregory, who emerged around the same time as Cosby, was more overtly politicised and confronted civil rights issues in his act. He had been sitting in a restaurant in the South, Gregory used to say in his early days,

and a white waitress had told him: 'We don't serve Negroes.' 'That's OK,' was the reply, 'I don't eat them. Bring me some Southern fried chicken.' Unlike Cosby, Gregory, however gently, would acknowledge 'racial' differences: 'Wouldn't it be a hell of a thing if all this was burnt cork and you people were being tolerant for nothing?' (Watkins, 1994: 496–7).

Cosby, Gregory, Bruce, Sahl and others were part, more than anything, of a rising libertarianism in American comedy which challenged the political and cultural constraints within which the previous generation of comedians had worked. Joan Rivers describes this transition. In Greenwich Village in the early sixties, she recalls, the comedians worked amid a growing awareness of the Vietnam war – they might come on after a band who'd been 'singing about what the fuck are we getting killed for' – and the increasing use of drugs like LSD and marijuana:

> I did not, of course, know that this was the leading edge of my own future, that it would overwhelm . . . the Bob Hopes and Danny Thomases and Milton Berles who had staffs of writers turning out what I had thought was comedy. Nichols and May, mingling acting and comedy, had been the dignified pioneers, and then Lenny Bruce had blown away all reserve. Now we young comics, along with the country, were being liberated to go our own way, to develop our own very personal comedy, which we learned to write for ourselves, current humour describing human behaviour by describing our own behaviour, material nobody else could perform. I would leave far behind the one-liners I had once so avidly written in my notebook: 'I was so anaemic, when mosquitoes landed on me, all they got was practice.
>
> (Rivers and Meryman 1986: 326)

This new cultural impulse was, of course, important, both politically and commercially. As Rivers implies, it exalted the politics of the personal; it undertook to tell it as it was for people, be they black, liberal, female or of some other minority outside the consensus of mainstream America. Although the split with the one-liner was not as clear as Rivers claims, the new comedy tended to address audiences who ordinarily had constituted 'the other' in the comedy of Bob Hope. And, in relation to presidential and congressional politics, comedians like Sahl and Gregory wanted to talk about what politicians did at *work*; they recognised that to reduce the President to his golf handicap was effectively to depoliticise him. Moreover, this tell-it-like-it-is-ness offered a new range of commercial possibilities: as apparent spokespeople for a new, free-talking, free-thinking

America, the young comedians of the 1960s were attractive to advertisers and entrepreneurs and each might bring access to a newer or more specialist consumer market than had been addressed by the radio comedians of the 1950s. It's significant, for example, that most of the new performers of this period were promoted by the *Playboy* empire and played the *Playboy* clubs in Northern cities like Chicago.

Established American comedy, and the assumptions upon which it had been based, now began slowly to recede, leaving some traditional practitioners confused. Sid Caesar, for example, who had had a top TV show in the early 1950s (*Your Show of Shows*, whose writers included the film-maker Mel Brooks and Neil Simon, the playwright) was appalled by much of the new humour and suffered a prolonged breakdown (Caesar and Davidson, 1982), while his contemporary Red Skelton was moved by anti-war demonstrations to recite the Pledge of Allegiance on his TV show one night in 1969 (Marx, 1979: 287). Other veteran comedians embraced the new political discourse. Groucho Marx, by now in his seventies, condemned United States' involvement in Vietnam:

'It would be different if we were fighting a just war, if there is any such thing. If I were a youngster, I wouldn't march into the firing lines with any bravado. I would go to Canada or Sweden or hide or go to jail. If I had a son twenty years old I'd encourage him to evade the war. He has a right to his life'.

(Adamson, 1976: 211)

Later Groucho risked prosecution by saying 'The only hope this country has is Nixon's assassination.' Meanwhile, as *bona fide* representatives of new social trends and ideologies, the new US comedians gradually got more media work, initially mostly as writers: Mort Sahl wrote jokes for John F. Kennedy's presidential campaign in 1960, Rivers wrote for the TV show *Candid Camera*; and Richard Pryor, another rising black comedian, wrote TV scripts, some for the white performer Lily Tomlin. Then, one by one and with various compromises, they entered the wider public arena. The black comedians were most important in this context. As Watkins observes, television now carried violent images of racial confrontation in the South into millions of American homes, bringing home the contradiction between segregation and democracy: the visibility of African American entertainers made them *de facto* representatives of the black community and gave them a 'disproportionately significant role' in the growing struggle for civil rights.

Bill Cosby took the leading role – next to white actor Robert Culp – in *I Spy*, an action-adventure TV series begun by NBC in 1965. This made Cosby one of the most conspicuous representatives of the assimilationist, move-on-up strategy favoured by the black middle class in America. He attended the funeral of Martin Luther King in 1968 and his principal quasi-political work since then has been concerned with encouraging African Americans to be upwardly mobile in US society: Cosby himself studied for a BA, an MA and a doctorate in the 1970s and subsequently did much work in educational television (Latham, 1985: 102–3). His successful situation comedy for NBC, begun in 1984, depicting the happy domestic life of a black middle-class family grows out of a concern to provide 'positive role models' and expresses the widespread anxiety in Middle America about violence on TV: having watched several violent films on cable TV, he resolved to re-create a black version of 1950s sitcom: 'Where is Lucille Ball when I need her?' Cosby, no less than Lucille Ball and her generation, has been successful in attracting sponsorship and has represented Ford, Coca-Cola and Jell-O, among others (Latham, 1985: 127–8, 143).

While Cosby put liberal politics into his comedy, Dick Gregory, the other major black comedian of the period, put his comedy into politics: he cancelled a lot of performances in order to pursue political activities. In 1966 he ran for mayor of Chicago and in 1968, with attorney Mark Lane, he stood for the Peace and Freedom Party in the presidential election, won by Richard Nixon. In 1971, he published an anti-racist history of the United States (Gregory, 1972).

In the 1970s, the resignation of Vice-President Agnew for tax evasion (in 1973) and President Nixon (in 1974) following the so-called Watergate affair brought formal discredit to the federal polity and thus lent an extra impetus to the politically satirical comedy pioneered by Bruce and Sahl a decade earlier. This comedy was admitted to television in 1975 in the form of NBC's *Saturday Night Live*. This show drew some of its inspiration from the British television's *That Was The Week That Was* (BBC, 1962–3) and consisted largely of showbusiness, media and political parodies. There was much satire of the Nixon administration, even after it had been disbanded, and the humour was, by the standards of American TV, harsh. Nevertheless, following the populist precedent of, among others, President Truman and President Nixon (who had appeared on the TV comedy show *Rowan and Martin's Laugh In* in 1969), President Ford was persuaded to tape an insert to the show in 1976.

John Belushi, a leading player in *Saturday Night Live* was held by his contemporaries to represent 'the old days – the Beat Generation, drugs and the vital Lenny Bruce era – nastiness, fuck-you, sick-comic daring'

(Woodward, 1985: 55) and imported some of that spirit into the pro-
gramme. Belushi's philosophy and his comedy drew heavily on the drug
culture of the 1960s and his work for *Saturday Night Live* often defined pol-
itics solely in these terms; politicians were simply people who wanted to
stop you taking drugs:

> I just went back to Chicago in 1976 and I saw my friend Steve
> Beshekas. I said 'Steve, who'd you vote for – Ford or Carter.' He
> said, 'I didn't vote. All politicians is the same.' I said, 'Who do
> you think makes the laws, Steeeeeve? Politicians!' He said, 'It
> doesn't make any difference.' I said, 'Doesn't make any difference?
> Possession of an ounce is a misdemeanor now!'
>
> (*Saturday Night Live*, 4 November 1978.
> Quoted in Woodward, 1985: 369–70)

An analagous, but qualitatively different, disdain for established political
culture was expressed by Richard Pryor, the most prominent black come-
dian of the 1970s. Pryor, who grew up in a brothel in Peoria, Illinois, in
the 1940s, has been described as a Dionysian comedian, in whose scata-
logical social commentary sex is an ever-present metaphor. Thus, for
Pryor, President Nixon was that most pathetic of men – one who couldn't
have an orgasm, while President Reagan was 'a penis in a suit' (Williams
and Williams, 1993: 104). Pryor has, of course, frequently brought the
sexual metaphor to bear on the matter of racism – 'Niggers be holding
their dicks. Some white people go, "Why you guys hold your things?"
Say, "You done took everything else, motherfucker"' (Pryor and Gold,
1995: 49) – but, unlike Cosby and Gregory, he has held out no political
strategy to the black people of America. He once introduced Huey Newton
of the Black Panther movement on stage, but Pryor has remained a 'steady-
cussing, throw-down chronicler of lowly life' and a champion of 'the
other' (Williams and Williams, 1993: 95, 217). Modern American
comedy offers only personal salvation and, as Pryor now suggests, his use
on stage of the word 'Nigger' in his early performing years helped him
transcend a legacy of racism and self-hatred, but as for 'Nixon, the
Vietnam War, the Black Panthers, and shit. I didn't know anything about
that shit' (Pryor and Gold, 1995: 128, 130).

For many of the most successful American comedians of the 1970s,
1980s and 1990s Lenny Bruce became, effectively, a paradigm: they
worked within his assumptions, in dialogue, so to speak, with his ghost.
Roseanne Barr is another example here, often giving a feminist dimension
to Bruce's groundbreaking political profanities:

Let me juxtapose the most classic Lenny Bruce joke of all . . . the Jackie Kennedy joke. . . . Lenny said she climbed out of the car to get away, to save her own ass, he said this was the human natural response. I'm a woman and I know that is not true, she was sitting there next to her husband, saw his brain blown out onto the back of the car, and she was only going out there to clean up the mess, man.

(Barr, 1990: 176–7)

The post-Bruce comedians sought, with whatever success or justification, to give authentic voice to some of America's political and cultural minorities. These voices were often, according to the accepted standards of public discourse, angry, bleak and profane. The jokes the new comedians cracked therefore, simultaneously, raised questions outside of their immediate subject matter. Thus, for example, Bruce and Barr's reference to the assassination of President Kennedy, beside being a comment on politics or class or the social experience of women or whatever, is also an assertion of the right to freedom of speech. This becomes, in turn, an argument about commerce and free markets and consumer sovereignty – as Richard Pryor once said to the rising black comic Eddie Murphy: 'Whatever the fuck makes the people laugh, SAY THAT SHIT' (Hirshey, 1989: 18). Thus, for good or ill, human desire has progressively become the chief arbiter of content in the new American comedy.

By the late 1980s some version of this ethos had been enacted in relation to a succession of previously neglected social constituencies. Sahl had told it like it was for the middle-class left, Cosby and Gregory for the black bourgeoisie, Pryor for the increasingly ghettoised black underclass, Rivers, Barr and others for women. By the late 1980s, the most successful American comedians peddling the 'fuck-you' brand of comedy were apparently telling it like it was for the white male working class. In a comedic re-enactment of Richard Nixon's electoral strategy in 1968, some performers now turned on a number of groups (blacks, gays, women . . .), expressing a purportedly blue collar fury against them and the 'positive discrimination' and 'political correctness' from which these groups were perceived to benefit. This comedy was practised by a large number of performers, the best known, and rewarded, of whom were Andrew Dice Clay and Sam Kinison.

Clay and Kinison (the latter died in a car crash in 1992) were commercially very successful: Clay sold out the 21,500-seat Brendan Byrne arena in New Jersey and the prestigious Madison Square Garden (18,000) – a feat never achieved by comedians of the Hope/Burns generation (Hendra,

1990: 21). Their routines were pervasively derogatory about homosexuals, women, ethnic minorities and migrants. Clay appeared on stage as 'an Italian street hood', he told his audiences that his perfect woman had 'two tits, a hole and a heartbeat', that 'Chinks and Nips' shouldn't be allowed to drive, 'because you don't give cars to people you can blindfold with dental floss' and bemoaned the recent arrival in the United States of 'urine-coloured migrants, who, because they didn't speak English, should get the fuck out of the country' (quoted in Hendra, 1990: 21). Similarly, Kinison was known for his stark reflections on homosexuality:

> Goddam these fuckin' bastards – get off our back! Because a few fags fucked some monkeys . . . they got so bored that their own assholes weren't enough, they had to go in the fuckin' jungle, grab some fuckin' monkey and fuck him in the ass . . . and bring us back the Black Plague of the fuckin' eighties. Thanks guys! Because of this shit, they want us to wear fuckin' rubbers. . . . Do we like to wear rubbers, guys? WE HATE RUBBERS! WE FUCKIN' HATE 'EM!'
>
> (Kinison and Delsohn, 1994: 166–7)

Clay and Kinison and their school of comedy are important in the context of American politics, I think, for three reasons. Firstly, at the level of production, this comedy is linked to changes in the American mass media – in particular the deregulation of the media by the Reagan administration in the mid-1980s, and the rise of cable TV. This represented a fragmentation of media markets and, amid numerous invocations of free speech and the First Amendment, it brought, into some of these markets, the admission of previously excluded forms of discourse – sexually explicit, racially offensive, and so on. Both Clay and Kinison went out on cable, with big success. In this capacity, they acted as market testers, both for terrestrial networks and for advertisers. Clay did a spell on NBC's *Saturday Night Live*, bringing both complaints and high ratings, and, when Kinison did a routine about drugs and TV evangelists on the same show in 1986, NBC first banned him for life, then reinstated him following supportive audience reaction (Kinison and Delsohn, 1994: 13–19). Episodes such as this on the one hand identify trends in the market and, on the other, establish the comedian as the likeliest means of reaching that market. Condemnation by authority figures brings an enormous boost to public credibility and, thus, makes a comedian attractive to corporate interests: Dennis Leary, for example, another leading exponent of 'politically incorrect' comedy originally shunned by American TV, now advertises Holsten Pils lager (Sweeting, 1996).

Second, these comedians spoke, in some degree, to the contemporary world view of the white American working-class male, in which resentment against cheap foreign imports, the growing employment of women and affirmative action programmes loomed large. Kinison and Clay both claimed often that their audiences were too smart to take what they were saying seriously. Clay told one interviewer: 'If I really meant what I said on stage it would be terrible . . . horrible. It also wouldn't make people laugh' (quoted in Hendra, 1990: 21). But observers of gigs thought otherwise:

> There's no denying the sheer ugliness in the room when men and women who truly feel their jobs are threatened by foreign Hyundai-mongers, who have felt the reverse sting of affirmative action, are served up a heady mix of vicious racial slurs and vodka on the rocks. Look closely at the laughing faces. Watch men and women pumping their fists for Spick and Jap and 'fat, smelly bitch' jokes.
>
> (Hirshey, 1989: 19)

Thirdly, this comedy reflected a growing disenchantment with presidential politics and, if they looked at these politics at all, the 'politically incorrect' comedians preferred simply to sexualise those involved:

> During the presidential primaries, Sam began tapping into the doubting mood of the country. 'I'm just curious. Is anybody following the Democratic campaign? Bill Clinton. Yeah, now there's a cool fuckin' guy. Why doesn't he just campaign like this?' Sam put his microphone down by his crotch, then pointed it straight out like a hard-on. . . . 'Get your mind off fucking pussy, Clinton.'
>
> (Kinison and Delsohn, 1994: 283)

The political paradigm for this new comedy was a faltering America, betrayed by feckless politicians and beset by militant lobbies and 'minorities'. The comedians profited from the factional nature of lobby politics: African American groups were concerned, by definition, only with material offensive to blacks, women's groups with material about women, gay groups with anti-gay jokes, and so on (Hendra, 1990: 24). Equally, the artistic profanities emanating from these other groups 'gangsta rap', for instance – was far more likely to attract political criticism, particularly from the extreme right of the Republican Party (Hendra, 1990: 22, 24). This strengthened the view of the comedians as standing up for honest, decent blue-collar America against an army of special interests and pen-pushers.

Interestingly, in this context, Kinison briefly sought Bob Hope's role as state-envoy comedian. Hope, now in his late eighties, had joined the ranks of the aged, another group of special pleaders in contemporary market America and, thus, for stand-ups like Kinison, another herd of sacred cows awaiting slaughter: 'Bob Hope's gotta go out with a fuckin' walker, he can't read the cue cards, they gotta skywrite his jokes with an F–14' (Kinison and Delsohn, 1994: 265) . During the Gulf War of 1991, Kinison offered to entertain American troops himself; the State Department declined the offer.

NO POLITICS, PLEASE, WE'RE BRITISH

This section is necessarily shorter than the preceding one, partly because in Britain comedy and politics were kept apart for longer and partly because I have written elsewhere about the relationship between comedy and British politics (Wagg, 1992 and 1996). As I've tried to show, in the United States, before the late 1950s and early 1960s, the comedians conducted a relationship with politicians which was predicated on the legitimacy and superior power of the latter. The President was in the White House, the people were at his gate; the comedian mediated this relationship with a bit of institutionalised cheek and the President laughed to confirm that this was OK. Ultimately, though, this functioned as a kind of masked deference: the President was 'minding the shop' and ordinary folks had other things to get on with. Britain, though, had for much of its history been a society based on ascribed social position and therefore status divisions were culturally more deeply rooted during this period. For a comedian so much as publicly to mock the prime minister's golf handicap before 1960 would have been deemed improper. Theatre managements and the Lord Chamberlain's office imposed clear restrictions on performing comedians in matters of taste and decency and, when comedians gained access to a national audience through public service broadcasting, the BBC almost certainly widened the range of prohibited topics to which comedians were subject. Among these prohibitions, set out in the 'Green Book' issued to BBC comedy producers in 1949, was a section on Political References. Under this heading, the BBC reaffirms a directive of the previous year:

> We are not prepared in deference to protests from one party or another to deny ourselves legitimate topical references to political figures and affairs, which traditionally have been a source of comedians' material. We therefore reserve the right for Variety

programmes in moderation to take a crack at the Government of
the day and the Opposition so long as they do so sensibly, with-
out undue acidity, and above all funnily.

(quoted in Took, 1981: 88–9)

However, further guidelines make it clear that, in practice, this right will
be reserved by not exercising it: among the things that would be barred
altogether were

anything that we adjudge to go beyond fair comment . . . on a
matter of general topical interest . . . anything that can be con-
strued as personal abuse of Ministers, Party Leaders, or MPs,
malicious references to them, or references in bad taste; [and] . . .
anything that can reasonably be construed as derogatory to polit-
ical institutions, Acts of Parliament and the Constitution.

'Members of Parliament', it said in conclusion, 'may not be included in
programmes without special permission. This permission will not be
granted, whether or not the MP concerned is willing, for programmes in
which the BBC considers it unsuitable or undignified for a Member of
Parliament to appear' (Took, 1981: 89). Given that several of the phrases
in this passage ('construed as personal abuse', 'bad taste' . . .) were open
to wide interpretation, and that this interpretation would be essentially
paternalist, with no recourse to the audience, 'cracks at the government of
the day' were likely to be rare.

The distance between the social worlds of comedy and politics was
brought home in an episode of the early 1960s. Jimmy Edwards, a come-
dian and chair of the Variety Artistes' Federation was adopted as
Conservative Party candidate for the parliamentary seat of North
Paddington, in London. In his immediate dealings with the press, Edwards
was made to work hard to establish the seriousness and legitimacy of his
candidacy. 'This is no gimmick, chaps,' he told the *Daily Mirror* (12 March
1963). 'I want to become an MP to do something for the country.' The
Conservative Beaverbrook and Northcliffe press on the same day gave sim-
ilar priority to the fact that Edwards was a comedian and ignored his
parallel status as politician: 'Just imagine Jimmy Edwards as an MP,' chor-
tled the front page of the *Daily Express*. 'Why not? asked Jim last night.' The
Express cast around other comedians for a quote, Norman Wisdom yielding
the inevitable 'There are a lot of comics who are MPs already', while
Edwards told the *Daily Mail* that he'd asked an official at Conservative Party
Central Office whether it was 'seemly for a comic to represent a

constituency'. Illingworth, the Mail's cartoonist, captured this 'Whatever Next!?' mood with a picture showing the House of Commons crowded with well-known comedians (see Figure 1).

Figure 1. Cartoon from the Daily Mail (13 March, 1963). Courtesy of the Daily Mail.

However, the contours of a new relationship between comedians and the British polity had already been sketched out, in the form of the nascent 'satire movement'. The principal early manifestations of this movement in British popular culture was the BBC television programme That Was The Week That Was which ran for only two series (1962–3) and which served as a prototype for NBC's Saturday Night Live, and the magazine Private Eye. A satirical nightclub called The Establishment was also set up in London's Soho, and Lenny Bruce, with whom a number of the new comedians claimed professional kinship, was booked to appear there; the British government refused him entry however. In 1962, a number of Conservative MPs called upon the prime minister to intervene in the matter of That Was . . ., which they deemed scurrilous. He declined, conscious perhaps of the programme's eleven million viewers.

In 1963, following Macmillan's resignation, William Rushton, one of the performers of That Was . . ., stood against the new Prime Minister Sir Alec Douglas Home, in the parliamentary by-election called to enable Home to take his seat in the Commons. A chronicler of the satire movement describes this as a 'gesture of magnificent futility' (Wilmut, 1980: 70) and it invites parallels with Gracie Allen's campaign for President in 1940. Rushton, like Allen, was asserting the right of electors not to take politics or politicians too seriously. The point, which I have argued at greater length elsewhere (Wagg, 1992) is that in Britain, with its stronger tradition of paternalism and public service, such an attitude to politics had little

legitimacy before 1960. Moreover, in Britain it was asserted not by work-ing-class entertainers like Burns and Allen but by high-born humorists, schooled for the most part in the elite universities. 'Satire' in Britain seldom entailed the championing of particular political ideas; it involved, principally, a mockery of politics per se. This, in practice, meant a freer market in comedy. As one Cambridge-educated comedian suggested: 'Instead of doing "I say, I say, my mother-in-law" you could do "I say, I say, Harold Macmillan", and it could be the same joke – and very often was the same joke' (Wilmut, 1980: 72). The chief significance of these devel-opments was, I have suggested, in relation to political advertising. During the 1950s, amid such innovations as commercial television and the com-missioning of advertisers to handle election campaigns (first done by the Conservatives in 1959) younger politicians, particularly on the right, argued that politics was a matter not of civic duty but of consumption. Politics in this new view was just one competitor for the attention of con-sumers; the electorate became a market, wherein politicians had no moral claim to priority. This market was addressed increasingly via the electronic mass media and, in this context, the likely perceptions of different com-ponents of the 'target audience' had to be taken into account. This meant, in some small way, an acknowledgement of the satirical comedians, who, politicians now recognised, spoke for younger, less deferential voters. By the late 1950s, for example, during the premiership of Harold Macmillan, several comedians were doing impressions of him. Macmillan attended a performance of Beyond the Fringe, a satirical revue in the West End and was identified from the stage by one of the cast, Peter Cook, part of whose role in the show was to perform a lampoon of Macmillan (Wilmut, 1980: 20). Macmillan is said to have laughed ostentatiously. This was an early exam-ple, in Britain, of the sort of puncturing of the dignity of senior politicians that had, as we've seen, been common in the United States for decades. Macmillan, despite being steeped in the paternalist traditions of the Tory grandee, adapted to the new political circumstance. He recognised that, in the new political discourse, he was a 'text', often a comedic one; indeed, in the world of political performance, as it was now widely conceived, he was just one of several people playing 'Macmillan'.

The rise of 'alternative comedy' after 1979 gave further legitimation to a distance between people and organised politics. 'Satire' provided a new paradigm for the relationship between comedy, politics and the media in Britain, and 'alternative comedy' developed this paradigm in important directions (Wagg, 1996). Firstly, socially critical comedy was in some ways democratised: many performers, although most of them had gone through higher education, now came from outside the universities of

Oxford and Cambridge. There was also a marginal increase in the number of women involved and some of the newer comedians drew on their experience as members of ethnic or sexual minorities. Secondly, and related to this, 'alternative comedy' signalled a diversification of the comedy market: a number of British comedians emerged in the 1980s, each with identifiable, if overlapping, constituencies: there were gay comics, female comics, 'laddish' comics, left-wing comics and so on. Thirdly, although some of the most professionally admired comedians on the alternative circuit have worked from a Marxist perspective, the ideological flow of alternative comedy, historically, is chiefly towards the politics of the personal, of consumption and of desire. The mode of comedy is largely individualised stand-up and the topics of most comedy routines draw on private experiences (having sex, watching television, etc.) rather than public events. It's the difference, as a left-wing comedian put it recently, between taking on 'real issues' and discussing 'how awkward it is to find the end of a reel of Sellotape' (Steel, 1996: 10). But alternative comedians are used to this criticism and have ready replies: 'People don't like having politics rammed down their throats'; 'I try, but, like I was doing some material on *glasnost* at the Comedy Store and no one had heard of Gorbachev'; 'We all know politicians are wankers'; and so on.

This stock-in-trade iconoclasm has enhanced the commercial importance of the alternative comedian, who has become, in many cases, the accredited voice, not only of a generalised sceptical consumer, but of a specific market niche. The alternative comedians now provide ironic discourse for advertisements and for a variety of TV and radio formats; they are, in effect, symbols of consumer sovereignty. It is in this light that the contemporary relationship between politics and comedy in Britain can be understood. This relationship is a fitful one – inevitably, since, in a culture now reflectively suspicious of politicians, a close public association with 'politics' might destroy a comedian's credibility – but a number of examples are instructive.
1. From the 1960s, the practice of having showbusiness figures support political candidates in General Elections, grew, albeit modestly, in Britain. But the first organised and nationally visible involvement of comedians in this process was a 'youth rally' held at London's Wembley Conference Centre by the Conservative Party during the General Election campaign of 1983. It was hosted by the 'variety' comedians Bob Monkhouse and Jimmy Tarbuck and featured the comedian disc jockey Kenny Everett. Two things are interesting about this event. Firstly, for comedians like Monkhouse and Tarbuck, doing a show for the Conservatives is unlikely to have been conceived as 'political'. In Monkhouse's autobiography, though, published ten years later (Monkhouse, 1993), there is no mention either of the rally at

which he welcomed Prime Minister Margaret Thatcher on stage, or of politics. To comedians of the Monkhouse/Tarbuck generation, jokes about trade union leaders, Labour politicians and skiving workers were the common coin of professional life, in the same way that jokes about mothers-in-law, nagging wives and homosexuals were. Being booked to do this rally, therefore, might be no different in kind from doing a West End cabaret or a TV spectacular. Secondly, though, Conservative election strategists clearly recognised the less inhibited, more hedonistic lifestyles of their younger supporters. This explains the presence of Everett. 'LET'S BOMB RUSSIA!', cried Everett as he strode on stage. Later he claimed to have been talking to 'Maggie' Thatcher: 'I said: "Maggie, you're rolling that joint all wrong . . ."'. Everett's appearance caused widespread recrimination: most left-of-centre politicians found it offensive and those people advising either the Conservatives or Everett himself came to pronounce a 'public relations disaster' for both clients. Everett reflected later:

> The only political feelings that I have are that I'm doing quite well now, and I'd like to keep it that way, so I suppose I am a Conservative. If I wasn't doing well, I'd want to change things so then I'd probably vote Labour. It's as simple as that to me. The Labour Party keeps saying offensive things like, 'We're going to squeeze the rich.' . . . Margaret Thatcher is monstrously condescending, a really iron-clad person. I wouldn't like her to be involved directly in my life. But when you have horrors like [trade union leader] Arthur Scargill ranting away, you need someone like her to neutralise him.
>
> (Lister, 1996: 169–70)

2. In 1985, the comic actor and writer John Cleese made a party political broadcast for the Social Democratic Party: 'I'm sorry,' he told the audience, 'but this is a party political broadcast, and you know how boring they are. This one, I'm afraid, promises to be quite outstandingly tedious, because it's all about proportional representation' (Margolis, 1994: 209). Here, Cleese employs the technique he has adopted in advocating a wide range of commercial goods and services: he anticipates consumer resistance and gets his irony in first.

3. In the General Election of 1987, the Labour Party held a similar rally to the Wembley event of 1983 and the comedian Ben Elton was one of those present to give public support to the new Labour leader Neil Kinnock. No British comedian has been criticised more widely or vehemently in the context of the relationship between comedy and politics than Elton has.

Elton made his name nationally as host of *Saturday Live*, a television showcase for alternative comedians, loosely derived from NBC's *Saturday Night Live* and put out by Channel Four between 1985 and 1988. Elton's routines were consistently mocking of Thatcher administrations and established him, for most observers, as the country's leading 'political comedian'. Elton was manifestly unpopular among comedians, however, and this, I suggest, was because he would not accept what was in effect the new political consensus of comedy in Britain: that when making fun of politicians, you made fun of them all, or that, if your comedy was to flow from a specific political position (invariably, in practice, a left position) you accepted the responsibilities of that position and became an activist. Elton's problem was that he placed himself in both camps at once, claiming both to be an upholder of the mainstream values of English comedy *and* a social commentator; the comedic right, therefore, tended to see him as holier-than-thou and 'political', while the left saw him as a charlatan (see Wagg, 1996).

4. In 1994 the gay comedian Julian Clary took part in a televised awards ceremony along with, among others, the Right Honorable Norman Lamont, who had recently resigned as Chancellor of the Exchequer. When Clary came to the rostrum, he apologised to the audience for being late – he had been having sex with Lamont. A minor furore ensued over the next couple of days.

Clary has never been a politicised gay man, but his remark speaks for its time, in that, symbolically, it places desire above duty, sexuality above citizenship. In a gesture the cultural lineage of which can be traced back through Pryor and Kinison to Bob Hope, the dignity of the politician is destroyed by reducing him to his body. In an extra twist, he is made the object of gay longing: of all the cultural minorities to have registered themselves politically in Britain and the United States since 1960, the gay community has gained the least legitimacy.

5. By the 1960s the spoof had become politically more complex and diverse than in the time of Gracie Allen. For example, in the *Mark Thomas Comedy Product*, put out by Channel Four in 1996, Thomas, a comedian of the anarchist left, played pranks on current newsmakers. These included: persuading a Conservative MP to dress up as a penis; driving a tank to the house of a government minister implicated in the 'Arms to Iran' scandal; standing as candidate in a parliamentary by-election; and donating a tanker full of water to a privatised water company as 'a gift from the people of Ethiopia'. This is comedy as political critique: drawing on Situationism, the comedian plays straight man to the state (Barber, 1996).

The same year Labour Party leader Tony Blair agreed to be interviewed

at a Young Socialists meeting during the party's annual conference by comedian Steve Coogan, Coogan being in character as the fictional TV talk-show host Alan Partridge. This recalls Harry Truman's remark to Jack Benny ('Not too dignified, Jack'), but recasts the surrender of dignity in a postmodern setting, celebrating the notion of artifice and performance, mixing parody with reality and, once again, getting its irony in first.

6. The most sustained political or quasi-political intervention by comedians in British life has been through the raising of money for specific causes. (Comedians have been involved in this kind of work throughout this century, both in Britain and in the United States. In Britain the focus for such activity was The Grand Order of Water Rats, founded in 1890, and, latterly, the Variety Club of Great Britain; in the US top comedians took part in the March of Dimes of 1933, to raise money for research into infantile paralysis and comedians of the Hope generation might have played two benefits a week.) In Britain the principal fund-raising in the 1980s and 1990s has been for liberal causes such as Amnesty International, famine relief (notably through a series of 'Red Nose' days) and issues of sexual health such as AIDS. All this is compatible with the the post-satire politics of comedy in Britain. In this politics politicians are essentially intruders and are universally dismissable – John Cleese suggested in 1980 that all politicians were 'just working out their childhood problems' (Margolis, 1994: 208). Causes, therefore, which monitor the oppressive-ness of state apparatuses (Amnesty) or which might appear to lie outside the scope of governments (famine relief and AIDS) are acceptable (for a fuller discussion see Wagg, 1992).

Stands against some politicians and governments, as distinct from all of them, are more rarely taken, but they are taken nevertheless. For instance, the comedian Jeremy Hardy, through benefits and via his weekly column in the *Guardian*, has been one of the Major administration's most effective critics from the left on the matters concerning Northern Ireland. And, in 1994, sixty-seven comedians went to London's Isle of Dogs to campaign against the re-election of a councillor from the racist British National Party (Steel, 1996: 167–8).

CLOSING THE SHOW: COMEDY AND POLITICS IN THE UNITED STATES AND BRITAIN

Comedians, on the whole, are natural populists: it is their job to judge what people already think and to address them accordingly. The political visibility of comedians has therefore been greater in the United States, which has had a more populist political culture. In the context of this

culture, comedians have sought, at different times, to speak to different Americas. Invariably, in this quest, they have claimed to be unpolitical and to have no interest in politics: this denial has often been most insistent when, as with Hope, the proximity of the comedian to politicians and to affairs of state has been closest. In Britain, which has had a more caste-like political culture and a stronger tradition of public service, the social worlds of comedy and politics took longer to converge, but, when they did, it was around a similar consensus view. This view, rooted in neo-liberalism (Wagg, 1992) is in essence that politics itself, as distinct from individual office holders, need not be taken seriously. Comedic expressions of this view are more vehement in the United States where anti-state feeling is more developed.

An important paradox to emerge from this is that, in a political environment frequently styled as 'postmodern', the comedian, now widely acknowledged, in the age of impression management, as truth-teller and iconoclast, may carry more public credibility than the politician.

ACKNOWLEDGEMENTS

I'd like to thank Alec McAulay, Garry Whannel, Philip Davies and Cassie Wagg for various valuable advice and information during the writing of this chapter.

The prefacing quotation from Groucho Marx is taken from his book *The Groucho Letters*, London: Sphere Books 1969: 239.

BIBLIOGRAPHY

Arnaz, Desi (1976) *A Book*, New York: William Morrow.

Adamson, Joe (1976) *Groucho, Harpo, Chico and Sometimes Zeppo*, London: Coronet Books.

Barber, Nicholas (1996) 'The tank driver' [profile of Mark Thomas], *Independent on Sunday* (14 April).

Benny, Jack and Benny, Joan (1990) *Sunday Nights at Seven: The Jack Benny Story*, New York: Warner Books.

Bruce, Honey and Benenson, Dana (1976) *Honey: The Life and Loves of Lenny's Shady Lady*, Chicago: Playboy Press.

Burns, George (1990) *Gracie: A Love Story*, London: New English Library.

Caesar, Sid with Davidson, Bill (1982) *Where Have I Been? An Autobiography*, New York: Crown Publishers.

Cantor, Eddie with Ardmore, Jane Kesner (1957) *Take My Life*, New York: Doubleday.

Carroll, Peter N. and Noble, David W. (1979) *The Free and the Unfree: A New History of the United States*, Harmondsworth: Penguin.

Gitlin, Todd (1994) '1968: The two cultures', in Michael Klein (ed.) *An American Half Century: Postwar Culture and Politics in the USA*, London: Pluto Press.

Gregory, Dick (1972) *No More Lies: The Myth and the Reality of American History*, New York: Harper & Row.

Hendra, Tony (1990) 'The comedy of hate', *The Sunday Correspondent* (28 October).

Herberg, Will (1960) Protestant, Catholic, Jew, New York: Doubleday.

Hirshey, Gerri (1989) 'Vicious boys', Time Out (29 November–6 December).

Hope, Bob and Martin, Pete (1954) Have Tux, Will Travel, New York: Simon & Schuster.

Hope, Bob and Martin, Pete (1974) The Last Christmas Show, New York: Doubleday.

Hope, Bob and Shavelson, Melville (1990) Don't Shoot, It's Only Me, New York: G. P. Putnam's Sons.

Kinison, Bill with Delsohn, Steve (1994) Brother Sam: The Short, Spectacular Life of Sam Kinison, New York: William Morrow.

Latham, Caroline (1985) Bill Cosby – For Real, New York: Tom Doherty Associates.

Lister, David (1996) In the Best Possible Taste: The Crazy Life of Kenny Everett, London: Bloomsbury Publishing.

Margolis, Jonathan (1994) Cleese Encounters, London: Orion.

Marx, Arthur (1954) Life With Groucho: A Son's Eye View, New York: Simon & Schuster.

Marx, Arthur (1979) Red Skelton: An Authorised Biography, New York: E. P. Dutton.

Marx, Harpo and Rowland Barber (1985) Harpo Speaks, London: Coronet.

Mills, C. Wright (1959) The Power Elite, London: Oxford University Press.

Monkhouse, Bob (1993) Crying With Laughter, London: Arrow Books.

Morella, Joe, Epstein, Edward Z. and Clark, Eleanor (1973) The Amazing Careers of Bob Hope, New Rochelle: Arlington House.

Pryor, Richard and Gold, Todd (1995) Pryor Convictions and Other Life Sentences, London: Heinemann.

Rivers, Joan with Meryman, Richard (1986) Enter Talking, New York: Delacorte/Dell.

Sahl, Mort (1960) 1960 or Look Forward in Anger, USA: Verve Records.

Silvers, Phil with Saffron, Robert (1974) The Man Who Was Bilko, London: W. H. Allen.

Smith, Ronald I. (1988) Cosby, London: Star Books.

Steel, Mark (1996) It's Not a Runner Bean: Dispatches From a Slightly Successful Comedian, London: Do Not Press.

Sweeting, Adam (1996) 'Rise of Mr Incorrect' [Profile of Denis Leary] The Guardian (3 December).

Thompson, Charles (1982) Bob Hope: Portrait of a Superstar, London: Fontana.

Took, Barry (1981) Laughter in the Air: An Informal History of British Radio Comedy, London: Robson Books/BBC.

Watkins, Mel (1994) Laughing, Lying and Signifying, New York: Touchstone Books.

Wagg, Stephen (1992) 'You've never had it so silly: The politics of British satirical comedy from Beyond the Fringe to Spitting Image', in Dominic Strinati and Stephen Wagg (eds) Come on Down? Popular Media Culture in Post-War Britain, London: Routledge.

Wagg, Stephen (1996) 'Everything else is propaganda: The politics of alternative comedy', in George E. C. Paton, Chris Powell and Stephen Wagg (eds) The Social Faces of Humour: Practices and Issues, Aldershot: Arena Press.

Williams, John A. and Williams, Dennis A. (1993) If I Stop I'll Die: The Comedy and Tragedy of Richard Pryor, New York: Thunder's Mouth Press.

Wilmut, Roger (1980) From Fringe to Flying Circus, London: Eyre Methuen.

Woodward, Bob (1985) Wired: The Short Life and Fast Times of John Belushi, London: Faber & Faber.

14

VIZ

Gender, class and taboo

Dave Huxley

VIZ: TRADITION AND SUCCESS

Viz has been called the publishing success of the 1980s, a decade when its sales figures moved from 250,000 copies per issue to one and a half million. This chapter will attempt to analyse some of the reasons for its phenomenal success, and to place it in the overall history of British humour comics aimed at adults. In the 1960s and 1970s this kind of humour comic tended to be categorised as 'underground' or 'alternative', and the extent to which Viz can be regarded as part of that tradition will be discussed. Critical responses to the comic and in particular its treatment of class and gender will then be examined.

Viz first appeared in 1980, produced in Newcastle upon Tyne in small enough numbers to have individually numbered copies, like a limited edition. In some ways it was unlike anything that had gone before. It was perhaps the ultimate hedonistic comic. It had no pretensions, no respect for anything serious, and its drawing styles and production values were basic to the point of ineptitude. The reason for this range of qualities was that the comic was, in its initial stages, produced in its entirety by two teenage brothers Chris and Simon Donald, and aimed, essentially, at their contemporaries.

Its style is summed up by some of the names of its most famous characters: 'Johnny Fartpants' ('There's always a commotion going on in his underpants'), 'Buster Gonad' ('and his unfeasibly large testicles') and the 'Fat Slags' ('Oh dear, I don't fancy yours much'). There is little room here for nuance and subtlety: the comic will make jokes at almost anyone's expense and doesn't seem to care who it offends. More recent issues have improved the quality of drawing and production, but only slightly. The comic is a mixture. It looks like a less efficiently drawn *Beano*, and reads like a surreal cross between a *Carry On* film and a Lenny Bruce monologue. Its least popular strip is consistently 'Billy the Fish' which is in fact much

273

more subtle than many of the strips in the comic; a surreal parody of 'Roy of the Rovers'. In the *Viz* version Fulchester United's star player is their goalkeeper Billy the Fish ('Born half man and half fish'), who undergoes terrible hardships for his team, which include, in one episode, being buried under the pitch during a game, although this is not discovered until a player trips over his gravestone. In another episode Billy is nearly seduced by rival team boss Gus Parker, disguised as a beautiful model (Cindy Smallpiece) in an attempt to make him miss the cup final. These exaggerated, yet somehow uncannily accurate, parodies of the off-pitch tribulations of the original Roy give the strip an 'aesthetic of the second degree', a characteristic attributed to 'Biff cartoons by Dick Hebdige. 'Biff' is the pen name of Mick Kidd and Chris Garrett whose *Guardian* comic strips feature collages of 1950s and 1960s advertising images. The targets of their satire tend to be more esoteric than those of *Viz* – Chris Garrett describes their subject matter as 'pretension facade living, mail order lifestyles'. In a typical example of 'Sincerely Yours . . .' from *The Guardian* in 1985, the entire strip is spent with three characters discussing the cultural and Freudian overtones of crisp flavourings. Chris Garrett also explains the source of their inspiration: 'You run into some pretty esoteric, crackpot theories analysing sitcoms, soap operas etc. For some reason these theories are always written in tortuous language rich with useful terms like 'diagesis', 'paradigmatic', 'post-Lacanian' etc.[1] Dick Hebdige, who readily admits that he is a candidate for 'Biff's satire, comments:

> 'Biff' represents the self-conscious parody of a completely ungrounded mediated set of interlocking image-saturated cultures – the shift, in other words, from somewhere to anywhere, from satire to pastiche, from feminism to what Jean Baudrillard has called the 'fascination of the code' – from feminism to ungendered fascination or shift from the language, however lightly used, of 'cultural politics', and 'intervention' (the language of the 1970s) to the language of postmodernism and play (the language of the 1980s).
>
> (Hebdige, 1988)

Hebdige also quotes Roland Barthes on what Barthes called 'an aesthetic of the second degree'. Essentially this consists of 'dislocation: parody: surreptitious quotation'. Despite the fact that 'Biff' is continually mocking people's pretensions it is necessary for its audience to be aware of the subtleties of these pretensions. Without a reasonable knowledge of their targets on the part of the audience, the jokes are only half-formed. In

effect, the best audience for 'Biff' are those who are being mocked. This multi-layered knowing 'postmodern' humour is not found in all of the material in *Viz*, but does occur in some of the newspaper parodies as well as 'Billy the Fish'. The *Viz* parody of *The Dandy's* 'Black Bob': 'Black Bag, the faithful border bin-liner', carries similar overtones of surrealist parody.

Whatever the strengths or shortcomings of the comic might be, it is hard to dislike it, partially because its creators never pretend that it is anything other, or better, than it really is. In 1990 Graham Dury, currently one of the four main artist-writers of the comic, described the still basic *Viz* production values: 'The cartoons are shite and the comic's crap so there's no point in printing it on luxury paper.'[2] It has certainly had a remarkable press since its rise to fame. On the one hand it has found favour in *The Listener* where Andy Medhurst saw it as 'the foul-mouthed monster from the *Beano's* id', continuing '*Viz* is a joke about comics as well as a comic with jokes. . . . *Viz* has an extremely shrewd grasp of popular culture. It knows precisely which personalities to go for, the ones its audience can be guaranteed to enjoy seeing assassinated' (Medhurst, 1988). On the other hand, and perhaps equally surprisingly, it has also been given a glowing review in the *Sun*. Here it was perceived as a rags to riches story in terms that sound almost like one of the paper's own adverts: 'There's no biz like show *Viz*. It's rude, crude and very vulgar. *Viz* magazine is the comic sweeping Britain – and its readers are in stitches. The biggest joke of all is that its startled Geordie creators are laughing all the way to the bank.' The fact that most issues of the comic contain accurate scathing parodies of the *Sun* itself seems to have escaped the notice of the paper.

The literary merits of the comic have been extolled by Auberon Waugh:

> I think if future generations look back on the literature of the age they'll more usefully look back to *Viz*, than, for instance, to the novels of Peter Ackroyd or Julian Barnes . . . simply because *Viz* has got a genuine vitality, and a vitality of its own, a vitality which comes up from the society it represents and these novelists don't.[3]

Although Waugh made these comments in the course of a largely tongue-in-cheek documentary, the fact that he was willing to take part at all is significant, and he also confides that his favourite strip is the *Nineteen Eighty-Four*-like 'Bottom Inspectors'.

In 1986 *Viz* was taken over by Virgin Books, and in 1987 Virgin executive John Brown broke away from the company, taking *Viz* with him. During this period its sales rose dramatically, as can be seen from the publicity material aimed at potential advertisers by John Brown Publishing

in 1988. Brown's publicity leaflet showed that the readership at that time was over 500,000 and also indicated that its readership is 85 per cent male and 82 per cent under 25. Asked about whether this takeover affected the comic's content in any way, Chris Donald claims: 'Well we had to drop all the rude bits and we've had to make it less funny in order to appeal to a commercial market.'[4] Whatever the nature of its appeal one thing is certain: it is very widespread. Tony Bennett of Knockabout Comics believes that the role of the present publisher John Brown has been vital: 'That's part of the key to the success of *Viz* – they appeal to a much wider range of people than ordinary comic buyers. John Brown has got to take a lot of credit for that – he's done a very good job for them.'[5]

The most spectacular rise in the sales figures for *Viz* began in the late 1980s and it is illuminating to look at the increasing print runs for the year 1989:

1989	Print Run
Issue 34	615,000
Issue 35	816,000
Issue 36	832,900
Issue 37	817,000
Issue 38	974,000
Issue 39	1,251,356[6]

On all these issues, actual sales figures were over 90 per cent of the print run numbers. Inevitably such success has led to a rash of imitators, including *Gas*, *Poot*, *Smut* and *Brain Damage*, all of which Simon Donald dismisses as 'not funny'. Others are less generous. Robert Grant comments in an article which is a 'qualified defence' of *Viz*: 'Its pathetic and repellent imitator *Gas*, by contrast, is beyond redemption!' (Grant, 1992).

Up to 1982 there had been no major commercial successes in the field of British underground and alternative comics: none had ever been financially successful enough to endure for more than ten issues published at consistent intervals. Any attempt to give a precise definition of British alternative comics is fraught with problems. It is an area which is approximately synonymous with the field of 'underground' comics, but it also covers a wider range of material. Indeed, the phrase 'underground comics' itself is by no means exact. The usage of the word 'underground' to mean 'in a hidden or obscure manner' originated in the seventeenth century. It was obviously something of a misnomer for the anti-establishment comics of the late nineteen sixties which depended on publicity and widening sales for their survival. In America in 1968, Tom Forcade, the Underground Press

Syndicate co-ordinator wrote: 'Underground is a sloppy word and a lot of us are sorry we got stuck with it. Underground is meaningless, ambiguous, irrelevant, wildly imprecise, undefinitive, uncontrollable and used up. Despite this extreme dissatisfaction the word 'underground' stuck, perhaps because it was in fact not an unreasonable approximation of the early manifestations of the movement. John Wilcock wrote in 1970:

> Like so many other over-used words, 'Underground' means too many different things to different people. If it is still used by people who are underground themselves (by any definition) this is mainly because no other word conveys so simply a whole class of people and their activities.

The word 'underground' carried connotations of a culture that was not only opposed to the existing establishment, but also trying to operate totally outside the artefacts of that establishment. Thus the true 'underground press' wrote, printed and distributed their newspapers or comics totally independently of established organisations. Small offset litho machines, local distribution (often street vendors) were the mechanisms of this kind of periodical. There was a widespread belief that this kind of independence would enable these practitioners to avoid 'selling out'. The concept of 'selling out', or co-operating with the establishment, was rarely avoided in practice. Part of the problem was that in order to expand and produce periodicals with national distribution it was almost inevitable that existing printing and distribution facilities would have to be utilised.[7]

Moreover, society often has a surprising capacity for absorbing or deflecting what seem to be dangerous ideas. Walter Benjamin said in 1934:

> Transmitting an apparatus of production without – as much as possible – transforming it, is a highly debatable procedure even when the content of the apparatus which is transmitted seems to be revolutionary. In point of fact we are faced with a situation – for which the last decade in Germany furnishes complete proof – in which the bourgeois apparatus of production and publication can assimilate an astonishing number of revolutionary themes and can even propagate them without seriously placing its own existence or the existence of the class that possesses them into question.
>
> (Walsh, 1981: 6)

Thus in the counterculture, or underground, we find a tension between

the original aim of destroying existing cultural assumptions and power structures and the continual temptation to collaborate to some extent with these structures. Within this output success is, of course, a relative term. There have been many individual stories and comics which have been successful within their own terms. The lasting effect of the underground comics of the period 1966 to 1986 has been felt through the artists and writers who have moved from the underground into 'mainstream' comics. This has led to a situation where the distinction between the two fields has begun to blur. Eventually this may create a climate akin to a European attitude to comics, whereby the form does not dictate the content in any way. Comics could then cease to be just for children – the 'funny papers' – in the American idiom. The reaction of the 'well-educated' person to comics in Britain is summarised by Richard Hoggart's comment, 'At the lowest level all this is illustrated in the sales of American comics . . . a passive visual taking-on of bad mass-art geared to a very low mental age' (Hoggart, 1957). The reasons for the failure of British underground and alternative – essentially a failure to *sell* – are obviously many and varied, and the extent to which each element played its part is difficult to assess. But it is possible to discover some of the principal reasons. Firstly, these comics have all been produced in an atmosphere in which the status of comics as a medium was very much at the bottom of the cultural pyramid. This prejudice against comics seems to be more deeply entrenched in Britain than in any other country in the Western world. This meant that on the one hand comics of any kind simply sold less in this country than in many others. On the other hand there was also a barrier which meant that comics were regarded purely as children's fodder, and thus no pre-existing distribution method for adult comics was in place. Secondly, there was the attitude of many of these comics' producers to this problem of distribution. Too often there has been a rush to produce a comic without even a thought as to what will happen to it when it is printed. This attitude is perfectly reasonable for a single work of art, or a very limited number of reproduced objects, but rather more rash when several hundred (or many more) printed items are left as an end product. It may be that some of this attitude resulted from the background of many of the people involved in the field which was often art college and fine art orientated, but it was also an attitude which characterised the early issues of *Viz*. Thirdly, this art background also often led to a particular type of comic being produced which lacked the wider appeal of its American counterpart. Essentially many British underground comics have been elitist, addressing themselves to the problems of, and using references familiar to, other college graduates, but consequently obscure and irrelevant to

many other readers. Fourth, it must be remembered that British comics were in competition with their American counterparts for what market there was in this country. British readers were familiar with American underground artists through *International Times* and *Oz*. American comics such as *Zap* were also available in their original editions in many specialist shops. The importance of this is that in the main the American comics, quite simply, were better. They were better printed and produced and more importantly, better written and drawn, often with a vitality and power that struck a chord with many people within the underground, and some outside it. This is a sweeping statement but all the available evidence from the use of American work in *Oz* to the comments of countless British practitioners supports this premise. American underground comics boasted the work of Gilbert Shelton (whose *The Fabulous Furry Freak Brothers* have outlasted all fashion changes), Robert Williams, Victor Moscosco and, most importantly, Robert Crumb.

Fifth, it is necessary to explain why comics which achieved something of the feel of American comics or were simply high-quality works also failed to sell. Sometimes it may have been because of the distribution problems mentioned earlier. Another important factor, however, has been censorship. The most famous censorship trial of this period was, of course, the *Oz* trial in 1971. Interestingly some of the most contentious parts of the issue in question, the Schoolkids issue (no. 28), were cartoons and drawings, including a sexual version of 'Rupert the Bear'. In fact the strip was a collage with Rupert the Bear's head added to page 10 and 11 of Robert Crumb's strip, 'Eggs Ackley among the vulture demonesses' from *Big Ass* Comic no. 1 of June 1969. The guilty verdict at this trial led to a feeling of unease and paranoia amongst underground publishers that was almost the opposite of the new sense of freedom which followed the trial of *Lady Chatterley's Lover* in 1963.

Following in the wake of the highly publicised *Oz* trial, two of the most successful underground or alternative comics in Britain were also the subject of Crown prosecutions: *Nasty Tales* in 1972 and *Knockabout Comics* in 1983. The trials of *Nasty Tales* and *Knockabout*, although their outcomes were different from *Oz* in that the defendants were acquitted, were damaging both financially to the companies involved and to the image of underground comics.

Typical of the censorship problems encountered by British comics in the 'grey' area between the adult and the children's market is the history of *Oink*, a humour comic which began life in 1986. Basically intended as a *Beano* for the 1980s, *Oink* was produced in Manchester by Mark Rodgers, Tony Husband and Patrick Gallagher, and published in London by IPC. Its

audience was to be as wide as possible – 'from eight to eighty' – and its humour (largely parody) varied from the childishly scatological to the broadly satirical. It was initially highly successful, appealing both to children and the maturer student audience of *Viz*. Its best work, by artists like Tony Husband himself and 'Banx', both veterans of *Punch* and *Private Eye*, was genuinely funny and original. However problems arose with distributors W H Smith who decreed that the comic should be sold from upper shelves – next to *Private Eye* in fact. W H Smith, of course, had for a long period refused to handle *Private Eye* at all, and have a history of conservatism in their selection of material. The number of outlets that they control can mean that their refusal to handle a publication cuts its circulation by hundreds of thousands. *Oink's* physical positioning where most children could not even reach it had a detrimental effect on sales.

Oink's attempt to reach a wider audience also led to problems in the sort of material that was included in the comic. At one point the comic featured in the tabloids when a 'Rambo' parody accidentally happened to appear in the same week as the Hungerford massacre. On another a mother took *Oink* to the Press Council, on the charge that it mocked family values. The strip, 'Janine and John and the Parachute' (*Oink* no. 7, 1986), which is in fact a slightly cruel parody on impossibly nice 1930s comic strips, was found to be in bad taste, but nevertheless not guilty of this charge. Such publicity, however, did not ease distribution problems and in 1988 *Oink* ceased publication due to declining sales.

There is certainly a widespread prejudice against comics in Britain, as we have already seen. This spreads out to all kinds of cartoons, and to a lesser extent to all things visual. It is reflected strongly in a review of cartoonists' work in *The Guardian* in 1984 by Roy Hattersley. The books reviewed included the collected works of Steve Bell, Gary Trudeau, Ralph Steadman and Raymond Briggs. Hattersley opened the review:

> Try as I may I am wholly incapable of understanding why anyone chooses to pay good money to buy a book of cartoons. For cartoons are, by their nature, an often trivial and usually transient commentary on our social and political order, drawings to be looked at, laughed at and then forgotten.
>
> (Hattersley, 1994)

Where this leaves the work of Daumier, Hogarth or Rowlandson and many others is not quite clear. That these views stem from blind prejudice is categorically revealed by Hattersley's later comment: 'Ralph Steadman's book I shall not open at all. It is so violent in both concept and execution that the nausea which it produces anaesthetizes the sensibilities' (Hattersley, 1994).

Whilst feeling sympathy for anybody of such a sensitive nature there must also be envy of the X-ray eyes which allow Hattersley to assess the book without even opening it. Yet this is absolutely typical of such critiques, which either refuse to look at the evidence at all, or dismiss it out of hand without proper examination. The only kind words in the review are reserved for Nicholas Garland, but it ends with a comment which illustrates exactly where Hattersley thinks this kind of thing belongs: 'Each of the books is ideal to take to the lavatory after Christmas dinner. But each will be finished before another replete diner begins to knock on the door' (Hattersley, 1994).

We must now return to the question of the success of *Viz*. In 1982 it would have been possible to state that there had never been any financially successful adult comics in Britain. *Viz* has changed that. Some people, of course, would quibble with the labelling of *Viz* as 'adult', but it does actually state on its cover that it is 'not for sale to children'. So what does the success of *Viz* mean? Is it based on the fact that many of its readers did not really want to give up the *Beano*?

If the reasons proffered for the failure of previous 'adult' comics are reasonably accurate, then theoretically *Viz* should conform to few, if any, of these criteria. Certainly *Viz* has overcome the distribution problems that have dogged so many publications. Initially the comic was produced in such small numbers that distribution was not particularly a problem. As its print run gradually increased it was certainly able to benefit from the great number of specialist comic shops that had spread across the country throughout the later nineteen seventies and nineteen eighties. However the key to its success has been sales through traditional newsagent outlets, and in this regard it was its publishing by Virgin Books in 1985 which allowed it to reach a much wider audience.

But, although it may have benefited from these distribution organisations which had developed independently, it is obviously the wide appeal of the comic that is the crux of its success. Here, the accusations of elitism can hardly be applied. Its creators describe themselves as 'middle class' but whatever other characteristics the comic displays, obscure intellectual references, a subtlety of allusion or hidden nuances of meaning are not paramount amongst them, although this is not to say that they are not sometimes present, as we have seen.

In relation to competition from America the situation is also rather different. During the nineteen eighties there had been an explosion of American 'independent' comics aimed at an 'adult' audience. Some undergrounds also continue, like Robert Crumb's *Weirdo* or Gilbert Shelton's *Rip Off Comix* and *The Fabulous Furry Freak Brothers*. But none of these

is really in competition with *Viz*. As we have seen, *Viz* does have its imitators, but they, as well as *Viz* itself, are a very British phenomenon. It is not impossible that *Viz* could establish a cult following in America, just as the *Carry On* films did in some quarters, but essentially its humour is uniquely British, and the majority of its audience are not regular buyers of comics at all.[8]

Viz has also escaped any serious establishment attacks on the grounds of censorship. Despite occasional complaints it has carved a niche for comics in newsagents which are aimed at adults only. This, in a sense, may be one of its lasting contributions to British comics. Part of the reason for its acceptance is that, despite its vulgarity in both words and pictures, it is not perceived as being dangerous. It can be seen as part of a tradition which stretches back through the *Carry On* films via seaside postcards to British music-hall comedians. It might gnaw at the edges of the perceptions of mainstream society but it does not try to destroy its fundamental tenets as some previous underground publications attempted to do.

VIZ: CLASS AND GENDER

This section will concentrate on some of the key elements in the success of *Viz*, in particular its approaches to gender, class and the breaking of taboos. The breaking or challenging of taboos is a common strategy in humour. The double entendre is a classic example of drawing close to a taboo but at the same time not quite breaking it because of the potential ambiguity of the final punch line: *Carry On* films survived for over twenty years largely by trespassing on the boundaries of sexual taboos. Such 'seaside postcard' humour is part of the staple diet of established comedy and indeed *Viz* has sometimes been seen as part of this tradition.

But *Viz* makes much more direct challenges to moral and sexual taboos. These challenges are much more akin to Bernard Shaw's 'bloody' line from *My Fair Lady* which gave audiences a frisson of excitement as well as humour in the presentation of a word not normally heard in polite society. Indeed *Viz* uses such 'inappropriate' swearing in a very similar way: lower-class characters swear unknowingly and automatically and thereby cause offence to a notional 'middle-class' sensibility. Of course the chief difference is that these *Viz* characters continue to swear at every possible opportunity.

This attacking of taboos is quite deliberate. Elaine Chaika, although in fact describing the black oral tradition of 'toasting', could equally well be discussing the position of *Viz*: 'In fact, one suspects that taboos are deliberately woven throughout. Although they offend sensibilities, profanity and taboo

subjects are an integral part of any sociology of language as they reflect social conditions and attitudes' (Chaika, 1989: 154). Just as 'toasting' may offend 'middle-class' sensibilities, so *Viz* might offend many people who pick it up, but both are aimed at a specific audience who will enjoy profanities partially because of the offence they might cause to others.

As we have seen, this swearing is one indicator of a character's lower class. Francisco Yus Ramos points out that the use of phonetic spelling emphasises not just lower-class status but also regional origins. He reproduces two panels in which the Bacon family discuss whether or not their mother can be described as ' dorty hooer' (Ramos, 1995). Several of the important characters in *Viz* retain a distinct North Eastern flavour in the expressions they use ('man', 'pet', 'howay', etc.) and the way that a Newcastle accent is rendered phonetically.

But the character humour in the majority of the items in *Viz* can broadly be classified into three types. It tends to be based either on parody of a specific source, on a central character defect or twist or, finally, on some kind of ridiculous physical quality. All three types depend on exaggeration and caricature, and there are areas of overlap. 'Roger Mellie', for example, although depending for much of its humour on the 'character defect' of a presenter who constantly drinks and then swears at inappropriate times, also contains elements of parody of television programmes and media mores. However if the main thrust behind various items is examined they could be divided in this way:

PARODY	CHARACTER DEFECT	PHYSICAL QUALITY
Billy the Fish (Roy of the Rovers)	Roger Mellie	Buster Gonad
Black Bag (Black Bob)	Fat Slags	Johnny Fartpants
Photo Strips	Big Vern	
Newspaper Articles	Spoilt Bastard Roger Irrelevant Postman Plod Millie Tant	

Strips like 'Black Bag: The faithful border bin-liner' are very specific parodies of an original source – in this case, 'Black Bob: The faithful border collie' – to the extent that some images may be lifted wholesale from the original strip in the *Dandy*. Without knowledge of the original strip the already surreal narratives must seem even stranger. What links the parodies

of comics in *Viz* with the jokes about physical exaggeration ('Buster Gonad' etc.) is that there is no *obvious* disapproval of the characters. The humour lies in the incongruity of Johnny Fartpants's extensive flatulence or Black Bag's ability to rescue his 'master' from dire situations even though he is in reality only a plastic bin-liner.

However, the majority of the 'defective characters' in *Viz* are presented with a certain degree of disapproval. This is a complicated area but an important one because it is central to criticisms of the comic. 'Sid' is by definition a sexist, but does this make a comic strip about him sexist in itself? Obviously it does not necessarily follow that it is sexist, but some critics would argue that it is. Of course a wide range of behaviour might be described as sexist. At one end of the scale is a 'grey area' of behaviour which some might regard as perfectly normal and acceptable, but which others might regard as mildly sexist. Sid (whose surname is Smutt), exhibits a form of sexism which could be described as coming from the other end of the scale. His introductory remarks to the women he meets include: 'Howman hinny, d'yu bang like a fuckin' shithoose door in the wind or what!?' (issue 23, April 1987); 'Let's taalk aboot the weather . . . whether or not ya ganna suck us off th' neet (issue 40, February 1990). Many other examples could be given but Sid's conversation tends to have a terrible predictability about it. It seems evident that 'disapproval' of these characters varies from one character to another. At the bottom, or worst end of the scale there is 'Big Vern', who is basically a psychopath, and 'Spoilt Bastard', whose name is self-explanatory. 'Sid the Sexist', for all his irredeemably awful behaviour, is so constantly ridiculed and humiliated that he ends up a rather sad figure. 'Roger Mellie', despite his incredible boorishness, tends to swear in formal situations which could leave the reader with a grudging admiration.

Something which adds to the confusion about the status of these characters is the extent to which they may be portrayed as 'heroes', not so much in the strips themselves, but in merchandising such as T-shirts. Theoretically 'bad' comic characters like 'Dennis the Menace' have long been used in merchandising. This is a complicated issue which cannot be fully investigated here. However people's identification with these characters is not simple or straightforward – people will wear T-shirts featuring characters such as the hapless 'Rimmer' from the television series *Red Dwarf* or the serial killer 'Freddy' from the *Nightmare on Elm Street* films. Presumably in neither of these cases does the wearing of the T-shirt indicate great respect or a desire to be like that character. In the case of 'Rimmer' or 'Sid the Sexist' part of the enjoyment of the characters may be that whatever one's own shortcomings it is possible to feel superior to

two of life's ultimate losers. But the wearing of a T-shirt featuring the characters goes one step further. The reading of a particular comic or the watching of a particular television programme can largely be hidden from the world. The wearing of a T-shirt featuring 'Sid the Sexist' proclaims your allegiance to that character for everyone to see.

What really divides these different types of character in *Viz* is the out-come of their stories. 'Sid the Sexist' inevitably suffers some form of retribution; 'Roger Mellie', whatever his gaffes, tends to 'get away with it'; while the 'Fat Slags' earn a reward (exactly what they were looking for at the start of the story), which is normally food, drink and sex, preferably in that order. Reducing stories to this formulaic level can oversimplify their structures. However, the resolution of stories is a key element in answering critics of various characters.

It seems generally accepted that the most vociferous criticism of the humour in *Viz* comes from a feminist point of view. Jeff Hearn certainly seems to take this for granted when he claims:

> Most obviously *Viz* is anti-woman, as in the cartoon strips 'Millie Tant', 'Mrs Brady Old Lady' and the 'Fat Slags'. More generally the main currency of *Viz* is sex, violence, sexual violence and of course sexism.
>
> (Hearn, 1994: 70)

In a footnote to this section he adds:

> I have learnt from a man of one feminist who found positive images in the 'Fat Slags' strip. It is probable that different readings of *Viz* could be made from the perspective of this and indeed other feminist readers. Here, however, I am concerned with the domi-nant meanings of the text for male readers.
>
> (Hearn, 1994: 70)

What is not in doubt here is the fact that the majority of *Viz* readers are male (between 74 per cent and 81 per cent according to Hearn, 85 per cent according to *Viz*'s own survey in 1989) and its authors/artists are also male. However it then requires a leap of imagination to assert that the comic is 'obviously anti-woman'. The 'Fat Slags' are successful in their own terms as is 'Mrs Brady' – only 'Millie Tant' suffers for her behaviour. The comic is actually read by a large number of women (25 per cent of the 1989 circulation figures would be a quarter of a million female read-ers). They are obviously finding something which Hearn does not see in

the comic. The rumoured feminist who finds 'something positive' in the comic is certainly not unique. Indeed in 1989 Helen Oldfield, writing on *The Guardian's* women's page argues: 'Amongst the smutty juvenilia and parodies of *Beano*, 'Roy of the Rovers', *The Sun* and *Private Eye* that make up *Viz*, the 'Fat Slags' stand out as the most appalling and the funniest strip, perhaps because they contain a hint of truth and tragedy' (Oldfield, 1989). For Oldfield 'they are far from being victims of the drunken sots with whom they fraternise'.

The dichotomy between the two extremes of feminist reaction to the 'Fat Slags' was ably demonstrated in the Granada television programme *Up Front*, broadcast in 1992. The comic was debated by Simon Donald and a studio audience. What might be described as the 'mainstream feminist' view, or at least the view that seems to be expected of feminists by Hearn, was expressed by the writer Dahlian Kirby: 'I don't mind laughing at myself as a Northern working-class woman. What I mind is the rest of Britain seeing that's what the representation of Northern working-class women is.' As well as seeing the 'Fat Slags' as this kind of archetypal figure, Kirby claimed: 'I think you are part of the establishment. You are using all these four-letter words as if they are disgusting. You talk about parts of a woman's boy as if there's something peculiar and dirty about it. Men have done that for a long time. Are you radical?' This echoes a criticism made by Hearn that 'In contrast to its heretical image, *Viz* is carefully constructed, cautious and above (or below) all deeply (or shallowly) conservative (Hearn, 1994: 73). In one sense, there is an element of truth in this because *Viz* does not espouse any of the radical causes found in the kind of alternative comics discussed earlier. Their humour can be described as 'safe' or 'not radical'; but this does not mean that it is conservative or establishment humour – it can still be irreverent and knowing. Simon Donald replied: 'The joke is that people treat the parts of women's bodies as if they're a joke.'

The opposing feminist point of view was expressed on the programme by Val Langmuir of 'Feminists Against Censorship'. She stressed the differences between the treatment meted out to the 'Fat Slags' and 'Sid the Sexist':

> I think the 'Fat Slags' are hilarious. I'm fat and they're funny. I think they're very successful. They always have a great time – they're some of the most happy characters in the whole comic, they're always eating, drinking and having sex, they always have a screw at the end of the strip . . . they're much more successful than old Sid the Sexist – all he gets is beaten up for his trouble.

It may be that part of the difference between female reactions to the 'Fat Slags' is age. In the 1990 survey eleven female readers of *Viz* between the ages of 18 and 27 replied to the questionnaire. Of these, eight specifically mentioned the 'Fat Slags' as one of the 'stories you particularly enjoy'. In answer to the question, 'What do you enjoy about them', comments about the 'Fat Slags' included:

'I can relate to the characters.'
'Fat Slags – so real to life.'
'The mixture of a typical cartoon character with real people.'[9]

Although the number of responses here is not enough to draw absolute conclusions it is striking that such a high percentage of those female readers find the 'Fat Slags' one of the most enjoyable, if not the most enjoyable strip in the comic. Equally their reasons, when stated, fit incredibly closely with Oldfield's view that for all their seeming excess the appeal of the 'Fat Slags' lies in the 'hint of truth'.

'Millie Tant', *Viz*'s 'answer' to feminists, is more problematic. The structure of 'Millie Tant' stories is very similar to those of 'Sid the Sexist'. Each character goes about the usual business of their life. For Sid this normally involves making lewd, drunken advances to a woman in the most boastful and off-putting terms. For Millie it will normally involve arranging protests against non-existent or redundant threats (such as phallic pillar boxes) and misinterpreting innocent remarks. The results of their activities are almost inevitably some type of swift retribution in the form of humiliation or physical violence or both. This close similarity indicates that both Millie and Sid have similar, high ratings on the 'disapproval scale'.

Of course there is no doubt that humour can be cruel and can hurt people. Freud characterises a 'hostile' joke as a joke that will

> allow us to exploit something ridiculous in our enemy which we could not, on account of obstacles in the way, bring forward openly or consciously; once again, then, the joke will evade restrictions and open sources of pleasure that have become inaccessible.
>
> (Freud, 1991: 147)

This is certainly more true of 'Millie Tant' than it is of the 'Fat Slags'. Indeed in the light of the various feminist responses to the 'Fat Slags', and the intentions of their author, it can be argued that they do not constitute 'the enemy'. For others an element of cruelty is a part of humour that has

to be accepted, as in W. C. Fields' maxim that 'I never saw anything funny that wasn't terrible, that didn't cause pain.'

In *Viz* it is a question of the targets involved. For some *Viz* does not go far enough. Robert Grant reports: 'For Nicholas Farrell of the *Sunday Telegraph*, *Viz* "lacks real nerve, it does not make fun of Blacks and Arabs". But why should it?' (Grant, 1992). Although they have been accused of picking on vulnerable, easy targets it is evident that potentially racist strips are carefully excluded from *Viz*. They could be accused of being 'regionalist' (against themselves) but that is all. In 1990 they also banned all 'chat-line' adverts from the comic, which tends to support the notion that they are able to distinguish between the satire of sexism in 'Sid the Sexist' and accusations of the real thing. Nevertheless, criticisms of the comic continue and Hearn perceives 'myths of male reproduction' in 'Felix and his Amazing Underpants', continuing: '*Viz* is a homoerotic, homosexual and homoreproductive (cult)ural product of seething pre-dictability: an erotic exchange of bits of male bodies between men . . . no wonder men love it (Hearn, 1994: 72). This conclusion is partially based on some of the objects which find they way into Felix's underpants, including eggs (for incubation), buns and elephant droppings. For Hearn this represents the 'celebration of male reproduction due to the "buns" in Felix's "oven", and more subtly in the storing of shit' (Hearn, 1994: 74). However, given that on other occasions Felix's underpants are filled with vomit, chocolate, a bomb, a Christmas tree and nuclear waste, then any potential meanings of these objects may be more complicated. Equally it has to be said that the obvious link between all the objects is that they are not entirely sensible things to put in your underpants. This is not to say that stories like this in *Viz* cannot contain other meanings imparted either deliberately or unknowingly by the authors. The 'Felix' strip, like the 'Bottom Inspectors', is full of references to, and guilt about, dirty under-wear and sexual embarrassment relating in particular to the fears of childhood and adolescence. After the initial humour of the increasing incongruity of what Felix puts in his underpants there is another level of the strip which plays on these fears of going out into the world totally vul-nerable, dressed only in your underwear.

One of Hearn's most contentious assertions is that 'It is a little-known fact that the very concept of *Viz* was carefully planned and created fol-lowing extensive market research, by Hopper and Jollard's Consultancy' (Hearn, 1994: 73). This is a little-known fact because it is not a fact. Market research certainly was carried out once *Viz* was becoming big business, but as has already been pointed out in this chapter, its origins were absolutely personal, regional and very small scale. Its success has

partly been based on the fact that it was originally produced for fun, and some of its continuing success has been due to the comic's ability to retain the feeling that it is still fun to produce. It is only necessary to look at almost any of the *Viz* imitations to see how 'impersonal' they appear by comparison, whatever their relative merits in other areas.

The *Viz* artist-writers are acutely aware of the nature of the criticism made against them. In 1990, after there had been a furore about the banning of the comic by student unions, they attacked themselves with the subtitle 'Ban this filth' on the cover of issue no 44. Inside, their mock-tabloid article gave fulsome support to the attempts to ban *Viz* by Student Union President 'Nigel Wankshaft' who 'plans to take a year off at the end of his course, grow half a stupid bum-fluff beard and travel around Europe by train, picking grapes and wearing flip-flops'. A form at the end sums up the argument succinctly:

> Dear Unions Shop Management Person
> I'm all in favour of free speech and I oppose any form of censorship, like you get in South America, but I don't agree with *Viz* and I think it should be banned so that people less intelligent than me can't read it (unless of course they walk fifty yards to the nearest newsagents).

Despite a recent fall in sales, *Viz* remains pre-eminent in its field. Its sales, either for a comic or for a humour magazine, have been unique in recent British publishing history. Although minor characters come and go, *Viz* is largely unchanging. The range of humour in *Viz*, whatever its strengths and weaknesses, has struck a chord with a young, mainly male audience. Simon Donald describes its appeal in this way:

> the kind of humour that everybody laughs at but they tend not to admit it . . . I think our comic is probably the first time this schoolboy, cheap, vulgar humour [which] everybody has a laugh at – maybe some more than others – but its the first time its been on paper.

NOTES

1 Chris Garrett discusses the methods of 'Biff' in the exhibition catalogue, *Graphic Rap*, ICA, 1982.
2 Unpublished interview by Emma Craven with Chris Donald, Simon Thorp and Graham Drury, 20 February 1990.

3 Waugh's comments were made to Philip Brantson on *Viz: The Documentary*, Channel 4, 1990.
4 Chris Donald, interviewed by Emma Craven, 20 February 1990.
5 Interview with Tony Bennett, 18 April 1990.
6 *Viz* kindly supplied these figures to Emma Craven at my request.
7 The printing history of *International Times* exemplifies this. It experienced great difficulty in finding printers capable of producing the magazine, without at the same time imposing restrictions on its content which amounted to censorship.
8 This fact is evident from the volume of sales itself, but it also tended to be confirmed by a survey carried out by Emma Craven in 1989, for a BA Humanities thesis at Manchester Polytechnic. Out of forty-three returned questionnaires, only two respondents counted themselves regular readers of other comics, and twenty-eight read no other comics at all.
9 These questionnaires were kindly given to me by Emma Craven for use in my research.

BIBLIOGRAPHY

Chaika, Elaine (1989) *Language: The Social Mirror*, London: Newbury House.
Freud, Sigmund (1991) *Jokes and Their Relation to the Unconscious* [1916], Harmondsworth, Penguin.
Forcade, Tom (1968) *Orpheus* (18 August).
Grant, Robert (1992) 'Viz: A qualified defence', *Times Literary Supplement* (7 February), p. 11.
Hattersley, Roy (1984) 'At just below the pound', *The Guardian* (6 December).
Hearn, Jeff (1994) 'Viz: The naming of the pose' [1], *Journal of Gender Studies* 3(1): 69–75.
Hebdige, Dick (1988) *Hiding in the Light: On Images and Things*, London: Routledge.
Hoggart, Richard (1957) *The Uses of Literacy*, London: Penguin.
Medhurst, Andy (1988) 'Comic uncut', *The Listener* (3 November): p. 88.
Oldfield, Helen (1989) 'Comic strippers', *The Guardian* (7 November): p. 21.
Ramos, Francisco Yus (1995) *Conversational Cooperation in Alternative Comics*, Alicante: Universidad de Alicante.
Walsh, Martin (1981) *The Brechtian Aspects of Radical Cinema*, London: British Film Institute.
Wilcock, John (1970) *Countdown*, London: NAL.

15

HEARD THE ONE ABOUT THE WHITE MIDDLE-CLASS HETEROSEXUAL FATHER-IN-LAW?

Gender, ethnicity and political correctness in comedy

Jane Littlewood and Michael Pickering

Comedy is homeopathic: it cures folly by folly. Yet anarchy exposed and enjoyed presupposes a minimal just order.

Gillian Rose: 'Love's Work'

[I]t went badly when people put on these spectacles to see rightly and to be just: and then the demon laughed till his paunch shook for it tickled him so. But without, some little fragments of glass still floated about in the air – and now we shall hear.

Hans Christian Andersen: 'The Snow Queen'

INTRODUCTION

We begin with a common assumption. This is that any attempt to question the moral proprieties of comedy is doomed to failure for the simple reason that it mistakes the very nature of the comic impulse. It fails to appreciate what is essential to the comic element in cultural performance and interaction. This apparent essence can be described in various ways, but what such descriptions usually share is the sense that humour and comedy work precisely by subverting moral proprieties, by challenging us to laugh at the seriousness with which we take our own codes, precepts, values and beliefs. Peter Cook's statement that 'one of the ways of getting out of anything which you find you are taking over-seriously at the time is to escalate it into comedy' is based solidly on this conception of comic effect (Nathan, 1971: 139). This view is sometimes extended to say that humour and comedy work by disturbing, by turning inside out, popular

notions and shibboleths. They do so by delivering some unexpected take on what we normally take for granted. Joking as a form of human interaction plays disrespectfully on our sense of what is socially respectable or ethically correct. Some would go even further and say that all instances of the comic are founded on the transgression of decorum, propriety, and gravity in human affairs, that this transgression is its very *raison d'être*.

Perhaps the most extreme case of this assumption about humour is found in the antic spirit behind sick jokes. By definition, sick jokes flaunt their bad taste, their callous insensitivity to human tragedy and suffering. An example offered by Sean French (1989) surfaced in the aftermath of the disaster at Sheffield Wednesday's football stadium where a number of supporters were crushed to death:

– What was the bloke doing waiting outside Hillsborough?
– Waiting for his flat mate.

Another example from the same part of the world was heard on football terraces during the hunt for the serial woman killer, Peter Sutcliffe. Blake Morrison included this grim joke in his *Ballad of the Yorkshire Ripper*:

> Everyweer in Yorkshire
> were a creepin fear an thrill.
> At Elland Road fans chanted
> 'Ripper 12 Police Nil'.
>
> (Morrison, 1987: 130)

One which we remember from roughly this time is the student joke following the IRA murder of Lord Mountbatten, who was blown up on his yacht moored off the Irish coast:

– How do they know Lord Mountbatten suffered from dandruff?
– Because they found his Head and Shoulders.

Such jokes fly in the face of compassion, grief and outrage. That is precisely their point. In this respect, French dissociates them from racist or homophobic humour, which ridicules members of subordinate ethnic and sexual categories, in that they depend on an awareness of inappropriate response: it is this that they play on and delight in, rather than appealing to over-familiar stereotypes, to which the response is all too appropriate.[1] He thus characterises the comic impulse behind sick jokes as 'a little demon, working mischief in forbidden areas' and obeying a

populist imperative by providing a way of fighting back against govern-
ment- or media-induced conformity – hence the notoriously 'bad-taste'
jokes among soldiers, whose obedience is subject to rigid authoritarian
command. The examples cited are then justifiable because, however per-
versely, they enable people to say, in response to commercially motivated,
front-page pictures and headlines in the tabloid press, 'that they won't
have their emotions dictated from Fleet Street' (French, 1989).

Like many common assumptions, there is some truth in this conception
of the comic, or at least there is for us when jokes make us laugh where
we might otherwise condemn. It hardly need be said that as an explana-
tion of the sources or functions of humour this conception is over-simple
and partial, and is opposed by other forms of explanation, such as those
which approach humour in terms of social control or the power structures
of social relations. But the problem with most theories of humour and
comedy is that they claim an excessive applicability for themselves. They
strive to embrace far too much. Humour is a multiform and dynamic
human phenomenon, and has no universally essential feature. Attempts to
establish an all-embracing abstract body of explication for every manifes-
tation, every form and function of humour are likely to fall short of the
target. For theories of humour which claim to be comprehensive, you can
usually find a number of exceptions which don't prove the rule. In this
chapter, we advance no general theory and offer only certain tentative
observations on the problems faced by what, for want of a better phrase,
we may call progressive comedy, as well as the particular ways in which
such comedy in the 1980s and 1990s has negotiated the commonsense
notion that comedy, of whatever kind, provides 'a licence to be silly', a
licence to be anti-serious.[2] The major problem we wish to address can be
roughly stated in the following way. If we accept that it is culturally per-
nicious to revoke or drastically curb this licence, for among other things
it helps us to maintain some measure of balance and proportion in our
lives, then the question to which we must continually return is on what
grounds should the licence operate?

In the contemporary context, this question is perhaps most directly rel-
evant to the fraught issue of 'political correctness' in its application to the
content of stage and media comedy. Political correctness is easily pilloried,
and in many respects this is justified. We certainly do not intend to argue
for it wholesale. Our main reason for examining it is the interesting
dilemma which it poses. This is in the first instance a dilemma of choice.
If we reject any attempt to denounce or control humour and comedy, we
are immediately faced with the issue as to whether such rejection means
opting for a position which simply permits, without qualification, all

293

forms of comic discourse, regardless of their content and presentation. Any invocation of our irrepressible comic demon, working mischief in forbidden areas, obviously lends support to this position, but in its populist appeal it raises the difficult issues of moral relativism. In this respect, it is no more helpful as a means of defending the freedom of expression of comic writers, actors and stand-up comedians than high-handed pieties are for the open discussion of questions of comic aggression and offensiveness. Posing the dilemma in this way is misconceived because it sets out the alternatives as if they were absolute: either complete freedom of comic expression on the grounds that the question 'what's funny?' is socially and culturally relative, or complete acceptance of censorship whenever any social group or even any individual takes moral or political umbrage at an instance of perceived comic aggression. Because of its either/or formulation, this construction of moral choice is untenable for both criticism and comedy. It leaves open no possibilities other than those each sets up in a relation of mutual condemnation. Yet if we accept that it is unhealthy to allow the existence of any sacred cows in comedy, on what grounds is it possible to say that certain forms of comic bovine slaughter are, so to speak, cruel or otherwise objectionable?

The dilemma we are addressing arises from the desire to uphold a belief in the folly of comic censorship at the same time as opposing racism and sexism in the comedy of stage and screen. Can these be reconciled, or does such opposition necessarily imply some form of control over what comics may say or do? Clearly, official attempts at censorship are often misconceived, even absurd, as for instance in the BBC's restriction of Johnny Speight to twenty 'bloodies' per script of *Till Death Us Do Part*, a policy wonderfully sent up at the time by Peter Cook and Dudley Moore in a sketch written for *Not Only But Also* (Nathan, 1971: 111–16). The following short extract gives at least a flavour of their satirical take on BBC proprieties. Cook is complaining about the number of 'bums' in a comedy script:

MOORE: So what's wrong with that? So I've got thirty bums in the script.
COOK: Thirty-one.
MOORE: Thirty-one, give or take a bum. The bums are all there for a dramatic cumulative effect. You're not going to tell me that bums don't exist.
COOK: No.
MOORE: I've got a bum, you've got a bum.
COOK: We've all got a bum, Johnny. I would not pretend that bums don't exist. But what I do ask you, Johnny, and I ask you this very seriously, does an ordinary English family sitting at home early in the evening

want to have a barrage of thirty-one bums thrown in their faces in the privacy of their own living-room? I think not, I think not. I don't think we're ready yet to break through the bum-barrier.

MOORE: Don't give me that. Only two years ago Kenneth Tynan said f-f-f. . .

COOK: I don't care what Kenneth Tynan said. That was a live, unscripted programme over which we had no control and I must tell you, Johnny, that it is very seldom that we allow a bum to slip out before 11 o'clock in the evening.

MOORE: What miracle happens at 11 o'clock in the evening that takes the sting out of a bum?

Since the sixties, and particularly as a result of the abolition of theatrical censorship in 1968, comedy has become less and less subject to official control of this kind, though of course there remains legal limits (such as definitions of obscenity and libel) and institutional control over comic material and performance continues to be variably applied according to cultural medium and context, and, we should add, gender. For example, reference to the word 'clitoris' by French and Saunders in Channel Four's The Entertainers series led to the rescheduling of their show to 11.15 p.m. and a consequent loss of ratings, whereas the use of the word 'penis' in another show within the same series went out at 8.30 p.m. (before the 9 p.m. watershed) without objection from the channel's executives (Wilmut and Rosengard, 1989: 128). Nevertheless, it is within this thankfully more open context that new questions of comic offensiveness have arisen, either through the backlash of right-wing moral entrepreneurship, or in the wake of the new social movements of feminism, anti-racism and gay rights. As far as those associated with the latter are concerned, they continue to manifest themselves in terms of dilemmas. For example, in a rather crude sense, we could say that where joke-structures are dependent on the identification of a butt, on a target of ridicule or abuse, all comedians are faced with the choice of whether they direct their comic aggression at those who are in positions of power and authority, or at those who are relatively powerless and subordinated. In other words, do they kick up or down?

Posing the choice in this way is rather crude because, among other reasons, it makes it sound too much a matter of rational decision and conscious intention. Sometime around 1970, Marti Caine did a stag-do in Sunderland, which along with other towns in the north-east of England was referred to by comedians as 'Calvary' for the very good reason that 'most acts were crucified there'. Following the obligatory stripper at this

working men's club, Caine's appearance on stage was greeted by calls of 'ger em off!' and 'we want tits'. Her inspired response to her male heck-lers was: 'You'd look bright sparks with tits'. This comic retort hinged on her reversal of the intended butt, for at the heckler's call for 'tits oot' the drunken male audience 'all fell about', and without her comic skill and guts in turning the laughter back into the face of her audience, she would not only have been in danger of 'dying' right at the start of her spot, but would also have allowed that initial drunken laughter to have confirmed the prevailing assumptions of the occasion. Her overturning of these assumptions was at best only momentary, although in the context of the all-male bastion in which it was achieved, it could also be said to have been momentous in its checking of a sexist onslaught. It was, however, achieved solely as a 'defence mechanism': it was not meant as a calculated attempt at oppositional female humour. As she herself said of her comic retort: 'God knows where it came from' (Caine, 1990: 13–16. 93).[3] Kicking up, as in this case against male aggressors, may therefore be an unintended consequence, an indirect product of the struggle to maintain stage presence, rather than a rationally intended cause of the humour. Nevertheless, the choice of comic target always obtains, regardless of whether it is applied unthinkingly, or is deliberately made as, for exam-ple, in the case of left-wing satire or political cabaret.

THE ANTI-RACIST, ANTI-SEXIST SHIFT

It was perhaps the hallmark of so-called alternative comedy that it delib-erately rejected comic material which was racist or sexist in content and import. This anti-sexist, anti-racist comedy was pioneered at London's cel-ebrated Comedy Store in the early 1980s by stand-up comics like Tony Allen, Alexei Sayle and Jim Barclay, and was directly in opposition to the stereotypical mother-in-law, 'thick Mick' type of joke associated with such comedians as Bernard Manning, Les Dawson and Lenny Bennett. This type of joke was typical of the style of comedy which had hardened in the working men's clubs of the 1950s and 1960s where comedians reeled off, in an aggressive, take-no-shit style of delivery, narratively unconnected reams of short, quick-fire gags, many of them second-hand and taken from general circulation. In certain ways this kind of style and material can be traced back to its roots in music hall, variety theatre and blackface entertainments, but in many respects it represented a stripping away of many other features of its antecedents in comic sketches, stump speeches, trademark theatrical personae and the like.[4] The Sunderland venue and occasion described by Marti Caine was a perhaps somewhat extreme, but

by no means untypical example of club atmosphere in the 1960s and 1970s where this whole comic mode reigned supreme.

What has characterised pub and club comedy most of all, apart from its crude obscenity and its function as an accompaniment to the striptease, are the almost exclusively white male performances and the aggressively masculinist jokes where women, 'queers' and ethnic minorities are the staple butts. In identifying it thus, there is of course a real danger of rendering such comedy homogeneous, and of playing down the skill and virtuosity of the more distinguished artists. Clearly, the comedy of Les Dawson cannot be indiscriminately lumped together with that of Bernard Manning, though they have both made wife and mother-in-law jokes part of their stock in trade, and arguably the figurative inventiveness and comic personae of Dawson were richer, more varied and studied, than is the more unadulterated misogyny and racism of Manning. But the attenuation of music hall tradition and the rigid constraints on variation of content and theatrical presence have applied to all acts in this kind of venue. Despite the restriction on most forms of swearing and the dilution of its clubland aggressiveness and blue material, the influence of club comedy style on mainstream media comedy in the sixties and seventies was pervasive, and not only in its more direct adaptations such as Granada's *The Comedians*. During this period, racism and sexism were common elements of prime time television and radio comedy, tabloid cartoons and comic strips. By the eighties there was a widening recognition that such content was not only offensive, but had also become tired and worn-out.

'Alternative cabaret' performers and certain early Comedy Store novitiates acted on this recognition. As live, stand-up comedy, their work was simultaneously a reaction to the easy, repetitive, stock one-liners of comedians like Jimmy Tarbuck, and more self-aware of its ethical and political implications. There was also in part a move towards social realism in that 'new-wave' comedians built many of their routines around their own personalities and their own everyday experience, around events and situations that were directly personal but at the same time common enough in their general reference – Andy de la Tour's observations on pornographic magazines, or Ben Elton's recollections of student digs based around the communal fringe, are fine examples, but the move has been characteristic as well of artists on the fringe of the 'alternative' scene, such as Billy Connolly and Victoria Wood. In broad terms, the new-wave appeal was to provincial disenchantment and the quiddities of mundane experience, while the performance aesthetic was quasi-punk; but again, it is important to be aware of the many distinctions between various stand-up acts, routines and personae, and to avoid throwing them together holus-bolus

under any single descriptive term.[5] It should also be emphasised that the turn to anti-racist and anti-sexist comedy did not involve any clean-cut break, but rather emerged out of a struggle between what Tony Allen has referred to as 'old-fashioned stuff' centring on stunted, reductive categories – 'Waiter, waiter, there's a racial stereotype in my soup!' – and the attempt to carve out new comic areas into which audiences could be drawn in challenge to habitual patterns of response (Wilmut and Rosengard, 1989: 29). Yet what actually constituted 'alternative' comedy, and the manner in which it was realised, cannot be generalised, except perhaps in relation to its ethical influence, though this in itself has been variably inflected.

The degree to which it was politically oppositional was relatively short-lived, and confined more to its initial movers and shakers, though again not in any easily pigeon-holed manner. The early alternative comics were all left-wing, but both their political alignment and their approach to the 'political' in comedy were in various ways quite different. For example, Keith Allen's anarchic individualism diverged significantly from Alexei Sayle's identification with the working class and anger at their mainstream cultural under-representation. The so-called 'second generation' who developed in their wake – Mayall and Edmondson, Richardson and Planer, French and Saunders, among others – did not have the same 'definite political motivations', though they generally held left-wing beliefs, and tended to see themselves 'simply as comics'. Politics and comedy are an unpredictable, hazardous mix. The message can easily override or annul the funniness of an act, lead to charges of preaching, self-righteousness and sanctimony, and of course be quite dangerous – Keith Allen was once knocked out by an angry soldier for a joke about the Hyde Park IRA bomb which blew up an RAF band (the reason for this being, according to Allen, because they were playing out of tune) (Wilmut and Rosengard, 1989: 47–53). As Jerry Palmer has neatly put it: 'excessive contentiousness produces offence instead of humour, excessive politeness produces boredom: one of the arts demanded of the comedian is the ability to tread this dividing line' (Palmer, 1987: 175: see also Palmer, 1994, Chapter 13). This is always a perilous exercise. Returning to our opening assumption, comedy only seems to be innovative, to break with what has become well tried and stale, when comedians dare to take risks, to let the antic demon work its mischief in the dark corners of taboo, to tempt offence in the interests of defying boredom. The 'second' generation of alternative comedians broke new ground in other ways aside from pouring the volatile liquids of politics and comedy together, though as a stand-up comedian Ben Elton is the most obvious (because most

successful) exception, and it is significant that they tended to operate more with character sketches, comic narrative and parody rather than stand-up, in writing rather than performance, of which Elton was a key collaborator.[6] The Young Ones (BBC TV 1982–4) was the cream of that development, and its imaginative challenges were more to the limits of conventional TV than to the political establishment or the neo-liberal values of the New Right.

For reasons of revenue, ratings and the constraints of state control, politically challenging material is the exception rather than the rule in the broadcast media, and despite what we might want to say of our little comic demon, it would be naive or idealist to expect television or radio comedy to be any different to other genres of programming. In view of this, it is important to give credit to the more indirect way in which change has occurred, that is not so much by overt attack on the openly identified values of racism and sexism (though of course, and quite properly, this has occurred) as by tackling the issue at the level of content through the refusal to make women or ethnic categories the subject of comic abuse.[7] One of the beneficial effects of this refusal has been that its influence has been considerable without the need to resort to official compulsion. Such humour on stage or screen is now less common, and even comedians who have in the past relied heavily on such derogatory jokes, Jim Davidson being an example, have now toned down their acts and become more self-conscious of their content, uttering disclaimers or resorting to narrative devices designed to shield the teller from the attribution of racism or sexism. Another strategy adopted in media and stage comedy is the modification or softening of the negative stereotyping of minorities or out-groups by the tellers of jokes presenting themselves as stupid and/or relatively powerless – this is, for instance, something which distinguishes Roy 'Chubby' Brown from Bernard Manning. Manning's comedy remains resolutely unaffected in the virulence of its offensiveness to women and non-white ethnic groups.[8] Yet what is in some ways a further indication of the degree of shift to a more socially responsible attitude in professional comedy was provided by the controversy following a performance given by Manning to 300 police detectives at a charity dinner that took place at the Park Suite, Haydock Race Course, near Liverpool, in March 1995.

Manning was the star guest. He referred throughout to 'niggers' and 'coons', talked of feeling 'like a fucking spot on a domino' when he visited Bradford, spoke in disparaging tones of special Asian television and radio programmes – 'You've never heard such shit in your fucking life' – and commented on the Rodney King beating by police in Los Angeles: 'I

thought, fuck me, that's not on – not enough police there'. The audience was all-male, and the one black officer present at the occasion was singled out for special attention. Manning asked this officer if he considered 'having a night out with nice people' preferable to 'swinging through the fucking trees', and then went on: 'Do you think it makes any difference what colour you are? You bet your fucking bollocks it does.'[9] This typical club performance by Manning was roundly condemned, particularly in view of its all-police audience. The Chief Constable of Greater Manchester, various MPs and even the Tory Prime Minister, John Major, commented adversely on it (the *Guardian*, 26 April 1995). Such condemnation signifies the extent to which there has been at last a modified change in public recognition of the moral depredation caused by racist terms and racist humour. Yet there is little room for complacency. Manning remains representative of this kind of comic abuse in pub and club comedy, and he's not simply relaying at a different level the usual content of 'canteen culture' in the British constabulary, for what was noteworthy about the charity dinner at Haydock was the seniority of the officers involved. Crude racism was being encouraged and applauded at command level, rather than being confined to offensive banter among 'ordinary coppers on the beat'.

ELITISM IN ALTERNATIVE COMEDY

In the face of Manning's abhorrent racism, not to mention his equally unadulterated misogyny, the stance taken by alternative comedy would appear to be obviously all to the good. Yet such comedy has displayed continuing forms of bias and discrimination. Most importantly, it has remained elitist in that the majority of alternative comedians have been male, white and heterosexual. Certainly, there have been important exceptions, including among the women Pauline Melville, Helen Lederer, Jenny Lecoat, Linda Smith and Claire Dowie, as well as others already mentioned. But there have been fewer female stand-ups, primarily, it would seem, because of the various disadvantages they face. Three in particular are worth mentioning. First, as we have seen with Marti Caine, heckling can be both aggressive and crude. Some female comics have responded to this by themselves being aggressive and crude in their stage act: an obvious example is Ellie Laine. The principle here is one of attack as the best form of defence. As Adele Anderson has put it: 'I was very worried about being vulnerable because I felt that if I did open myself up then I would be torn to pieces' (Banks and Swift, 1986: 18). Women are undoubtedly heckled for reasons of gender, and the 'worst heckling tends to be of women by men' (Wilmut and Rosengard, 1989: 220). In Donna McPhail's view:

'With men, it comes from being intimidated by a woman onstage and trying to humiliate her' (Cook, 1994: 229). Most male comedians talk of being occasionally heckled, but Rhona Cameron's experience is of being heckled all the time 'because I'm a woman and seem very confident. Men will think, oh – who does she think she is, and try to challenge that.'[10] Jo Brand, in particular, has been the target of fierce, misogynistic abuse, particularly at student gigs. As she puts it:

> But when I go in and say, 'The way to a man's heart is through his hanky pocket with a bread knife', the male students haven't reached the stage when they've got enough of a developed ego to be able to withstand the irony of that joke, and just have a laugh about it. They're also far more right wing than they used to be, and if they're not more right wing then they're completely politically illiterate.
>
> (Cook, 1994: 152)

Second, 'an attractive woman telling jokes is a potential threat to women in the audience' in a way in which a stereotypically handsome male comic is not (Banks and Swift, 1986: 22; Cook, 1994: 206). Common ways of reducing this threat have been to adopt conventionally unattractive character roles, and to engage in self-disparaging humour. Third, there is the question of who to make the comic butt. Some female comics simply invert sexist humour, turning their wit and invective on men. Jo Brand and Jenny Lecoat have been brilliantly inventive in this regard, and such ridiculing of men does at least serve to redress the balance. These kind of jokes, and what Dillie Keane has called the 'bash-'em-over-the-head-I-want-to-talk-about-thrush-and-menstruation' approach, need to be understood in the context of a long-established tradition of male-dominated and male-orientated comedy (Banks and Swift, 1987: 185). Both are very much a retaliation against this tradition, albeit largely in it pre-alternative manifestations where women figured among various inferiorised 'others' as stereotypical butts of the humour. While they bring various advantages, though, the problem with all the strategies of response and manoeuvre we have mentioned is that they either imitate too completely in-yer-face, male forms of performance, indirectly endorse patriarchal values and expectations, fail to challenge conventional gender roles and identities, or border closely on self-hate, as for instance in Joan Rivers' comedy. They are strategies of adaptation rather than of subversion. This is true also of female comedy which turns sexist jokes on their head: inversion is not the same as subversion, or changing the frame. Yet it is

difficult to see how truly alternative strategies can develop and flourish while the majority of performers, scriptwriters, show-business impresarios and media executives are male.

The same applies to anti-racist comedy. On the cabaret circuit, both black performers and black punters are rare: black comics in particular are even more unusual than women comics. This is not surprising when most of the humour, although eschewing any racist content, is nevertheless framed within a white perspective and deals mainly with white experience. There are now a few black comedy venues, such as London's Hackney Empire and Birmingham's The Cave, but these are isolated cases. As for television, Lenny Henry is a singular exception proving a white-dominated rule. The comedian Felix Dexter finds that 'the TV establishment is resistant to black artistes in general', and without a fundamental erosion of this resistance, black comedy will remain under-represented in mainstream broadcasting. In Curtis Walker's view, major media breakthrough represents the only substantial way forward for black comics: 'The ultimate aim of every comedian is to get on TV and until that happens regularly, there's nowhere for us to go' (Cook, 1993). The situation is even worse for black political cabaret, which is doubly disadvantaged by being both 'alternative' and 'black'. This means that black political comedians run twice the risk taken by their white counterparts. Even the fact of being a comedian who is black is politically resonant, as a contributor to a Radio 4 programme on 'alternative' black comedy commented:

> Any black comedian who steps up on stage in this country and talks on their own terms is already making a political statement because that has never been the way. Some of the questions we are asked about how black is our material, you wouldn't get Irish Scousers being asked how scouse is your material or how Irish is it. Just by being yourself in a climate which is often hostile to you and your culture, you're making a political statement.[11]

As these examples demonstrate, politically correct comedy in the 1980s served a useful, if self-regarding purpose at the time, but was limited in the longer term by the inherent contradictions of political correctness as a strategy for dealing with the ideological dilemma which we sketched at the start. Although one can demonstrably and commendably strive for political correctness in comedy, this doesn't alter the relationship between dominant teller and the 'other-who-is-told', even if told afresh. Political correctness remains a symptom of the construction of otherness, for even when it inverts it, it is still pivotally dependent on it for its practice of

comic innovation. It is still semantically moored to it in its own distinctive version of the art of being funny.

POLITICAL CORRECTNESS AND HUMOUR

In June 1994, damages of £5,900 were awarded by an industrial tribunal to a Northern Irishman, Trevor McAuley, who had been subjected to a torrent of anti-Irish jokes at his place of work. These constant jokes and jibes were ruled as tantamount to direct racial discrimination, and part of the award was made for 'injury to feelings' (the *Guardian*, 8 June 1994). This ruling led to the usual taunts of PC lunacy – would Scousers or even 'Essex girls' now be able to claim they are victims of racial discrimination? – and commenting on the case in a feature article, Suzanne Moore noted that two things seemed to be most at stake in the controversy. First, there is 'that untouchable institution, the great British sense of humour' where 'not being able to take a joke is the ultimate sin'; and second, there is the fear that such rulings interfere with freedom of expression (Moore, 1994). With respect to the first point, what has to be remembered is that racism and sexism radically diminish the status of their object. Their occurrence in humour is often claimed to annul this diminution and thus render objections to it ineffectual. After all, as the claim has it, it's only a joke and if you don't laugh you have no sense of humour yourself. This claim usually relies for its credence on the ambivalence which is inherent in humour as a specific form of discourse, or what Palmer has called the 'logic of the absurd' by which it operates – a particular combination of plausibility and implausibility 'unequally balanced in favour of greater implausibility': it is then the 'implausibility of what is attributed' which 'disarms criticism' (Palmer, 1987: 198–99). The elements of greater implausibility may appear to undermine the plausibility of behaviour or traits attributed to the comic butt, yet the ambivalence which is built into the semiotic dynamic of the joke-structure means that where 'a particular audience is already ill-disposed toward the butt of the joke, then it will no doubt be inclined to accept the attribution' (210). The favourable audience response to Manning's Haydock Park performances provides a graphic illustration of this. In this way, then, the removal of humour from the serious domain 'makes it useful for certain serious purposes' (Mulkay, 1988: 138).[12] The serious purpose in sexist humour, for example, is the definition of patriarchal/masculine otherness in terms of demeaning and insulting stereotypes, the consequence of which is to reduce the claim of 'the other' to equal status in our common humanity. As Moore puts it, what is offensive about sexist and racist jokes is that 'they are used to tell you

that you are reducible to nothing more than a "thick Paddy", "a daft bimbo" or another "crazy nigger"' (Moore, 1994). While acknowledging that using the law in this way is a heavy-handed way to deal with the issue (a point made by the psychiatrist and broadcaster, Anthony Clare), Moore then dealt with the second point by asking if making people think a little more about the implications of the language they use – the clichés and codes relating to the stupidity of Irish people, blacks or women – really constitutes a great assault on their freedom. For what characterises such language is not its creative freedom, but its numbing conventionality.

Deborah Cameron has more thoroughly analysed what is involved in representations of the advocacy of non-racist and non-sexist language as an attack on freedom of speech. She has shown that resistance to these particular forms of 'verbal hygiene' are not only motivated by hostility to multiculturalism or feminism, but in many cases reflect 'a second and deeper level of disturbance to people's common-sense notions of language' (Cameron, 1995: 121). Two key examples of this kind of response are Robert Hughes's *Culture of Complaint* (Hughes, 1994) and Christopher Hitchens' reviews of this book (Hitchens, 1993 and 1994). Among other things, both argue contradictorily that 'euphemistic' labels and 'speech codes' do nothing to alter oppression and social disadvantage, and that such PC practices abuse and pervert language. The first charge obviously carries some weight when, in Barbara Ehrenreich's words, 'there is a tendency to confuse verbal purification with real social change' (Ehrenreich, 1992: 335: cf. Hughes's, 1994: 20 on the 'linguistic Lourdes' of PC-speak), although this tendency is more often assumed than demonstrated. Unqualified Whorfian conceptions of language are rarely made in defence of 'PC' language, whereas the quite different view that particular forms of language help to naturalise and reproduce certain values and beliefs is now a prevalent one.[13] As Cameron puts it, 'drawing attention to someone's use of language is one way of making previously unremarked assumptions manifest to them, and this can on occasion be the first step in changing their attitudes.' It can, in other words, begin the process desired by Ehrenreich. There is, therefore, 'nothing trivial about trying to institutionalise a public norm of respect rather than disrespect, and one of the most important ways in which respect is made manifest is through linguistic choices' (Cameron, 1995: 142–3). These choices relate closely to the dilemma with which we began, though again we should stress that the choices involved in progressive comedy should not be conceived as between absolutes, but rather as among particulars.

The second charge seems, in its general usage, to assume that there are fixed and shared meanings attached to words: it is these which are being

abused and perverted. The radical case for 'verbal hygiene' argues to the contrary, that linguistic meanings are context-dependent, and 'a crucial element' of context is formed by 'the power relations operating within it'. For this reason, it is 'always worth asking why, and from whose point of view, one way of using language seems obvious, natural and neutral, while another seems ludicrous, loaded and perverse' (Cameron, 1995: 157–9). The charge that PCers are infringing freedom of speech, or seeking to control what we laugh at, is then in Cameron's analysis more a sign of resentment that received wisdom about language is under challenge. The questions that are brought by this challenge are precisely: whose language?, whose humour and comedy?, whose freedom of expression? What these questions entail is the politicisation of language and comedy, or rather that the political issues involved in symbolic lexicons and the comic dramaturgy of identity have become more visible and prominent. What is now more fully discussed and debated are the norms and conventions attached to words, to figures of speech, to jokes and comic narratives. To see this as an infringement of freedom of speech seems in this respect to be itself perverse, in the sense that it can be argued for as an expansion of the basis for such freedom, but that it may seem to demand compulsion and ideological control is perhaps more to do with the ambiguities and confusions generated by PC and the 'PC wars' than with an outmoded conception of language.

PC has been bred from the splintering of politics into separate campaigns, and distinct identity concerns, which can no longer be subsumed under any one overarching category, such as that of social class. It is concerned with a politics of representation, and articulates an alternative recognition of power as dispersed across a range of public and private spheres, and as constructed within different orders and practices of discourse. It is a multiple, fragmented phenomenon which itself reflects the multiple, fragmented politics of our time, and which for that reason traverses the left/right divide and divides the Left against itself (Hall, 1994). At its best, PC may be understood as the effort 'to respect each politically constructed identity, culture and lifestyle on its own terms' (Ohmann, 1995: 17). While this itself carries with it various problems of moral and cultural relativism, what is in a sense a more distinctive feature is that the term does not refer directly and singly to any particular reality: it is rather an ideological category whose meanings have shifted fluidly according to location and purpose. This means, as David Chaney has pointed out, that 'there is an infinite regress of correction because language is not being shifted towards more accurate forms of representation but rather is being remodelled towards continually changing expectations' (Chaney, 1994:

122–3). What this ignores, however, is that the term is now largely viewed in a negative light as a result of its reconstruction by the Right. In this respect it is riddled with irony.

For example, its earliest use on the Left appears to have been as a way of satirising those whose 'correct lineism' showed a moral self-righteousness and an absence of humour (Epstein, 1992; Isserman, 1991; Perry, 1992), whereas in the 1990s the term has been redeployed by right-wing critics as part of the institutionalised political backlash against sixties liberalism and the alternative politics of the counter culture. The irony is not only that this backlash often includes the charge of PC humourlessness, but also that it is itself 'a triumph of the politics of definition, of linguistic intervention' with which right-wing politicians and Murdoch-owned newspapers have sought to discredit the 'loony Left' (Cameron, 1995: 123). A further irony is that in its current, mainly derogatory sense, it is used in reference backwards to what was not, in exactly the selfsame way, PC under another name – that is, the policies and positions of the Greater London Council and municipal socialism in the early 1980s, which is now part of the broader context in which alternative comedy has to be historically understood (see Hall, 1994: 166, 171–4; also Syal, 1994, and Livingstone, 1987, particularly Chapter 7). Now of course, what subsequently became defined as PC in Britain was not only the result of a concerted campaign of tabloid vilification, but also a symptom of the failure of political will and direction on the Left, particularly during the second Thatcher administration and since. At its worst, PC has descended into a 'dystopian orthodoxy of sanctioned discourse', a 'self-indulgent substitute for politics, a holier-than-thou moralism of the good, a politics of surfaces and gestures' (Chaney, 1994: 122; Ohmann, 1995: 19). In such manifestations, as Stuart Hall has pointed out, PC betokens a latter-day Puritanism: 'A strong strain of moral self-righteousness has often been PC's most characteristic "voice"' (Hall, 1994; 168: cf. Appignanesi, 1994). This takes us back to our caveat about the use of comedy as a political vehicle, and in response to this 'voice', it is not difficult to imagine our little comic demon rubbing his hands with glee at the unabashed meta-comment uttered by Billy Connolly following a joke about cleft palettes: 'This is not politically correct. I am fucking delighted to say this is not fucking politically correct!'[14]

Connolly's delight in this comment derives from the comic resistance to what is morally forbidden or tabooed, which was our initial point of entry into the debates about political correctness. Viewed another way of course, it could also be said to bolster the prejudices which have formed around the now-common reactionary use to which the term PC is put. Both PC as

moral authoritarianism and the right-wing ideological capital made of it demand the defiant attention of the comic demon. The key question is always which way the defiance turns. What is good about demons is that they are always up to no good. That is why they are both attractive and repellent. Our little comic demon can, like any other demon, be either genius or fool, be at work in favour of the powerful or the powerless. In this instance, Connolly invokes its antic spirit only against the moral compulsions of PC. With this limitation, it is of course effective, and we certainly have need of it. Our comic sprite is spun into agitated defiance not only because of PC's divisive vanguardism and nominalist tendencies, but also, and more importantly, because of its attempt to 'police' it, to codify it into a 'correct' position.[15] In such cases, it will always kick out, whether the target is up or down the status hierarchy. PC's major weakness lies in its sense that one, true, correct position will naturally be established after all the nasty boo-words have been dispelled, and only politically 'nice' jokes will be told. It is this, most of all, which makes the comic genie push up hard against the cork in the bottle. To quote Chaney again:

> To recognise the dramaturgy of others' forms of life is respectful and enlightening, but to assume that difference commands an autonomy in description and imagination that must be protected by sanctions . . . is to create a barrier to intercourse that is the antithesis of tolerance. The reflexivity of culture demands that we are continually open to the play of other perceptions not isolated by self-serving fictions.
>
> (Chaney, 1994: 123)

This is well put, but if the folly of so-called PC is to believe that the 'truth' can be legislated into existence, this should not diminish the attention which PC, in its more radical forms, has drawn to the fact that language and discourse are not politically innocent. Rather they are areas of struggle over how people are categorised and represented, over how diversity is constructed and how difference is negotiated. The influence of this on professional comedy has at least encouraged performers and audiences to be more sensitive to the stereotypical content of jokes and comic routines, to the variable category-relationship between comic, butt and audience and the implications these have for structures of power. Now of course 'winning identification' is always about more than this. In its own way, it is clearly progressive for Ben Elton to do a stand-up routine on menstruation, demonstrating how attitudes to it would be considerably different if it

happened every month to men. But either as a performer or writer, he is a member of a socially dominant category. There are obvious and important exceptions, but male, white, university graduates like Ben Elton have too generally been typical of what alternative comedy is taken to represent. The gender of a comedian always affects the production and reception of comedy, and in this case it signals a politically 'right-on' man using stand-up comedy as a pulpit, rather than a female performer speaking as a minority member of a male-dominated tradition and, against the grain of that tradition, finding humour in her own experience.

CONCLUSION

There can be no significant context-shift until members of subordinated groups are the ones who are telling the jokes, regardless of their content. Indeed, in such cases the material may be similar to 'politically incorrect' comedy. But the change in identity and role produces a more telling change in the context in which humour is conveyed and received than would be brought about by a white male heterosexual comedian adhering to an anti-racist, anti-sexist, anti-homophobic 'correct' line. A classic example of this is where a black comedian tells a white audience that they all look the same to him. Another is provided by Jenny Lecoat in her satirical take on the 'feminist comedian': 'Hey, look, women menstruate and that's *Really Important*' (Gray, 1994: 148). A line like that could not easily be transposed into the 'motormouth' of Ben Elton. It is, then, the shifts in comic discourse, as political correctness potentially 'declines' or becomes diluted, which are significant, and lesbian humour has provided some relevant examples of what this involves (see e.g. Pershing, 1991, and Chapter 8 in this book). These shifts represent an opening-up of creative public space for minority groups – or at the very least, for white, middle-class women – in terms of comic possibilities, which of course were initially opened up by politically correct humour, but which stand now to supersede it. Potentially, this could lead not only to new cultural ground but also to new social relations in comedy. For example, as progressive humour creates a greater acceptance of members of minority groups as legitimate 'tellers' in stage and media comedy, this may facilitate a greater opportunity and scope for the comic exploration of character, which would then replace the dominance of social category in politically correct humour. This may then become the point of most significant advance in post-alternative comedy.

The most successful female comics to have emerged over the last fifteen years or so have all at certain times done stand-up routines, or have

combined stand-up with other elements in a mixed variety-style assemblage. Yet this particular comic mode has a definite masculine stamp on it, and as we have seen, it has not been easy for women to work within it. It may be that stand-up could become further transformed, though there are few immediate signs of this happening.[16] Where female comics, past and present, have particularly excelled is in character studies. We remain agnostic as to whether there is a distinctively female as opposed to male humour, but there is no doubt that this kind of comedy is one which women have made a speciality. There are of course male comics who have worked successfully in this area, but in contrast to stand-up, character studies have acquired a definite female identity. Contemporary performers such as Victoria Wood, French and Saunders, Helen Lederer, Pauline Melville and numerous others have, in such studies, been building on a distinctive female tradition of comic monologue that extends back to revue performers of the mid-century such as Joyce Grenfell and Hermione Gingold, and to character comedy as developed by music hall artistes like Jenny Hill, Bessie Bellwood, Vesta Tilley, Nellie Wallace and Marie Lloyd. It was this tradition which tended to become submerged during the ascendancy of the club style in the 1960s and 1970s, though performers as diverse as Beryl Reid and Eleanor Bron continued to work in it. The major difference is that the focus is 'not just on the line or the delivery of the joke' but equally on 'the performance, the concept behind it, and the character' (Vicky Pile, cited in Banks and Swift, 1987: 209). In the hands of Victoria Wood in particular, whether as a writer or performer, the comic possibilities of 'ordinary' characters are drawn in such a way that they exceed 'ordinariness' and reveal the tensions and contradictions of women's experience beyond the hackneyed repertoire of female impersonation. Most importantly, Wood, French and Saunders and others use comic licence not as a means of controlling exteriorised 'others', but as providing access to a territory in which gender, identity, sexuality, language and social experience in everyday life can be creatively explored.

In Stuart Hall's view, the 'really difficult task now is trying to hold fast to some perspective of changing the world, making it a better place, while *accepting and negotiating difference*' (Hall, 1994: 18; emphasis in original). Accepting and negotiating difference was perhaps the key PC task for male alternative comedians. It is of course an important as well as difficult task, but for women the emphasis may be rather different. It could be said that, for women, it is the unbridled comic exploration of the experience of 'being female', with all the diversity of cultural affiliation and identity this involves, which now counts. In Helen Lederer's words: 'the battle is not focusing on difference but trying to get into being female and being as

funny as we can' (Banks and Swift, 1987: 32). In the light of this distinction, creating the need for an 'alternative' alternative comedy may turn out to have been PC's most significant legacy. One of the directions in which it now most fruitfully points is the comic scrutiny of identity and subjectivity. It is in the spaces created for this comic scrutiny that the critique of sexism and racism in comedy may be said to have had a more satisfactory and lasting consequence. Indeed, for the present, no other means of avoiding the horns of the dilemma posed by political correctness seem to be possible in contemporary stage and media comedy.

An abbreviated version of this chapter was given as a talk at the Gender Studies Research Forum on Gender in Literature and the Media at Loughborough University on 25 October 1995. We would like to thank the organisers and members of the forum for the opportunity to participate in this event, and to the School of Human and Environmental Studies for help with research funding.

NOTES

1 For some of the problems associated with the concept of the stereotype, see Pickering,1995, and the various references therein.

2 The phrase 'a licence to be silly' is Jenny Eclair's (see Cook, 1994: 287). Jenny Eclair won the 1995 Perrier award for comedy, and was the first woman to have done so.

3 See also Banks and Swift (1987: 14) for a somewhat different, orally related version of the story.

4 For recent critical work on British music hall and minstrelsy, see Bailey, 1986 and 1994; Bratton, 1986; Bratton et al., 1991; Pickering, 1993; Russell, 1987.

5 For such differences, see Wilmut and Rosengard, 1989, and Cook, 1994.

6 Both Edmondson and Saunders have denied that they were stand-up performers in the conventional sense, and in the French/Saunders act, 'there are few actual joke lines, the humour being more in the performance, which they honed into detailed character studies' (Wilmut and Rosengard, 1987:66, 75).

7 As Dave Hill puts it, tilting the comic prism to refract light sharply and critically on the misogynistic and xenophobic abuses of traditional comedy has been a significant achievement, and he quotes Alexei Sayle: 'One of the things I'm proudest of is that a couple of us in alternative cabaret brought that non-sexist, non-racist thing right into the mainstream in Britain which is a fantastic achievement. A lot of comics would like to get rid of it, but they're not allowed to, and I think that's great' (Hill, 1993).

8 For example, Manning's unabashed stance is indicated by the title of one of his videos: An Unbelievably Dirty Evening with Bernard Manning and Sixteen Young Strippers (Polygram Video Ltd., 1994).

9 This performance by British comedy's Humpty Dumpty from Hell was covertly taped and excerpts broadcast in a World in Action programme, 'Black and Blue', ITV1, 24 April 1995.

10 This quotation is taken from a discussion on male and female comedians held on Radio 4's The Locker Room (May 1994) between Tom Robinson, Rhona Cameron, Micky Hutton and Stewart Lee.

11 Joking Apart: Black Comedy's New Wave, Radio 4, March 1995. Thanks to Alec Hargreaves for this reference.

12 See Pickering, 1994 for further elaboration of this issue in racist and sexist humour.

13 The linguist Benjamin Lee Whorf argued that language structurally conditions human experience and observation, that we understand such notions as time and space, or natural phenomena, because of the grammatical structures of our language and the available lexical resources it makes available to us. His most famous example is his comparison between understandings of time in relation to the Hopi and English languages (see Whorf, 1956). One of the abiding problems of this is that, paradoxically, it argues for cultural relativism on the basis of linguistic determinism. Such determinism is total, ignoring, or at least playing down, differences between specific discourses within a language, or differences between social dialects or subcultural idioms.

14 This line is taken from the video Billy Connolly 'LIVE 1994', Vision Video Ltd.

15 It is easy to slip into short-hand jargon, and it may be useful to add a brief note of explanation here. First, we are referring to the disproportionate emphasis sometimes placed on striving to be first and foremost in denouncing 'bad' verbal practice, with such practice being 'exposed' by the moral zealots of PC more among their political allies than their enemies. In doing so, we are adapting the phrase 'defensive vanguardism' used by Stuart Hall (1994) with reference to PC. While we note the 'defensive' aspect of this in the 1980s as a counter-strategy to Thatcherite discourse, we stress the divisiveness of it as a principle for terminological sensitivity where 'defensiveness' turns into an underhand form of complacent self-congratulation at being morally ahead of the rest. Second, we are pointing up the tendency to operate with a notion of objects of thought as consisting entirely of the words, the names, used to articulate them. To argue that changing names, or the terms of classification, guarantees a change in consciousness and action, seems to us a specious form of reasoning.

16 Allison Fraiberg is more sanguine about the situation in the United States. While acknowledging that 'the field of stand-up comedy is still overwhelmingly male-defined,' she notes that today 'a large number of women nonetheless make their way performing, and headlining, stand-up acts'. She focuses on three comedians in particular: Paula Poundstone, Ellen DeGeneres, and Margaret Cho (Fraiberg, 1994: 318 passim).

BIBLIOGRAPHY

Appignanesi, L. (1994) 'Liberté, Égalité and Fraternité: PC and the French', in S. Dunant (ed.) The War of the Words: The Political Correctness Debate, London: Virago.

Bailey, P. (ed.) (1986) Music Hall: the Business of Pleasure, Milton Keynes and Philadelphia: Open University Press.

Bailey, P. (1994) 'Conspiracies of meaning: Music-hall and the knowingness of popular culture', Past and Present, 144 (August).

Banks, M. and Swift, A. (1987) The Joke's On Us: Women in Comedy from Music Hall to the Present Day, London: Pandora.

Bratton, J.S. (ed.) (1986) Music Hall Performance and Style, Milton Keynes and Philadelphia: Open University Press.

Bratton, J.S. et al. (ed.) (1991) Acts of Supremacy, Manchester and New York: Manchester University Press.

Caine, M. (1990) A Coward's Chronicles, London, Sydney, Auckland and Johannesburg: Century.

Cameron, D. (1995) Verbal Hygiene, London and New York: Routledge.

Chaney, D. (1994) The Cultural Turn, London and New York: Routledge.

Cook, W. (1993) 'The colour code', the Guardian, 8 December.

Cook, W. (1994) Ha Bloody Ha: Comedians Talking, London: Fourth Estate.

Dunant, S. (ed.) (1994) The War of the Words: The Political Correctness Debate, London: Virago.

Ehrenreich, B. (1992) 'The challenge for the Left', in P. Berman (ed.), Debating PC: The Controversy Over Political Correctness on College Campuses, New York: Laurel.

Epstein, B. (1992) 'Political correctness and identity politics', in P. Aufderheide (ed.), Beyond PC: Towards a Politics of Understanding, St Paul, Minn.: Graywolf Press.

Fraiberg, A. (1994) 'Between the laughter: Bridging feminist studies through women's stand-up comedy', in G. Finney (ed.), Look Who's Laughing: Gender and Comedy, Reading, UK: Gordon and Breach.

French, S. (1989) 'The "healthy" impulse behind sick jokes', the Guardian, 10 May.

Gray, F. (1994) Women and Laughter, Houndmills and London: Macmillan.

Hall, S. (1994) 'Some "politically incorrect" pathways through PC', in S. Dunant (ed.) The War of the Words: The Political Correctness Debate, London: Virago.

Hill, D. (1993) 'Sayle's pitch', the Guardian, 28 December.

Hitchens, C. (1993) 'Politically correct' in C. Hitchens (ed.) For the Sake of Argument, London and New York: Verso.

Hitchens, C. (1994) 'The fraying of America: A review of Culture of Complaint', in S. Dunant (ed.) The War of the Words: The Political Correctness Debate, London: Virago.

Hughes, R. (1994) Culture of Complaint, The Fraying of America, London: Harvill.

Isserman, M. (1991) 'Travels with Dinesh', Tikkun, 6(5).

Livingstone, K. (1987) If Voting Changed Anything, They'd Abolish It, London: Collins.

Moore, S. (1994) 'Laughing on the other side of their faces', the Guardian, 10 June.

Morrison, B. (1987) The Ballad of the Yorkshire Ripper, London: Chatto and Windus.

Mulkay, M. (1988) On Humour, Cambridge and Oxford: Polity.

Nathan, D. (1971) The Laughtermakers, London: Peter Owen.

Ohmann, R. (1995) 'On "PC" and related matters', in J. Williams (ed.) PC Wars: Politics and Theory in the Academy, New York and London: Routledge.

Palmer, J. (1987) The Logic of the Absurd, London: British Film Institute.

Palmer, J. (1994) Taking Humour Seriously, London and New York: Routledge.

Perry, R. (1992) 'Historically correct', Women's Review of Books, 9(5).

Pershing, L. (1991) 'There's a joker in the menstrual hut: A performance analysis of comedian Kate Clinton', in J. Sochen (ed.) Women's Comic Visions, Detroit: Wayne State University Press.

Pickering, M. (1993) 'Music hall entertainment', in G.A. Cevasco (ed.) The 1890s: An Encyclopaedia of British Literature, Art and Culture, Hamden: Garland.

Pickering, M. (1994) 'Race, gender and broadcast comedy: The case of the BBC's Kentucky minstrels', European Journal of Communication, 9(3).

Pickering, M. (1995) 'The politics and psychology of stereotyping', Media, Culture and Society, 17(4).

Russell, D. (1987) Popular Music in England, 1840–1914, Kingston and Montreal: McGill-Queen's University Press.

Syal, M. (1994) 'PC: GLC', in S. Dunant (ed.) The War of the Words: The Political Correctness Debate, London: Virago.

Whorf, B.L. (1956) Language, Thought and Reality, Cambridge, Mass: MIT Press.

Wilmut, R. and Rosengard, P. (1989) Didn't You Kill My Mother-in-Law?, London: Methuen.

INDEX

313